GOING INTO THE CITY

GOING INTO THE CITY

portrait of a critic as a young man

ROBERT CHRISTGAU

DEY ST.
AN IMPRINT OF WILLIAM MORROW *PUBLISHERS*

Excerpts in Chapter 9 first published in *The Village Voice*, a Voice Media Group publication

HarperCollins books may be purchased for educational, business, or sales promotional use. For information please write the Special Markets Department at SPsales@harpercollins.com.

FIRST EDITION

Designed by Lorie Pagnozzi

Library of Congress Cataloging-in-Publication Data has been applied for.

ISBN 978-0-06-223879-5

15 16 17 18 19 OV/RRD 10 9 8 7 6 5 4 3 2 1

TO EVERY FRIEND AND LOVED ONE MENTIONED IN THIS BOOK,
AND PLENTY WHO AREN'T. OTHER PEOPLE ARE WHAT
MAKE GOOD LIVES POSSIBLE.

CONTENTS

GOING INTO THE CITY

INTRODUCTION

Most memoirs fall roughly into four categories. First is a subset of the full-fledged autobiography: *I Am a Big Deal and This Happened to Me*. Second is a specialty of hangers-on, who home in on a single personage, and journalists, who spread themselves around: *Fame: An Inside View*. Third is the song of the unsung hero: *My Adventure*. Number four became a growth sector as fiction and confessional veered into one of their half-assed affairs: *My Battle with (and Triumph Over!) Dysfunction*.

It's absolutely possible to work up a fine book from any of these templates. But none of them is for me. I'm a rock critic for Chrissake, only a teensy bit famous no matter how much of my small pond I hog, who decided early on that intimacy with the truly famous would mess up his response mechanisms and analytic equilibrium. Between my hitchhiking miles and my slum apartments, I've had my share of adventures, but nothing all that spine-chilling or at all epic. I've never overdone drugs or alcohol. Although I write more about fucking than some think appropriate, the nearest I come to a sexual kink is how healthy my appetite is. And although my rebellion against my parents' values was

painful and decisive, I was never anything like abused or neglected. As writers go, I'm a fairly normal guy.

Some might hold that if my life has been interesting enough to write about, it cannot have been normal. As a democrat in all things, I say that's snobbish baloney. All lives are interesting—how interesting depends on the telling. To choose a single example from my favorite art form, consider John Prine's "Donald and Lydia," in which a fat arcade cashier and a buzzcut PFC dream all too separately of a sexual bliss Donald tries his hand at in the latrine. These lost kids wouldn't be much fun at a party. But their story is riveting, and all I can say to anyone ill-informed enough to argue that that's because their lives are abnormally sad is, "If only." It's probably truer that my own life has been abnormally happy. But since I know many others who enjoy their work and cherish their spouses, I'd postulate instead that Prine's tale and mine both fall within normal range. Like most people, I grew up by resolving conflicts and overcoming difficulties less gothic than the dysfunction-hawking norm. What's abnormal about me is every good critic's stock in trade—my sensibility, honed by the excess of thought I've put into my history, my values, and my prose. My zeal at pursuing the fundamental human task of incremental growth is the main reason I get to peddle my ideas about popular music. And it's also why I get to publish a memoir.

Right, I'm the Dean of American Rock Critics. I was present at the creation of an influential strain of cultural discourse that some believe presaged "postmodernism," if that's a selling point. Without half trying, I've met more famous people than Donald or Lydia could dream. Trying with all my might, I've reviewed more record albums than most people could stand. I'm a renowned editor and respected teacher who's published millions of words and five books. All these accomplishments pack enough intrinsic interest to generate some stories worth repeating and some ideas worth hammering home. The informed celebration of

popular culture has been a mission for me, and a memoir is a great place to evangelize about it. It's also the perfect place to expand on the theoretical differences that separate me from my compeers old and young. And of course, it's where I get to put some backstory into those values I put so much thought into.

But I'm more normal than the strange job I made up for myself. My life paralleled a lot of American lives before the Janus-headed quants of the banking and computer industries worked their more-is-less wham-jam on the national weal. It was the explosion of popular culture as both biz and way of art that made rock criticism inevitable, not vice versa. Plenty of baby boomers swam against the suburban tide to reclaim the urban center and then gentrify it past the tipping point. Plenty busted out of the born-again straitjacket like Hugh Hefner and Martin Luther King before them. And plenty found the meaning of their lives in an eros that endures. One of the secrets of rock criticism is that all of us were well-situated to get on top of these cultural developments sensibility-wise, and I in particular had quite the leg up. Not only did my urban journey suit a music whose first major history was called *The Sound of the City*, my religious angst suited a music invented mostly by restless Christians. So did a 1942 birth date that made me a little younger than the rock and roll artists who lit up the '50s and a little older than the boomers who stormed the '60s.

But let me get on my soapbox here. This being American popular music, race greatly complicates the story. Crucial though it was that the cities Charlie Gillett praised were centers of commerce and hotbeds of hippiedom, the post-Great Migration demography in which the term "urban music" would become a polite way to signify "black music" was much more to the point. Most of the white Christians who jump-started rock and roll were Southerners hell-bent on the sin and salvation they equated with the music cannonading out of the new black radio stations. Most of their black Christian counterparts

adapted gospel usages that put a big fat extra layer of African retention on rock and roll's all too fifty-fifty blues-meets-country origin myth. And while African-American baby boomers were buoyed somewhat by the so-called affluent society, capitalism cheated them so callously that they conceived themselves as the black power generation instead.

Romantic marriage—a possibility first explored by the original Romantics that's run parallel to free love in twentieth-century bohemia and proved the preferred domestic arrangement of the '60s counterculture and its children—plays an even larger role in this book than the church and the city. But at first it was a clumsier fit with rock and roll. Shortsightedly, early rock criticism was so busy kicking out the sociosexual jams that it scorned what was called moon-June-spoon sentimentality, and love songs along numb-come-yum or crave-brave-save lines are tricky to bring off even today. Nevertheless, rock generated Our Songs that knew something about love from the beginning—to limit myself to a mere half dozen: Chuck Berry's "You Never Can Tell," the Lovin' Spoonful's "Darling Be Home Soon," John Lennon's "Oh Yoko!," Bonnie Raitt's "Good Enough," Ashford & Simpson's "Is It Still Good to Ya," Marshall Crenshaw's "Monday Morning Rock." And as the music turned out, its mesh with romantic marriage was uncanny. Conceived for teenagers, rock was so fixated on the generation gap that it produced an unprecedented plethora of songs about getting older— and older. As it kept on coming, it demonstrated that a lifetime spent with your first true love was a less naive proposition than cynics claim.

The main way marriage impacted my vocation, however, was intellectually. That's why I feel deprived when, for example, Christopher Hitchens or Ed Sanders or Richard Hell—all of whose recommended memoirs share ground with mine, and all of whom have their reasons—fail to indicate how their wives changed their lives and I bet their work. My '60s partnership with Ellen Willis wasn't a marriage—Ellen didn't believe in marriage. But I pursued it as I would have a marriage. And since Ellen

was both a rockcrit elder and a conceptual dynamo, she set me on the path I've followed ever since. But that path had more bumps and twists than she cared to map out, with me or anyone else. So instead my chief guide has been my legally wedded wife of four decades, Carola Dibbell, who's also a fine rock critic when I can kid her into it. And in the end, her aesthetic ideas and perceptions enriched mine more decisively than Ellen's shaped them. No banal bow to discretion or cool could tempt me to minimize the place of these relationships in my life, or to mince words about them either. They constituted an emotional education more action-packed than my professional progress, and more of a challenge too. Having found all too little writing with useful information to offer in this crucial matter, I've tried to provide a little myself. Till death do us part, my marriage is my most satisfying achievement.

To sum up, then: I Am Not a Big Deal and This Happened to Me Anyway. I hope my story is representative enough to engage readers with only marginal interest in my small claim to fame. But I'm also aware that it wouldn't have come to market if I wasn't some kind of deal—in particular, someone whose appetite for music fuels a knack for aesthetic response, conjecture, theory, and value judgment others find enlightening, useful, and good for a laugh. The biographical info serves to flesh out the critical work, and should—although I've edged away from the first person over the years, I certainly don't abstain from it, and consider any critic who makes too big a show of objectivity a professional liar. I write what I'm proud to designate my journalism as a specific individual whose identity is out front, a thinking human being with all the contradictions, limitations, and biases mortality entails.

Since I'm a critic, however, it had better also be true that works of art themselves have changed my life—otherwise, why bother? So I've paused the narrative occasionally to focus in on some music or a book

or two very different pairs of poems or in one pivotal period a movie and a painting. Especially in my teens and early twenties, these were life-changers and then some—I spent years thinking about *Crime and Punishment*, "Vacillation," *Jules and Jim*, and that Tom Wesselmann nude whose title I don't even know—and the later books loom large for me too. *All That Is Solid Melts into Air* is a bible for a worldwide host of left-humanist intellectuals who will never delve that deep into *Faust* themselves, and *Sister Carrie, The Man Who Loved Children*, and *Mumbo Jumbo* all flout propriety with a boldness that frees their fans to ascribe just as much value to *Plastic Ono Band, Marquee Moon*, and "Looking for the Perfect Beat." But because I love pop for its abundance most of all, I could have picked altogether different records—half a century of grading albums Consumer Guide-style has left me too aware of how much is out there to waste precious cred on pantheon construction. So having put myself in the historical mood by matching the music in my CD changer to the era I was writing about, I geared my critical interludes to what sounded good as I worked and meshed with the way the story was going.

Some consider criticism parasitic, and I agree that it's second-hand—it recycles the energy generated by humans who have made the most of the deep-seated human need to conjure something out of nothing, to add order and beauty to the inchoate world that radiates out from each of us. But in every culture some humans are better at this than others, and as cultures get more complex, the art they produce starts seeming pretty inchoate itself. So criticism conjures order and beauty from that. What sells it is sensibility—a brew of genre knowledge, general knowledge, aesthetic insight, moral passion, palpable delight, prose style, more prose style, and what-have-you. But always lurking in the background is judgment. "Judge not, that ye be not judged," I was warned by Presbyterians who judged plenty themselves, and as the firstborn son of a father with an ego, I was inclined to do

as they did, not as they said. Only then I made judgment a discipline, and by the time I'd reviewed two or three thousand albums—I'm at five times that now—I'd gotten pretty matter-of-fact about it. The trick is waiting for the music to come to you or finding out that it doesn't, then resisting the temptation to fib about the process. This is more exciting work than is often assumed. But it's also harder. To the eternal "Opinions are like assholes—everybody's got one," I just say, "Yeah, but not everybody's got ten thousand of them." It distresses me that the wit of this riposte so often fails to impress the asshole I'm talking to.

I love narrative so much I originally aspired to write novels and then reportage; I love narrative so much I've written a memoir. But since I turned out to be a discursive kind of guy, it's part of my brief to furnish an informed assessment of the critical genre I helped invent and the journalistic culture that made it possible. Hence I've incorporated many abstractions into my tale. Most of these are good English words that I explain in context or employ conventionally enough, but two demand extra elucidation. The first is "contingency," a term I latched on to as an eighteen-year-old who'd abandoned his faith in Jesus Christ and finally found something else to believe in—namely, nothing, or was it everything, or maybe what the anti-Christian Nietzsche called the transvaluation of all values, only he meant something different (because while I agreed and in fact still agree that joy is more moral than pity, I was never quite callow or callous enough to reject compassion per se the way Nietzsche did to get a rise out of us and Ayn Rand did to get laid. That's why I became a leftist when I grew up, and remain one). I explain contingency three different ways: once in the college chapter, once in the '60s chapter, once in the *Voice* chapter. That more or less gets it—finalizing the idea would betray its spirit. Nuff said? In a contingent world, mais oui.

The other abstraction at issue is "theory of pop," which as I've noted in the introductions to each of my previous non-Consumer Guide

books was never a theory at all, although Willis and I called it that in conversation and might have formulated a real one had we stayed together. Here's how I put it in 1997: "I worked from a 'theory' of pop that was more an elaborate hunch. In essence it asserted the aesthetic and political equality of not just 'folk,' not just 'popular,' but crass and abject 'mass' culture. Naive, defensive, and/or self-evident although the point may now seem, it felt essential in a reflexively hierarchical cultural environment to argue that rock and roll was 'art' every bit as worthy as the English lit of my baccalaureate and the jazz, classical, and folk to which it was invidiously compared." And as I went on in 2000: "These hunches, which I shared with hundreds of thousands of contemporaries who never got them into print, have had a strange history. There's a sense in which they now enjoy more currency in academia, where they inform the cultural studies movement, than in rock criticism, where the old anti-'commercial' tendencies mocked throughout this book have been bulked up into a worldview by the runaway growth of what I call semipopular music." (Oh yeah, "semipopular music." Er, "music more popular in form than in market share." At least when it starts out. Under the rubric "alternative," now also an established image-making strategy that informs many of the "brands" ambitious young musicians concoct for themselves. Stubbornly, I believe semipopular music can be bigger and better than such strategies and also more perverse and ironic.)

I should also mention that in this century, confusingly in my opinion, the term "pop" has been absorbed by the "anti-rockism" debate that began in Britain shortly before *Going into the City* ends. From the beginning I found this kerfuffle asinine, mostly because I'd always thought "rock" *was* "pop." But under the terminological circumstances I'd best emphasize that the concept of "pop" was not a major rock-critical preoccupation in the '60s. Instead, even those of us who cared about pop focused on an amorphous "counterculture" with which all

rock critics identified, usually from the margins. To a person we celebrated and critiqued the vagaries of hippies, radicals, space cadets, weekend potheads, and under-assistant West Coast promo men as reflected in the art form that fed their heads. In an America where most rock musicians of any status had been folk musicians not long before, rock criticism was soon dominated institutionally by simplistic folkie notions of authenticity and the folkie assumption that the music business was bad until proven otherwise and probably after. The term "rock," as opposed to both "pop" and "rock and roll," became a metonym for this counterculture.

Willis and I didn't think it was so simple, especially since we didn't regard "commercial" as a self-evident insult. The mere fact that the theory of pop we failed to finalize was pro-"commercial" set us apart—especially since we were also unusually explicit about our political proclivities. But as *Creem* came along to challenge *Rolling Stone* and the alt-weeklies sorted themselves out, we picked up allies—although by then we weren't a "we," with Willis devoting her theoretical energies to the women's movement while I parceled out letter grades as the Dean of American Rock Critics. "Pop" didn't work out as well as we'd hoped, that's for sure. But as cynical reactionary moneybags launched a counterattack on idealistic counterculture lazybones that necessitated, among other vile maneuvers, new degrees of corporate integration in the culture industry itself, our political fantasies worked out even worse. That was the real problem.

With a little noodging from my friends, I decided I had a memoir to write in 2007, the year after I was offed by the Arizonans who'd overrun New York's self-proclaimed weekly newspaper. But since I lacked both a raconteur's comprehensive recall and a raconteur's willingness to make shit up, I knew my memoir wasn't going to be written from

memory except in the most general way, especially given how much bil-dungsroman there'd be in it. Once I bore down, buried details from fifty and sixty years back did rise to the surface, and I had already told some stories many times. But so as not to make shit up, I imposed guidelines. Most important, I kept dialogue to a minimum. In a few cases—"I don't even care if she's Jewish," "I was just thinking about you"—I'm as posi-tive as can be that the wording is precise, and even that doesn't mean I'm right. But at the very least I'm sure that what little quoted speech I retained for pace or drama meets the accepted journalistic standard of scrupulous good-faith approximation. In addition I double-checked key exchanges and nailed down stray details whenever the relevant princi-pal was alive and findable, interviewing dear friends and people I hadn't conversed with in half a century. Sometimes they had no memory of the incident that meant so much to me, and sometimes they concurred with my account. But in some cases they corrected me on matters large and small and almost always they provided context I had forgotten or never known. I should also add that I respect discretion enough to have changed a few names, although not many.

In addition to rereading many touchstone books, I delved into aux-iliary history (special thanks to Chris Miller on Dartmouth, Alice Echols on the women's movement, the tendentious but thorough Kevin Michael McAuliffe on the *Voice*, and a search engine that will remain nameless on matters large and small). My published journal-ism provided recollections, facts, and the occasional scrap of language, as did my unpublished journalism. My old friend Larry Dietz lent me his complete bound *Cheetah*. Notebooks from my early twenties were essential to the chapter called "American Studies." And I read a lot of my own letters—to Ellen Willis and Greil Marcus and my parents and my college girlfriend and my well-organized Dartmouth classmate Bill Hjortsberg (who'd prefer that I and probably you call him Gatz). I also examined letters from all these people and many more. The col-

lege correspondence alone took me two weeks to plow through, and provided a major chunk of that chapter's material—most decisively as regards my callow and clumsy romantic progress, malfeasance, and travail. And that requires more exegesis.

As indicated, I first conceptualized my life by isolating the four themes adduced above: religion, popular culture, romantic marriage, and going into the city itself. But schemas seldom work out as planned. Going into the city proved more substratum than theme, and religion, while formative, faded from my story not too long after it faded from my life. Popular culture as concept and content, on the other hand, has been my intellectual reason for being, nourishing almost everything I write and in my backpack whenever I foray into such territory as Jimmy Carter, yogurt, or banksta crap. And of course, the pursuit of romantic marriage has proven equally foundational.

I don't mean just emotionally or intellectually in the way already described, although this is where I should report that the recall of the storyteller I married is all over the final third of a book I decided to end with our hard-gained parenthood. I mean that the emotional growth was also intellectual growth, and that this is especially true insofar as sensibility is intellectual. Both my emotional capacities and my critical acuities were shaped and enlarged not just by Ellen but by my college sweetheart and several other women I cared for. But all of us still had a lot to learn, and the marriage proper dwarfed all the earlier love and growth that made it possible. The therapeutically correct thing to say now is that Carola and I have a lot to learn even so—that the process is never-ending. And in the sense that life starts changing as fast when you're eighty-five as when you're fifteen, that's all too true. But only in that sense. How far we've come right now is our joy, our pride, and the reason I ended up writing so effusively about my rather vanilla love life. OK, maybe it was just the excuse. I do think the stories are pretty good.

Since I'm hardly self-effacing in print, my regular readers get this.

In the '10s, when I got to know my fanbase via the commenting community generated by the Expert Witness iteration of the Consumer Guide, I wasn't surprised to find that this self-selecting band of aging male music obsessives—a type whose male chauvinism goes back to the blues boys of the '60s—were a lot more into their wives than demography would predict. They too know the intellectual and aesthetic benefits of the uxorious way of knowledge—the way it compels you to understand, enjoy, and occasionally adore at a higher level of empathy and intensity. There are other ways to gain such listening skills, of course. But the self-renewing enthusiasm of my marital relationship obviously has its correlative in my continuing musical engagement. That's why I think romantic marriage is so suitable for rock critics like me—and her. In the manner of the musicians we love, we're just trying to carve out some room, explore a few ideas, and have a little fun without ever lying about what feels truest to us. We're inspired by these artists' all-out emotion and all-in turns of phrase, their sweet sincerity and ungodly jokes, their starry eyes and reluctant compromises and normality and determination to go on. I've spent my life trying to pass those truths on.

One of my favorite rock and roll songs ever is Jessie Hill's "Ooh Poo Pah Doo," a 1960 hit I first heard or maybe just noticed on a reissue that came in the mail in 1986. That kind of belated discovery happens to critics more than it does to almost anybody, and in this case it helped that the critic in question had taken it upon himself to dance his one-year-old daughter to sleep every night—finally a girl who could follow his lead! Hill's record is famous for its title and beloved for its groove, as it should be. But its genius moment is a single climactic line: "I won't stop tryin' till I create a disturbance in your mind."

Me neither.

1

THE EIGHTY-HOUR WEEK

In my Manhattan dining room hangs a framed enlargement of a family snapshot my dad inscribed "Asbury Aug. '40." Let's guess it was taken Saturday, August 3, the day after laughing Virginia's twenty-third birthday. She's my mom and quite a looker: curly brown hair surrounding a heart-shaped face with a bow mouth and big brown eyes. Gamely she stands midair on a platform of crossed arms provided by her lean and beaming blue-eyed George, still a fair-haired boy at twenty-four, and a beer-gutted, pipe-clenching older guy believed to be the mysterious Uncle Wally. A slighter and swarthier figure of a man peers around his athletic son-in-law while steadying his daughter from behind: my beloved grandfather Tom Snyder, cherishing his sole offspring as always and as always enjoying whatever entertainment comes his way. Dad wears trim trunks, Mom a fetching one-piece. From the canopied boardwalk in the background, three well-dressed elders smile down upon the fun.

A lifetime later, my parents' sexiness in this photo still awes me. They look like they're having one of those perfect days nobody gets enough

of. Thinking about it, I recognize that this reach for heaven is temporary and if you want to get technical about it an illusion. Sexually, as my father will confide when I'm twenty-four myself, "the earth didn't move" for Virginia until two years after they started trying (which was, believe it, their wedding night). Historically, World War II is on its way to America, and although my father won't join up, he'll put in four years of eighty-hour weeks as a New York City fireman and continue to labor just as hard firefighting and moonlighting until he retires from the NYFD in 1961. Yet as a rock critic I refuse to deny the reality of that illusion.

My parents' youthful aura isn't an act—it springs from an innate vitality they're making the most of. Married not quite a year after five years of putting it off, their imitation of teenagers in love is convincing because in love they remain. As the O'Jays put it in one of the many songs to have a go at the idea, these young marrieds are living for the weekend, achieving a liberation so fleeting some would hold it's no liberation at all. But one aim of my vocation is to map such liberations, which for many Americans are the main thing the pursuit of happiness means. Because my parents settled just a few miles from where their not-so-distant ancestors got off the boat, they were a little less American geographically than their fellow Germans who migrated into the heartland. And by that token they were also more urbane, very much New Yorkers—luckily for me, highly intelligent ones. But even after they started subscribing to *The New Yorker* soi-même in the '70s, they were never sophisticates. They still equated the pursuit of happiness with a day at the beach, although by then it was Robert Moses's Jones in Nassau County rather than Bruce Springsteen's Asbury Park on the Jersey Shore. I've put in many eighty-hour weeks thinking about all the things that might mean.

For as far back as our scant family lore goes, all the Christgaus and all the Snyders were New Yorkers. My surname is apparently Danish—

there's a snapshot of my globe-trotting maiden aunt Mildred in front of a Christgau Kaffe ad at a bus stop in Denmark to prove it. But my Christgau forebears were German—Schleswig-Holstein, my dad ventured. North German for sure. Protestant. My mom's side were Snyders who arrived as Schneiders. South German for sure. Catholic. We assume both sides were first-wave immigrants. My father's people still spoke a little German when I was a kid, and supposedly the first American Schneider was born on the boat in New York Harbor in 1860, though since he squeezed eleven kids in before Grandpa Tommy was born in 1888, maybe not. Tommy did like to tell stories.

Both families were from Ridgewood, on the Queens side of the Brooklyn-Queens border. When Clara Helmke married George Lawrence Christgau in 1908, they bought a brownstone off Fresh Pond Road that remained Christgau until Aunt Mildred moved to a senior residence in Flushing in 1995. The Snyders were more footloose; after my mom married, Williamsburg-raised Tommy led his Kitty even deeper into Queens—to a neat, upwardly mobile little apartment in Forest Hills, which he decorated by gluing photos clipped from *Better Homes and Gardens* to burlap-covered wood. The two clans were very different and very stereotypical—the North Germans stiff-necked, the South Germans fun-loving. My mother marveled that my dashing dad could have come out of "that family." But don't infer hostility there; my mother was an agreeable woman who kept her smarts sheathed. An only child, she brought her parents to Christmas with the Christgaus—Mom and Pop, they were called by their children and then their grandchildren—where Tommy's presents were the main event. Sometimes he'd backbite coyly about how cheap the Christgaus were, and I'm sure they tsk-tsked over his spiked Manhattans, easy tears, and spendthrift ways. But such conflicts were muted and rare. These were placid, ordinary people.

Yet as I delve deeper I wonder how placid and ordinary they really were. Since I'm about to bombard you with a bunch of names that will

disappear from my tale as fast as Uncle Wally's, I'll simplify things by organizing possible exceptions in the outline form I was taught in elementary school. I'm pretty sure this is the first time I've employed that tool in my professional writing career.

1. Above all, intermarriage, in which my mom and dad had plenty of company. Protestants marrying Catholics may not seem like much in the twenty-first century, but in the early nineteen hundreds it was verboten—so much so that when Protestant only child Catherine Neu married Catholic letter carrier Thomas Snyder, her printer father fled New York, emigrating with her mother to San Francisco. Two of Tommy's siblings married Protestants and converted, and one of their kids married a Catholic, and on the Christgau side my paternal great-grandfather Henry Christgau, who owned a bar on Spring Street off the Bowery, wed an Irish girl after my great-grandmother died. Then there was Tommy's legendary stepbrother Leppy, orphaned child of a Jewish family next door who Tommy told us had been raised by his own mother. Then he went his own way. That was a strange story.

2. A modicum of madness. One of Tommy's brothers spent half his life in Queens Village's notorious Creedmoor, and a sister tried to gas herself with her husband after he had a heart attack (she failed, he didn't). Also, both my grandmothers suffered "nervous breakdowns," Clara Christgau after a second daughter named Ruth died in infancy, Kitty Snyder after Tommy was arrested in a Times Square men's room circa 1952.

3. Failure to propagate. By my count, Tommy and his many siblings had only four children among them. What I know about his family setup is: father hardworking steamfitter, mother hardworking saint, thirteen children, four dead in infancy. So maybe things weren't as colorful as Tommy made them sound when he wetly whispered Williamsburg tales to his "firstborn"—that is, me—in front of the electric fireplace in Forest Hills. In any case, no one in his enormous

family had more than two kids and many were childless for reasons unknown. Some Catholics they were.

4. A miracle. The German migration to Ridgewood from Dutchtown on the Lower East Side was sparked on June 15, 1904, when some thousand would-be picnickers from St. Mark's Lutheran Church on East 6th Street burned to death or drowned after a criminally ill-maintained excursion boat called the *General Slocum* caught fire on the East River in one of the worst naval disasters in history. About three hundred survived, including my grandmother, Clara Helmke, and her cousin, Etta Tinken. Supposedly Clara made it ashore carrying her shoes above her head. They were, after all, her best shoes.

5. Lives in the arts.

a. Tommy started frequenting Broadway shows as soon as he had some silver in his pocket in the '00s and kept it up once installed as a postman at the now boarded-up Stuyvesant Station on 14th Street near Avenue A. One of his stories recalled the time he and his sister Betty sang at a party for society bandleader Vincent Lopez, and I have a framed photograph of him entertaining the Christmas revelers at Cravath, Swaine & Moore, the white-shoe law firm where he took a post-retirement messenger's job after failing to find late-life employment as an interior decorator. Tommy is tomming a little—acting the fool for posh straights happy to give it up to someone better at blowing off steam than they are. But he's also showing off, and he's also having fun. I figure he's regaling the swells with a song lost to history called, he always announced, "Hyman Goodman Was a Scootsman," although usually he rolled his pants up to simulate a kilt for that one, and in this picture he can't because he's holding a cocktail.

b. In his youth my dad was taken up by an arty unmarried cousin of his mother he called Aunt Louise, who lived off a small annuity and liked to paint. Enjoyed classical music, too, I was told. I never

saw a smidgen of that in my dad. But Louise could be why he read Thomas Wolfe and Kenneth Lewis Roberts. Or maybe it was the Leopold Schepp Foundation fellowship that insisted he abjure "trashy magazines."

c. My dad summered as a teenager with the former Etta Tinken and her husband, George Sturmer, in Rhinebeck, north of the city. This Uncle George—there were many Uncle Georges—was an electrician who owned a gas station. He was also the head of the volunteer fire department and the local bootlegger. Many decades after I learned this, a nonagenarian family friend phoned me out of the blue and told me something even more surprising: that before moving upstate George Sturmer was a high-living limo driver for the Broadway stars. Whenever we visited the Sturmers in the '50s, I thought they were even more boring than Mom and Pop. Appearances are deceiving? By then they were? Or both?

I feel obliged to bring up this marginally remarkable stuff because I'm so invested in the idea of the ordinary. What's always given me something special to write about is a gift for finding the putatively ordinary complex, fascinating, and inspirational, often in terms typical of the bohemian folkways that informed my journey from Queens back to the Lower East Side, where Clara spent her girlhood, Tommy delivered the mail, and I've lived my entire adult life. That's not all I do as a critic, but it's near the center of it. My friend Greil Marcus once wrote a terrific book about Bob Dylan's *Basement Tapes* that was initially called *Invisible Republic* and then underwent a title change after its central conceit caught the literary fancy: *The Old, Weird America.* I prefer the invisible republic notion myself. In fact, shortly after the book appeared I wrote a Willie Nelson piece that ended: "If Bob Dylan seeks to capture what Greil Marcus has dubbed 'the old, weird America,' then Willie Nelson is after the enduring, commonplace America. One is as great a mystery as the other."

So the story I have to tell is a lucky one of a commonplace and, in the unlikely event that later generations are as lucky economically as mine, enduring kind—as I like to say, a democratic kind. Of course I struggled—whenever someone doesn't, figure a poorer person put in the time for them. As it happens, I underwent considerable spiritual torment on my way to a critical semi-populism more optimistic than most, just as I underwent serious spells of loneliness on my way to a life partnership that means more to me than any words I've written or music I've heard. But these adversities were within normal range, and they gave back. The particulars of my journey brought me to not just any city, but a metropolis so blessed with multiple perspectives that it's also beset by self-regarding myopia. New York isn't the easiest place to be an American democrat. But it has some major advantages, and listening to too much rock and roll enhances them.

My parents were golden children in a just barely lower-middle-class way. Tommy adored his bright, fun-loving, petite, delicate wife, Kitty, who still had her waist-length red hair when she died at sixty-nine, and adored his barely taller and even brighter and prettier Virginia just as much, although Virginia would have traded some of that in on a sibling or two. She graduated at sixteen near the top of her class from Grover Cleveland High School, where she won a French prize she finally put to use on her Quebec honeymoon after Dad's old Plymouth bit the dust. Christened George Henry and named for his father George Lawrence and his grandfather Henry, my father was the child Clara bore after the doomed Ruth and, crucially, her only boy. Called "Brother" in the German manner by his mother, the grossma who cared for him while his mother continued to languish, his two sisters, his aunt Louise, and his reserved, prematurely bald, headache-prone father, he was a lively, forceful, handsome, well-built presence in a hyper-conventional family,

a gifted athlete with brains who in eighth grade won that Leopold Schepp fellowship, which guaranteed him college tuition after he graduated from Brooklyn Tech. Where he very nearly bombed out.

My mother didn't attend college because she was a girl and it was the Depression. Instead a cousin's husband found her a secretarial job with the German-American pencil manufacturer Eberhard Faber. My father didn't attend college because he played too much ball. And even if he'd pulled better grades, his family didn't have the money for college, scholarship or no scholarship. Soon after the crash of 1929, his father's solid bookkeeping job went the way of his permeable stock portfolio, instilling in all the Christgaus an obsessive lifelong frugality. When he finally found work, through his church, it was a night job as a bank guard that he held on to for thirty years. Pop was a high school graduate and a Mason whose brother Bill had gone to Dartmouth on a football scholarship. But although there were no Masons, college boys, or annuities in Tommy's family, simply by cashing a government paycheck for forty years he ended up with slightly more money and professional status. Classwise the two were pretty far down and just about even up.

Since this is no way a dysfunction saga—Tommy's Manhattans lubricated him without pixilating him, Mom and Pop were repressed but not repressive—it's axiomatic that Virginia and George were instead living out upward mobility sagas. Back then that's how it worked in most American families of limited means, a vast swath of citizens who assumed that material comfort—not luxury, not culture, just some combination of security and pleasure—was a precondition of the happiness their liberty freed them to pursue. And for both of my parents, as for most such ordinary strivers, upward mobility also involved a gentility quest. But within these parameters the two young Queens German-Americans were rather different.

Virginia was her parents' daughter. Like them, she was a Catholic who attended mass without getting heated about it. Built into her

notion of gentility was the lesson in tolerance of their intermarriage, and like interior decorator manque Tommy, she was interested in beauty as well as respectability. Dad was much less his parents' son: a rebel, albeit one without a single act of defiance brazen enough to have entered the annals. Although his animal spirits and male privilege instilled in him a cockiness reinforced by his success at sports, where he learned to augment his real but sub-championship strength and speed and coordination with stamina, tactical cunning, and a bold look in his eye, he also wanted things he couldn't compete his way into. Aunt Louise had taught him that genteel needn't be stodgy, and although he'd screwed up Brooklyn Tech, he believed in educational self-improvement. Because Virginia was an A student who knew French and aspired to refinement without being phony or gauche about it, she spoke to these ambitions. Yet unlike the Christgaus, she knew how to have fun. And she was a beauty.

So in the lore, my fourteen-year-old dad is throwing snowballs from a roof with his Middle Village friend Artie Arent when he spies a girl in a green coat and declares her off limits. It is also Artie Arent who four years later engineers a maneuver in which my father ends up on a date with a friend of the girl Artie has his eye on. In both cases the girl Dad has his eye on is Virginia, and in the second he's quickly hooked. Protestant was no big deal for my mother, who'd survived a breakup with a Jewish boyfriend in high school—a breakup forced by his parents, not the Snyders, whose idea of making it was the predominantly Jewish Forest Hills apartment development where they'd end up. But for the Christgaus, Catholic was a big deal, and shortly after the two started dating, Pop mysteriously decided to take Brother on a cross-country bus tour. This ploy failed as Virginia applied herself to the test with long, immaculately typed letters from Eberhard Faber. My sister, Georgia Christgau, read from the first at Virginia's funeral in 2007. It begins with a sentence I like so much I quote it at

any excuse: "I've got so much to say about nothing that I don't know where to begin."

This was clearly too delightful a prose stylist to pass up, and before long George popped the question on the raft in Lake Peekskill forty miles upstate, where yet more Snyders had a country place; ever confident, he had the ring in his trunks. The engagement lasted so long my mom never got over it. But she hung in at Eberhard Faber while her affianced sampled jobs—Macy's shoe salesman, pioneer air-conditioning technician, Con Ed meter man. They were finally married on Tommy's fifty-first birthday, September 16, 1939, at Ridgewood Presbyterian Church—Virginia converted. Putting their disastrous Quebec honeymoon behind them, they settled into a three-room apartment in Elmhurst, a few stops on the IND from the spiffy new Snyder place in Forest Hills. Tommy decorated it. The piano he'd bought Virginia for graduation was a showpiece.

I don't read music or play an instrument. When piano lessons were forced on me at eight, I refused to practice because I preferred reading; when I hired my own teacher at forty, I failed to practice because I preferred listening. So I don't want to make too much of my musical background. But like many striving Americans and many German-Americans, my family was into the piano. My mother executed show tunes as well as she spoke French and used to play to calm herself before giving a dinner party. My father's Schepp application listed the piano along with carpentry among his extracurricular interests, but in his adulthood he played strictly by ear, keeping time with a rocking-chair left hand as he picked out melodies with his right. Aunt Mildred knew enough music to change keys and was the de facto pianist at Ridgewood Presbyterian for half a century. Tommy could execute a mean "Dill Pickle Rag" and (my mother claimed al-

though my sister disagrees) not much else. But my parents were also music consumers, and not just of the sheet music they kept in the piano bench. Their other prized furnishing was a mahogany Emerson radio-phonograph console, and they owned three or four dozen seventy-eights: Glenn Miller, Artie Shaw, Frank Sinatra, and my two favorites, Bing Crosby's "Swinging on a Star" and Fats Waller's "All That Meat and No Potatoes."

I can only surmise how Mr. and Mrs. George H. Christgau spent the two and a half years before Robert Thomas Christgau was born on April 18, 1942—in Manhattan, at St. Vincent's Hospital in Greenwich Village, a Catholic institution renowned in my parents' world as the best place in New York to have a baby. But I wouldn't have begun with that snapshot from Asbury Park if I didn't believe they had some fun. The real downside of that reach for heaven isn't how sexy they were or weren't—it's the eighty-hour week my father had in store. Strong though he was, George was still haunted by the Depression as the world underwent yet another crisis. So as Nazi Germany overran Europe and 1940 turned to 1941, he decided on a career nobler and more promising than Con Ed, and after some night classes joined the fire department. Nor was Mom exempted from the breadwinning—pregnant that July, she stayed at Eberhard Faber well after she started showing. Yet the will to fun stayed with her. According to the lore, she took me to hear Sinatra at the Paramount while I was in the womb, but that can't be. Sinatra's conquest of the bobby-soxers commenced December 30, 1942, when I was eight months old. So presumably the story got embroidered; presumably Virginia carted Robert over to her parents and, at twenty-five, went to see Frankie on her own. That's just as good a story by me. You go Mom.

All her life my mother's verbal abilities were channeled into the Sunday crossword, the church bulletin, and her sweet, shrewd, putatively modest conversations with her girlfriends, husband, and chil-

dren. But in 1986 my sister tapped this natural resource by asking her to review a Fred Astaire VHS for *High Fidelity*. Under protest, Virginia came up with four hundred words, then stonewalled Georgia when she tried to edit them for publication. So Mom would be appalled that I'm quoting them here; if she was right about heaven, she *is* appalled, although I hope eternity has softened her up a little. Anyway, here are her three grafs, untouched except for a few typos and some title itals. The lead really does need work.

That Adele Astaire's younger brother, Fred, was already a performer at the peak of his own career at the time his partnership with Ginger Rogers began in 1936, is evidenced by the writers who produced the words and music for his film songs. Jerome Kern—Dorothy Fields—George and Ira Gershwin—Harold Arlen—Johnny Mercer—the names read like a "who's who" of American popular music.

And they did well by Fred. Many of the tunes are still being heard today, almost 50 years later. They managed to achieve a lively diversity in spite of having to accommodate the range of the music to his rather thin baritone and somehow in spite of his vocal limitations Astaire managed to imbue his songs with the same style and elegance—"class" if you will—that was his trademark. Above all, of course, was the beat, for you were always aware that at some point in the singing the dance would begin. And with Fred Astaire, that was what it was all about, wasn't it? Whether in a ship's engine room with the marvelously innovative "Slap That Bass" (*Shall We Dance?*) or on a dancing school floor when, with "Pick Yourself Up" (*Swing Time*), Fred almost convinced dance instructress Ginger that he had two left feet, it was, after all, the dancing that you had come to see.

These movies, with their songs and dances, belong to an historic world in which you had to have change of a quarter to get a pack of cigarettes; a movie world where people drove their cars with the tops down in a snow storm and never got wet or felt the cold; where Ginger could emerge from her room in the

middle of shampooing her hair to listen to the smitten Fred singing "Just the Way You Look Tonight" (*Swing Time*) and have the shampoo wreathe her head like an attractive turban, not a false eyelash out of place, mind you, or a smear to her lipstick. But no matter . . . what does matter is that on these tapes we have preserved the magic of an inimitable performer. His grace and charm, his consummate dancing artistry, and yes, even his singing, have been made available for all of us to marvel at and enjoy. Forever?

My mother is quoted in my Nat King Cole piece for the *Voice* and the Tom Jones-Engelbert Humperdinck diptych I wrote for *Newsday*, where her "What seemed to be so natural with Tom Jones with this guy is so contrived" elicited a heap of hate mail from the Nassau County chapter of Housewives for Humperdinck. A fifteen-minute chat with eighty-year-old Virginia inspired an add-on graf—about sex, fancy that—for my Frank Sinatra obit. In her Astaire draft I love the quiet female pride of the Adele Astaire, Dorothy Fields, and "instructress" mentions; the cigarette metaphor from someone who hated smoking; the un-final "Forever?" I note that "class," her quotation marks but also her aspiration, is a praiseword I distrust. And this is the place to mention that even more than the piano, my parents loved to dance. Virginia had lessons from Tommy, but my sister thinks George was even better: "When I danced with Dad, *I* knew how to dance. People don't talk this way anymore, but he knew how to lead." Their specialty was the Peabody, a quick ragtime one-step partygoers would stop dancing themselves to watch them execute. Unfortunately, the grace my dad showed off with Virginia in his arms was one of the many physical gifts he failed to pass on to his firstborn.

Because firemen with children couldn't be drafted, Dad credited me more than once with saving him from that. Saving him from what

we never discussed, but I believe there were two answers: leaving his family and learning to kill or be killed. Cowards don't become fire-fighters, and my father's competitive mettle was a wonder, but he had so little taste for violence that he was never even much of a football, boxing, or hockey fan, preferring baseball, basketball, and especially tennis, which he taught himself against a handball wall. It's true that Ridgewood was a stronghold of a pro-Nazi German-American Bund divided into "Gaus," as the Nazis designated regions, and Americans of every heritage took anti-Semitism for granted back then. But I never got that vibe from the stodgy Christgaus. They were too mild, and probably too Christian too, to do much hating. I know there must have been a learning curve about tolerance in there. But I also know that Aunt Mildred, a quintessential old maid whose conversational staple was long tales in which a stubborn woman bested a mealy-mouthed retail clerk, developed a very-late-life gentleman friend she'd met during her decades of service to Christian Endeavor. Because we thought of Mildred as a comically conventional person, everyone was amused when this friend turned out to be African-American. But no one was astonished, much less offended.

Yet though Dad didn't want to leave his family, the twenty-four on and twenty-four off into which the fire department divided his eighty-hour week that was actually eighty-four cut drastically into his face time with me and my mom. Much later a therapist would find it very interesting that my early life consisted of a full day's unimpeded access to my wondrous mother followed by a full day of losing her to my won-drous father. And lose her I did. Although my father taught me that real men love babies—repressed though they were, the Christgaus were kissers—his competitive mettle was especially well-developed when it came to female attention. He would have hogged my mother for my entire childhood except for one thing—over the dozen years after World War II ended, the eighty-hour week remained his norm. My father wasn't a workaholic. He didn't work because he couldn't stand

not working or didn't want to be home; in a formulation I took to heart, he defined a job as "something you don't want to do." But because the Depression was a trauma he never forgot, he was an indefatigable provider—always earning, always saving, always on the lookout for ways to improve our lot. And when he was out earning, my mother was boss. She was no pushover. But she was a nicer boss than my dad.

The Elmhurst apartment at 86-22 Dongan Avenue was one of eighty-four units in a six-story yellow-brick building on a dead-end street a few blocks from the IND. My worst memory of the place is the boogie-man stories spun by a girl in a maroon coat in the empty lot across the street, my happiest the daily walks I took with my mom to the hedge at the end of the street, behind which chickens scurried and squawked because that's how Queens was back then. Dimly, I remember being scared of the dark and struggling with the lampswitch when I heard Daddy come in the front door; vividly, I remember Grandma and Grandpa taking me to Coney Island for the day—Grandpa couldn't drive (neither could Pop), but he loved the bumper cars. What I don't remember at all is the birth of my brother on October 12, 1945. I felt or at least acted protective of Dougie, as he was called until he was in high school—there's photographic evidence. But my competitive feelings were apparently stronger. As my dad's firstborn, I do like to compete.

2

THE TWO SIDES OF MURRAY STREET

Early in 1947 our family of four made the big leap to Flushing, which would remain the center of my Queens for the rest of my life. Flushing is in a part of the borough just out of reach of the subway—what is now called the 7 train and was then the Flushing IRT ends at Main Street, where Flushing begins. Something similar happens in the East Bronx, and in pockets of Brooklyn. But in Queens it signifies not just distance from the center but closeness to the periphery. The city line beckoned the entire eastern third of Queens in the '50s, from South Jamaica through Flushing up to Whitestone and out through Fresh Meadows and Auburndale and Bayside and all the neighborhoods further out. My elders saw Nassau County's lawn-graced, Levittown-style developments as the suburban dream to their half measure. I was one of the war babies whose dreams pointed me back toward the concentration, ambition, and grime of the city.

Shaped like Wisconsin elongated onto a forty-by-a-hundred lot, 43-47 159th Street wasn't the nicest house on a tree-lined block where nearly every dwelling was different, but it was the second-nicest on our side, which is pretty much how we were. Designed by its original owner in the early '20s, it was white with green trim, with a tiny sloped lawn up front and in back a two-car garage and a garden and a big old sassafras tree and two rosebushes my mother loved. There was also a working fireplace my father loved, and early on he built handsome wrought-iron-and-pine bookcases each side of it. So while 159th Street was urban by heartland standards, it was roomy by New York City's. The move took place around my fifth birthday, for which I received a tricycle. We were always landlords on 159th Street—three rooms on the top floor went for forty dollars a month, first to an elderly couple who covered their gray Plymouth between Sunday drives and then to Mrs. Koch and her daughter Linda, whose perfume inspired throat-clutching pantomime by the boys on the stoop. We lived in the finished basement for a while, then moved to the first floor and rented out three rooms below. A little after Georgia arrived in 1950, the whole bottom of the house became ours, and until I graduated from college the basement where all the kids slept was my refuge.

In June I got very sick—measles and whooping cough simultaneously, weeks of fever and my mother's love, with the voices of the little girls next door pealing in through the screen door. The rest of that year is sketchy: coasting down the driveway on my tricycle before lurching right to avoid the forbidden street, the dark-green 1947 Chevy my dad bought for cash, and—this strictly hearsay—sitting on a post office counter singing "Take Me Out to the Ball Game" at the top of my four-year-old lungs. But I know that two other firemen lived on our side, with four cops across the street—the firemen grunts like my dad, one Italian and one Irish, the cops German and Irish officers, with all but one of the six Catholic. I also know that within a year my parents

joined the First Presbyterian Church of Flushing—socially and philosophically, the most important decision they ever made not just for themselves but for their children.

Protestant denominationalism is a puzzle to anyone who doesn't live it and often to those who do, and in New York City it's complicated by both a relative lack of Protestant power and a tax code in which church property remains in God's hands as everything around it is transmuted by capitalism. Take St. Mark's Lutheran Church on East 6th Street, whence sprang the Slocum disaster and the Ridgewood exodus. The modest brick building remains. But now it's a synagogue, its Lutheran remnant having long since moved up Second Avenue to St. Mark's Church-in-the-Bowery, which later turned Episcopalian—and which for the half century I've been an East Villager has been less a church than a do-gooder hub and the arts center where Patti Smith got her start. (The synagogue is now pretty much an arts center too, but that came later.) Over in Queens circa 1908, nominally Lutheran Mom and Pop joined the Ridgewood Presbyterian Church. In their Elmhurst years my parents probably took the Ridgewood bus some Sundays and on others dropped in at the nearby Reformed Church of Newtown or skipped services altogether. For sure they didn't join First Pres because Dad felt committed to Presbyterianism. They joined because First Pres was "welcoming."

Ridgewood Presbyterian was theologically conservative. It promulgated biblical inerrancy and literal salvation from an eternity in hell by the grace of our Lord Jesus Christ, with no hint of "modernism." But First Pres, dominated by a clique of Southern Baptists who'd come north to ply the insurance trade, took conservatism a step further by embracing the term "born again." Our sister churches were North Shore Baptist and Bayside Baptist, both one step closer to Nassau County, and to hear the elders talk, these were the only born-again havens in our sinful quadrant of Queens—even though, as I figured out

decades later, there was a good-sized Church of Christ on the very next corner and a smaller Disciples of Christ congregation a few blocks east. These were ignored on class grounds. Both denominations sprang from revivalist insurgencies against mainline bluenoses, and both attracted vulgar Pentecostal types, including our foul-mouthed, beer-guzzling, exhaust-spewing next-door neighbor Bob Green, the lowest of all the 159th Streeters Mom and Dad looked down on for no readily apparent reason. The more practiced First Pres gentry knew how to do snobbery right—by mixing it with a Southern hospitality that in Queens had the allure of an exotic piece of Americana. "Welcoming" in a way the rigid Ridgewooders never were, they were warm proselytizers for their way of life in Jesus Christ to anyone ready to respect their respectability. This my parents were—my mother especially. In a sense that was why she had come to Flushing. It was why she loved those rosebushes.

First Pres was located at Barclay Avenue and Murray Street, near the Murray Hill station of the Long Island Railroad. In its wittingly plain way the white-shingled sanctuary was handsome enough, and would soon grow a brick annex called Faith Hall. But since this was Queens in the '40s, it was also catty-corner from a Chef Boy-Ar-Dee cannery and directly across from the cinder parking lot and worn brick walls of PS 22, where in September I would begin my eleven years with the New York City Board of Education.

My very bright stay-at-home mother did not teach me to read. The alphabet, sure; the words to "Take Me Out to the Ball Game," maybe (although that might have been Tommy, making up for his inability to throw or catch a ball). Reading, no, and no matter. Due to my April 18 birthdate—April 30 was the cutoff—my parents had the option of enrolling me directly into first grade, and as soon as Miss Buhl deciphered the letters of the giant-sized *Fun with Dick and Jane* for us, I got

it. Picked up that afternoon by both parents (and I guess Dougie in his carriage), I bragged that I could spell three words. One of them was "Dick." Hero worship.

I loved reading so much that I would sneak a flashlight under the covers after bedtime, loved reading so much that the doctor blamed my earaches on it, loved reading so much that I refused to take piano lessons. I was messy and clumsy and bad at art and never began my fifth-grade current events notebook, but my passion for reading was unending. I raced through my mother's Bobbsey Twins books and First Pres's Sugar Creek Gang collection. I read every baseball novel in the Depot Road library and every short story in Grandpa's women's magazines and every children's classic Santa could afford. I read my teachers' kids' discards while slower students got schooled. I read the Bible, absorbing King James English for life. I read *Reader's Digest* and then Reader's Digest Condensed Books and then Book-of-the-Month Club selections as my parents strove to keep me sated. Set on self-improvement, Dad would do *Reader's Digest*'s "It Pays to Increase Your Word Power" with me every month. On Saturday mornings the kids would climb into bed with Mommy and Daddy and examine the colored plates of gems and flags in the three-volume unabridged Merriam-Webster he'd bought. Soon there was a *Columbia Encyclopedia* too, and a Rand-McNally atlas I'd pore over late at night in the basement bathroom.

Even so, I was no kind of star at PS 22. Good at arithmetic, an ace at history, and by no means shy in class, I lacked the girlish virtues—penmanship, neatness, punctuality, neatness, decorum, always doing your homework, keeping your shirttails in, and neatness—that turned Satisfactorys into Outstandings in the grade schools of the time. Yet I was too much of a goody-goody and not enough of an athlete to stand out among the boys. Quick and sure-handed, I was also a shrimp who never learned to punch a spaldeen overhand, and I was pathetic at being bad. Once a moralizing chapter about hooky in a Sugar Hill

Gang book alerted me to a piece of boyhood mischief I'd been missing, so one afternoon I hid out dead bored in one of the overgrown empty lots that were still plentiful in my neck of Flushing and then forged an excuse from my mother, I hope on the typewriter although I may have been stupid enough to try and fake more than her signature. Either way, I got caught. Then there was the Halloween I chalked half an insult about the principal in the PS 22 doorway before proceeding to a First Pres event designed to forestall just such shenanigans—only to be interrupted by Miss Tobin herself, striding indignantly out of the shadows. She probably had dreams of apprehending the Laughlin gang, the chronically Unsatisfactory Catholic punks who were certainly vandalizing something that night. Instead she nabbed Reader Rob, a.k.a. Lose-a-Ma-Thing, the goody-goody the Laughlin gang chased every time he got near their block.

In part because everyone on 159th Street attended parochial school or the bigger PS 107 to the east, I didn't make many friends at PS 22, although I did forge a temporary alliance with a rough sixth grader who was crammed into my 5-1/6-3 when he moved to 159th Street midyear—we had a jolly time with the baseball field we built of Venetian blind slats in a middle room Georgia took over once she was out of her crib. There were, however, three longer relationships that I never forgot even though they existed only in my mind. For two steadfast years apiece, I nurtured crushes on female classmates who shared with my mother academic excellence, good looks, and diminutive stature: Suffolk County-bound June Nienstedt first and second, First Pres preacher's daughter Sherrill Blair third and fourth, and, most significantly, Nan Younger fifth and sixth. I can't have been the only boy in love with blond-ringleted Nan, the prettiest, smartest, nicest, and shortest girl in the class—the girl who had the courage to try and spell "hippopotamus" for Mrs. Villaverde, and of course succeeded, because it's spelled exactly the way it sounds. But I am the boy who walked her

down Murray Street every day at noon and three, parting with a quick left and a quicker bye as she turned toward her big house a block away on 149th Street and I dashed down the hill past Laughlin turf and toward 159th.

P.S. 22 Robert Christgau
5-1 Oct. 26, 1951

My Problems

I have many problems. One of them is playing hard or rough games. I'm not as rough as some of the other boys on the block and the games they play (at some times) seem too hard to me. Another problem is to overcome bad habits such as reading when I'm not supposed to and not paying attention to my teacher, mother etc. My third problem is not to do other things that I'm not supposed to.

As indicated, I was short like my mom, and early on my five-eleven father concluded correctly that I'd never be his match as an athlete. This would be a comfort to him all his life—as a cripple of eighty-eight who thought walkers were for old people, he snorted indulgently when I disclosed that by using me as his crutch in hospital corridors he was pulling my right arm out of its damn socket. But my dad never gave me up for a wuss, a klutz, or a nerd. He played plenty of catch, equipped the garage with a homemade Ping-Pong table, showed me how to plant my feet for a set shot, and always encouraged me to outdo myself.

This could be traumatic—my failure as a five-year-old to locate the needle-nosed pliers in his furnace-room workshop set off a yelling-at I never forgot or forgave. But it could also be empowering—by eight I was playing three-handed canasta with Mommy and Daddy, and canasta is a game any moderately intelligent human can win with a little

luck. Frowned upon at First Pres, cards were a Christgau family tradition and major at my house—I even sat in once or twice when my mother was short a bridge lady. Board games, particularly Sorry and a Scrabble knockoff called Keyword, were also staples. My father was a relentless, analytic competitor in every game he played, and he played to win even when his opponent was eight years old. If I'd never beaten him I suppose I might have been damaged. But sometimes I did.

Physically, however, I remained timid, and the doctor said my earaches required fresh air. So I was forced out among the rough boys, and soon I was a regular in diamondball and punchball and stoopball, potsy and hide-and-seek and ringolevio too. Because I was quick and surehanded and also because I was competitive, I was good enough at these games without excelling, and would play various kinds of ball through high school and beyond. Eventually the older Catholic boys decided to foment a rivalry between me and the Protestant kid across the street, goading us into fights in which I avoided fisticuffs by wrestling him down and applying a scissorlock; when a fat and hapless Jewish kid moved in briefly down the block, they set us on each other with more venom. So I guess I was bullied a little. But this stuff was less scary than the Laughlin gang, who cost me sleep, and even they proved a harmless lesson in gritting my teeth and getting through it. I lost more sleep over my current events notebook.

Occasionally between ages five and ten my father spanked me, bare ass open hand five reps, for offenses that have passed from the record, sometimes after a report from my mother and sometimes because he had a temper. That temper surfaced all his life in sarcastic asides and the occasional tirade, and my brother and sister tell me it remained fearsome until after they were out of the house. But without question it was exacerbated by fatigue when I was coming up. Firemen were forbidden to moonlight, but Dad never missed a chance: housepainting with Artie Arent and solo, selling mutual funds, umpiring little

league, Friday-night bartending at the Sanford Hotel, afternoon hours as a lathe operator without ever having operated a lathe, and teaching shop for the Board of Ed. The last was the big one—a gig he landed four years after becoming one of six city employees to qualify for a tuition-free BA at NYU night school in 1951. He aced a test. It pays to increase your word power.

Dad's eighty-hour week was less '50s ambition than '30s fear, less materialism than frugality, less upwardly mobile than soberly stable. That he could maintain it was a tribute to his physical endurance and his gift for the catnap. But it also reflected his abilities as a hustler. My father wasn't slick, but like most good card players he was shrewd and persistent and had an affability about him. Knowing the fire department was a Catholic fiefdom, he joined the Protestant St. George Association and with an ace typist at home volunteered to serve as secretary. And after Flushingite Peter Loftus became Chief of Department in 1948, he started reporting to the Murray Street firehouse two blocks from church as Loftus's Protestant driver. This was not always a cushy job—it meant working the big fires, the details of which he kept to himself even when he came home smelling of smoke. But it afforded him the flexibility he needed to moonlight and go to college while remaining the kind of family man who painted his green-and-white house gray-and-pink, fixed what got broken, built new stuff, carved out quality time with his wife and kids, and—even after Loftus was forced out in 1955—always managed a summer vacation. Plus some competitive leisure. Whenever he could, he drove to big grassy Kissena Park six blocks away to play tennis, which he'd pursue into his eighties, well after his bad foot was kicking his butt.

Lacking the arm strength to be any good, I quit tennis quick myself—unlike Doug, who did push-ups until he was sinewy enough to captain his college wrestling team and still couldn't beat Dad on the court. That was my pattern with Doug. The day after Georgia was born

in February 1950, I walked him to kindergarten exulting that with a girl in the house we'd soon be off dishwashing duty, but our structural rivalry left me with only one earlier memory of him: the great insulation hustle of 1948, when in return for a banana split at Woolworth's (as with hooky, I was a sucker for delights I knew only from literature) my father inveigled his five-year-old son into spending a Saturday wriggling from a crawlhole to install insulation above the bedroom ceiling as every other kid in the neighborhood built a play circus in the dirt of our backyard. Hot and miserable, I peered out of a vent and Dougie, blond and cute and in my mind gloating although I'm sure he wasn't, grinned up and waved.

Once our sister arrived, however, we became buddies. Quickly figuring out that it would be many years before I was relieved of my gender-inappropriate dishwashing job, I was entranced by Georgia, the wellspring of my lifelong love of babies, and began to take pride in older brotherhood. With Georgia it was play and indulgence and occasional bouts of true responsibility. With Doug there was both the lovelike gratification of nurturance and the vicarious prestige of sponsorship— plus, of course, the ego-building kick of teasing him, defeating him, and bossing him around. Doug wore glasses from age four and remembers himself as passive. But although I was the mouthy one, I was also Doug's first wrestling partner, and he was always game. As Dad's temper got worse, we formed an alliance in which one of us, usually Doug, would report on the emotional temperature upstairs whenever the other entered our basement fastness through the cellar door. All three kids remember the time when dinner at Grandma and Grandpa's ended with an enraged Dad, perhaps after the highball or extra beer he never had at home, storming out toting Georgia over his shoulder as Mommy and the boys trailed fearfully behind. But none of us recalls what set him off. My guess is that he'd suddenly had enough of Tommy "spoiling" us. There may well have been Chiclets involved.

Dinner at the Snyders' was a treat that only started with their unconditional love. Tommy played chef for French fries and potato salad, always served "Jewish rye" from Jay Dee's on Queens Boulevard, and generally slipped me a quarter for an ice cream soda. Best of all were the July events when Grandpa would break out the change jar where he emptied his pockets after every workday. As summer began, he would divide the take equally among the grandchildren. This was a lot of money for a fireman's kid, twenty-five or thirty bucks, and Doug still tears up remembering it. A favorite place to spend our stash was the snack bar of Chenango Valley State Park near Binghamton, where we vacationed every year between 1950 and 1955 in a cabin or tent. Those were idyllic times—hot dogs and marshmallows over the fire, Keyword on the beach lawn, Yankee games on the boathouse radio, the Yankee farm team the Triplets live in town, sunset swimming races with the other men that Daddy didn't always win but never turned down. But Chenango was also the site of two life-altering crises.

The first began at a campground softball game when I was ten. Daddy and I were on opposite sides, and I'd managed to reach first, probably on an error—I was a terrible hitter. The next batter singled, and I seized the chance to show off my speed Phil Rizzuto-style by advancing to third, which was Daddy's position. The throw came in and I slid—clumsily, of course. The first words out of my mouth were "I was safe," the next "I think I broke my arm." Two years before I'd busted a wrist falling from an overcrowded seesaw at a church picnic, but this was much worse, badly dislocated an inch above the left elbow. My dad wept on my chest in the ambulance. They put me under to set it, and when offered the choice between the elbow looking better or moving better, Dad of course chose the latter. But even after it healed I couldn't get my left hand near my left shoulder. And thus—who knew?—I was spared the ordeal of what to do about Vietnam.

In the other crisis, my parents flew into an unusually heated argument

in the car, set off by three kids clamoring in the back and a spaldeen I'd been bouncing off Dougie's head ricocheting into the front seat. After Dad tried to backhand me while driving, Mom started yelling. Two minutes later he pulled furiously onto the shoulder, where they got out and walked through a stand of trees to the shore of the shallow Chenango River, leaving us untended for what seemed like a very long time. When they got back they were lovebirds, and lovebirds they remained until after we returned to Flushing. My wife believes I learned something crucial about marriage that day.

Without any newfangled enrichment strategies—"music appreciation" involved the memorization of ten classical themes, with Grieg's "In the Hall of the Mountain King" an especially faithful earworm—I got a good elementary school education at PS 22: reading, writing, 'rithmetic, "social studies." My appetite for the written word, as well as my competitiveness as regards crossword puzzles and geopolitical factoids, augmented the basics. But it was across Murray Street at the First Presbyterian Church of Flushing that I was given something to think about.

Although like all theologically conservative churches, First Pres was an indoctrination center, with me this backfired. My lifelong taste for abstractions began with the biblical exegeses that were everywhere on Sunday, and my leftism began with 1 Corinthians 13:13: "And now abideth faith, hope, charity, these three; but the greatest of these is charity." As a concept, the avoidance of sin came less naturally to someone whose parents played bridge and danced the Peabody than to, say, John Archibald—whose Scottish-born father, Queens College mathematics professor Dr. Ralph Archibald, led fifth graders through the wilds of the evolution heresy without ever getting down to brass tacks about whether the earth began in 4004 B.C. or Methuselah lived nine hundred years. Nevertheless, I did my best to take sin literally. I never lied

about whether a ball was inside or outside the line; I (almost) never peeked on tests; I censured my father's expletives ("Balls!" "Goddammit!") when he fixed the washing machine (although I did steal from my mother's change bowl to go feast on brown licorice and Mission Orange at the 'round-the-corner store). But well before I started doing my Methuselah math the contradictory complexity of much vaster scriptural concepts was on my mind.

Grace/saved/born again were troublingly elusive. Divine omniscience was a mindbender. And then there was the universal rabbit hole: absolute predestination. I'm not the only eight-year-old to get twisted about whether it was predestined that I'd be sitting under the sassafras tree pondering predestination instead of watching the ballgame on TV. The empiricist version of the same question—"the problem of determinism," it's called—has cost many philosophers of science their most productive years, and I pondered it long after I'd become an empiricist myself. At stake always was the reality of individual responsibility. I never went the next step, which is doing whatever you want because everything is "foreordained" anyway. Or maybe I just didn't want that much—in most things I was quite the moral person. But that black hole in which there were no rules was to grow large for me, and still occasionally messes with my head as a solid citizen on the bohemian fringe, situated between do-the-right-thing and anything-is-possible in lifestyle, aesthetic judgment, and the hustlers, idealists, and nuts he sees more of than he would have in Queens.

Soon my interest in abstractions would extend beyond First Pres. The children's classic that topped *Treasure Island* and *Tom Sawyer* for me was *Peter Pan*. What got my attention was its big idea, which synched up perfectly with everything I knew: the proposition that being a kid for life was a worthy ambition. I had it good and I knew it. Watching my father conk out on the couch ninety seconds after he arrived home from doing something he didn't want to do, I became

very aware that I was having a ball even if I couldn't punch a spal-deen overhand. If only Peter Pan could have forgotten Tinkerbell and paired up with Wendy, the nearest thing to Nan Younger I'd encoun-tered in literature, he'd have had life beat. That was my dream, and I thought about it a lot.

By then I'd graduated into the world of grown-up reading, my in-troduction a Book-of-the-Month Club edition of Thor Heyerdahl's million-selling *Kon-Tiki*. Almost as if it's great literature, Heyerdahl's adventure story in which six Scandinavian landlubbers cross the Pa-cific on an unmodified replica of a five-hundred-year-old Peruvian raft has never gone out of print, and when I reread it after sixty years I found out why. This was a page-turner with content. Reencountering the voyagers' first grueling nights at sea, I realized there was no way a nine-year-old could have comprehended their desperate, unyielding endurance—in my mind, that was just what grown men did. But I was doubly struck that I'd forgotten the astonishing sea creatures Heyerdahl encountered mid-ocean. Instead what got my theologically attuned at-tention was his intellectual audacity. I loved and always remembered that this adventure was undertaken not to show off anyone's manliness but to prove an idea—Heyerdahl's theory that Polynesia was populated from pre-Inca Peru.

In the end, I regret to report, he failed to establish his thesis. What he did establish, however, was the narrow-mindedness of the academ-ically certified anthropologists who dismissed this heterodox fancy on the grounds that the Peruvians couldn't have reached Polynesia because they didn't have boats. About that the professoriat was dead wrong. Without an inkling of the DNA research that would eventu-ally support their supposition that Polynesians descended from Asians, they were grasping at the nearest straw to get a vulgarian out of their office. *Kon-Tiki* had many ramifications, from the Tiki Room at Dis-neyland to Heyerdahl's early, influential commitment to ecological

one-worldism. He had constructed what cultural historian Gary Kroll rightly calls an "underdog narrative," and it captured my imagination. So would many others.

When I read *Kon-Tiki*, it was only six years after the end of World War II. But when you're not yet ten, six years is a realm of pure history. For adults, the mythic Pacific that pervaded postwar middlebrow culture was a way of remembering the war not as a European nightmare but as a new chapter in manifest destiny—and to put a happy face on both the atomic nightmare and the prophetically bumbled Korean "police action." For a kid, though, it was just stories: Iwo Jima and *The Caine Mutiny*, which I absorbed at the time, *The Naked and the Dead* and *From Here to Eternity*, which I got to a big five or ten years later. Mailer's novel had its own profound effect on me. But not like *South Pacific*.

South Pacific was a story too, adapted by Oscar Hammerstein II and Joshua Logan from James Michener's *Tales of the South Pacific* to become one of several post-World War II parables of racial tolerance in which Asians stood in for the African-Americans whose even lower status and deeper grievances would soon jolt America's future, and the world's; the major Asian role, Bloody Mary, was played by the classically trained African-American theater-blues singer Juanita Hall. When I finally saw it on Broadway with Grandpa, I had all the right responses to this parable—racial tolerance was an easy sell for me. But I was there because I already loved the music. In our house, *South Pacific* had been a totemic masterpiece ever since the muggy summer night Aunt Mildred babysat and my parents went out to celebrate Virginia's thirty-third birthday. Next morning, Mommy was glowing: "Oh Robert, we saw such a wonderful show last night." Soon the Emerson radio-phonograph had acquired a new status symbol: our first record album, a sturdy cardboard case of seventy-eights featuring every new song Rodgers & Hammerstein had written.

My hostility to the cult of the Broadway musical—and to the Tin Pan Alley pantheon canonized by midlevel songwriter turned nitpicking powermonger Alec Wilder's *American Popular Song*—is informed, considered, and permanent. Early on, the championing of this style was an underdog narrative—an argument for the American vernacular against a Germanophile musicological establishment that protects its academic suzerainty to this day. But classic Tin Pan Alley exploited that vernacular not just to reconstitute the harmonic usages of nineteenth-century classical music but to fend off the impressionist, polytonal, and dodecaphonic avant-gardes. Nor did Victor Herbert, George Gershwin, and the boys have the recorded vernacular to themselves at a time when Louis Armstrong, Charley Patton, and the Carter Family were also hitting the mic. However. Pop music is always about tunes, and Tin Pan Alley knew how to raid the longhairs for them, sometimes whole (Handel's *Messiah*, meet "Yes! We Have No Bananas") but more often by mastering classical's tricky key changes and trickier chromaticism to fashion new ones. And the hugely popular *South Pacific* had some tunes. The one-upping Wilder found them lacking in "fire, impact, purity, naturalness, need, friendliness, and, most of all, wit." But for an eight-year-old the fourteen songs on the original cast album had all of these things except purity, which didn't move him any more then than it does now. And sixty-odd years later they still do. Alec Wilder can go fuck a duck.

It's impossible for me to be objective about music I fell for at eight—music sinks too deep into the nervous system to uproot like that. But I can recollect, and I can count. I loved every song on *South Pacific* except the four by straight men Ezio Pinza and William Tabbert, and the only two I avoided were Pinza's "This Nearly Was Mine" and Tabbert's "Younger Than Springtime"—the first of thousands of male romantic ballads in the general vicinity of what my people soon called schlager to rub me the wrong way. My favorites were the two comedy numbers for male chorus: "Bloody Mary," with its D-word-flaunting "Ain't that

too damn bad," and "There Is Nothin' Like a Dame," revived two generations later by David Johansen d/b/a Buster Poindexter ten years after the New York Dolls were history. But I also felt Juanita Hall in both ballad and novelty modes, fell for the French lesson "Dites-moi" because it evoked my mom, and admired Pinza's aria manque "Some Enchanted Evening" for the same reason plus it was a doozy of a song. And I was knocked out by Mary Martin numbers like "I'm Gonna Wash That Man Right Outa My Hair," which whether or not Hammerstein wrote them funny had a tomboy sauciness simply because Mary Martin was singing them. Her next Broadway role: Peter Pan.

Although our version of *South Pacific* was on ten-inch seventy-eights, one of its historical distinctions is that it was the first megahit LP, perched for sixty-nine weeks atop the chart *Billboard* devoted to the twelve-inch thirty-three-rpm discs Columbia Records introduced in 1948. In 1949, RCA introduced its own microgrooved item, the seven-inch forty-five so beloved of '50s teens. Past sixty, Grandpa thought forty-fives were so cute he bought his own fat-spindled player so he could play the family the new novelty classics "Hernando's Hideaway" ("Olé!") and "The Naughty Lady of Shady Lane" ("And she's only nine days old!"), and soon thereafter my dad equipped our Emerson with a three-speed Webcor changer even though his preference in seven inches of entertainment was the screen of the Motorola TV he'd bought back in 1949 and upgraded to a thirteen-inch Admiral a few years later.

The Emerson remained in a front corner of the living room, where I spent hours on the scratchy wall-to-wall carpet listening to both the radio and the record player. But the TV got its own nook, which my father created by partitioning off the southern third of the dining room with a divider he built, solid on the bottom and divided into big open squares on top. We could all squeeze in there with me and Dougie on

the floor, and sometimes I'd bring my pillow up from the bedroom. Even today I'm picky about my pillows, which look like saggy sacks of junk to everyone else, and one night, having stayed up way past my bedtime in the downstairs bathroom as usual, I discovered that I'd left it in the TV room. It was past eleven. So I tiptoed up the stairs and across the creaky kitchen floor, where at the dining room doorway I was stopped cold by voices from the bedroom. This wasn't like the time I sent Dougie upstairs when Mommy didn't respond to my earachey wails because she was getting busy with my father, who was furious. This was two adults discussing something serious in the night. Afraid they'd hear me retreating, I lowered myself to the floor, eased under the mahogany cabinet in the dining room, and listened.

The general subject was Grandma's "nervous breakdown," which—as I knew because my mother was outraged—had led to electroshock treatments at Creedmoor that didn't improve her nerves in the slightest. The specific was what caused it: Tommy's arrest. When I asked my mother about this forty years later, she indignantly clammed up. So most of what I know I learned hiding in the dark when I was ten, and it isn't much—it was two years before I'd learn the facts of life from a clinical little book entitled *Growing Up,* and five before I'd work from a *Reader's Digest* article to the dictionary and half figure out what "homosexual" meant. To grasp how long ago this was, reflect for a moment that there were public restrooms in the Times Square subway station. One of these was where the incident occurred. Tommy claimed he didn't understand what was happening, that he'd politely complied when some man he didn't know beckoned him I don't know where—into a stall, presumably. There, after who can say what else, the police intervened.

I don't know if there was a trial, only that Grandma had a "nervous breakdown." And I also know that in 1971, a few months before he died stricken with an Alzheimer's that didn't yet know its name,

Grandpa was seized by a compulsion to tell me about his first job. One of the disgracefully few times I visited him at his horrible Bayside old-age home—part of the Bernard Bergman network that Jack Newfield would expose in *The Village Voice* a few years later—we went out for a drive and tried to talk, which with Alzheimer's is never easy. So I listened. Compelled to leave high school to earn money for the family, Tommy had found work as a baker's assistant. And the baker made him . . . well, I don't recall Grandpa's wording, and I'm not even positive who sucked who. He didn't want to. He really didn't want to. But it happened many times, and he felt the need to confess. I told him it wasn't his fault. But before we said good-bye he'd confessed again. He had Alzheimer's, after all.

Overshadowed by an adoring husband five years her senior who swept her away from her family when she was under twenty, Grandma was a sweet, intelligent, affectionate woman. She could be pensive, but she loved to laugh, and having once thought Tommy the most elegant man she'd ever met, she was still cackling at his silly stories and tipsy antics fifty years later. She'd gotten to eighth grade and Tommy to tenth, and although they subscribed to many magazines, there were just four books in their apartment. These were arrayed on top of the TV, where I peered at their spines many times. Two of them I no longer remember. One was by Havelock Ellis and had the word "sex" in its title, but there are so many such that, although Ellis is often credited with inventing the term "homosexuality," I have no idea whether what used to be called inversion came up in that one.

The fourth was a rather dry piece of popular sociology that was published in 1929 and never hinted that homosexuality existed. *What Is Right with Marriage?* counterposed a "domestic theory" of man's troth with woman to the dreamy "schoolgirl theory" and the predatory "tomcat theory." The authors, NYU professor Robert C. Binkley and his wife, Frances Williams Binkley, took a putatively openminded view

of sexual fidelity, an issue they deemed best left to the mutual con-clusions of individual couples. But it wasn't hard to suss out the view they preferred when they observed that "the sex-liberty ideal" was as naive as the "schoolgirl theory," because in both love is "a feeling that comes upon one" without "will-commitment." What my grandparents made of these theories I can't know. But it's clear that feelings had come upon Tommy that damaged his marriage's will-commitment, and probably not just the time he got caught. And it's also clear that he loved Kitty so much that he felt bad about this for as long as he was fully cognizant, and after.

3

THE WONDERFUL
WORLD OF JEWS

When I was ten, the Board of Ed administered IQ tests to all sixth graders. My score, which I snuck a peek at while doing service for my high school guidance counselor, was 139—high enough to qualify me for New York City's SP program and transform my life.

SP stood for the "special progress" of students who proceeded directly from seventh to ninth grade. But in my time, that wasn't all. Later Doug and Georgia would become SPs at a brand-new junior high a mile down Sanford Avenue in Flushing. In 1953, however, New York City was just beginning to convert from a two-tiered system of elementary school through eighth grade followed by four years of high school. Only a few districts had junior highs—seventh, eighth, and ninth grades, where today the trauma centers dubbed middle schools run seven-eight or, more humanely, six-seven-eight. In northeast Queens the nearest one was JHS 16 on 104th Street in Corona. For me, it was forty minutes away—Q65 bus to Main Street, three stops on the

IRT. For the Bayside contingent who dominated the SPs, the trip was longer. But the biggest distance was cultural. Although Flushing was more cramped than Bayside, both were leafy, upwardly mobile, and all white. Corona was Italian working-class with small but visible Negro and Puerto Rican minorities. In a usage that remains remarkably fresh, it was a rough neighborhood. Years later I'd learn that Louis Armstrong lived on an Italian block half a mile away.

I'd never taken public transportation alone in my life, much less to a scary place like Corona. Already the youngest kid in my class, if I skipped I'd be barely sixteen when I graduated from high school. Nor would anyone have called me socially advanced for my age. Yet my father's inclination to give me my head prevailed. Just as he assumed I could find the needle-nosed pliers when I was five and play three-handed canasta at eight, he assumed I could handle the subway and a few tough kids at eleven. I was a smart boy, and this was an honor he wouldn't deny me or himself. How reluctant my mom was I don't know—possibly not much, although somebody must have instigated those family confabs. But I thank my father for the chance.

As it turned out, Corona was exciting, but not too exciting. This was the most urban place I'd ever known. In Corona, the same Roosevelt Avenue that was slightly snazzy in Flushing was under the el tracks, and 104th Street, although no wider than 159th, was a commercial strip with a candy store on the corner and, exotic for the time, a pizzeria—slices fifteen cents, heroes a quarter. Across from the school, by a block-square park where I had my lunch stolen once or twice, a Sabrett's wagon dealt hot dogs with mustard and sauerkraut two for a quarter. Lunchroom lunch was ninety cents a week, but I quickly devised a secret alternate plan, pocketing the change to spend on 104th Street fare and then when I arrived home wolfing down some combination of Quik, Jell-O, PBJ, cottage cheese and sour cream, and the applesauce my mom concocted in her Foley mill. Athletic enough to compete in the schoolyard, I nonetheless spent many lunch hours am-

bulating around the sparsely populated blocks just south playing geography with fat, shy, unathletic Christopher Devine, a future professor of chemistry and philosophy who planned on the priesthood at the time. But I never explored Corona all that much—just handled what I was handed. There was action enough inside the classroom. SP was my introduction the Wonderful World of Jews.

Of the five SPs from PS 22, the only Jewish kid was one of the very few in the school: Peter Drezner, a short, pink, myopic, game-mad doctor's son who would become my best friend. The four Murray Hill goyim were joined in the SPs' 7-107 homeroom by five others, including Christopher Devine and an Italian from Corona who wore his hair in a DA and moved to Nassau County the next year. That's nine in a class of over thirty that split two-to-one boys due to the rough-neighborhood factor. All the teachers were Jewish too. This may seem normal for New York City in 1953, but PS 22 was a neighborhood school with neighborhood demographics; my first- and second-grade teachers, Miss Buhl and Miss Dalton, shared a tidy house a few blocks from mine where I hope but doubt they made sweet love in their off hours, and other teachers lived nearby as well. Because Corona had to import its Board of Ed-certified guardians of gentility, it got better ones. I had such a man-crush on my two young math teachers, Mr. Soffer and Mr. Reznikoff, that I feel as if I loved them all, which I didn't. But from Mr. Gross teaching us four French words for "immediately" to Miss Wolff climaxing her counterproductive weekly music class with her rendition of "Trees," I can still remember every Jewish teacher who oversaw my smart Jewish class in a school short on both smarts and Jews.

Most explicit was Mr. Austern, 9-405's gruff science and homeroom teacher—a bearish man with an unkind sense of humor who pelted loudmouths with chalk and lectured us dolefully as a group when Jewish nogoodniks were collared in one of the shock-horror juvenile delinquency scandals the tabloids loved. Where nowadays younger New Yorkers identify Judaism with visibly Orthodox sectarians typified

by the then-exotic Hasids, Mr. Austern was addressing the children or grandchildren of strivers who emigrated from eastern Europe between 1880 and 1924—some quite religious and others more cultural about it, a few leftist and most not, but all more secular than any Hasid. Like Mr. Austern himself, they sprang from the same culture that produced the New York intellectuals, most of America's comedians and songwriters, and the novels of Mailer and Bellow with more to come—the nation's second-liveliest subculture, mine for the taking as a native New Yorker. And though I doubt any of the goyish SPs got the grades of Diana Kahn, Steven Blitz, Paul Alter, Barbara Browner, or Ellen Willis, most of us admired our Jewish classmates' bold good cheer—and in my case at least, aspired to it. Given its outsider status within the school, our SP class was a cohesive unit because it had to be. And it was also brought together by three very different homeroom teachers.

I doted on 7-107's nurturing Mrs. Kagan, a feather-haired, kind-hearted brunette who left midyear to have a baby, though the only specific that stays with me is the debate she set up to mark the 1953 mayoral election: dynastic pol Robert F. Wagner Jr. for the Democrats versus colorless postmaster Harold Riegelman for the Republicans versus crime-busting prodigy Rudolph Halley for the Liberals versus the ringer, Popular Front front Clifford McAvoy for the soon-defunct American Labor Party. I figured out years later that much-married labor activist McAvoy was essentially a Communist. Yet Fred Baskind wanted to speak for him, which made such an impression that I remember it six decades later. Me, I was a minor member of a badly outnumbered Riegelman team led by Philip Sherman, a 22-er who ended up in prep school. Although my father registered Democrat to fool the Tammany machine he was convinced ran everything, he disliked Wagner for no especially good reason, and I would remain a nominal Republican until JFK in 1960. But I sensed that Riegelman was a turkey just as I sensed that Fred Baskind was onto something. And then came May 17, 1954.

By then 7-107 was under the thumb of Mrs. Kagan's replacement, a

paunchy, proudly histrionic out-of-work actor in his mid-thirties named Nathan Segal. Mr. Segal's idea of teaching English and social studies was to mount a play: an adaptation of Stephen Vincent Benet's historical fable "The Devil and Daniel Webster." So most of us spent our spring afternoons sitting in the auditorium watching him show loquacious Danny Martin (Webster), wise-ass Chuck Rowars (Mr. Scratch), and class sweetheart Phyllis Blaustein (Mary) how an actor delivered his lines—floridly, and from the thorax. Assigned the non-speaking role I deserved, I was just as glad to look on as Chuck learned to wheedle and Danny learned to orate. Benet was no radical, just a New Deal patriot-populist like Carl Sandburg, but he imputed rather strong antislavery sentiments to the Compromiser of 1850. In 1937, when the play was written, his rhetoric had a Popular Front tinge. In 1954, it seemed so right and natural I barely noticed it.

But what happened one warm Tuesday morning I noticed. On May 18, we trooped into homeroom from Chinese handball to find Mr. Segal brandishing that day's *New York Herald Tribune*. "Supreme Court, 9-0, Bars Segregation in Schools" wasn't the only banner headline. There were two, the topmost of which dealt with a suspension of the McCarthy hearings. There was also coverage of Guatemala's "Left Wing regime"; the day before, the lead story had French forces in Indo-China thirty miles from a place called Dienbienphu. But none of that registered with me, not even the McCarthy hearings, which had been on TV at home. I'm not sure these other events registered with Mr. Segal either. It was the segregation decision—"the most momentous the court has made since the early days of the New Deal"—that moved him.

The *Herald Trib* was my family paper; a decade later it would employ me as a copyboy and barely a year after that publish my breakthrough magazine piece. A broadsheet aimed like the *Times* at the

educated classes, the *Trib* was much less staid, presumably to attract rude upwardly mobiles like my dad. So where the *Times* augmented the one-column headline "1896 Ruling Upset" with what 43rd Street probably considered a splashy two-column photo of the three NAACP attorneys, the *Trib* ran with the story and so did Mr. Segal. He was elated, almost transfigured. This was an historic day, he exclaimed. Remember Daniel Webster? Finally the evils of slavery would be truly redressed.

Mr. Segal's excitement was a revelation. As a white Northern twelve-year-old with a good heart, I was pleased by the desegregation decision. But excited? That was new. My parents were faithful voters less cynical about politics than most un-unionized Americans of their class—my father rocked the house when Thomas Dewey was nominated in 1948. But the idea that I should have personal feelings about Negro students south of the Mason-Dixon Line was foreign to me. Social conscience wasn't part of my upbringing the way it was for Fred Baskind. That sort of empathy-once-removed was reserved for church, where it was voiced by furloughed missionaries and regularly transformed—didactically and, beneath shows of honeyed compassion, patronizingly—into the obligation of witness: conveying Christ's message to the unsaved who so outnumbered us in New York City. Augmented by his dramatic training, Mr. Segal's politics—liberal? socialist? Communist? bohemian? decent guy?—radiated more human concern, more "charity," than anything that ever issued from the pulpit at First Pres. I wasn't converted into a radical overnight—that was a lifetime away. But it was as Mr. Segal explained the larger implications of *Brown v. Board of Education* that I internalized a commitment to racial justice already set in motion by some alchemical combination of the Bible, *South Pacific*, and Willie Mays—plus the overtly apolitical example of my kindly, sentimental grandpa, who knew a sad plight when he saw one and wasn't about to stop himself from clucking in sympathy.

This commitment wasn't coherent or consistent. JHS 16 was integrated, and two years later a Negro track star would be elected to head Flushing High School's student organization, but I made not a single black acquaintance at either location. In fact, my most embarrassing moment at 16—worse than getting caught lying about Mr. Austern's science notebook, which like that current events notebook I'd never even begun—was one of the social dancing classes that periodically replaced gym. Victim of the SP gender ratio, I was so phobic about sexual contact that I would come in just ahead of Christopher Devine among all aspirants, and in this case my partner was an African-American girl six inches taller than me whose long, dry fingers still grasp mine limply in my mind as we circle the basketball court in a stiff skip-to-my-lou.

At a safe distance, however, Negroes interested me. TV made some small difference in this—the heavily stereotyped Aunt Jemima sitcom *Beulah*, Jimmy Durante's black sidekick Eddie Jackson, young phenom Sammy Davis Jr. But mostly it was baseball. I'd started collecting baseball cards in 1950, finishing off a complete set of Topps in 1952 by trading for Ron Northey in the PS 22 schoolyard. Because my chief athletic gift was speed, I identified with twenty-eight-year-old 1950 Rookie of the Year and stolen bases leader Sam Jethroe (who was actually thirty-three, and was discarded by the Braves in 1953). Because I had a thing for older players, I couldn't resist the great Satchel Paige, whose autobiography would be picked up by Grove Press in 1963. I loved Giant Monte Irvin as well as Mays. I winced when the racist owners of my Yankees traded the eagerly awaited minor leaguer Vic Power to the Athletics before the 1954 season, and was relieved when they compensated, very belatedly, by bringing Elston Howard up in 1955.

But truly putting the desegregation decision in perspective was Alan Freed. Freed is mythic, but he changed my life even more than he changed millions of others, so let me tell his story my way. Born in 1921 and raised in the coal towns of Pennsylvania and Ohio, Freed was the

son of a mild-mannered Jewish retail clerk and his strong, piano-playing Baptist wife. This was a musical family like mine only much more so, with Sunday-night sings occasionally enlivened by two maternal uncles who'd performed as blackface minstrels. Freed played trombone seriously, sang in an Episcopalian choir, amassed a large classical LP collection, and was established as a go-getting swing DJ in Akron before he was twenty-five. In 1951, hipped by a Cleveland record-store owner, he became one of many white DJs nationwide specializing in the rhythm and blues of black teenagers. By 1954, he was the most famed of these by far.

That was the year Freed came east and signed with WINS, also "the radio home of the New York Yankees," where he debuted on September 7. I was onto Alan Freed's Rock and Roll Party early, preferring the fast ones: better Big Joe Turner's jolly "Shake, Rattle and Roll" and LaVern Baker's silly "Tweedlee Dee" than the Penguins' sacrosanct "Earth Angel," "Pledging My Love" by late great Russian roulette victim Johnny Ace, or a song Freed had a piece of, the Moonglows' "Sincerely." I never shared the confusion over the racial identity of the drawling, howling, jive-talking, phonebook-banging Freed, in part because I noticed his Jewish name. But in a time when several of those songs sold much better in cover versions by Bill Haley, Georgia Gibbs, and the McGuire Sisters, I knew that the cover artists were white and the originals were by Negroes. Not that Freed put it that way. But we knew. "Originals" was a big concept for him, and like Mr. Segal he got downright preachy about it. He would only play "originals." The fact that he was often taking payola to play them has never bothered me. He was right—they were better.

Pop music was on my radar by ninth grade. A faithful follower of Jack Lacy's Top 40 countdown on WINS, I'd already purchased my first forty-fives with help from Grandpa: Doris Day's "Secret Love" in early 1954

and then the Crew Cuts' "Sh-Boom," which I played to death on the Chenango jukebox that pre-Freed summer. At a winter handball date with Philip Sherman, we raved about Freed and also the Joan Weber one-shot "Let Me Go Lover," which I'm not positive Freed even played.

I never stopped liking these records, not even when I found out "Sh-Boom" was a cover. Fact is, the Chords' original, a segregation-defying pop chart-topper in the L.A. market that desegregation-decision spring, didn't shame its carpetbagging rival the way the Moonglows' "Sincerely" did the McGuire Sisters' or Little Richard's "Tutti Frutti" did Pat Boone's. The Chords' tenor sax solo (by future Freed bandleader Sam "The Man" Taylor) booms louder in retrospect than the Crew Cuts' subatomic tympani, but the Canadians' neat diction (the Crew Cuts were Torontonians like the Diamonds and the Four Lads) isn't the usual travesty, in part because the Chords weren't terribly good—they never got near another hit. "Secret Love," an Oscar-winning 1954 megahit, fed an appetite for pop melody I've never lost. Without a thought to the romanticism unbound of its lyric, a good autobiographical fit for me, I just hummed along the way I did with Freddy Fender's guileless 1977 remake although not Sinead O'Connor's sexed-up 1992 version. And "Let Me Go Lover" was in its own category—not a great record and arguably not a good one, but extraordinary nonetheless.

An anti-drinking song rejiggered into the torchy theme of a *Studio One* drama about a disc jockey murdered by his girlfriend, "Let Me Go Lover" went number one for the pregnant, eighteen-year-old Weber, a bandleader's wife at the time, who would die in a mental hospital in 1981—biography I knew nothing of at the time. The understated schlock of Mitch Miller's production left plenty of room for the low end of Weber's contralto, into which she sank in uncontrollable despair on almost every line. As on Johnnie Ray's "Cry" only without his canny musicality, this abject emotionalism exposed the inhibitions of "Secret Love" and countless lesser songs, as did the high-spirited non-

sense and mindless repetition of "Sh-Boom": "Life could be a dream" a dozen times keyed to nonsense title phrase. Soon something would pop. But music wasn't yet life-changing at JHS 16. That distinction went to *Mad*, which epitomized the Wonderful World of Jews.

My role in 7-107 and 9-405 was delighted spectator. I wasn't shy, talked my share in class, but I was kind of strange—in ninth grade I briefly developed a ritual of depositing Red Hots in the inkwells of favored classmates before attendance—and didn't make any close friends beyond Peter Drezner. Varying my elementary-school pattern of the two-year infatuation, I nursed fluctuating crushes on classmates who were pretty and short: Phyllis Blaustein, Michelle Schiffman, Barbara Browner, and, though she was then taller than me, Miriam Meyer. But I was relieved to be cut out of the birthday parties where the wiseasses initiated kissing games, the idea of which terrified me. In retrospect, my terror is pretty funny, because I'm almost certainly the only SP boy who ever, pardon the baseball metaphor, scored with an SP girl. Two of them, in fact, occupied eight years of my sex life: Miriam Meyer, the significant other of my college years, and Ellen Willis, my lover, companion, and intellectual goad through the high '60s. At a class reunion in 2010, retired bank vice president Phyllis Blaustein told me those kissing games scared her too.

Then again, Phyllis, who I thought such a star and cutie-pie, also told me she found the whole SP experience kind of awful. As an outsider, I didn't. I watched. I took it all in—at our reunion, I was the one coming up with teachers' names. And I laughed. It was a major up to be surrounded by smart kids; competitive though I was, I didn't worry much then about who was smarter. But what I liked best about school was how funny everyone was—the teachers, especially the two math guys, but the students even more. Well, mostly the boys—although I was to learn firsthand that at least two of those girls had plenty of wit about them, only boisterous future schoolteacher-bohemian Ann Lynn

got loud enough for me to notice. But eight or ten of the boys were irrepressible. In class and out, they never shut up, and always they were trying to outjoke each other. I'd known nothing remotely similar at First Pres or on 159th Street. Except when I was the butt, which happened, it was like my own private *Colgate Comedy Hour*.

But *Colgate Comedy Hour*, initially anchored in New York by popeyed Eddie Cantor and in Hollywood by dipsomaniac Romeo Dean Martin and self-made idiot savant Jerry Lewis, represented the vaudeville era of Jewish-American humor. We '50s kids had something cruder and edgier that flowered just a little earlier than rock and roll. My time at JHS 16 coincided with what is now mythologized as the Harvey Kurtzman era of *Mad*, which launched as a dime comic book in late 1952 and was expanded into a black-and-white twenty-five-cent magazine just before we graduated in 1955.

I was never a big comic book person except insofar as I would read anything, which means I downed hundreds in my parents' friends' children's bedrooms and on the summer stoops of 159th Street. I greatly preferred *Scrooge McDuck*, *Archie,* and *Classics Illustrated* to the grotesque horror-crime-war genres that would soon be suppressed in a campaign led by left-wing child psychiatrist Fredric Wertham. But it was the pioneering horror house EC that published *Mad*, which became 9-405's defining fad. Looking back at the issues of that year, I'm still astonished by how adventurous they were—and how funny, because they still make me chuckle. *Mad*'s meat was parody. Kurtzman began by skewering EC's staples ("Horror Dept.," "Crime Dept.") before moving on to rival books and strips ("Superduperman," "Prince Violent"), TV and movies ("Dragged Net," "Shame"). Its artists—especially Will Elder, celebrated in a "Special Art Issue" for his lifelong mastery of his favorite medium, chicken fat—crammed the panels with in-jokes that demanded rereading.

Mad's "humor in a jugular vein" was pretty harsh. Less than a decade

after Hiroshima, Walt Kelly's *Pogo* is blown up in a mushroom cloud to the mild dismay of the swamp animals' Disneyfied city cousins, who had advised the rubes to learn "parlor tricks," not "politics." Galusha Sturdley of "Poontang, O." surfaces in a "Believe It or Don't" spread; in one of the "Scenes We'd . . . Like to See!!" the Nazis get the bomb. Issue 20, fondly remembered for its marbled composition-book cover, featured the Wertham-worthy mayhem of the Katchandhammer Kids—based, of course, on the Katzenjammer Kids, two anti-authoritarian German-American brothers whose comics-page run spanned three centuries dating back to 1897, when Germans were still a recognizable immigrant strain. The first three panels are in actual German—a garbled fraternal discussion of how *der Jugend* will take to European unity—before settling into Katzenjammer pidgin. In one Elder in-joke, their godfather and torture object the Captain posts a sign: "FOR SALE A KUPPLA NIZE, YUNG HELTY AYRIAN BOYS!!" But there are no takers. After incinerating the Captain's life savings, Hans and Feetz set an explosion that costs him several limbs and an eye and run a kidnapping operation out of his top floor.

The *Mad* fad had twists I couldn't have noticed at the time. This was the Wonderful World of Jews, definitely. But why? When I was in high school Kurtzman, a painstaking artistic idealist who had his greatest commercial success at *Playboy*, would quit the mag-sized *Mad* to start the short-lived comic book *Humbug* and become my first cult artist. But in junior high I doubt I knew his name, tucked away in tiny type in a credits paragraph, and the names we did know—cartoonists Will Elder and Wallace Wood—were not Jewish. Yet in fact chicken-fat specialist Elder was born Wolf William Eisenberg and attended the High School of Music & Art with Kurtzman as well as later *Mad* stalwarts Al Feldstein and Al Jaffee. So though part of what was going on at *Mad* was the already established American pattern of Jewish impresarios corralling eccentric heartland talent—Minnesotan Wood, Georgian Jack

Davis, Oregonian Basil Wolverton, and others—the other part was a World/Cold War-generated black humor soon to be personified by Mort Sahl and Lenny Bruce. This I sensed even if I didn't know exactly what an Ayrian boy was, much less that I qualified myself. Yet my Ayrian life continued apace.

In ninth grade my parents prevailed upon me to check out First Pres's newly formed branch of the Christian Service Brigade, a resurgent evangelicalism's plot to overthrow the Boy Scouts of America. That was fine with me. Although my father had been a Life (not Eagle) Scout, I had rejected the Boy Scouts because I found them insufficiently Christian—those boys at the organization meeting swore worse than the Laughlin gang. So I stuck with Brigade, and pretty soon, for no obvious reason except brains, I was sergeant of our battalion. The appointment came from the real-life navy commander who served as our adult captain, even though, as he let me know many times, my rear end stuck out when I stood at attention and I held my hip like a girl. Brigade would be a big part of my actually existing social life till I was fifteen, and it had other repercussions. It taught me I could lead, which had never occurred to me. It transformed my brother Doug, who through my pull was allowed to join at ten and who ended up working for Brigade as an adult. It occasioned the longest ball I ever hit, a triple, after I'd realistically batted myself seventh against North Shore Baptist. And it compelled me to publicly profess my Christian faith.

By the time I graduated from junior high, there were fissures in that faith I'd always thought so much about. But they were of the sort most young born-again Christians suffer, questioning the strength of my own commitment rather than the veracity of biblical doctrine. Am I really saved? Has the Holy Ghost truly entered my soul? And if so, why don't I live every day overflowing with the spirit the way I'm told all Christians

do? How all this related to the Wonderful World of Jews I didn't give much thought. I just assumed, blithely but also abstractly, that they'd go to hell because they weren't saved. Non-Christians find this cast of mind appalling, convinced it equals a moral judgment, but in general it just doesn't, especially in a place dominated by unbelievers like New York City. In New York you interact with the damned so often that the simple intellectual business of registering the fact of their damnation could exhaust you. Even the dourest First Pres elders honored the precept of love-thy-neighbor, and I was fine with leaving it there.

But as I got older my neighborhood expanded. By the end of seventh grade my hang was the slightly classier vicinity of 149th Street and 38th Avenue, where I played ball in the tree-filled double yard of Peter Drezner and his brother Paul. Regulars included Philip Sherman, a lawyer's son named Tony Fisher, a well-put-together Catholic prep school kid named Nicky Angrisano, and the tall blond brothers John and Wesley Garvin. Peter was even shorter than me, with no speed or jumping ability and the terrible eyesight of a near albino. So it says a lot for him that he was so eager to compete with these guys. As for myself, I was having more fun than I ever did on 159th Street. Now I realize that this gang was a step or two up the class ladder from the kids I'd grown up around. Then I just knew where I wanted to be.

The Drezners' was a strange menage. Their big house accommodated bald, mustached, seldom-seen Dr. Nathan, his modish wife, Edith, the two boys, and the boys' aunt and uncle on Edith's side. But I was made welcome there until the nuclear four moved to truly ritzy digs in Bayside Estates in 1956—studying for the bio Regents in Peter's bedroom provided my first taste of home air-conditioning. We shared a smart-boys' bond based on baseball fandom and an appetite for competition, softball/basketball/touch football outside, cards and board games inside—especially Peter's other obsession, bridge. The bond was strictly presexual with no girl gossip, but because baseball geeks have a lot to

talk about and shared time is an emotional currency, there was an intimacy there—limited, of course, by our immaturity and the sports fan ethos of never exploring anything deep. We didn't share a single secret. Peter must have known about First Pres and maybe Brigade too. But did I witness to him? Did I even consider it? Of course not.

Once I had a real opportunity. In the strangest of my strange practices, I had set up a private experiment that would not so much test God's omniscience as put it to work. For my entire lifespan, I decided, my left foot would touch the ground twice as often as my right foot. I knew I had some making up to do, and so when I jiggled my leg the way I did and still sometimes do, I would tap my left foot dozens or hundreds of times. As an everyday strategy, however, I merely brushed the ground with my left foot before putting it down, maintaining a two-to-one ratio. I figured that when I died I could ask God whether I'd made my quota, and that this would be interesting. In the meantime, however, Edith Drezner the doctor's wife—unlike anybody in my family—worried that her son's friend was limping. I could have explained about divine omniscience. But I didn't. Instead I told some dumb lie and walked conventionally when Mrs. Drezner was around.

I pursued this experiment for many months until some combination of boredom and common sense intervened. I didn't know at the time that I have a condition called Morton's neuroma in both feet—an inflammation of the plantar nerve between the third and fourth toes. The neuroma in my right foot surfaced when I was fifty. The one in my left foot was operated on when I was twenty-six.

Nathan Segal's 9-405 replacement in English and social studies was a sarcastic bore named Melvin Brenner. Mr. Brenner followed curriculum, which made him an improvement in principle. But all I remember about my ninth-grade training in those subjects, which would soon be

my academic passions, is the wiseasses driving Mr. Brenner crazy while Peter and I exchanged notes about our favorite subject.

The year culminated with one of those awful speech exercises in which students deliver five-minute oral arguments on topics of their choosing while the teacher sits in back making sure Charlie Rowars isn't copping any feels. Peter polished up a pet theory of his: "Why Eddie Mathews Will Break Babe Ruth's Home Run Record." He made a good case, too, but although his math was excellent as usual, it made no provision for rotator cuffs, and the twenty-three-year-old Braves third baseman then launching his third straight forty-home-run season would retire at thirty-six, 202 short of the Babe. I doubt my case was as solid, but I'm sure it was more substantial than Mr. Brenner believed. All these decades later I'm still slightly flabbergasted that as I turned thirteen I could see my lifework shining before my eyes. My topic: "Why 'Casey at the Bat' Is a Better Poem Than 'The Rime of the Ancient Mariner.'"

When I reexamined the two poems in my sixties, my natural sympathies sprang eternal. True, "hope which springs eternal" was lifted from Alexander Pope, and I was bummed to learn that in the original my favorite line, "But the former was a pudding and the latter was a fake," went instead "And the former was a lulu and the latter was a cake"; as I hope you can see, the obscure but evocative "pudding" juxtaposes more piquantly against the blatant "fake" than the ambiguous "lulu" does against the obscure and unevocative "cake." Nevertheless, "Casey at the Bat" exemplifies the power of lowbrow entertainments to survive that creaky shibboleth of high-culture shills, "the test of time." From "The outlook wasn't brilliant for the Mudville nine that day" to "But there is no joy in Mudville—mighty Casey has struck out," it lives on in the American vernacular. It was also the basis of several poorly regarded short films and an opera by Pulitzer Prize winner William Schuman.

Problem is, this test works out even better for Coleridge's standard-bearing gothic ballad. The skinny-handed graybeard who "stoppeth

one of three" is at least as familiar as the Mudville nine's outlook, and that's only the beginning. There's "Water, water everywhere and not a drop to drink," "all things great and small," and "sadder but wiser," although note that these maxims are all worded more archaically by Coleridge. There's the albatross itself, a harmless avian known to land-lubbers solely via its Coleridge-imposed metaphorical status as a curse, a burden, a temptation to awful sin. And the poem pops up endlessly in subsequent culture: explicit references in, among hundreds of literary works, *Frankenstein, Dracula, Moby-Dick, Naked Lunch, Black Athena,* and *The Incredible Hulk,* songs by Fleetwood Mac, Public Image Ltd., and—for thirteen minutes—Iron Maiden. It's also the model for a 336-page graphic novel by UK cartoonist Nick Hayes: *The Rime of the Modern Mariner,* an ecological tract that nails prosody like: "Swathes of polystyrene bobbed / With tonnes of neoprene / And polymethyl methacrylate / Stretched across the scene."

I assume I read "The Ancient Mariner" twice in junior high—once to get mad at it, and at least once (I hope) to frame my attack. My next encounter came during Dartmouth's English Honors program, where I worshipped Blake, felt Keats's intensity and Wordsworth's flow, dug Byron's sardonic swagger, found Shelley too flowery, and was left cold by Samuel Taylor Coleridge. Only the penciled notes in my Modern Library Coleridge convince me I even reread his consensus masterwork. Fifty years later, my first read had me nodding off so often it took me four passes to finish. At moments, however, I found Coleridge's terseness miraculous. Tropical sunset in fourteen Anglo-Saxon words: "The Sun's rim dips; the stars rush out: / At one stride comes the dark"; good day at sea in twelve: "The fair breeze blew, the white foam flew / The furrow followed free." And a bunch of secondary research piqued my interest.

My working assumption as a critic is that the raw enjoyment of works of art shouldn't require research, but I know that's a crude rule. A single acute review can render a recalcitrant work intelligible, auxiliary information enhances appreciation, and the repeated exposure I've forced

on myself for forty years is a kind of research itself: from James Fenimore Cooper to TV on the Radio, I've slogged through artists I didn't dig on somebody's say-so and come out a convert on the other side. In fact, dabbling through reams of "Ancient Mariner" crit hasn't just clarified the poem for me, it's helped me understand why the Board of Ed's middle-brow mandarins thought it suitable for 9-405. To slot it as a gothic ballad is to stress one of Romanticism's many downsides: a post-Enlightenment attraction to the picturesque and the weird that eventuated in, among many other and often better things, EC Comics and Black Sabbath. But I'm sure some ninth graders were drawn to it for the same reasons they were drawn to horror comics. Me, I had no use for horror comics. That may be why I ignored Coleridge's explicitly Christian imagery, which transforms the dead albatross into his slayer's "cross."

On the other hand, I was only a kid, and no one is sure what that imagery means. In his 1994 *Coleridge's Submerged Politics*, an even-keeled scholar named Patrick J. Keane posits a long-standing interpretive "deadlock" between believers like New Critic Robert Penn Warren, who see the poem the way Coleridge eventually claimed to, as a painful allegory of Christian suffering and redemption, and skeptics like William Empson, for whom it depicts a world so bleak and irrational it obliterates its own pious prayers for "All things both great and small." Keane works the post-New Historicist wrinkle that what Coleridge famously called a work of "pure imagination" reflected the political and moral turmoil of 1798. For Keane, the pivotal reconciliation with the water snakes may well have signified, as I jotted in my Modern Library edition, "bless life; do not concern yourself with what death you have caused." But it also signified Coleridge's fearful capitulation to the "despotism" of "that Satanic serpent William Pitt."

I'm glad Keane respects Coleridge's politics, and I'm not against interpretation. As a teenager discovering literature's storied realms I was gaga for it—J. Dover Wilson on the mousetrap scene in *Hamlet*, the shadings of courage in "The Bear." But whether they're scrupulously

textual and rationalist like Warren's famous essay or scrupulously contextual and open-ended like Keane's little-known book, I believe that by attaching so much import to Coleridge's every word all these exegeses expect too much of him. Even Keane, a sensible humanist who makes a point of leaving his conclusions tentative, wants the Genius to shore up his own sensible-humanist worldview. Only believers like Warren, a non-churchgoer who identified his religious orientation as "yearner," insist that "The Rime of the Ancient Mariner," allusive throughout and unparsable geographically in Part V, is altogether consistent, transforming it into a sacred text because that's how they secretly view all Great Art. And that's something I intuited and rejected before I reached high school.

Historically, "The Ancient Mariner"'s greatest claim to fame—and one reason it's so worried over—is as Coleridge's major contribution to the official launching pad of English Romantic poetry *Lyrical Ballads, with a Few Other Poems*. Published in 1798, *Lyrical Ballads* was dominated by Coleridge's effusive partner Wordsworth, whose 1800 introduction to the second edition is a brief for "the real language of men in a state of vivid sensation" that for all its pastoral gush could double as a founding document of rock criticism. Coleridge's reflections surfaced in his 1817 memoir *Biographia Literaria*. As he described *Lyrical Ballads*, Wordsworth's assignment was "awakening the mind's attention" by imparting "the charm of novelty to things of the every day." His own was directed toward "persons and characters supernatural, or at least romantic," which he strove to render "so as to transfer from our inward nature a human interest and a semblance of truth sufficient to procure for these shadows of imagination that willing suspension of disbelief for the moment, which constitutes poetic faith."

As my life turned out, I treasure these prose texts more than any poetry of the period. I know Coleridge didn't formulate the precious concept of "willing suspension of disbelief" as my OK to take what

I wanted from "Ancient Mariner" and leave the rest. Functionally, however, that's what it is, because it establishes the reader's freedom to make decisive aesthetic distinctions. So even after we conclude that by most metrics "The Rime of the Ancient Mariner" is a better poem than "Casey at the Bat," we're not obliged to cogitate about what it means. Insofar as it's an obscurantist fantasy, say, or a muddled morality tale, it's of compelling interest only to readers for whom Coleridge seems so seminal that his missteps are worth poring over and his inconsistencies invitations to rationalization. For other readers—in an ideal world, sometimes the same ones—"Casey at the Bat" inspires its own species of "poetic faith." It would appear to require no suspension of disbelief whatsoever, because its dramatis personae are burlesques up front. But since grasping its significance does require an act of will for anyone sophisticated enough to know what suspension of disbelief is, let me tell its story.

As a poet, Ernest Thayer was like Joan Weber—a one-hit wonder. A *Harvard Lampoon* editor who loved W. S. Gilbert and pursued his literary dreams at the San Francisco *Examiner* before returning to Worcester to run the family wool mill, he wrote "Casey at the Bat" back east but published it in the *Examiner*. As he intended, it captured a moment when baseball was the very male and rather rowdy wonder of the booming young entertainment industry and mimicked the mock-grandiose exaggeration of the sportswriting baseball occasioned. Handed on by the long-forgotten bestselling novelist A. C. Gunter, it reached Broadway headliner and "biggest baseball crank in the country" DeWolf Hopper, and became the star turn of Hopper's touring career after the headlines shrank to agate: a virtuosic recitation whose overstated comic-opera musicality was splendidly tailored to the vocal imperatives of the pre-microphone era, from shrieked "Kill the umpire" to basso "The multitude was awed." Reluctant at first because he didn't want anyone stealing his shtick, Hopper eventually recorded "Casey" three times.

Good-humored though it strives to be, Schuman's opera doesn't compare. James Earl Jones updated Hopper to Coplandesque strains in a puckishly dignified cover version that shames Schuman's opus, and Garrison Keillor concocted a cutting parody written from the Boston-accented POV of the Dustburg fans. But when I was coming up, midway between Casey's birth and these historically conscious tributes, the poem was still asserting its contemporaneity. The 1947 Disney short featuring Jerry Colonna is indeed terrible—condescending music, hack rewrites, sexist sideswipes. But others did better with it. Although I don't recall encountering Jack Davis's *Mad* version, which retains Thayer's language while reducing the crowd to two very bad boys who shoot Casey one pitch after he gallantly prevents them from doing the same to the umpire, or Jackie Gleason in Reginald Van Gleason mode doing a complicated class-fuck that understates the strike calls hilariously but blows the ending, I note that both employ the "pudding"-"fake" pairing and assume both moved me. And the unrehearsed introduction to my future hero Jean Shepherd's casual reading is on point: "A great classic in, uh, let's say, uh, substrata literature. And it is far more American than any of the American things that are determinedly American. It couldn't have been written in any other country."

You get Shepherd's drift. He's overstating less deftly than DeWolf Hopper—Walt Whitman and Buster Keaton and Louis Jordan are every bit as American as "Casey at the Bat." Not Cooper or Chaplin or Sinatra, however. Current though it remained in 1955, it's also pretty "substrata," not least in how it both adores and makes sport of the power of lowbrow entertainments. And substrata though it may be, it lives on—as does W. S. Gilbert, but not A. C. Gunter. Jean Shepherd had his limitations. But like a lot of freethinking Americans in the '50s, he discerned currents in American life that Robert Penn Warren did not. In my stumbling, callow, nascently wiseass way, so did I. And

within a couple of years, millions of other teenagers would be formulating their own versions of this poetic faith.

"CLASS / of / JUNE 1955 / CORONA J.H.S. / 9-405," reads the legend for the graduation photo propped against Ann Lynn's legs. Nineteen of the honorees are male, twelve female—several unpleasant boys had departed and several brave girls stepped up since seventh grade. Although visibly taller than Fred Baskind next to me, I am all the way to the right, behind Phyllis Blaustein and Barbara Browner; Peter Drezner is all the way to the left, behind Michelle Schiffman and kindly new girl Vicki Custer. Ellen Willis and Miriam Meyer surround Ann in the middle, with three yet taller girls in the center of the row behind me. Like almost all the boys, I am wearing a dark suit. Phyllis's head conceals my left lapel, so I can't tell whether my Sunday school attendance pins are there. I hope not.

Graduation took place at a movie theater where air-conditioning eased the heat as we yawned through a local legislator's address. To my surprise, I got an award: runner-up in the Newtown High School Mathematics Contest. Ellen Willis won, and several other smart girls grumbled that I didn't deserve it, which in some respects I didn't. This was my first experience of the glories of the standardized test, but as I would find out when I peeked at Mrs. Goldman's file cards, I'd already aced another one—the IQ test administered during our final term. I still remember it, because it included a reading comprehension section about the origins of the Hebrew-derived word "shibboleth"—a word that appears earlier in this chapter because it entered my vocabulary forever that day. Anyway, you may recall that I made SP with an IQ score of 139. Two years later that score had risen to 151. There are many ways to explain this multi-determined anomaly, which is small enough to be a statistical glitch. But one of them is how much I learned in the Wonderful World of Jews.

4

NONCONFORMISM
CAN BE FUN

At the end of my first year at Flushing High School, a bored phys ed teacher took a break by organizing a game of dodgeball, tossing us a basketball because the volleyballs were in back somewhere. Except for my French teacher Miss Worms, gym was the only thing about Flushing High I didn't like. Still short and now wearing glasses, I felt shrimpier than ever doing push-ups or climbing a rope, and in an adolescent update of my rough boys problem, hated stripping in front of foulmouthed goons with their voices changing and their dicks hanging down. But dodgeball was my game. Exploiting my quick reflexes and tactical smarts, I hid my skinny self behind bigger, more prestigious targets, and was soon one of three or four survivors. Forced to notice me, one of the bigger goons raised the basketball over his head and hurled it with a vengeance, and though I jumped high, it clipped my foot and sent me sprawling. Thus ensued my third broken arm. In July I'd spend

the first of my two weeks at Christian Service Brigade camp in a cast, which had advantages in tetherball, and the second too weak to swim, which had no advantages whatsoever.

Remarkably, that broken arm was the worst thing that ever happened to me at Flushing High School. Adolescence was hard. Extended into college when I was sixteen, it was agony. But high school wasn't. My three years at Flushing formed an unbroken upward trajectory even though I remained half an outsider, which by the end I'd half learned to make work for me. I don't want to be a Pollyanna. The Bill Haley-powered "juvenile delinquency" flick *Blackboard Jungle* was a New York City tale, and the city's black parents would have many decades of inequities to revolt against just a decade after I graduated. But Flushing High was neither disastrously cliquish nor a violence-ridden dead end. Its African-American ten percent was way too invisible, and goons, jocks, and underachievers resented all us nerds who didn't yet know our name. But in the striving Flushing of the '50s, we were too busy getting ahead, and too aware of how far back our parents had been when they brought us into the world, to let any of that worry us—yet. And further easing our minds was an excellent fail-safe: free, city-subsidized Queens College a mile from my house, which it was assumed I'd attend along with dozens of my fellow graduates.

I always had a social life at Flushing High School. By some alchemy a few of my randomly assigned lunchroom tablemates became friends simply because they were outsiders too. Looking back at shaky-handed Tony from the projects across Main Street and Bill the playwright's nephew on hiatus from private school, I wonder how many of my de facto allies were gay like David the prospective priest, who in our college years came out as an opera queen. But I was still nodding acquaintances with Flushing's ten or so SPs, and the other half of me was a normal and quite heterosexual thirteen-year-old boy whose fear of goons didn't diminish his enthusiasm for whatever sport was in season

in Peter Drezner's yard. There I could trash-talk with anybody, and there I bonded with the kid who'd be my best friend after Peter moved up up and away.

Two years my senior like most normal sophomores and headed for six feet, gawky John Garvin lived with his handsome younger brother Wesley and parents much older than mine in a ramshackle Northern Boulevard two-story that also housed many cats. His gray-haired beanpole of a father managed a small co-op grocery on 150th Street; his mother dressed in some modulation of Mennonite or Quaker black and eschewed makeup. I suppose she was somewhat witchlike, especially given the cats, but to me she was what she was—friendly, good to her boys, and a warm presence at a modernist church I visited once. John and I started walking home together, and though often we headed straight to Peter's, I'd occasionally spent time in the big bedroom the brothers shared. And sometime that year Wesley convinced his parents to let them subscribe to *Cash Box*.

The Garvin boys were pop culture aficionados. It was John, for instance, who introduced me to Ray's, the shingled comics shack midway to the Garvin manse on a then-underdeveloped block of zooming Northern Boulevard—the same thoroughfare that connected Gatsby's West Egg pile to Manhattan's bright lights. The Garvins were also math whizzes and stat geeks, and eventually a subscription to the weekly baseball paper *The Sporting News*, which published box scores of every major league game, augmented *Cash Box*. But by then we had discovered the trade magazine's Top 100, which provided WINS DJ Jack Lacy with his Top 40 countdowns and included such stat-geek goodies as highest position reached, previous week's placement, and label, which was normally something you only learned by buying the record. Soon we were all rooting for labels. John went for Bill Haley's Decca and Wesley for Elvis's RCA while their visionary redheaded friend Eddie O'Malley supported the emergent r&b powerhouse At-

lantic. Yankee fan that I was, I chose the least rock and roll of the majors, Columbia.

"Secret Love" notwithstanding, it's not like I was a Columbia fan musically. I enjoyed the Four Lads' "Standing on the Corner" and still consider Guy Mitchell's "Singing the Blues" a perfect pop record. But I was an Alan Freed fan, my musical inclinations hot and indie. The 1955–56 year is hail-hailed for rock and roll, with Elvis its metonym. But in New York City, it was less Elvis's year than it was Freed's. Yes I recall the excited homeroom chatter following Presley's winter TV appearances, but to be honest, I don't remember seeing him on TV myself until he hit *Ed Sullivan* in September. His RCA debut "Heartbreak Hotel" wasn't out until March, and not until "Don't Be Cruel" in August did I feel one of his songs.

These judgments, which I outgrew, also reflected my rough boys problem—with his leather jacket and ducktail do, Elvis dressed like what was soon called a "rock." But by August many records I loved more than "Don't Be Cruel" had marked me, starting with Chuck Berry's life-changing "Maybellene" a year before: Fats Domino's second-lining "Ain't That a Shame" and "I'm in Love Again," the Platters' sweet "Only You" and "The Great Pretender," Little Richard's crazy "Tutti Frutti" and "Long Tall Sally," Carl Perkins's defiant "Blue Suede Shoes," Frankie Lymon's airy "Why Do Fools Fall in Love?," Gogi Grant's pop-country "The Wayward Wind," and let us not forget Tennessee Ernie Ford's grave, grooving "Sixteen Tons." Most of these preceded "Heartbreak Hotel," and, although the majority were by black artists, most broke pop, which in New York meant spins from Jack Lacy and WMGM's Peter Tripp as well as proud purist Freed. But some were "originals"—the biggest-selling versions of "Ain't That a Shame" and "Tutti Frutti" were by Pat Boone, the most notorious of the white "cover artists." Like several lesser poachers, Boone was on Dot; Coral and Mercury also put back into the scam. We *Cash Box* adepts noticed, and disapproved.

By my sophomore spring I was spending Grandpa money on forty-fives from Gould's on Main Street, and the next fall I entered unknown territory when I lay down in front of the Emerson one gray afternoon and played the first side of Bill Doggett's "Honky Tonk" for an hour straight. That year I logged Peter Tripp's countdown *Cash Box*-style on loose-leaf paper and then calculated the results like batting averages and categorized them like baseball cards. In night owl mode I ventured up the dial to tune in Harlem's WOV, where original rapper Jocko Henderson hipped me to the likes of the Casuals' "So Tough" and the Gladiolas' "Little Darlin'." And before too long the Garvins made a discovery that rivaled *Cash Box* itself: used jukebox records three for a dollar in Times Square. It was to score cheap records that I started going into the city, as generations of bridge-and-tunnel people have designated the pilgrimage to Manhattan, with ramifications I didn't begin to understand.

Flushing High School was a white brick hybrid a few blocks from Main Street and just across Northern from Bowne House and the Quaker Meeting House, seventeenth-century remnants of Flushing's first claim to history—in 1662 peg-legged New Amsterdam autocrat Peter Stuyvesant deported John Bowne to the Netherlands, where he was tried by the Dutch West India Company for hosting a Quaker meeting and came back having established religious tolerance in what became New York. Flushing High's western wing was a bizarre nineteenth-century neo-Gothic festooned with the gargoyles that gave the school yearbook its name, its eastern half a bland box completed the year before I arrived. Even before the attack of the baby boomers, Flushing needed that gym-garnished annex, which by my junior year enabled it to force-feed three thousand students in a staggered split session that began before eight in the morning.

One reason high school can be so wrenching is that everybody's on their own, and this is brought into relief when there are three thousand everybodys. Where at JHS 16 I cheered on a tiny cast of permanent players who vouchsafed me a bit role, at Flushing the flux of four-minute period breaks transported me from one assortment of acne-challenged ciphers to another. But whatever its social distortions, Flushing worked the way high school is supposed to work and too often doesn't—it stimulated me intellectually. Forget French because I did—even when black-clad aesthete Miss Rubinow replaced bright-suited priss Miss Worms, I was stuck with my father's aptitudes. And although I found my wisecracking bio teacher engaging enough, Mrs. Bickerton's distracted chemistry class locked in an indifference to science I look back at with regret. But this ennui did not extend to math—I was jazzed by the irrefutable logic of plane geometry and in algebra mastered a cross-multiplication trick that proved useful on many standardized tests. And even more important, Flushing's history and English teachers obliterated the separate but equal nullities of Mr. Segal's histrionics and Mr. Brenner's quiet desperation.

As a quiz show fan who pored over *World Almanac* factoids and was captivated by the stat-geck details of presidential conventions with their "favorite sons" and "dark horses," I was ready for some actual history specialists. My favorite was warm, wry Mrs. Goldman, who as my guidance counselor suggested I start building a service resume by working for her. A sardonic skeptic named Mr. Esterowitz seated me next to my SP classmate Julien Yoseloff, son of publisher Thomas Yoseloff, who soon gave me a book that replaced the almanac as my late-night reading: Stefan Lorant's glossy 766-page *The Presidency*, which broke election returns down to fourth-party also-rans and collected a thousand vintage illustrations, including hundreds of nineteenth-century political cartoons whose crude-to-elaborate draftsmanship and xeno-

phobic racism forever inflected how I understood American culture. Beginning with my father's copy of *Arundel* from the 159th Street hall, I also devoured bestselling historical novelist Kenneth Lewis Roberts, a maverick New England patriot whose underdog narratives chronicled the revolutionary era with uncommon sympathy for the Loyalists although not the British. But the first literary work to move me at Flushing was stuck in the middle of the short story textbook of my otherwise uninspiring English class, where I emerged as a hand-waving standout: "One Friday Morning," an atypically unnuanced Langston Hughes set piece in which a high school student's art scholarship is revoked because she's a Negro.

Yet although I can't recall taking a class that included one of the three dozen or so African-Americans who graduated with me in 1958, with typical adolescent myopia I didn't connect Hughes's fable to Flushing, which certainly ranked in the top quarter of New York City public high schools in the upwardly mobile '50s. I figure there were a few I just didn't retain, but maybe not. When I talked this over with one of the two black graduates to attend our fiftieth reunion, she told me an alarming thing—that when she announced her intention of getting the academic diploma she ultimately earned, she was advised against it by my beloved Mrs. Goldman. Clearly, black students were tracked toward the "general," non-college-bound diploma, and effectively separated from their best shot at upward mobility as well as from us white nerds.

This was somewhat less true in sports. A few blacks excelled in football or track and the track star who was my first student council president became the city's finest collegiate miler at St. John's (and then joined the Marines). And although all the starters on the playoff-bound 1956–57 basketball team were white, several blacks started the following year, one of whom went on to Maryland's historically black Morgan State and a distinguished career in urban planning. He recalls

zero racial tension at Flushing, where as a senior he dated a Jewish girl. The rebel couple sought respite from her distressed parents by going into the city, Greenwich Village in particular: "The bohemian thing was happening." But that was a year later, by which time I was seeking respite in the Village myself.

Comparing my fiftieth reunion handbook to my old *Gargoyle* and commencement program, I note with interest how some marked for prominence floundered or disappeared while success accrued to under-achievers the *Gargoyle* staff had trouble describing and in a few cases spelling—a museum director, an artist, an audiologist, a CPA, an anti-racism consultant, many engineers. Still, in the days before the great American higher education hustle was ushered in by the then-nascent SATs, Flushing's tracking system was hearteningly primitive. About half the graduates got academic diplomas, with the rest either general, including a few of the late bloomers, or commercial, which provided secretarial training for girls. Not counting the Problems in American Democracy course Mrs. Goldman offered seniors, what would now be called advanced placement options were limited to English honors. And inconveniently for the anti-elitist I became, English honors changed my life, just like SP.

Maybe I would have become a writer anyway—I had the profile. But although in the same spirit as I'd played hooky I once made up a rather sketchy imaginary friend—a girl, it was platonic—I was not one of those ten-year-olds who undertook fan fiction starring Mr. Peepers and his pixie-cut beloved Nancy Remington. My big show of class-room "creativity" till then was a sixth-grade geography report involving an airplane tour of South American capitals, typed up by my mother for that professional look, and although I'd end up winning the 1958 English Department Award for Creative Writing, my chief sponsor had his reservations: Mr. Gerlich, my sixth- and seventh-term English teacher as well as the faculty advisor who appointed me editor of the

Flushing literary magazine the *Folio*. "Fine scholarship," "quick mind," swore the college recommendation he wrote for me, but only "some creative ability."

Of course, fine scholarship was all that was required for English honors. Like many of my future *Folio* colleagues, I was smitten with an unabashedly literary, visibly free-spirited, exotically olive-skinned young teacher named Miss Konstant, who would return in 1956–57 as Mrs. Spielberg—so smitten that I would have sworn she taught me two terms running. Instead, the record indicates that my first honors teacher was a somewhat older woman named Mrs. Kessler, who also wrote me a recommendation: "An unusually serious boy." But I'm pretty sure it was for Mrs. Spielberg that I wrote the book report that proved my most creative act at Flushing High.

The text is lost, but the feeling isn't—the memory retains the same hazy immediacy as the weeks of fever when I was four, because a fever is what it was. It began when we were taken down to the gym-turned-library in the old basement to find a likely-looking novel. By some happenstance I'd call miraculous if magical thinking wasn't contra-indicated, I pulled from the shelf a five-hundred-pager by a writer I'd never heard of: Fyodor Dostoyevsky's *Crime and Punishment*. Possibly I was attracted by the title, or by the sheer difficulty of the prospect. Presumably I examined a few pages. Definitely I took it home, gulped it down, and within a few weeks had written an impassioned meditation on sin, guilt, forgiveness, and salvation, although I wonder how much I dared say about the ex-prostitute Sonya, who I loved at least as much as experimental murderer Raskolnikov did. My teacher's enthusiasm was so vocal that at my class's fiftieth reunion I met a woman who still remembered that I'd read *Crime and Punishment* at fourteen. Soon I was one of two students chosen to go into the city one cold autumn Saturday for a yearbook conference at Columbia University. The first of several crucial status leaps for me at Flushing High, that classroom

assignment forced me to come to grips with my Christianity in critical form. Was what I wrote "creative"? With all respect and affection for Mr. Gerlich, I'd judge yes.

Dostoyevsky was my constant companion as I grew into a young man. I read *Crime and Punishment* again and *The Brothers Karamazov* too and *The Idiot* in a fit of adolescent assholery on Aunt Junerose's living room floor after Christmas dinner, and as a college sophomore I gave my Russian Civ prof a *Notes from Underground* paper so intense and poetic that it got to my creative writing prof Jack Hirschman, who happened to be Mr. Gerlich's nephew-in-law. By the high '60s, however, I felt as if I'd outgrown Dostoyevsky's anguished night thoughts, verbose soliloquies, and wandering debates, not to mention his anti-socialist pan-Slavism, and didn't turn to him again until 2008.

Whereupon I reread *Crime and Punishment* and realized I was right the first time. With a lifetime's worth of nineteenth-century fiction under my belt, I noticed three things. One, it moves, a pop work with the pull of the detective fiction it half is. Two, although Dostoyevsky's youthful socialism had deteriorated into nationalist mysticism, he conveys the pain of poverty in a physical detail that exceeds that of any contemporary I've read except Dickens, who doesn't approach Dostoyevsky's psychological acuity. Always deeply class-conscious, he despises the rich in this book, and few of his successors render privation so graphically—Zola when he's got a reason; the Dreiser of *Sister Carrie* and the Steinbeck of *The Grapes of Wrath*; outliers like, for instance, Knut Hamsun in *Hunger* or Agnes Smedley in *Daughter of Earth* or Ousmane Sembene in *God's Bits of Wood*. Thus his politics have a righteousness whatever his ideology. Which brings us to three, which I knew already, only it's one of those things you never remember as vividly as it deserves, like your wife's body. In *Crime and Punishment* above

all, Dostoyevsky is alone among major nineteenth-century novelists in anticipating the great philosophical ideologies of the twentieth century—or anyway, *my* twentieth century. Simplistically and with vulgarity aforethought, call them religious moralism, progressive socialism, and existentialist skepticism. (Right, I'm leaving market capitalism out except to venture without further comment that it cannibalizes and/or perverts all three.)

Nothing in *A Christmas Carol* or *A Tale of Two Cities* or Roberts's *Rabble in Arms* could have prepared me for Raskolnikov's bedridden withdrawal and hand-to-mouth day-to-day, much less the claustrophobic wretchedness and delusory pretensions of the Marmeladov family he befriends. For a good Christian boy ensconced in a security-conscious lower-middle class that remembered the Great Depression, these visions of material deprivation and its spiritual consequences were nightmares. But for a good Christian boy beginning to question the patently unempirical religious moralism he'd been steeped in, the debates were even scarier.

As Dostoyevsky's wiser admirers understand, there's a big difference between what we assume Dostoyevsky believed from his journalism and notebooks and what his novels end up "saying." Craft alone compels novelists to give characters their way and stand by as plots proceed to unforeseen denouements. But as Mikhail Bakhtin liked so very much to put it, his countryman was more "polyphonic" than that. The secondary evidence suggests that Dostoyevsky is in full agreement with the soft-spoken Sonya, who strangely enough is the only forthrightly Christian *theorist* in the novel, although Raskolnikov's strong-willed sister Dunya and reliable friend Razumikhin embody Christian principles. But the primary evidence establishes how compelling he found all the lines of thought that were drawing and quartering nineteenth-century piety.

Crime and Punishment declines to lay out these lines of thought co-

herently or conclusively. Raskolnikov is forever shifting his argument and altering his behavior, sometimes within seconds. The "presumption" and "self-conceit" even humble Sonya sees in him excites fits of self-laceration, and one reason Sonya loves him is that although he longs to be a "Napoleon," a superman with a special right to kill, he's outraged by injustices grand and petty and is moved to prove how "extraordinary" he is with kindness as well as cruelty and capital crime. Raskolnikov's double by critical acclamation, a middle-aged predator named Svidrigailov who's one of two rich men Dunya rejects—and who in A. D. Nuttall's phrase is "unfettered by theory" (and hence more purely "extraordinary")—betrays his own existential autonomy with acts of charity before establishing his superiority to Raskolnikov with a bullet to his own temple. Raskolnikov's interlocutor, the slyly humane police inspector Porfiry Petrovich, spouts an opportunistic welter of social, psychological, and aesthetic liberalisms. The character whose ideas Dostoyevsky dislikes most—the relatively minor Lebezyatnikov maundering on about Fourier, communal living, and free love—is also the "very kind little man" who foils the plot of the book's wealthiest and most evil character, the intellectually inert Luzhin, to despoil Sonya and force Dunya's hand.

So most of *Crime and Punishment*'s debates aren't debates at all. They're colloquies Raskolnikov plays out either internally or as he explains himself to Sonya and others. It's a formal feat to make a bestselling detective novel out of a book where readers can't help empathizing with the perpetrator of a heinously "philosophical" murder, and where the mystery is whether or not he'll confess. But we don't value Dostoyevsky as much for his skillful narratives as for his mad grasp of psychology. Just old enough to have more thoughts than I could handle rattling my skull, I was transfixed as Raskolnikov opened a window on my dread, and as his creator's hyperactive intellect introduced me to ideas I'd thrash around in for the next decade. Only a "convinced

Christian" like I supposedly was could feel how powerful those ideas must have been to Dostoyevsky himself. To the normal secular humanist, including most academic critics, there's something barmy about his notion that utilitarianism and nihilism are peas in a pod. Not to me—I already sensed or feared that without faith, as Ivan Karamazov would soon be telling me, anything was permitted. I'd pulled a book blind off a shelf and come away with literature's greatest Christian novelist—especially, despite what First Pres would have labeled his heretical Russian Orthodox "sect," as I'd been taught Christianity.

This is the man, after all, who wrote at the end of his long Siberian prison term on trumped-up charges of radical activity: "If someone proved to me that Christ was other than the truth, and it *really* might be that the truth was other than Christ, then I would rather remain with Christ than with the truth." Siberia is where Raskolnikov has his own epiphany, in an epilogue name academics dismiss as a tacked-on sop to Russian religiosity and his own febrile conscience; Bakhtin found it insufficiently carnivalesque, while Harold Bloom assures us that "Dostoyevsky himself scarcely believed" this "unfortunate" device. The motley dissenters from this view include my friend Marshall Berman, who always dreamed of writing a full-length celebration of romantic love. They also include a post-glasnost scholar unloosed from her secular chains who argues that Dostoyevsky described Sonya in terms meant to evoke Russian Orthodox icons of the Virgin Mother, and God help us she could be right. But so what. My own reading, fundamentally unchanged since I was fourteen, favors Geir Kjetsaa's biography, which suggests just as credibly that Sonya evoked for Dostoyevsky his secretary Anna Grigoryevna Snitkina, the twenty-year-old he soon married. I believe Raskolnikov was redeemed by what the great Staten Island philosopher David Johansen called "love l-u-v."

There are many kinds of love, and I'm not denigrating any of them—not the flashes of agape that soften Raskolnikov's pretensions to *Übermenschlichkeit*, not his filial love for the mother and sister some cynics

argue he subconsciously hates, not even the divine love that bucks up the fallen Sonya no less than it did Joan of Arc and Martin Luther King. But if the epilogue is a resurrection fable, then it's one that has no need of the Virgin Mary. Raskolnikov is redeemed when he fully understands that he's in love with Sonya—whose foot he kisses, yum yum, on page 324 of the Constance Garnett translation I read back then. God is present too, of course; Dostoyevsky is nothing if not polyphonic. And let it be said that Sonya wasn't as much my type as Dunya even then. Nevertheless, it is Sonya the flesh-and-blood woman whose love saves the formerly unrepentant murderer. As Dostoyevsky tells us on the final page: "Instead of dialectics, there was life, and something completely different had to work itself out in his consciousness." Amen to that.

One reason Dostoyevsky was so life-changing was First Pres, where my Brigade leadership only deepened my worries about the intensity of my commitment to Jesus Christ. There my intellectual guide was a dapper, gray-haired Southern lawyer named Bill Sargent, an intelligent, open-minded man saddled with the thankless responsibility of teaching Sunday school to adolescent boys. I was by no means his only bright student—a classmate ended up the history chair at Taylor University in Indiana, where my sister would earn her BA. But I was definitely his biggest challenge. As a compulsively honest kid who never stopped thinking, I couldn't stop poking at biblical inerrancy, and as the increasingly cocky son of an argumentative father, I wasn't shy about airing my thoughts. Post-*Crime and Punishment*, the deductive method plane geometry shared with rationalism both existentialist and utilitarian buttressed my rarely articulated anxieties about who was saved and who wasn't, which in turn got me wrought up about whatever scriptural oddment I brought to the surface on any particular Sunday morning.

Rather than resenting my outspokenness, Mr. Sargent welcomed my seriousness. As an attorney, he enjoyed disputation himself, and

understood that his best chance of shoring up my faith was to meet my doubts out in the open—"convinced Christian" is a term I learned from him. For quite a while he held my incipient apostasy at bay, and even after I'd gone over to the other side, he went out of his way to show respect. In 1960, when one of the Christianist agitators already sowing discord and intolerance across the land dropped by First Pres to explain how a papist president would betray America's heritage, I deployed my Stefan Lorant to point out that two of the first six presidents were Unitarians, heretics in our world, and another a deist, just like Tom Paine. Mr. Sargent came over after the discussion period to grant that I had a point while questioning whether Jefferson was truly a deist. In 1976, I got so fed up with my *Voice* homeboys bitching that born-again Jimmy Carter was by that sole token unfit for the presidency that I wrote a long piece arguing that he might well be a good guy. Mr. Sargent was one of my first interviewees.

Although the religious turmoil of my high school years surfaced less explicitly at home than in Sunday school, it bothered my parents plenty. For my father, it was above all an affront to his authority, but my mother was sincerely concerned about my soul. Mom had grown devout without getting self-righteous about it. As she learned to sort out First Pres's snobberies, its upwardly mobile facade began showing holes—she perceived, for instance, that Dad might make deacon without approaching church elder, a status marker they both coveted. But soon she'd helped build a less affluent, genteel, and priggish cohort of congregants. The anchors were a showgirl from Arkansas who'd married a swarthy Brazilian translator-chef and the schoolteacher wife of a feckless chiropractor, among whose many Jewish friends, it would develop, was the mother of SDS heavy Todd Gitlin. Significantly, none of the Rodrigues's two kids or the Veltens' three remained in Christ; three of the five pursued careers in the arts, and the other two were a fireman in an interracial marriage and a lesbian letter carrier. None

were anything like disowned by their parents. Fundamentalist Christianity is less monolithic than bigots believe.

But those kids were all younger than me and would make their moves in a radically different era. For me it was still 1956, and although rock and roll would prove a cultural turning point just as Dostoyevsky proved a personal one, I was flying blind. Of course, so were the cooler classmates I gravitated toward. Unsurprisingly for someone who'd just figured out how to masturbate—at first I wondered why I'd never noticed how good it felt to urinate, but I caught on fast—much of this attraction was hormonal. Not that I dreamed of asking anyone for a date—I saved my dreaming for vague fantasies about paperback covers, brassiere ads, and Song of Solomon. But I was so deep into fluctuating-crush syndrome that I began compiling top tens. Among the perpetual finishers were two older exotics who were completely beyond me: a handsome blonde from a distinguished Latvian family who had spent her childhood under Hitler and Stalin, and a Chinese-American cheerleader who was the most beautiful girl in the school three years running. My female counterpart at the Columbia yearbook conference was so smart and cute she made my brain tumesce, but boasted of a college boyfriend who was probably an exaggeration. And then, early junior year, a new student visited the library, where I was door monitor: SP Miriam Meyer, who had just quit the ballet program at Manhattan's High School of Performing Arts. She went right on my list.

Girls aside, I was feeling more centered. The Drezner gang didn't quite become the Christgau gang, but it did often convene in the Christgaus' backyard, which Dad paved and equipped with a homemade backboard, a hoop, and a net, sometimes even swishing in some set shots with us before dinner. Having finally started to grow, I practiced the recently invented turn-around jumper until I was good enough to buy a gym pass. I liked my teachers even though only thrillingly ironic math guy Mr. Schwartzberg gave me nineties. And I got to know the other bright

college-bounds. Attending basketball games in the new gym became a fad I could get behind, and soon many of us were traveling to away games as well. It was on one such trip that Miriam Meyer slipped on the ice and in an atypical feat of coordination I stuck out my right hand to steady her at the top of her hip. It wasn't erotic, but it was a meaningful touch of the opposite sex—my first, and it stayed with me.

Still, my grades were nothing special, which I assume reflected my work habits. Having gone so far as to make up the term "Peter Panism," I consciously valued being a kid and regularly exercised my right to play. I took a hundred foul shots a night in a never-completed march to seventy percent, followed baseball religiously, and read like crazy. I did my homework as fast as I could, never wrote drafts, and studied lightly for all tests except Regents exams. I put more work into compiling Peter Tripp's Top 40 than into any of my subjects. And while I'm not bragging—properly motivated, I became a more diligent student, and would soon learn to rewrite assiduously when the results mattered to me—I chose a good thing to waste my time on.

I believe 1956–57 meant more to rock and roll than the year Elvis broke, beginning in September with the two greatest singles of the '50s. Bill Doggett's aforementioned "Honky Tonk" proved the bestselling r&b instrumental ever and sank an affinity for blues into my personality structure. Like everyone else, I bought it for the hit side, Clifford Scott's tenor sax spilling and shouting and spluttering and rejoicing till everyone goes nuts. But I fell in love with side one, where over fat discrepant hand-claps, simple drums, and eventually some bass, Billy Butler spends three understated choruses establishing and elaborating a blues riff as elemental as the one Elmore James lifted from Robert Johnson. Shaman Doggett plays organ.

That's the classical one. The avant-garde one is the Five Satins' "In the Still of the Nite." Not that it was blatantly disruptive like the Silhouettes' "Get a Job" or Link Wray's "Rumble"—just a slow-dancing doowop one-shot written and sung by GI Fred Parris and recorded over

rudimentary piano-bass-drums in the basement of a Catholic church in New Haven, Connecticut. Parris's plaintive lead, which lingers on a long embrace from something like a barracks, is less theme statement than decoration over a tune-bed comprising three choral repeats, the killer of which goes "sho-dout shoby-doo," with all "o" sounds defying orthography; although Vinny Mazetta's slow, crude, inspired sax break proved a hum-along, indistinct snare hits were the loudest things on the record. In the Penguins' doowop milestone "Earth Angel," the spiritual aspirations are of this world—a celestial crush made manifest among us. "In the Still of the Nite"'s muffled sonics and eerie gestalt are a waking dreamscape—maybe a half-plastered moment after the party lights have dimmed, maybe a peek at another dimension. The record never cracked Top 20 nationally but was huge in New York, and sold millions in the '60s as the oldies market got behind what rookie rock historian Charlie Gillett called its "random harmonies and unpredictable rhythms." Other Satins wound up in better jobs than you might fear—psychologist, sound man at posh jazz club. But Parris was still touring behind his pop moment fifty years later.

And that's just two songs. At precisely the same time arose two New York doowop classics that never even went Top 40 national, with the Heartbeats' "A Thousand Miles Away" up close and personal and the Channels' polyphonic-and-a-half "The Closer You Are" a thousand miles away. Then came two indelible novelties from indie labels with major-label mojo: Jim Lowe's "The Green Door" for Dot, which no one dreamed was a porn reference (porn? what?), and Patience & Prudence's "Tonight You Belong to Me" for Liberty, in which a teen-and-tween sister act played dress-up by dallying with their sweety till dawn, way later than little Susie overslept at the drive-in in the scandalous Everly Brothers hit of a year later. Even the winter smash "Young Love," a cynical Capitol concoction for country star in waiting Sonny James, pushed the right buttons. In spring sprang the Diamonds' "Little Darlin'," a Toronto cover version that was, sorry Mr. Freed, as wacky as

the Gladiolas' Tennessee original, and the biracial Dell-Vikings' liberating "Come Go with Me." Chuck Berry had his first major hit in two years with "School Day" and Fats Domino came into his own. And in May, Hall of Famers surfaced every week: the crisp, prophetic country-rock of the Everly Brothers, Ricky Nelson and his secret weapon James Burton, the first of the Johnny Mathis singles that would put his greatest hits album on the charts for 490 weeks, and then, blowing them all away, the Coasters' "Searchin'," a pop culture history lesson that established Jerry Leiber and Mike Stoller's perfectionist r&b by blowing it up. What could possibly top that? How about Buddy Holly, in August?

When I look back at that school year, I'm grateful that I was the youngest boy in my class, and that I had the common sense to admire Peter Pan. My immersion in rock and roll went deeper than Top 40 scholarship. There were constant discussions with the Garvin brothers and a young Christian friend of Doug's across the street, and frequent expeditions into a Times Square dotted with arcades and branded by Nedicks's to buy jukebox singles—and also to glimpse the titty-mag covers in back, to take in the cheapo movie houses that would educate me till they were pornified and then gentrified out of existence, to follow 42nd Street beyond the Sixth Avenue where I'd buy used books and LPs a few years hence and then past the holy Fifth Avenue Library to Grand Central. But my nerdish hobby undergirded it all, storehousing bedrock factual knowledge that ultimately helped me invent a job for myself. That none of it was undertaken with thought of the future only made the attachment more organic. Rock and roll was here to stay a year before Danny and the Juniors proved that claim worth thinking about by selling it on the radio.

Junior year I ate lunch with the aforementioned Bill and David, two articulate but solitary guys who didn't mind that I wasn't actually shy except with girls—that I was an opinionated bigmouth given to mock-

ing people I was too unhip to call squares. For us a key concept was "non-conformism," a term that originally scapegoated such non-Anglicans as Quakers and Presbyterians. By the early '50s it had become a piece of psychobabble taken up by radio raconteur Jean Shepherd, with whom I shared lots more than "Casey at the Bat." As New Jerseyite Donald Fagen recollected in 2013, a whole generation of vaguely disaffected metropolitan-area kids was captivated by Shepherd, an identifiably Middle American radio natural who kidded the Middle American status quo in a voice "cozy, yet abounding with jest." Shepherd was less universal at Flushing than *Mad* had been in junior high, but it wasn't just the "sorry-ass misfits" Fagen posits who tuned in. On an occasional basis it was almost every smart boy I knew well enough to ask, rendering every one some sort of nonconformist in his own mind. Shepherd was on till one—later than Jocko Henderson, and too late for a fourteen-year-old who was due at school before eight. But I stayed up anyway to hear this genially loopy Hoosier ramble cannily about night people, creeping meatballism, jam sessions, and the deserted streets of Greenwich Village on the Fourth of July.

Bound for glory, condemned to hell, who knew what I was? Not me. But I knew I was a nonconformist, and so did Bill and David and the Garvins and dozens of other kids vaguely skeptical about the older generation's Depression-generated caution and war-tested good cheer—half measures most of our better-adjusted peers would see through soon enough. And I knew something else. Jean Shepherd had a column in a weekly newspaper he talked up called *The Village Voice*. For two bucks I could subscribe for six months. I put my bills in an envelope and mailed them off to Sheridan Square. Every week the thin tabloid came in the mail—my first exposure to such presences in my life as Norman Mailer, Gilbert Seldes, and my longtime colleague Nat Hentoff. My parents weren't happy about it. But they didn't try to stop me either. And so I began to access, very much at a secondhand distance to begin, a bohe-

mian Manhattan the *Herald Trib* barely hinted at in the '50s, although it would prove to be a journalistic and economic staple before the next decade was over—and also prove to be my city.

Then that spring, my life was turned topsy-turvy by an event not at all nonconformist and very un-rock and roll. A special after-school test was announced for something called the National Merit Scholarship. It was free for honor roll students, but underachievers like me could take it for a fee I remember as identical to the cost of my *Voice* subscription. My father—who was about to get his BA because he'd taken a test, and who dragged me every year to the Delehanty Institute on Union Square for the St. George Association scholarship exam, where every year but one I finished second to the same girl I never met—gave me the money. And in May I learned that I was Flushing's only National Merit finalist.

No one expected this including me, and it was a very big deal—psychologically, bigger than winning a Guggenheim thirty years later. It wasn't just that Flushing's lofty college advisor, a PhD in who knows what who insisted on being called Dr. Gray, summoned me to his office and asked indignantly why he didn't know who I was. It was that the cool kids were buzzed. I'd already grown close to the Drezner gang's Tony Fisher, who would test right along with me for the rest of our time at Flushing. I was a fixture in English honors too. But now I was a celebrity. It was exhilarating, and inspirational. Senior year my grade average rose five points.

I didn't win a National Merit, of course. With savvier parents maybe I wouldn't have typed my little essays directly onto the application form, but even so I wouldn't have won one. Not counting two weeks at Brigade camp, where several times I hid in the woods and jerked off to Song of Solomon, and the occasional weeknight trip to Times Square, where my dad had hustled himself an assignment monitoring Broadway theaters for the FDNY and got me into shows like *West Side Story*, I

spent the summer hanging out on 159th Street. There I endured the heaviest crush of my life on an outlier from my top ten list, a bright, fun-loving, self-possessed, Chinese-American twelve-year-old from four doors down. After a summer in which I did a great deal of mooning about, either I found the gumption to declare myself or she up and addressed the obvious. I was too old for her, she told me. Forget it.

As it turned out, this was progress. Lots of important things happened senior year. I edited the *Folio*. I was seated all the way in back in economics with the good-hearted SP Vicki Custer, whose ear I talked off with music news and whispered witticisms, and who saw to it that I got invited to parties. I began hanging out in gym with class clown and Jean Shepherd fanatic Lenny Lipton. I narrowed my college search to an upstate men's college with what I mistook for a nonconformist ethos named Hamilton, coed lower-Ivy Cornell, and male-only long shot Dartmouth, where my never-graduated great-uncle Bill was a gung ho alumnus. But the most important was that I started walking Miriam Meyer home.

Miriam was a sweet-faced individualist who hid her insecurities behind a whimsical air. She had a small-breasted, long-legged dancer's body, straight dark-brown hair long enough for a ponytail, and a winsome comeliness both pensive and amused. Her totem was the unicorn. Miriam was an honors student who left Performing Arts because she was too interested in ideas to achieve the narrowness of intellectual focus ballet requires. She shared an apartment near Peter Drezner's old house with her parents and a soon-married sister who danced better than she did. Her dad had an adjudication job that seemed to require legal training but not bar certification. The Meyers counted among their family members two hundred exterminated in the Holocaust. They hated Volkswagens.

I didn't know it, but Miriam was considered a catch. In a micro-cosm where few paired off before senior year, many boys thought she was quite cute. Fortunately, none of them went home on Northern Boulevard. Soon an early pattern in which I'd catch up on my bike, dismount, and walk her to 149th Street evolved into a friendship ritual qua unofficial date. For me it was simple—top tens begone, I was in love. But although I was sure Miriam liked me—however inept I was socially, my nonconformism impressed unicorn fans—I couldn't be-lieve she liked me that way. For every time we'd stand and talk outside her building, there were two when I'd hop on my bike and pedal off the way I'd dashed away from Nan Younger in fifth grade. Nevertheless, it was understood there was a bond there, and not just by the two of us. People noticed. I didn't know it, but we were an item.

The first of my two major goings into the city that year fit Miriam's arty style: an English honors student's publicist father arranged an ex-cursion to a play based on the Grand Inquisitor chapter of *The Brothers Karamazov* at the Gate Theatre on Second Avenue. It stuck with me. But what hit me just as hard was my first glimpse of the still unchris-tened East Village. There'd been heavy snow, the streets were empty and silent, and as we made our way past St. Mark's Church in the chill dark I felt I needed to come back.

But the East Village was in a sense inevitable. Not so a winter trek to Brooklyn's Midwood High School, where I was one of a three-person Flushing delegation to a citywide mock Congress. One of the others was a girl I barely knew named Blanche Wiesen, later to emerge as the leftist lesbian historian and Eleanor Roosevelt biographer Blanche Wiesen Cook—who had earlier, I now know, invited the black student Mrs. Goldman had warned off the academic track to her family's seder. We Flushingites proposed a revision of the Immigration Act of 1924, which drastically curtailed entry by Jews and eastern Europeans and banned it outright for Asians. We wanted an end to all ethnic quotas.

Although our fairness fantasy was only eight years from realization by Teddy Kennedy in Washington, at Midwood we were boxed out by operators who passed some trivial presidential term wrinkle. On the long subway ride home I stood in the front of the first car with Blanche, where we watched the rails rush up as kids liked to do. Blanche was nothing if not forthright, so I assume she instigated the religious discussion that led to my telling her I was born again—a commitment I had purportedly cemented when I answered Billy Graham's call at a Madison Square Garden revival the previous summer. Forthrightly, Blanche proceeded to the hell question. Did I believe Jews would go to hell? Er, yes. Did I believe *she* would go to hell? Regretfully, yes. Then she hit me with a sucker punch. Did I believe Miriam Meyer would go to hell? I don't remember my less than forthright answer—I hope something in the vicinity of Er, maybe not. But right then I knew what I thought. And though this was not, strictly speaking, the end of my Christian faith, it was definitely the beginning of the end.

Every morning my mom would come downstairs at seven fifteen and roust me out of my Jean Shepherd-impaired slumber, then chat for the five minutes it took me to wolf down the eggs she'd scrambled and hightail it schoolward. But one day that winter, she skipped the small talk. I was old enough, she told me, to start dating. And after my evasive response, she had something else to tell me. "It's OK if she's not a Christian." Pause. "I don't even care if she's Jewish."

The next line in this story would be "Little did she know," only the next line is really "She saw the handwriting on the wall." My mother understood that her conflicted willingness to send me off to SP had changed me to the point where most of my friends were Jewish. And that's when she told me the story of the Jewish boyfriend whose parents broke them up—not as a warning, although it had its predictive

merits, but as a statement of solidarity. I blame my mother's First Pres puritanism for much of my personal brand of erotic dysfunction. But I thank her for that. My parents always had the guts to let their kids pursue their own lives.

By the time of this conversation I was sometimes doing homework with Miriam in her apartment, where her mother and sister proved friendly enough and where I first heard the Weavers and Dave Brubeck. Once, just once, she came over to my house, where we hung out in the basement as I played jukebox forty-fives that I assume included Fats Domino and Chuck Berry and the 3 Friends' deeply sappy "Blanche," although the only one I'm sure of, to my eternal rock-critical shame, was Pat Boone's lyrically apt "Don't Forbid Me." Miriam also worked on the *Folio,* of course. The fall issue led with the best thing published in my tenure—"My Last Safari," a Lenny Lipton tale about getting jumped for wearing a pith helmet in which he ended up almost as dismayed by his nonconformist pals as by the rocks who cuffed him around. My own story assumed the voice of an inarticulate teenager forced by his mom to teach Vacation Bible School; it incorporated multiple "I mean"s that Mr. Gerlich, in the kind of editorial bad call I came to know well, cut to a minimum, thus changing the title from "I Mean, There's No Justice" to "There's No Justice." Miriam's contribution was a fable about a round-peg girl squeezed by "the gods" into a square hole. A crush on a boy was involved. I hoped that boy wasn't me, because I didn't want her to change. But I hoped even more that it wasn't anyone else.

I studied harder than I ever had, filled out applications, aced interviews, played basketball and Ping-Pong. But I was obsessed. I imagined slights and rivals, recalculating Miriam's degree of interest daily. One night in early spring I sank into a despair so all-encompassing that I entered a fugue state in which I biked down to the gym and, high on misery, sank seven thirty-foot set shots in a row. Yet in May, with my mother's words in the back of my mind, we got to her door and I

croaked out an invitation to the prom. Having waited months for such a moment, Miriam said yes right away, and right away my life changed completely.

As a nonconformist couple whose male half Vicki Custer failed to teach the lindy hop, we skipped the prom and hooked up with two other contrarian pairs, going first to Birdland and then the Roosevelt Hotel, where the music the gods dictated was Maynard Ferguson and Sammy Kaye, respectively. We took the first cab of my life all the way from Manhattan to a bagels-and-lox breakfast provided by some wise parent on the ritzier side of Northern Boulevard, and at around eight in the morning I walked Miriam one more time to 149th Street. Holding her hand even when it got really sweaty, I took her upstairs as I had after the two Broadway shows we'd seen that week. This time, however, we kissed—once, lips only. As she unlocked the door I strode to the elevator, where I determined that my penis was fully erect and leaking onto my underpants.

Oh yeah, I got into Dartmouth. Cornell and Hamilton couldn't find scholarship money, but Uncle Bill's place came up with twelve hundred a year, almost full tuition in those innocent days, as well as cafeteria work for my board. Miriam was headed for Queens.

5

VACILLATIONS

In early September my dad drove me up to Hanover, New Hampshire, with my Flushing High buddy Sam Rosenthal, a sardonic doctor's son who would room with me freshman year and never quite be my buddy again. The night before, a passionate farewell kissing session had only ended when Mrs. Meyer shooed Miriam and me from the hall in our separate directions, and I remember dozing tumescently in the sun-warmed backseat of our Chevy as I daydreamed about how we'd name our first kid Tommy after I'd enjoyed four years of intellectual stimulation with my fellow Ivy Leaguers. I was excited in more ways than one.

Intellectual stimulation? Not what I'd dreamed, although at least I stopped worrying I'd be overmatched. Love of my life? Not what I'd dreamed either, although my passion for Miriam persisted through two breakups and a hundred fits and starts. I wanted both these things, and I didn't give up on them. With the love part I both failed and hurt someone who didn't deserve it, but while I regret the hurt, I don't regret the effort. With the intellectual part, well, for all its wastrel ski slopes

and prep-school goons, Dartmouth was indeed an Ivy League school, and for four years I gobbled up its academic pretensions. A standout in a reading-intensive English Honors program that grounded me from Chaucer through the Romantics, I chose every elective for how much it would broaden me. I was a regular at special lectures and presentations, several of which hit me even harder than the concept of Literature in English 2. I inhaled unassigned Literature as well.

So I remained excited for the entirety of my four years at Dartmouth—but only if it's granted that excitement can coexist with misery. Within days I realized that bull sessions about the higher things were not materializing, and I was disheartened by how eagerly my fellow '62s took to the locker-room culture Dartmouth bred and breeds like no other Ivy League school—even our snobby-sounding third roommate George Szanto. Still a First Pres boy in so many ways, I hated the cursing and drinking and sexual braggartry, with its putatively pragmatic estimates of what would get you where how fast. As sardonic Sam organized the professionally printed membership roll of the V.O.A., a secret society of sexual uninitiates comprising seven Jewish Mass Hall residents and moi, I had the guts to dissent from all the crass girl talk and was labeled a prig for my trouble. Yet I suffered worst from my own girl problem: my adoration of Miriam waned more than it waxed without her there to touch and to talk to.

Although I wouldn't be the writer I am without Dartmouth, most of what I learned there was wrong. The raw content stayed with me along with the habit of hard thinking, a substratum I've built off ever since. And somewhere in there I began to internalize a pluralistic worldview, a belief in what I took to calling "contingency," that would eventually prevail. But granting a few exceptions and with the proviso that I wised up senior year, the ideology laid out in my classes and the aesthetic attitudes I developed in response were either fatally partial or totally fucked. It wasn't just that Literature, Great Art, and the rest of that

malarkey dovetailed rather too well with my religious training. It was that the Dartmouth version of what I later learned to call mass culture theory assumed an elitism that came naturally to an opinionated loud-mouth trying on existentialist notions of the ineluctable self. And my politics were asinine. The times they were a-changin' and my Christian notions of fairness ran deep; I rooted for JFK and became ever more racially aware. But when Miriam joined a Woolworth's picket line on Main Street in the spring of 1960, I had the stones to tease her about it. Jesus I could be such a jerk.

With the worldview I brought to Dartmouth crumbling, I desperately sought a replacement. Only years later did a therapist help me see that this search was complicated by the inadequacy of my preferred alternative—that my default substitute for God was women. Hence, Miriam's imperfections—some of them genuine incompatibilities, some the kind of everyday drawbacks infatuations are blind to, and some her lot as a mortal human inhabiting the space-time continuum—were more than romantic reversals for me. They were existential reversals.

Existential reversals came fast and furious, starting first trimester with Philosophy 1, which my kindly academic advisor, an eighteenth-century English lit specialist named John Hurd, warned was over my sixteen-year-old head. I aced it. It's not as if Mr. Sargent had prepared me directly for empiricism, idealism, intuitionism, vitalism, phenom-enalism, naturalism, determinism, and critical realism. But those Sunday school disputations laid the groundwork. And they guaran-teed I'd listen carefully when a tag team of philosophy profs spent two weeks arguing theism, mysticism, agnosticism, and atheism one after the other. Was I ever looking for an ism.

A crucial insight came my way during my first breakup with Miriam, which I instigated for no better reason than that she was away teaching

at a dance camp. Bravely albeit desperately, for the first time in my life, I cold-called a girl and asked her out: my PS 22 crush Nan Younger, who'd just graduated from Flushing High. Somehow I'd learned, maybe from my hopeful hinting mom, that Nan was a North Shore Baptist congregant on her way to the Harvard of fundamentalism, Wheaton in Illinois. So coming back from *Wild Strawberries* I stopped yapping about Miriam long enough to turn the conversation to religion. As we strolled down muggy 149th Street, I declared for what I'd concluded was the rational position: I was an agnostic. To my surprise, Nan quickly responded, "Oh you are not," and when I asked what she meant had her own question ready: "Well, do you live as if there is a God or as if there isn't one?" I thought for a moment and acknowledged that it was the latter. "Then you're an atheist," she said, and as with Blanche Wiesen I knew right away she had me. Nan majored in philosophy with a special interest in pragmatism, then went on to Cornell, where she met and married the distinguished philosopher of language Robert Stalnaker. She never sets foot in church anymore, she told me when I cold-called her fifty-four years later—it just doesn't feel comfortable.

But this decision for atheism in no way ended my quest for a code to live by, which lasted until midway through junior year, when I succeeded in embracing an idea I'd flirted with many times: that isms themselves were the problem. Hence I should instead settle for, indeed take joy in, Just Being Alive. This commonplace was no less smug than any better-developed belief system and further stunted my politics. But it had its uses for the healthy person I was on the long road to becoming. And in the meantime it cured the physical manifestation of my existential dread: a hollow feeling in the pit of my stomach that prevented me from taking a deep breath. Loving Cummings or hating Plato, gobbling up Yeats or battling Corneille, abstractly contemplating suicide or corporeally adoring my one-and-only, vanquishing all comers in Ping-Pong or worrying about the size of my penis, I'd think, "Take

a deep breath," and . . . fail to do so. For over two years I never freed myself from that hollow feeling—I was physically anxious all the time. Then one winter afternoon in 1961 I thought, "Take a deep breath," and . . . breathed deep. Somehow I'd outlasted my despair. The malady does return even now. But the relief I experienced that day had the weight of revelation.

The average secular humanist might wonder what I had to worry about. I've indicated one answer: the fact that Miriam Meyer was a mortal woman. But my therapist's conjecture didn't go deep enough, because my own mortality obsessed me even more. What secular humanists never seem to get about fundamentalist Christianity is that it shares its fundamental appeal with every other traditional religion: it "solves" the problem of death. "For God so loved the world, that he gave his only begotten son, that whosoever believeth in him, shall not perish, but have everlasting life." Half a century after I last read the third chapter of John, I just now typed out John 3:16 from memory, adding a comma and missing one word (it's "should," not "shall"). Christianity's deal-closer isn't heaven, where the details are so fuzzy—at least not for those with decent lives. It's the promise that this, this right here, I mean *this*, is everlasting. It will *never end*. I still don't like the thought of it ending. I still pop out of naps alarmed that my life is a quarter or a half or three-quarters or four-fifths over. Then I get up and get on with it.

Dartmouth's secular humanist agenda intensified these spiritual struggles. The ism that haunted me even more than atheism came up in Philosophy 1 but floored me in a course I hated and also aced: the dully conceived and abysmally taught Sociology 1, where cultural relativism was preached with a spiritual sensitivity worthy of evolution-fighting Dr. Ralph Archibald (who in a gruesome coincidence was then torturing Miriam in freshman math). As mortality ate at my gut, morality bounced around my brain. True, the focus was sex—as I

wrote Miriam, "Why is my morality 'right' at amoral Dartmouth? And why can't what's right for me be right to the Polynesians?"—but with Dostoyevsky always in the back of my mind, everything from lying and stealing to murder and suicide was on the table. I craved the certainty of a code. And providing hope of relief were two other Dartmouth-instigated isms: pragmatism and existentialism.

The former came my way as a freshman reading I devoured even though we were never tested on it. For a work of philosophy, William James's *Pragmatism* is extraordinarily readable, sensible, and thought-provoking, as is only appropriate given James's core belief that the universe is "unfinished, growing in all sorts of places, especially in the places where thinking beings are at work." But as if to prove the sanity of James's axiom that temperament trumps truth in anyone's choice of worldview, my overwrought sixteen-year-old self took more readily to a lecture on existentialism at Le Grenier Français—as the philosophy department prudently avoided this modish topic, its rivals over in French piled on Camus, Beckett, and Sartre options. "Man is in a state of constant anguish because he is continually forced to make moral choices in a world of chaos where no moral code is adequate" was how I summarized it for Miriam. For a while I hoped to achieve some new faith via religious existentialists Kierkegaard, Tillich, and Buber. But none of them connected, and slowly I grew into the life principle the pessimistic Frenchmen and optimistic Americans advised in common. I learned to revel in contingency, and leave the certainty of any code behind.

Although Dartmouth set off all this personal turmoil, it wasn't designed to ease it. I got good grades, kept my nose clean, and never thought about pursuing whatever counseling was available. Maybe math chair and future prexy John Kemeny told some higher-up that the scholarship boy with the 780/760 math SATs had refused to consider majoring in math even when summoned to his office for a stern face-

to-face. But I doubt anyone noticed that I took just three social science courses after comping out of my history prereq even though, like my father at NYU, I'd announced my career goal as law. Before classes even began, this hypothesis took a hit from a lecture called "The Aesthetic Life," which inspired a few freshmen to convene a short-lived cenacle we dubbed, with a self-mockery reminiscent of the Virgins of America, the Effete Aesthetes. And my legal plans went thataway in English 2: John Hurd guiding a class that included my friend for life Bruce Ennis through close readings of Hemingway, Lawrence, Faulkner, Joyce, and others who would long occupy my mind. Within a month my dream was to write fiction as good as "The Snows of Kilimanjaro" and "The Rocking-Horse Winner" while teaching college like John Hurd.

The Effete Aesthetes proved too flighty to provide life counsel any more reliable than that of the waggish V.O.A. For months, in fact, my most trusted advisor was confined to Queens and in over her head. But she was stalwart to hang in there at all. What was the chance that a couple who were an item at fifteen would undergo four years and 270 miles of separation and, without marrying or even considering it, remain an item at twenty? Yet Miriam and I did. The distance probably helped—because we never got habituated, we never got bored either. And probably if I'd gone someplace coed I'd have met someone smarter or cooler or wilier or merely closer and turned cad. Instead, Dartmouth's sexism shored up our relationship.

As described to me—I never observed this ritual—the routine was simple and pathetic. Dartmouth men would road-trip the 110 miles from Hanover to Smith or the 120 to Holyoke or maybe the tougher 130 to Skidmore (where, my roommate George reported, he'd "never seen girls so hot to trot") or maybe just the 35 to the much-mocked WASP bordello Colby Junior College. There they would buffalo and

bullshit till they "made out" or "got tit" or "got to third base" ("cunt" and "pussy" were not then in the ass-man lexicon) or finally, of course, "scored" or "went all the way." Conversation was strictly functional even when it feigned seriousness, and alcohol was always involved—always. Sometimes the ritual backfired, or accomplished its true goal, when the feigned seriousness of a line of bullshit deepened post-coitus, convincing the sated scorer that he was in love because he'd found a girl he could talk to.

This is a cartoon, of course; for a more sympathetic albeit no less grotesque version, see the "Road Trip" chapter of the Chris Miller memoir *The Real Animal House,* which more faithfully than the movie takes place at the Dartmouth of my and screenwriter Miller's era. But if the scuttlebutt that assigned Dartmouth the highest divorce rate in the Ivy League was accurate, the cartoon has explanatory power. And although I craved "experience" and would go on craving it for a very long time, I never really doubted that my way was better. When my father suggested I date other girls, I told him Miriam was my antidote to Dartmouth's "sex and money atmosphere" and he laid off. When my dormmates told me I was too young for Miriam, too intellectual for Miriam, too selfish for Miriam, I compared their sorry love lives and stuck with mine. When my fellow virgins whined that "there are no original, sincere girls willing to take chances," I knew I'd found an exception.

The thing was, I wasn't so naive as to believe Miriam was the only one. On the contrary, I assumed there were many—at Bennington, I imagined, or Radcliffe, I dreamed. And that wasn't all. Like for instance, I was too young for Miriam, too intellectual for Miriam, too selfish for Miriam, and in my own words, "a bit dense when it comes to empathy." Like for instance, when I told her I wanted her to "share" with me, and that verb was a mantra, it meant I wanted her to read everything I was reading including my Philosophy 1 textbook. Like

for instance, in what proved a lifelong practice plus I was rather less stable in my teens, I informed her immediately—by mail with its time lag, the telephone being too cumbersome and expensive—of my every mood change, most of which were dark in those days, and moral quandary, my battle with masturbation among them. For my entire freshman year, I was tortured by the natural fact that the only girl I'd ever touched didn't always occupy the forefront of my mind. I was depressed when I missed her and more depressed when I didn't.

Miriam was saner and more steadfast. Her feelings shifted less drastically, and since we weren't officially going steady, she assuaged her parents' anxieties as well as her own by dating once in a while. This hurt me, but I didn't try to stop it—in part because I wanted to reserve the freedom to date myself, in part because I knew it was unlikely she'd even (even! it would kill me!) kiss another guy good night, in part because she had the guts to insist that "sitting home every Sat. night rather than doing something interesting with someone interesting is pretty senseless." So she rode me like a tilt-a-whirl all year, and for all our ups and downs became firmer and more explicit in her affection and commitment, which were pretty firm and explicit to begin with. This pattern continued for four years. Through chronic conflict and many external obstacles, we spent the entirety of my time at Dartmouth trying to learn how to love each other.

Needless to say, we failed. I still own (and have been quoting from) some three hundred of our letters from the first two and a half years of this saga, during which we broke up twice. The first time, which lasted just a few weeks and ended when she got home, I figured out how much I valued Miriam as she was. On good days I remembered that the doubts that overcame me were "symptoms" rather than "reasons"—measures of my flux rather than her reality. So I toughed it out when her parents drove to 159th Street brandishing a letter that quoted *Lady Chatterley's Lover* and left a box of similar filth on the living room floor

after securing Mom and Dad's promise that they'd order me to terminate the relationship. My response was to add every day to an endless letter I felt sure she'd read when we got back together.

The earlier breakup had arrived none too soon for the Meyers. A starter boyfriend they could tolerate—I even came down for Passover freshman year. But soon it became clear they'd no longer sit by while their dreamy bohemian daughter neglected her grades in a long-distance romance with a German hyperintellectual who'd learned manners from a fireman who ate dinner in his sleeveless undershirt. Already rebelling against her parents—"The only way to know where I stand is to go on the assumption that I'm always wrong and then do what I please"—Miriam held her ground. Often we met in the apartment of her gay-I-think friend Angelo downstairs, who also provided a mail drop, and in January she faked a weekend with Vicki Custer at Cornell and snuck up to Hanover instead. It was so romantic I finally kissed and caressed her breasts, a mere year and a half after the prom. Not that we hadn't made out plenty before—like many virgins, we could neck hotly for hours. But after that icebreaker we proceeded hornily through all the usual stages except the big one. Our reluctance to go all the way wasn't about prudishness—we liked our bodies. It was about entrenched morality, most if not all of it mine.

My parents kept their word to the Meyers, and would have preferred I move on. But they were too decent and too realistic to lay down absolutes. So after bawling me out about D. H. Lawrence, they insisted I not communicate with Miriam till term's end and I embarked upon my epistolary memoir. By June we were back on full-time in New York, meeting at Angelo's and making out exactly where we'd always made out—in the stairwell to her roof, my sports jacket our pallet on the floor. All the Meyers got for their meddling was a good-hearted daughter who was mad at them. In 1961 they underwrote a term at Boston University, which was followed by a year in which Miriam

worked at the Fifth Avenue Library and attended Queens from a furnished room on West 87th Street. They knew damn well she was seeing me both places.

Exactly how many tastes and ideas Miriam and I "shared" and how many I imposed is hard to say, especially in the arts, where my burgeoning jazz jones took effect once we were old enough to nurse beers in bars. But in one thing we were committed equals: we hated Queens. Not Queens College, where I socialized some and audited American studies lectures by the college's charismatic young John J. McDermott. Just everything else, starting with parents who insisted I attend church and she dump me, respectively. We hated having nowhere to neck or see a foreign film or eat beef with black bean sauce; we hated the frigid air whistling into the Flushing IRT as it dragged us back to our separate beds. Once there was a long, blissful, drizzle-dampened tramp through the deserted grounds of the 1939 World's Fair at Flushing Meadows, lengthened by tree-sheltered lie-downs and topped off with half an hour on a park bench behind Grandma and Grandpa's. From there we could have phoned and gotten fed—Kitty, unlike Virginia, had already had us over to dinner, where Tommy made a conquest. But instead we dined on egg foo yung in the Queens Boulevard eatery Grandpa called The Chinese, then took the E train to the rerun haven the Thalia, two transfers away on the Upper West Side. And after *Les Enfants de Paradis* we took the IRT back to what was still, in cold fact, our home. "Queens as in querulous," Miriam used to say. "Queens as in queeeeasy."

Although John McDermott moved me more than any Dartmouth prof save one, most of my intellectual growth took place at the college I actually attended—but only if you don't count Manhattan. Call it urban studies, which like McDermott's American studies and the NAACP doings Miriam explored wasn't on the menu of my New

Hampshire citadel. From Queens, going into the city meant escape, sophistication, adulthood; from Hanover it meant both paradise and the real world, with my *Village Voice* subscription a lifeline. Our hangs included our meeting spot and Miriam's workplace the Fifth Avenue Library, Tad's Steaks in Times Square, the Thalia and then New Yorker rerun houses on upper Broadway, the Cloisters with its unicorn tapes-tries, a well-remembered Mott Street Cantonese called Hong Fat, and our mecca: a big used-and-new bookstore at Fifth Avenue and 18th called Barnes & Noble.

My college years coincided with the great flowering of foreign cinema in Manhattan, from the Upper West Side to the Blooming-dale's belt to Village houses like the Art and the 8th Street: Bergman and Kurosawa, Chabrol and de Broca and Malle and Resnais and Truf-faut, *Pather Panchali* and *He Who Must Die* and *La Dolce Vita*. But with guidance from *Voice* drama critic Jerry Tallmer, we remained playgoers as well, buying rear-balcony seats at Broadway dramas like *J.B.* and *The Visit* and cheaper downtown tickets, from semipro productions of *Our Town* and Elmer Rice's *The Adding Machine* to multiple viewings of Jack Gelber's junkie drama *The Connection* at the Living Theatre, with its mesmerizing interlude of actual junkie Jackie McLean shambling center stage for one of the best alto solos you could hear anywhere.

In search of more great solos we ventured east to the Jazz Gallery at 80 St. Mark's Place. My first show there came shortly after I turned eighteen, an astonishing bill pairing the Thelonious Monk Quartet with the John Coltrane Quartet. I returned often to the scene of this miracle, which cost just a buck in the jammed gallery section, so I don't remember exactly what happened when. I'm sure, however, that our guardian angel Angelo, a native Lower East Sider who knew enough about poverty to value Flushing's comforts and more about sex than me, came along at least once—I remember arguments in which he dis-puted whether this wide street where beatniks and Puerto Ricans took

the air together might be a good place to live and also whether the girl next to us wished her date would stop feeling her up. Reasonably, Angelo charged me with slumming and prudery, respectively. I still think I was right both times.

Both Monk (*Brilliant Corners*, then *Misterioso*) and Coltrane (*My Favorite Things*) were in my tiny LP collection, as were Dave Brubeck (*Jazz Goes to College*), Miles Davis (*Milestones*), Ornette Coleman (*Change of the Century*), and a live Billie Holiday bootleg. There were also three Charlie Parker albums: a live obscurity called *Diz 'n' Bird* that was mostly Diz, a collection of Dial masters, and the Verve masterpiece *Now's the Time*. One of the Parkers may have been a post-Dartmouth purchase, like Ray Charles's *What'd I Say*. And though my sophomore roommate had a hi-fi and I bought a portable after I graduated, junior and senior year I was obliged to do my listening in friends' rooms or on the few public phonographs scattered around campus. Nevertheless, listen I did.

Folk music's lefty vibe was a bad match at Dartmouth, and Joan Baez's grandiosity had killed my interest anyway. But jazz was collegiate in that moment. Chris Miller was a serious r&b fan who reports that among the bands his hang-loose fraternity imported was the Five Royales, a great lost treasure of '50s rock and roll who I didn't catch on to until 1978. But he also reports that Christmas break 1960 he had his life transfigured by John Coltrane at the Village Gate, as I did in the same venue eight months later, when I watched Coltrane trade laps with Eric Dolphy in an encore that had me trying to make more noise than they did, cheering and shouting and pretty much out of my head. That's still my most ecstatic musical experience in a life rich with them, including a Louis Armstrong concert freshman year that a sophomore later browbeat me into admitting might have been corny (which

it was, a little, and so what). Most Dartmouth men, however, dreamed a different species of ecstasy, preferring the Brubeck/Davis/MJQ vein—cool stuff, quiet stuff, seductive stuff.

Straight bebop was different—already past its cultural moment and strictly for the arty rebel I was becoming. Although I went for the bop-pish Monk and Davis and McLean, the main reason they're only -ish is that compared to Parker everybody is -ish. Schlock Bird could dig—the strings and choruses and orchestras Verve's Norman Granz pasted on felt like confirmations to him. His 1945 Slim Gaillard session is alt-r&b the way the jazz-friendly Pavement or Soul Coughing were alt-rock fifty years later, as were some of the Diz capers he joined in on. But while he might dip musically into Davis's cool or Gillespie's Afro-Cuban or McLean's soul, he died so young his playing remained bebop's most pure as well as its foundation—which was evident to arty rebels like me even if we were too unschooled to follow the tricky harmonic logic bebop imposed.

A romanticism surrounded bebop, but although many arty rebels were fascinated by Parker's heroin habit and alcoholic death, I never got that vibe from its Dartmouth clique. Our romanticism was about race, and we shared it with two new writers we admired, by which I do not, unfortunately, mean Ellison and Baldwin. I'd like to think I was already too hip to fall for Jack Kerouac's spontaneous bop invocation of "life, joy, kicks, darkness, music" in "the Denver colored section." But I wouldn't put such asininity past my young self. About Norman Mail-er's equally notorious "The White Negro," however, I feel less defen-sive. His hipster-hawking praise for the psychopath is the major gaffe in that manifesto, whereas "any Negro who wishes to live must live with danger from his first day, and no experience can ever be casual to him, no Negro can saunter down the street with any real certainty that violence will not visit him on his walk," totalizing and slightly dated though it may be, is the kind of stuff rappers still say every day.

About the jazz he often mentioned in passing, however, Mailer was of little practical use—"jazz is orgasm" isn't the stupidest thing he ever said about sex only because it has so much competition. Presumably he nursed a notion that improvisation required a courage the Negro's daily quota of danger instilled in him, then failed to flesh it out for lack of musical knowledge. So if Charlie Parker was the source of this paradigm, it was up to the arty rebels who admired both Mailer and Bird to figure out the details. But as a backslid Christian no less death-obsessed than Mailer, I didn't go to Bird for existential inspiration. I went for wit, joy, and skill. And where some got their kicks following the dim traces of bootlegged club and concert gigs, I always preferred Verve's professionally produced *Now's the Time*: a different quartet session on each side, bebop drummer supreme Max Roach plus piano and bass.

What I loved most about the Dials was the heads—the tunes Parker devised to launch his improvisations, sometimes adapting the changes of copyrighted standards to twistier and more abrupt melodies, "Ornithology" from "How High the Moon" or "Dexterity" from the eternal "I Got Rhythm." But on this LP only the classic "Confirmation" is that dexterous or ornithological. Yes there are tunes. Genuine respects are paid Kern-Hammerstein's "The Song Is You" and Mercer-Schertzinger's "I Remember You," and a Bird original named after his son Laird aspires to the same kind of relaxed melodicism. But the album comes down hardest on two Parker copyrights that are essentially simple (for him) improvisations—the "I Got Rhythm" race to the top "Kim," over twice before you know what hit you, and a blues called "Chi-Chi" that's most blueslike when Parker slows his alto down on the last of three takes (which was exhumed well after I left college). And then there's "Now's the Time" itself, which I loved without knowing that Parker had recorded a more thoughtful version for Savoy in 1945, much less that in 1949 it had been simplified by bari-sounding tenor sax honker

Paul Williams into a lazy, infinitely danceable r&b megahit called "The Hucklebuck." Parker's 1953 version, faster and fuller than his original and much faster than Williams's recasting, was my favorite thing on the album except the thrilling no-intro opener "The Song Is You."

Looking back, I'm struck that I singled out two pop moments on an album I adored, just as I preferred the themes to the solos on the Dials. But it wasn't their pop attributes I was stuck on. Giving not a thought to the choruses his sidemen squeezed into the final minute of each three-minute track, I heard the whole thing as the immersion in unsullied Bird improvisation the no-intro opener promises. I knew nothing of how arduously Parker practiced to achieve this spontaneous bop whatever, and failed to notice the rather similar phrases running through different stretches of his river of melody. At some level I wanted to believe in spontaneous bop myself.

Yet although Charlie Parker was the quintessential African-American artist for my collegiate self, he didn't make me wonder whether Negroes were more "spontaneous" than white eggheads like me because spontaneity didn't rank that high on my analytic agenda. My romanticism was both less specific and, I suppose, more essentialist. I relished the aural evidence of an identifiable African-American identity in the heat and body of my favorite soloists' sound (soon to be labeled "soul") and the spell of their swing (which gradually gave way to the apter, less rhythmically prescriptive "time"). You could hear that Negro sound every time, I'd swear as Miriam and I listened to Symphony Sid on WEVD—a not altogether indefensible notion that had a lot more truth value in 1960 than it does after another half century of musical race-mixing.

But if I was the theorist, it was Miriam who led us deeper into the

jazz world—and also, as a result, the Lower East Side. The conduit was her Fifth Avenue Library friend Joan, who paid the rent on a Forsyth Street tub-in-the-kitchen that she and her cordial, graying, piano-playing, supposedly junkie, definitely Negro boyfriend vacated once so Miriam and I could share an actual pallet on the floor. The boyfriend advised me to check out Lennie Tristano, and I did. But I didn't like him that much, and still don't. Too cerebral.

Angelo had a point—122 Forsyth was a dump. But it was cool to walk up bustling Orchard Street on a hot Sunday morning and end up fressing cherry-cheese knishes at Yonah Schimmel. This was my first serious taste of the slum I'd call home, which in that sector and moment was Orthodox Jewish and Puerto Rican with a minuscule bohemian admixture. And it beat the nights I'd spent with nowhere to go after sneaking down to the city without telling my parents. One winter weekend Tony Fisher found me a couch at Columbia, but I also slept in the subway and in warmer weather on park benches and even project lawns—at Queensbridge in Long Island City (after accompanying Miriam to Flushing), or the Alfred E. Smith Houses near the Manhattan Bridge (was that the time I wandered the Lower East Side for hours after reading *Voice* essayist Seymour Krim's *Views of a Nearsighted Cannoneer* by fluorescent streetlight?).

On July 14, 1961, I finally shed my V.O.A. membership at the Hotel Martinique on 32nd Street. This breakthrough took way too long, sick long—eighteen months from first kiss to breasts, another eighteen to put my penis in my beloved's vagina. By then we'd spent a bunch of nights in the same bed, contorted ourselves into positions unsuitable for stairwells, and left enough semen in my underpants to traumatize my mom on laundry day. So we set a date, fumbled the check-in, achieved intromission at night, tried something besides missionary in the minute or two at our disposal the next morning, and walked out to Burton-and-Taylor headlines feeling nothing like Burton and Taylor.

Soon Miriam had her bedsit, and senior year I damn near commuted there before skipping spring vacation in a failed attempt to knock off a thesis entitled, I swear, "Hemingway and Death."

As I followed my prescribed collegiate path toward the graduate studies my career plan dictated, it soon become evident that I loved literature for its content as much as its form. When possible, I conceived papers that let me explore the big ideas I couldn't get off my mind, which was easier when I had an underdog narrative like *Notes from Underground* to start from than when it came to scientific method as per Lucretius, organized religion as per Chaucer, or Swedenborgianism as per Blake. I didn't abstain from the first person, either, no doubt irritating my profs—at Harvard, I'm told, this transgression was verboten. My papers always read well—I'd learned more about prose from the New York Board of Ed than most of my classmates had in prep school—but got better, especially outside my major. Junior year I plighted my troth to contingency in a celebration of Nietzsche's *Thus Spake Zarathustra* and showed off my close reading skills by demonstrating that Beckett's *Endgame* was about progress, not futility. I continued to consume heaps of extracurricular fiction and poetry, and never let my emotional travails stop me from getting more A's than B's. But by the final trimester of my junior year, when the English Honors seminars began, I was suffering a whole new species of doubt.

These days the New Criticism is so old that I need to explain that it dominated American literary scholarship for decades after World War II and ruled Dartmouth's English department, which insisted that literary works were discrete, autonomous wholes just waiting to be pried open and broken down by trainees like me. At a time when such white Southerners as William Faulkner, Katherine Anne Porter, Eudora Welty, and William Styron still maintained their literary suzerainty

over a rabble of Jews and beats and even Negroes, the New Criticism's prototypical practitioners were white border-staters Allen Tate, John Crowe Ransom, Cleanth Brooks, and Robert Penn Warren. I was so clueless politically I had no idea that except for Warren—the only one who retains much currency today—all these major American intellectuals remained segregationists after *Brown v. Board of Education*. I was so clueless politically that although I'd encountered the left-identified Edmund Wilson, Alfred Kazin, Irving Howe, and Lionel Trilling researching papers and even accompanied Tony Fisher to a Trilling lecture at Columbia, I never wondered why we English majors were so seldom pointed in their direction. Moreover, and stupidly given my personal history, I failed to notice that except for the soon-gone Jack Hirschman, who was only there my sophomore and junior years, every single one of my English professors was a WASP.

I did come to suspect, however, that while the painful but liberating life lesson I'd learned from Dartmouth was to eschew the solace of my old religion, my course of study aimed to convert me to a new one: the religion of Art. And I also noticed something: none of the novelists and poets I cared about were English professors.

Jack Hirschman wasn't different just because he was Jewish. His teaching specialty was writing rather than the career I saw as a means to it, and in any case his impact was more cultural than academic. Since Dartmouth poet-in-residence Richard Eberhart had given Allen Ginsberg some of his earliest publicity in a 1956 *New York Times* report, it's possible he was hired expressly to shake things up a little. And he did. Hirschman represented for the other half of the artistic education I gulped down during my college years. He was bohemian Manhattan personified.

Skinny and hook-nosed, tie loose and jacket corduroy, sporting a

phlegmy Bronx accent, an uncommonly healthy thatch of curly hair, and a full repertoire of dramatic gestures, Hirschman was just twenty-five when he came to Dartmouth. As soon as I returned to Hanover sophomore year I visited him in the faculty housing he shared with Mr. Gerlich's niece Ruth, destined to run Los Angeles's independent KCRW-FM for three decades, and their two messy and lovable toddlers—one of whom, Celia, became a lifelong music bizzer. Immediately I signed on for his writing class, shouldering a four-course trimester that nearly broke me, although in the end I got three A's. Rereading as many of the poems and stories I wrote for him as I can stand, I figure his A was a gift from an easy grader. But I have a 1999 note from Celia in which Ruth still remembered my *Notes from Underground* essay, so maybe he counted that. Hirschman taught me to ponder every word, and was an important reason my prose improved. And socially he was a godsend.

Although I sometimes whined to Miriam that I had no friends at Dartmouth, that was my existential self-pity talking. What's truer is that I didn't have a gang, just pals impressed by my voluble indifference to button-down style—had there been a competition for worst-dressed '62, I'd have made the final cut. After a year spent feuding with Sam Rosenthal and George Szanto, I reconnected with them visiting the sweetest, funniest, and most thoughtful of the V.O.A. posse, friend for life Ed Hirsch. Easing this transition was a summer spent as a parkie around a gang of harmless Flushing rocks whose conversational folkways turned me into the foul-mouthed motherfucker I remain today, and also the news that Szanto had read sixty books over the summer. George was the son of a Jewish Austro-Hungarian mill manager from Manchester, New Hampshire, whose parents literally skied away from Nazi Germany to settle in Manchester, England—the source of what I'd heard as his snobby accent. He roomed with me senior year, became another friend for life, and eventually proved our class's most prolific published author unless album reviews count.

But one big thing I learned at Dartmouth was that not all the smart people in the world were Jewish, and except for a genial natural hipster named Bob Brower, who I met while trying out pluckily if absurdly for freshman basketball, the rest of my friends there were goyim—and also the nearest thing to an American studies minor the college could offer. My sophomore roommate was my Catholic doppelganger Mack Stone, a fat sufferer with a compulsive chuckle who retreated back to Pawtucket after two half-assed attempts at a suicide that remained strictly theoretical on my end. We lived in Wheeler Hall just down from Dartmouth's best Ping-Pong player, a junior who deputized me in Wheeler's intramural victory over the vainglorious jocks of Beta Theta Pi and was so suave some absurdly suspected he was, in campus parlance, "a light item." My English 2 classmate Bruce Ennis also lived in Wheeler, whence he rushed the declasse fraternity Phi Tau, where we both met quiz show whiz Basil Condos; from Kansas City and Chicago, respectively, they were the smartest guys I knew at Dartmouth. Downstairs I befriended a taciturn Minnesotan '63 named Charlie Berg, who came to Dartmouth for the woods, left for India, wound up in Mexico, resurfaced sporting a "shepherd" mane longer than I'd ever seen on a living male human being, was given a trip to the shrink instead of his scholarship back, and promptly returned south to become a bullfighter. I also befriended several light items who are marked in my reunion book with just an address, or a "Dartmouth has no information on this '62."

By Dartmouth standards, all these rather different guys who knew me but usually not each other shared one thing: they were weirdos. And although I was too apolitical to give much thought to how many of my classmates were preppies who came from money, they were just about all public school graduates. On a campus where four sophomores in five joined a fraternity, many of them didn't even rush, and Bruce and Basil's Phi Tau house, known campus-wide and in its own jovially ironic lore as "the Tool Shed," was described by Chris Miller as "bottom-of-

the-social-scale creepy." Of course, the Alpha Delta Phi animals Miller mythologized were weirdos too, enemies of the college spirit our all-male enclave tried to make compulsory. But they had each other. At Dartmouth, most weirdos were isolated. And for the arty rebels among them, that was where Jack Hirschman came in.

The Beats had gone pop my senior year in high school with the critical bust-outs of Ginsberg's *Howl* and Kerouac's *On the Road* and *San Francisco Chronicle* columnist Herb Caen's coinage of the term "beatnik." Early my sophomore October, I wrote Miriam slamming four attacks on the beats, including one that "*reeked* of quiet, condescending, intellectual elegance." But I was less tuned in than the guys who started a literary magazine called *Greensleeves*, where I felt outclassed as I never did academically. Then Hirschman crystallized a campus-wide microbohemia with a flamboyant reading of "Howl" in the English department's wood-paneled Sanborn House, the tweediest and handsomest building on campus. It was Hirschman who introduced most of us to Charles Olson, Robert Duncan, Frank O'Hara, my sentimental favorite John Wieners, and especially Robert Creeley. It was he who preached his own brand of American studies by insisting that the USA and the USSR shared a freewheeling vastness that made them natural allies, who directed me to D. H. Lawrence's *Studies in Classic American Literature* and William Carlos Williams's *In the American Grain*. And it was he who attracted a crowd whenever he sat down for coffee at the Green Lantern.

My way eased by these klatches, I got to know Dartmouth's cool kids. Son of classicist-translator Richmond Lattimore, poet Sandy Lattimore nicknamed me Xgau, spelled Europe "Yurrup," and pointed out a Johnny Griffin solo on Monk's "In Walked Bud" that's been a touchstone ever since. Poet Dewitt Beall lent me and Miriam a bed in Manhattan during our long virgin period and was chagrined to learn we hadn't consummated our love there. I also edged closer to charismatic

Manhattan-bred multi-talent Bill Hjortsberg, nicknamed Gatz not after Jay Gatsby but because the kids at Grace Church couldn't pronounce his Swedish name. Left pretty much broke by the death of his restaurateur father, Gatz worked a forty-hour week at Hanover's only pizzeria. His cartoons were as deft as his short stories; he wore a cape like bohemians past and parti-patched jeans like bohemians future; he smoked pot and imported peyote. Reviewing Tennessee Williams's *Camino Real* in November of 1961, *The Daily Dartmouth*'s Robert Christgau singled out Hjortsberg's tender body language in declaring his Casanova "every bit as excellent" as the Kilroy of a '63 named Michael Moriarty.

My first piece of published criticism, while showing authority and flair for a nineteen-year-old, was my sole journalistic venture at Dartmouth. But it stands as one more signal of how restless I was. For all my tumult and misery, all the inevitable personal development and intellectual exploration, I continued to take my courses seriously without being a grind. And a few epiphanies stuck in my forebrain forever. The elderly classics prof who responded to a question about the afterlife by grumping, "You're just dead, that's all." The beret-sporting old poet who taught a seminar in *Remembrance of Things Past* and nothing but *Remembrance of Things Past*. A half Latinate, half Anglo-Saxon turn of phrase from Thomas Browne's *Urne-Buriall*: "We mercifully preserve their bones, and pisse not upon their ashes." The philosophy chair who brought one of his Freud-based Philosophy of Human Nature lectures to a head-spinning climax by demonstrating that the ineluctable self was a chimera until it accrued concrete characteristics—that we couldn't talk about ourselves without situating and describing ourselves in relation to the world and other people. The Yeats prof who spun that idea by stressing the poet's belief in masks—the public personas with which everyone expresses and con-

ceals the self simultaneously. But by that senior seminar, which I'd instigated, I was no longer gung ho.

The prof's mask was supercilious pseudo-Oxonian, his signature witticism the suggestion that we assign unpleasant tasks to our "man," and he handed the young slob with the big mouth the third C plus of his college career. As the prof intended—or so he told me when I returned for a journalism panel at the college in 1968—this put a serious crimp in career plans that looked more putative every week. Although I loved the competitiveness and camaraderie of the English Honors cohort, I was also developing a theory that New Criticism was a high church theology in disguise, an apprehension so widespread that Methodist-turned-Episcopalian Cleanth Brooks took the trouble to warn against "conceptions that would turn literature into an ersatz religion." I was mad at myself for not creating any literature of my own. I was convinced that, English Honors be damned, I needed studies in classic American literature to prime my pump. And with Miriam beckoning from her bedsit, I was feeling the pull of Manhattan. By coincidence, the previous occupant of the off-campus lodgings I'd secured with George Szanto was the class of '61's top English scholar, a Henry James fanatic who studied so hard he was said never to leave his room. My program was to match his grades while hitchhiking to NYC every other weekend.

Downstairs from me and George resided two compatible juniors: a budding public interest lawyer named Bill Daniels, who introduced me to *Kind of Blue* on the hi-fi he let me use, and Dartmouth's finest actor, Michael Moriarty, who I once observed examining his boyish blond visage in a mirror and wishing out loud that he looked more like Cliff Ebrahim '60, a moon-faced hulk with acne craters who fashioned a long career in character parts. Shocked to find that Hirschman was no longer on the faculty, we bonded early by underwriting an anonymous flier charging that he'd been forced to vacate

to UCLA. I distributed it, using my honors keys to sneak into Sanborn after midnight. Having noted the missing "C" in Hirschman's name—error to Daniels, who oversaw printing—the paper phoned our hero in L.A., whence he insisted he'd left on his own. Reached in person by *Daily D* editor and honors colleague Dick Bragaw, I averred total ignorance. Misspelling his name—how dumb was that?

I arrived home for Christmas armed with a letter to my parents from John Hurd attesting to my scholastic excellence and explaining warmly why he supported my plan to drop out of school and spend a year writing. I'd arrived so young, and rightly craved the stimulation only New York could provide; he'd done the same thing, clocking a year of newspaper work before completing his Dartmouth BA. By then I was fighting with my father nonstop, especially about religion. He'd left the fire department with his pension as soon as his twenty years were up and was a little less stressed at forty-five. But his temper still scared me. So I announced my intentions to my mother first. Her response was to take me into the backyard and beg me to keep Hurd's letter to myself. "It would kill your father," she said, and although I knew she didn't mean it literally, I caved. Hostilities with my father continued for years, but I never broke off relations, and I never forgot how much I owed him. I never forgot how right my mom was either.

In school but no longer of it, I applied to zero graduate programs and kept putting off my crazy thesis, initially conceived to pack all my nagging existential despair and burgeoning American exceptionalism into one irrefutable farewell statement. Even if I'd holed up all winter I couldn't have brought it off. But I wasn't helped by a nitpicking advisor who, having sanely counseled me to detach Mailer and his heavyweight-champion notions of artistic genius and existential brinkmanship from my project, was so disdainful of my overreaching he could offer no positive feedback. Although like Hirschman he put in only two years at Dartmouth, this guy's hostility to grand ideas typified the rupture between those fearful sherry drinkers and their bright-

est students. A decade later, the same guy almost scotched the orals presentation of a Berkeley PhD candidate named Greil Marcus, who in the end decided not to write his thesis because he had better things to do. My own thesis ended with friends banging out my manuscript on unmatched typewriters in the honors library as I rushed futilely to scribble an ending. As things turned out, 1962 was the year the department cracked down on the tradition of the tardy honors thesis, and I was kicked out along with several others. When the ax fell, I called my mother and cried.

Not a single English professor of the slightest distinction emerged from English Honors. Even the Henry James grind who preceded me at 25 School Street quit academia after earning a Cambridge MLitt, becoming a well-regarded literary agent whose Pete Townshend memoir was regretfully panned by yours truly in the *Times* fifty years later. So it's fitting that like most of my best papers, the farewell statement I rode out on was generated outside the English department, in an aesthetics seminar. Target: Cleanth Brooks's sacral reading of Wordsworth. Title: "Goodbye to All That."

My senior year also produced the only thing I ever published in *Greensleeves*. Its lasting value is strictly autobiographical, but it's short enough, good enough, and prophetic enough to reprint:

> I will make poems
> for my own uses—
> musical as hurdygurdies
> and sad as the old man whimpers.
>
> To ignore the construct
> of counterpoints and symbols
> in harmony, choosing a more
> circusy flare of
> saxophones, drums.

> All for the slouched
> man who peers at the calf
> mooing in its strawfilled tent.
> And for that black cat
> there. With cymbals
> clashing for the acrobats.

Although like many wayward English majors I've lost the habit, I read a lot of poetry in college. Much of what I absorbed was classwork, Chaucer through the Romantics and plenty in French, but the twentieth century I gobbled up on my own, developing successive crushes on Cummings, Thomas, and Frost. All these were overwhelmed by Yeats—for half a century there's been no poet I love more. There was, however, an addition to my pantheon: Doctor of the American Demotic William Carlos Williams. I still pick up both, and when I do, I often begin with titles few would predict: Yeats's major but subcanonical "Vacillation" and the later of two Williams poems called "The Dance"—the one that begins "When the snow falls the flakes / spin upon the long axis," which was plucked up for Williams's expanded *Selected Poems* yet goes unremarked in the three biographies I've examined.

Both are findable online, so maybe you should go read them once or twice, as I have hundreds of times. Along with the Crazy Jane sequence and "Under Ben Bulben," "Vacillation" was why I organized that Yeats seminar; "The Dance" I discovered leafing through a *Hudson Review* in Sanborn House a year or so before Williams's death. Both are very much old men's poems, and both very much grabbed young me. I'll say too swiftly that "Vacillation" is about death and quite confidently that "The Dance" is about love, then admit cheerfully that both are also about Time; "The Dance," however, is more about death than "Vacillation" is about love, never Yeats's area of expertise. Neither whimpers for a microbeat.

These lyric-as-in-lyre poems wouldn't mean as much to me as "Honky Tonk" and "In Walked Bud" if they didn't present themselves music first. When I reread them I invariably find myself mouthing or voicing words I know almost by heart, physically reaccessing Williams's flow and Yeats's stops and starts, the different ways each renders the poetic concrete and makes the prosaic sing. "The Dance" is an outlier from a tenaciously plainspoken master of the quirky line. Its stanzas proceed with dancelike regularity, and its diction is abstract by the standards of the proud prophet of free-verse thingness—all the better to set off a climactic stanza that ends "bare twigs / have an actuality of their own" so that the "twigs" always come as a nice shock, making "actuality" crackle even sharper. From its opening "Between extremities / Man runs his course," "Vacillation" is a kind of outlier as well. In a section that begins "A tree there is that from its topmost bough / Is half all glittering flame and half all green," the sixty-six-year-old Yeats would seem to lapse back toward the borderline grandiosity of his myth-besotted youth. But this is a setup, an essential episode in a poem that means to map a life's progress. It's also radiant rather than pretentious even before it's completed by all the masterstrokes that follow—which include a late-life epiphany in "a crowded London shop," men who go "proud, open-eyed and laughing to the tomb," and a gloss on "the meaning of all song": "Let all things pass away."

A poem should not mean but be. Got it. Yet even as I address the musicality of these poems, I'm impelled toward the meaning their musicality powers. Like Robert Penn Warren parsing "The Rime of the Ancient Mariner," I love them not just as aesthetic structures but as guides to life and contemplation. This was my real quarrel with the English department, and I wasn't alone—so many of us wanted to not just penetrate form but extract content. Yeats was prey to more cockamamy ideas than Norman Mailer himself—cultic fancies that failed

to captivate a kid who'd checked out Swedenborgianism on his own, the erotic compulsions of a dirty old mystic making up for lost time. Yet immersing in "Vacillation," I perceived then and reexperience now the need to get straight with not just contingency but mortality itself, and remember how fundamental the contradictions he celebrates are to any conscious life. Williams was a womanizer married more than fifty years to his unsuspecting Flossie, to whom he lovingly directed "The Dance" and many other poems of his physical decline. Almost in a spirit of confession, its middle part goes on from "Breathlessly you will take / another partner" for a dozen lines. That non-monogamous path was one I'd reject after struggles I couldn't imagine at nineteen. The dedication in the worn copy of *Selected Poems* now on our shelves reads: "To Carola / The Sea Elephant p 36 / The Dance p 166 / Love / Bob." We've had it forty monogamous years as I write.

The errant lover in the midsection of "The Dance" "leaves off / on his way down as if / there were another direction." That's one reason it's a death poem. As for that sea elephant, the big thing he has to say is "Blouaugh! (feed / me)." And also: "But I / am love."

I graduated Phi Bet on June 10, 1962. Mom and Dad were there, Miriam too—they'd given her a lift. The two of us had trouble finding private time, but I warmly recall walking across a bridge and lying down with her in a Vermont meadow. Next day, as I strode from the stage with my diploma, I spied my dad midway down a middle row. He grinned and gave me the high sign and on impulse I flipped the diploma right into his sure hands, never to see it again until Georgia and I shoehorned him and Mom into a senior residence in 2003. Just a few weeks later I'd be earning thirty bucks a week at a menial job where my boss would teach me more than any professor about the musicality of hurdygurdies, the meaning of all song, and many closely related matters.

6

AMERICAN STUDIES

I didn't waste any time. Hitting the *Times* classifieds running, I found a job I figured would leave me time to write: thirty dollars a week for five days of four-thirty-to-eight-thirty a.m. filing at the Wall Street brokerage F.I. Dupont. As of July I was a resident of Manhattan, installed in a furnished fifth-floor garret at 215 West 70th Street: fifty a month for a single bed, a secretary-style desk, a table, two chairs, a fridge, and a stove, plus my own maroon plastic radio, portable phonograph, and bricks-and-boards bookshelves. Bathroom down the stairs. No phone.

My employment history befitted someone whose father had taught him that a job was something you didn't want to do. I'd been a crappy substitute paperboy, a crappy stock and delivery boy at Mr. Garvin's grocery store, a crappy parkie, a crappy Board of Ed recreation supervisor, a Dartmouth Dining Association dishwasher so crappy he got canned after two terms. Three years into a very part-time gig at the Dartmouth snack bar, I was still bussing tables—the Saturday when staff shortages squeezed me all the way up to grill

went down in hamburger infamy. Some of this was ineptitude, some sheer disinterest. In recreation jobs I got along great with kids from five to fifteen because I loved playing with them, but I disciplined sporadically and showed no initiative about organizing tournaments and such. I liked working the snack bar floor because I could sit and shoot the shit, including an ongoing philosophical discussion with an exchange student who later became prime minister of Finland (and also, supposedly, a Stasi agent).

The one exception was a gig filing for some sort of liberal canvassing effort my friend Bill's mom got me the August before freshman year, where my superior reading and math skills let me keep one eye on the work while jawing with the liberal teenagers alongside me. So in that respect I joined Dupont well equipped. But I had no plans to apply myself. The night preceding my first graveyard shift, Bruce Ennis was in town on his way to Europe, a graduation present before he hit the books at University of Chicago Law School. We repaired to the all-male McSorley's on East 7th Street, where I achieved the first drunk of my life on six or eight ales and proceeded east to the Jazz Gallery, emerging at around three rather less drunk and rather more nauseous. A kindly counterman at Gem Spa on Second Avenue gave me a glass of Coke syrup for the price of a soda, but although this home remedy did in fact calm my stomach, when I arrived at 149 Broadway I passed out on a desk in a darkened office. There I was awakened at four fifteen by a man who would change my life.

That's how I remember it, anyway, although it looks too perfect on paper. McSorley's yes, early I assume, but maybe the desk naps only came later. Certainly they happened more than once—up late and bushed, I'd bike down Broadway to Liberty Street to save subway fare and fall out at Dupont so as not to sleep through the alarm at home.

And certainly Bob Stanley would read the note I'd left in our big empty fluorescent office and come and get me. He treated everyone that way— on top of all his other virtues he was a good boss, and I wasn't the only filer who'd crash there sometimes. The crew was dominated by white white-collar grunts who needed thirty extra bucks a week and starred a black postal worker who put away twice the inches of anyone else. Most nights were slack, all our margin slips in place by eight, and Bob would circulate, talking guys up as he flipped casually through a drawer with his rubber finger cap. But when the market went nuts we'd all set to—there were mornings when Bob and I were still filing furiously at 8:55 as trader grunts trickled in with their coffees and hit the phones. Some mornings we'd walk the two miles to 29 Fifth Avenue, where Bob maintained a tiny studio in the Village apartment he shared with his wife, Jane, who ran Dupont's personnel department.

Ten years my senior, a serious gap when you're twenty, Bob Stanley grew up in Yonkers, the son of an itinerant housepainter who died when he was five and a mother who earned a teaching BA from Hunter in 1919 but soon switched to railroad claims adjustor—a miraculously fair and efficient one, I bet. She'd take Bob on long free train trips in the summer. After joyriding through high school, Bob graduated from a tolerant college in Atlanta while studying art at the local museum. Then he returned to New York, where having determined that an English MA at Columbia would require Latin or Greek he chose to paint instead, working at a clipping service and in libraries and once briefly stringing beads so he could layer pigment onto abstract expressionist canvases in cold-water lofts south of Houston. He had lots of colorful bohemian friends, some of whom became famous and some of whom died. He liked to tell the story of the year he and a confederate crashed the Greenwich Village Art Show.

A decade later we'd be close friends, and a decade after that equals. But in the beginning Bob was my teacher—almost a second father.

Although he distrusted my Ivy League degree, he soon decided I was OK—eager and earnest but also irreverent and intense about the arts, cocky in a way he liked, and a baseball fan, which mattered. Bob Stanley had a lot of autodidact in him, and relished the common culture like many bohemians over the years. What I loved most about him was how much he loved the world. As a fervent empiricist, materialist, and atheist, he believed this life was his shot, and set about enjoying as much of it as he could as fully as he could. We talked endlessly about the baby Mets, and—consequentially, as it turned out—about sportswriting too. We talked about how to mince garlic, which I'd been taught was a powder, and sautee mushrooms, which I knew as little brown things in a Campbell's soup can. We talked about how the sun hit the corroded facades of lower Manhattan's disused building stock. We talked about Antonioni's compositions and Monica Vitti's blonde elan. We talked about women, sex, and pornography, all of which he loved and none of which he believed were the same thing.

A voracious reader, Bob preferred the moderns, where his advice was wide-ranging and on point: Beckett's trilogy, Italo Svevo's smoking novel, Alexander Trocchi's junkie novel, George Mandel's World War II novel, the rivet-removal scenes in Richard McKenna's *The Sand Pebbles,* Leonard Cohen's *Beautiful Losers* well before Cohen discovered songwriting. While following foreign film he also pointed me toward the rerun flophouses of Times Square, where Marlon Brando's *One-Eyed Jacks* and Howard Hawks's *Rio Bravo* hit me hard as works in which devalued shards of culture—the stolen ring Brando makes a token of fidelity, the celebrity turns of callow Ricky Nelson and cynical Dean Martin—are transfigured by context and bravado. And most of all he schooled me about painting. As with poetry, my immersion was temporary—through the '60s, which proved to be Bob's heyday as a gallery artist. But it was also life-changing.

Miriam loved the Cloisters and once gave me a Chagall book for

Christmas; occasionally too she'd instigate visits to MOMA or the Met, where my annoying m.o. was to glance over a painting for the twenty seconds it took me to render up-or-down judgment and keep walking. Also, the walls of the reserve room in Dartmouth's Baker Library were covered with Jose Orozco's mytho-Marxist mural *The Epic of American Civilization,* which was hard to miss at thirty-two hundred square feet. But visual art was something I'd never found time for. I admired Bosch and Brueghel and van Gogh and Picasso and Orozco fan Pollock, based a prose poem for Jack Hirschman on Modigliani, and knew enough names to dislike arrant classicist Poussin, a hero of Bob's for how he subverted his own realism. But I'd never heard of Vermeer until Bob dispatched me to the Frick, and not only was I unaware of the Hudson River School and Stuart Davis and Joseph Cornell building his magic boxes a mile from 159th Street, I didn't know any abstract expressionists beyond Pollock. In 1962 the New York School was still mounting gallery shows, so that was where I began, falling for Gorky and Hofmann and Gottlieb and Kline and never warming to de Kooning or especially Rothko, whose mysticism still seems fatally muzzy to me. And that was just the beginning. But before I explain I need to mention one more art form and stop at one French film.

The art form was rock and roll. Omnivorous as always, Bob Stanley was a jazz fan, and doubled my classical repertoire by adding Bartok's First Piano Concerto to Marcel Proust's pick hit, Beethoven's C Sharp Minor Quartet. But omnivorous as always, Bob kept a radio at Dupont that blared WABC every workmorning. No new golden age was dawning on the day I happened to gain my first regular access to Top 40 radio in four years. Bobby Vinton and Brian Hyland and Connie Francis's "Vacation" were all over the hit parade. And it's not as if there'd been no great records after "the day the music died" (supposedly)—February 3, 1959, Buddy Holly RIP, me a college freshman with other things on my mind. But my Dupont tour coincided with the early days

of girl group (three Orlons hits and the Exciters' indelible "Tell Him"), Motown (three Mary Wells hits and the Miracles' indelible "You Really Got a Hold on Me"), and Phil Spector (the Crystals and—don't blame me, I think Spector's overrated—the delible Bob B. Soxx and the Blue Jeans). There were Ray Charles country moves kicked off by "I Can't Stop Loving You." There was the Four Seasons' never-equaled "Sherry"-"Walk Like a Man"-"Big Girls Don't Cry" sprint. There was the Rooftop Singers' driving repurposed folk song "Walk Right In."

For nerdy Christian me, masculinity was never one of rock and roll's attractions. So I can say quickly that we dug all these records without once reflecting that where '50s rock and roll was male with an exclamation point, these were mostly female or male trying to pass. But the rest of how we enjoyed them requires elucidation. The "we" had two components, of course: Bob Stanley, a stable married man who grew up in the '40s, and Bob Christgau, a jumpy post-adolescent who grew up in the '50s. Both were intellectually ambitious aesthetes, but the older man was, let us say, more sophisticated. So while I confusedly if delightedly reaccessed my rather recent youth, with full-on baseball fandom a corollary, Bob knew he was bridging a disconnect but also risking one. That is, he knew that the abstract expressionists at the Cedar Tavern often liked baseball but probably weren't into Mary Wells or the Four Seasons—knew that pop music had as yet accrued no cultural capital. So while our pleasure was spontaneous, it was a loser status-wise. But if as a result a measure of irony sometimes bent that pleasure, it varied widely case to case: nonexistent with Ray Charles and the Miracles and the Rooftop Singers, tinged with awe and affection with the wittingly innocent Wells, sensing the machinery that subtended the Orlons and the Crystals, in on the joke with the Four Seasons. And then there was the two Bobs' theme song: Marcie Blane's deeply simpy "Bobby's Girl," which featured prominently in *The Real Thing*, a sixteen-millimeter short Bob shot in the Dupont computer room and interspersed with porn clips. Our enjoyment of that record was camp that didn't know its name or sexual preference. Damn straight.

I still felt like a jazz fan—the autumn night that Charles Mingus closed the original Five Spot at 5 Cooper Square, I biked by on the way to Dupont to pay my respects. But something momentous was happening—although the concept wasn't in the program I'd laid out for myself and would take years to germinate qua concept, I was having fun. Even in my garret I listened to WABC and the ball game more than my jazz records, and to *What'd I Say* more than *Now's the Time*. The first book I finished after graduation was Bernard Malamud's baseball novel *The Natural,* and before summer was out I'd also read a biography of W. C. Fields, who I'd accessed along with the Marx Brothers at the New Yorker Theater. I expended many valuable hours on this stuff—most egregiously by playing a stupid game of baseball solitaire I'd invented. But its pull on me was continual, and exhilarating.

Unfortunately, this is not to claim I knew how exhilarated I was, because I was still also confused and unhappy. If well into my account of this formative period I have barely mentioned the duly designated emotional center of my life, it's because I remember very few details of what passed between me and Miriam that summer. She was taking summer courses, working at the library, and living at home as she ground toward the graduation our drama had delayed. She was strapped for time, forbidden to sleep over, and hard to reach by phone; she was feeling the civil rights movement and sick of my shit. Too young for Miriam, too intellectual for Miriam, and too selfish for Miriam, I wasn't therefore wrong to think not only that I could find a more suitable match but also that it was about time I risked trying. So let me quote an essay I began in 1970:

> I first saw Francois Truffaut's *Jules and Jim* in September 1962 with a girl named Miriam Meyer. I had been going with Miriam Meyer for five years at the time. The following day I broke up with her.
> Now, I don't want to exaggerate. Miriam and I had been breaking up all summer, and we'd just suffered through our second

bitter fight of the day at dinner, five minutes before walking into the movie. But *Jules and Jim* was the catalyst, the breaking point, the crucial metaphor. Or rather, not *Jules and Jim*. In the months—no, the years—that followed, whenever anyone wanted an explanation of why I broke up with Miriam, I had a succinct and arty reply: "Because she wasn't like Catherine." Pronounced in the Gallic style, please.

Movies played no role in my growing up. They weren't forbidden—I proudly remember my father, who'd attended many afternoon shows with his night watchman dad, taking me to *Twelve Angry Men* and *Stalag 17* and *A Place in the Sun*. But because my family was cheap and First Pres disapproved and I wasn't part of the 159th Street gang that trooped to the Roosevelt Theater every Saturday, I didn't see many till college, by which time they were artistic education rather than pop acculturation. Thus I knew Philippe de Broca and Ingmar Bergman better than Stanley Donen or John Ford, and thus too my ideas about love and marriage—not feelings, ideas, only I wasn't smart enough to know the difference—partook more of French cynicism and Swedish dolor than Hollywood ending, with too much Mailer and a dollop of Bill Manville's bed-hopping *Village Voice* Saloon Society column thrown in. Although I didn't always buy into these films' supposed realism and sophistication—the four-couple monte of Bergman's *Smiles of a Summer Night* annoyed me even then—some unexamined part of me believed happily-ever-after wasn't for cool people.

But there were bigger reasons I swallowed the values of François Truffaut's signature masterpiece so readily, such as it's gorgeous. The aplomb of its lyrical stop-and-go and changeable framing, the long follows and momentary freezes and cut-in newsreels and pace-slowing details—these are only preconditions of the visual pleasure that held me spellbound as a very young man. Over half a dozen viewings, I in-

ternalized the look and the content of its black-and-white imagery as if they were one thing. A departed bohemian Paris evoked in the decor of classic cafes that probably didn't need much set design. Uncramped old flats with their nineteenth-century beds, messy bookcases, and leafy vistas. Seaside, woodland, and forest pastorales surrounding comfortable if somewhat cramped hideaways. And traipsing through it all, three lovers with a gift for gaiety and idyll, three aesthetes who worked at their own pace and expected fun as a reward: chatting, conversing, debating, orating, flirting, kissing, embracing, strolling, striding, racing, kickboxing, playing dominoes, gliding around on their bicycles, plucking trash from the brush, and descending into the deep.

I had more in common with Oskar Werner's romantically maladroit Austrian intellectual Jules, whose steady intensity outlasts his friendship with the debonair Jim. Yet as Truffaut intended and Jeanne Moreau's performance of a lifetime guaranteed, I expended zero emotional energy on either of these male role models—for me, *Jules and Jim* was all Catherine. Why I was so smitten, however, is less obvious than it might seem. Knowing more about relationships from French movies than from my own life helped normalize her unmonogamous ways so that I rationalized her suicidal drive off the bridge with Jim as a plot element—having glimpsed the girl of my dreams, I wasn't about to let a little infidelity or murder wake me up. Still, why was she so hard to resist—not just for me and millions of other viewers, but for the men the film is named after?

When Jules tells Jim that Catherine isn't "particularly beautiful," he's just proving how conventional he is deep down. For the very reason that Moreau isn't cute or voluptuous the way screen beauties usually are, it's impossible to ignore her molded mouth and big dark expressive eyes, or resist her sexual vivacity, playfulness, and pride. If she fully believed she was men's equal—which took guts and an independent mind in a nation where women couldn't even vote until

1945—she wouldn't need their attention quite as much as she does. But she assumes she deserves parity, and that core conviction moved me as much as her elan—rather than scaring me, it attracted me. Truffaut's Catherine has no notable artistic gifts, although more is made of her talents in the Henri-Pierre Roché novel the film works from, and also of the little matter of how these non-rentiers pay the rent. But to quote her secret sharer Pauline Kael: "She is the enchantress who makes art out of life." With little thought to the consequences, I was ready to adore an enchantress like that.

Thus my quest for one kind of "experience" was initiated by the inspired fantasy of a Gallic gallivanter—a skirt-chasing survivor of parental neglect whose love for Hollywood didn't extend to happily-ever-after. Until 1966, this quest would leave me lonelier and hornier than any human being should be, although all too many are. Having devoted five years to the same girlfriend, I'd go on to enjoy only one sexual relationship that lasted longer than a weekend in the next three and a half, which I blamed on my own sexual insecurity and ineptitude. Twice I'd have my pins knocked out by women who could reasonably be designated Catherine figures, although only one of them made a project of it. She was also the one I slept with, and there was a long period when I feared she'd wrecked my sex life for good. In fact my quest had a happy ending. But that's not the kind of movie Truffaut wanted to make.

Jules and Jim changed my life, but that change would have come pretty quick anyway—still unformed and pained by it, I just wasn't destined to marry my high school sweetheart. It was in the even more fundamental project of finding my path as a writer that works of art would truly tell. The most mind-bending novel I read that first year was Joseph Heller's bestselling *Catch-22*. Close kin to the black humor of Lenny Bruce and

Will Elder, Heller's deadpan outrage has evolved into the lingua franca of a cliched cynicism that turns belief of any sort into a sick joke. So *Catch-22* seems brittler now, especially for its first two hundred pages. But it keeps deepening and darkening until it becomes America's most convincing antiwar novel. Anyhow, I was more cynical back then myself because I was younger, and my basic perception was correct: this novel for the millions was at least as substantial a literary work as, for instance, William Gaddis's *The Recognitions*, which I perused doggedly on some recommendation or other before putting it away after two hundred pages. I never forgot the Beckett trilogy, although I feel no need to return to *The Unnamable* and failed to get going on a *Malone Dies* reread. But I also had a fling with Richard Condon of *Manchurian Candidate* renown, and while I doubt I'll ever return to him either, I might well choose him over John Updike if I forget my bookbag when I visit your summer house.

And then in November—shortly after the Cuban missile crisis, the final day of which I spent with ex-basketballer Bob Brower and friends at the Cloisters simultaneously awaiting apocalypse and unconvinced a damn thing would happen—I had a conversion experience. Although Bob Stanley worked long and hard on his abstract expressionist canvases, they seldom satisfied him and never sold, and although he'd loved drawing since he was young enough to crawl under the Sunday funnies with his dad, he couldn't figure out how to integrate that passion into larger works. But loving drawing as he did, he was fine with representational imagery, and loved the big Pop "New Realists" exhibition mounted by the abstract expressionist Sidney Janis Gallery beginning October 31, 1962. I must have too. But I don't remember it. What I remember instead is a one-man show Bob recommended at the Green Gallery a few blocks west. It began two weeks later and featured "Great American Nudes" by one of Janis's fifty-four "New Realists": Tom Wesselmann.

Every fan of Pop Art has his or her own Pop pantheon, most commonly sure shots Warhol and Lichtenstein plus Rosenquist and Oldenburg, with Dine and then Wesselmann and maybe the Californian Thiebaud trailing behind. My own list would slot Thiebaud a painterly realist and Dine a dada-manque hustler and add the humanistic environmental sculptor George Segal, with auxiliary honors to ideologically simpatico English forebears Eduardo Paolozzi and Richard Hamilton. Plus Bob Stanley, obviously a biased choice. Anyone who considers Warhol some sort of a charlatan should go read some other book; as Peter Schjeldahl has put it, "Like the Beatles—his nearest equivalent in another field—Warhol invested vernacular idioms with a timeless eloquence." But after Warhol and Bob himself, it's Wesselmann who's meant the most to me. Having trolled vainly through Google Images and books of plates seeking the painting I'm about to describe from memory, I can't get over how droll, beautiful, brazen, and sexy all these pictures are. For better and worse, all of the Pop pantheon shared a conceptual éclat, to use Schjeldahl's term, with the abstract expressionist fathers they were slaying—although I hate to say it, I believe it limits Lichtenstein, an exceptionally gracious man I got to know as Bob's brother-in-law. Would-be heavyweight champions every one, they shared a will to art-historical magnitude. Like Paolozzi and Hamilton, Wesselmann was a detail man by comparison, but with more interest in shape and size.

So here I am, a twenty-year-old alone except for the pretty girl in the office. The Green is a spare space that's downtown in feel compared to the opulent investment houses of Sidney Janis and Leo Castelli. Up for sale are some dozen red-white-blue-and-pink canvases-plus reasonably described by Lucy Lippard as "fusing the arabesque and brilliant color of Matisse with the sinuous line of Modigliani and a more rigorous framework traceable to Mondrian." All depict nudes, flat pink except for their luscious nipples, lolling in suburban interiors replete with con-

sumer durables and decorated with a nice art print. I'm enchanted, smiling, although not as I recall any hornier than usual. Only then my reverie is interrupted by a familiar tune: Connie Francis's "Vacation." "V-A-C-A-T-I-O-N," she belts, and I smile a little more, wondering where this intrusion is coming from. After peering briefly into the silent office, I follow the sound to a painting that I can see incorporates a radio—which when the DJ starts blathering I determine is plugged into a wall socket and tuned to WABC.

In my memory, this nude reclines right-to-left on a chaise, an oil-rendered replica of some Cézanne flowers (??) over her right shoulder. Out the window to the left is collaged the kind of *House Beautiful* garden Grandpa might have glued on burlap. In addition to the too-large plastic radio, another household item may tweak the composition, or a brand-name product—Wesselmann favored both usages early on. My epiphany incandesces. It seems obvious half a century later, but in 1962 the idea that WABC was as suitable to the Green Gallery as to the margin department and my furnished room was impious in the extreme. Maybe it was no more impious than Wesselmann's other juxtapositions, or Lichtenstein's war-comic panel and Warhol's soup cans lording it over dozens of other so-called New Realists down the street. But it spoke louder to me.

In many expert accounts, what the twenty-year-old took away from the Green Gallery, and in a more general way from the New Realists exhibition too, is simplistic. But to me what's simplistic is the obtuse notion that the Pop artists were parodying the oppressive cliches of mass culture, which while rarefied over the years still underlies many accounts of their moment. Me, I always thought what satirical intent there was went the other way—that its target was effete aesthetes so disquieted by such imagery they had to rationalize it away. I believe this even though the artists—all of whom disavowed the existence of a Pop Art "movement," which strictly speaking was true, although it was

certainly a damn tendency—were reluctant to attribute any representational significance to their apparent content. As Wesselmann himself put it: "When people began to talk about Coca-Cola or that Campbell Soup cans and all that sort of stuff, I began to get very uneasy because that was subject-matter talk, and I was involved in important, aesthetic matters, I felt, not subject matter." As a corollary, Wesselmann always indignantly denied that the Great American Nudes were in any way erotic. Ditto, no doubt, for 1970's *Seascape No. 28*, dominated by a foregrounded, semi-erect penis.

I'm proud to report that, having switched abruptly to the flat, drawn, polarized two-tone images he'd explore and enrich until he died in 1997, my mentor Bob didn't explain them solely in terms of Poussin, who came up. "I loved the popular imagery," he told an interviewer in 1992. Although sports, porn, and rock and roll dominated his work for only five years, his *New York Times* obit observed that his "preferred subjects . . . always seemed to grate the pretenses of high art." Except in the case of Warhol, which is why he's the man, I don't doubt that "important, aesthetic" matters preoccupied the demigods of the Pop pantheon most of the time. But I also don't doubt that they meant to offend and, by the way, attract attention—or that a postwar decade-plus of expanding real income and material comfort had seduced every one of them. These guys dug the garish ubiquity of advertising and roadside architecture, the labor-saving convenience of home appliances, the lip-smacking zap of fast food. And then comes another layer, because as Lippard puts it, "enjoyment" doesn't equal "wholesale endorsement." As these artists dared effete aesthetes to try and stop them, they also poked indulgent fun at the hold the shallow satisfactions they valorized had on any American sophisticated enough to walk into an art gallery, themselves included.

Tom Wesselmann's Great American Nudes induced me to suck up these apparent incongruities while giving unmediated pleasure to my

unformed, willing eye, and if that response reduces once again to irony, so be it. In New Critical ideology, irony was a means to an advanced faith, protecting theology from science by holding the two in equipoise the way the metaphysical poets had centuries before; in postmodern culture, it deflects feeling, turning fun into a single-minded pursuit that gets pretty crass pretty fast. For both reasons, it has a bad name among many whose ideas I find amenable, and in many specific cases I agree with them. But I still believe that irony has not only its uses but its moral and aesthetic strengths, remaining fundamental to the fundamental human business of holding two or more clashing ideas in your head at the same time. At the Green Gallery in November 1962, it made me smile and blew my head off at the same time. I'd still be thinking about it when Bob Stanley was painting trees and trash and nudes and more nudes and the '60s were dead and gone.

Around this time I fell for my own Great American Nude. Not that I ever saw Nicky nude; I never kissed her. But she certainly pleased my unformed, willing eye while kicking up enticing incongruities in my twenty-year-old brain, and she was not only pink but blonde. Dyed, true, but that was an incongruity I loved, just as I loved her fellow Oklahoman Mickey Mantle, whose winning smile camouflaged knees so wrecked he winced every time he sped to first base. A University of Chicago freshman who bombed into town for a weekend with Bruce Ennis and his roommate Basil Condos, Nicky was pretty and intense and nuts about New York and so full of beans she became my first Catherine figure within, say, four hours. She barely knew what to make of the fever that followed, which had two focal points. In the first I hitchhiked to Chicago for New Year's Eve at a time when I'd never been further west than Niagara Falls, had my overtures politely but firmly rejected, and downed Basil's grain alcohol punch till I puked. In

the second I spent years imagining a novel called *American Beauty* in which a protagonist all too much like me chased a bottle blonde less like Nicky than I believed.

Nicky obsessed me into the following fall, but the Bennington girl Basil dated that weekend, most of which played out in the West End Avenue apartment Bob Brower shared with the Bennington girl he'd impregnated and married, assumed a larger role in my life on planet Earth. Judy Rosenberg made a kindly pass at my pitiable self that March and we slept together companionably until I left the city a month and a half later. We've been friends ever since, and I doubt the benefits she can count from that friendship outnumber mine. Her great love proved to be legendary lindy hopper Frankie Manning, who she relished, nurtured, and promoted for nearly three decades before he died at ninety-four in 2009.

The doomed hitchhiking trip played a larger role in my real life as well, initiating and inspiring the American adventure I'd dreamed of since *On the Road* convinced me I didn't have the guts to ride the rails; I was especially struck—thrilled, to be honest—by the spectacle of the faraway blast furnaces burning all night at the west end of the Indiana Toll Road. After all, if I was going to write a novel called *American Beauty,* I needed to see America. With the help of a $400 Dartmouth graduation loan, a temp photocopying gig at Seward Park High School on Ludlow Street, the buck or two I'd take out of my Dupont check, and the five bucks Grandpa slipped me on my weekly dinner visits, I'd accumulated over a grand. So I mapped out a plan in which I'd set off hitching right after I turned twenty-one April 18, refurbish my finances when summer ended, and start writing. Advised by my wilderness-savvy Dartmouth friend Charlie Berg, who'd yelled up to the fifth floor out of nowhere and was working at Dupont, I added a sturdy canvas backpack, some sturdy shoes, and a moneybelt with a secret compartment to a sleeping bag that dated to Chenango. The books in my pack

varied—I'd mail them back to 159th Street when done—but my Yeats was always with me, and by then a core of American studies urtexts, from Henry Nash Smith's *Virgin Land* to Morton and Lucia White's *The Intellectual Versus the City*, was already under my belt.

Over five months and fifteen thousand miles, I had a few adventures. I made out with a girl at Goddard and spent two days in middle-class Negro Charlotte with a guy I'd met at Brandeis and stayed with my generous downstairs neighbor Bill Daniels in Beverly Hills. I was held at gunpoint by a drunk hillbilly electrician I sipped corn with the next morning, spent two hours between rides in Kentucky memorizing "Vacillation," survived a '48 Ford with no brakes in South Dakota only to climb into a '62 Chevy five miles from blowing its transmission, commandeered a four-by-four equipment shed to escape the knee-deep Glacier National Park snow on Jesus H. June 25, made ninety fatalistic miles in sixty frightened minutes with two Oregon railroad men who shared their six-pack with me, caught rides with three different beatniks including a mother and her four kids between Berkeley and Yosemite, shared a joint in a Big Sur-bound Triumph TR3, and canoed twelve days in the Atikokan with Charlie Berg. I slept in woods and campgrounds and jails and laundromats and a church and the Berkeley hills and a hollow near an Idaho roadhouse booming "Ring of Fire" and once right alongside an interstate in Washington; I also slept for a month on Bruce and Basil's couch in Chicago and another month on the Berkeley floors of Judy Rosenberg's tolerant friends, though by mutual agreement no longer with Judy herself. I walked nine miles alone in San Francisco on the Fourth of July and declined to shoplift from the unattended basement of City Lights Books. I stole books and food elsewhere. I traversed a lot of terrain and tasted a bunch of cities and filled too few pages of my notebook. I gained ten pounds, most of it muscle.

As a New Yorker whose father freaked the first time I took a wide turn and never gave me a lesson again, I still couldn't drive, but I ac-

cepted the hitchhiker's bargain: help the guy stay awake. Thus I always responded to conversational gambits and made it a principle to volunteer a few questions, which didn't come naturally when I was out of my cultural comfort zone. By mastering these skills I met a lot of Americans: the secretly married hot rodder who kept his ring on his gearstick, the real estate salesman who drove a hundred thousand miles a year without leaving Iowa, the South Dakotan youth who'd never knowingly laid eyes on a Jew, the Hungarian refugee who'd abandoned his family to escape the Communists, dogged truckers and well-meaning squares, racists and hustlers and hopheads and numbskulls and a weatherman who fed me for two days in Yellowstone and the Tetons without the hint of a sexual advance, which I doubt was his program because I got those rides too. Let me pay tribute as well to the Idaho seamstress who repaired my jeans for a quarter and the Glacier park campground mom who patched up my thumb when I sliced it open with an ax.

This was the first of some dozen long-distance road trips across forty-seven states, several more of them hitchhiked, with the net result a grounded respect for a wide swath of citizens with less cultural capital than me. I like to think that combined with my 159th Street upbringing and my First Pres acculturation, these American studies added a level of sophistication to a Manhattan chauvinism I'm proud to proselytize for. But its direct literary payoff was nada. I should have made a short story out of the hot rodder, although the one about the electrician went nowhere special, and I should have written out a full plot for *American Beauty* instead of just jotting down what embellishments occurred to me. The only such reflection I can stand to quote came May 30: "A novel about a young kid in search of a girl who symbolizes America? Can I be serious?"

Nevertheless, I was learning to write, experimenting every time I added to my journal. Maybe I wasn't gathering useful material, but I was gaining an empirical grasp of the extremities between which my brain

was then running its course: America versus Yurrup, city versus nature, city as nature, popular culture as folk culture, pop culture as lived life, games as lived life. And although my notebook didn't advance my fiction, where my ineptitude at lying proved to have a counterpart in my ineptitude at storytelling, it was where I began adding descriptive flights and epigrammatic punch to the faux-Hemingway understatement of my fictional prose and the subjective belletrism of my best college papers. It was educational as well to dip into Basil's copy of Dwight Macdonald's *Against the American Grain*. Except for his attack on the Revised Standard translation of the Bible, I was usually 180 degrees from Macdonald—160, anyway. But "Masscult and Midcult" sparked my lifelong cage match with the Frankfurt School, and his attack on Webster's Third turned me into a structural linguistics fan who was nonetheless convinced of the absolute distinction between "infer" and "imply." More than any of his *Partisan Review* comrades, Macdonald was a belletrist with moxie, a journalist at heart whose humor and polemical vigor kept me on my toes for years.

Taking my work break in Chicago, I found a room in Hyde Park and a writing job at a cut-rate encyclopedia where I picked up the invaluable knack of summarizing baseball in 280 sixty-character lines and Isaak Babel in eleven—as well as a *Saturday Review* where I read an intriguing report on an English rock group whose wisecracking leader had gone to art school, hmm. Aside from a sex life starring a beautiful freshman who couldn't get me to beat her up a little and an unintellectual girlfriend of Basil's whose invitation to bed I declined out of a loyalty her boyfriend didn't expect, I had a good time there. I competed briefly with Bruce for the petite law student he'd marry, lost at cards to poker fiend Basil, played championship-level Password with *Law Review* heavies, caught Paul Butterfield at the student center and Muddy Waters at Pepper's Lounge, purloined *The Freewheelin' Bob Dylan* from the Columbia Record Club, bought the English rock

group's "She Loves You" on Swan, hung with a Dartmouth '61 painter I'd helped become a Dupont '63 margin clerk, and when I got my draft notice followed this wise head's "queering out" instructions. I'd had nightmares about this—even someone as politically inert as me could see that the coups in Saigon boded ill, plus I had Joseph Heller telling me the army was a madhouse and my dad telling me to stay alive. So when no one took me aside for a talk about my tastes in dick, I panicked. Then I was instructed to hold my arms akimbo as a doctor dug his fingers painfully into my deformed left elbow joint. A minute later, in a thick Eastern European accent I can still hear, he shared with a colleague five words that were a gift from the God I didn't believe in: "He's out, jah, he's out."

I also worked on some short stories—longhand, with Basil's girl typing them up. I was still jotting down ideas for *American Beauty* as late as January 1966, and by then had written two chapters I can read without wincing—in the first, a cornfed blonde cons a horny Second Avenue dry goods dealer out of a bolt of red silk. But two revelations had intervened. In the first I looked up Jack Hirschman at UCLA. He was very late, and I had the humiliating hunch that he'd been ducking me, yet my notebook noted: "If Berg is the self-willed primitive, Hirschman is the self-willed vulgarian. Double negatives, arrantly tasteless clothing. But talking to him was valuable as always." What I failed to write down was the most valuable thing he said, because it hurt—that he'd always thought I should write criticism, not fiction. Then in Chicago I picked up a collection of boxing pieces by a writer I'd never heard of, although I've since wolfed down his reporting on subjects from French cooking to the Brill Building. A. J. Liebling's *The Sweet Science* had me from an epigraph that ended "I should have put the bum away early, but my timing was a fraction of an iota off," with the clincher "Ahab and Nemesis," in which light-skinned Afro-American Archie Moore represents art and reason while sun-

bronzed "white" Rocky Marciano takes the role of nature—and in which Liebling fresses a "smoked-salmon sandwich on a soft onion roll" while two nearby cops wonder why Disney never adapted Kafka's "Metamorphosis."

As with Miriam going to hell, my conversion wasn't immediate. But right then I felt the aha. Instantly I knew that if I ever wrote anything as good as "Ahab and Nemesis" I'd be all the literary champion I needed to be. And more dimly I glimpsed that my dad notwithstanding, journalism might be a job I wanted to do. When I returned to the Bay Area in May at the behest of Charlie Berg—who'd left his canoe-guide gig to sell office equipment like his dad—the most important writing work I did also involved office equipment: lugging an ancient Underwood upright elite from a pawnshop to my skid row room in one-block laps. It cost thirty-five dollars. I'd write all my '60s journalism on it and kept going till I broke the X key many years later.

Charlie Berg was a sandy-haired, rough-faced hunk with penetrating brown eyes who'd impact my life until he died of cancer in 1979, and he was indeed a self-willed primitive. In an extreme version of a Midwestern folkway, Charlie talked so slow you couldn't believe he was smart enough to be lying. But in fact he was always smart and often lying, as well as a storyteller with a mean sense of humor. All this fed into a mythic persona his friends honored and put up with, and in recompense he treated the people he cared about like myths themselves. In San Francisco he ran with a swashbuckling Iranian student I didn't like much, and I still wonder if that guy's myth was how Charlie ended up running guns and contracting hepatitis in Afghanistan. Me, I was The Writer, complete with office equipment: a high-end manila folder to which Charlie affixed a metal strip bearing a hand-punched legend that began "THIS FILE CONTAINS THE WRITINGS OF ROBERT CHRISTGAU" and threatened thieves with "THE WRATH OF THE SWEDISH GYPSY." It was Charlie who finally taught me to drive, fast-

tracking my clutch skills in the Haight and instructing me to look both ways for black-and-whites at red lights in the North Mission.

Shortly after I escaped the San Francisco chill for two balmy months in Berkeley, I obtained another life-changing device: a transistor radio a GI friend scored me with his PX discount. Soon I was strolling Telegraph Avenue with the ebulliently ubiquitous Beatles, the ebulliently Californian Beach Boys, and the ebulliently soulful local hero Bobby Freeman in my earpiece. Then my landlord offered me a quintessential American machine: a '50 Plymouth in good running order for a hundred bucks. He didn't know I only had a learner's permit when I test-drove it. After a once-over from Charlie, who would soon begin a career as a freelance auto repairman, I made the deal. Yes, it was love. Yes, it had a radio.

Early in August, I headed south in that Plymouth. I slept on the beach in Santa Barbara and revved to a hundred at sunrise just to see how it felt, then drove to L.A. There I visited my jazz-loving Queens College pal Michael Levin and took his girlfriend M. to Disneyland, where she nestled back softly between my legs on the Matterhorn. A sexpot and a femme fatale, M. was alert and hungry, a Robert Creeley fan who got your jokes and made her own, and when I learned she was returning to Michigan State in September I offered to drop her off in Chicago. There were two other guys in the Plymouth and I drove a lot for someone who only had a learner's permit, but by Iowa we were making out in the backseat and in Chicago I borrowed a friend's apartment and we slept together. She had an exceptionally moist and succulent cunt. And when I think about it, she also had a smaller version of Jeanne Moreau's bowed mouth, shapely and pliant.

I fell so hard I was still flying when I sailed through the Holland Tunnel. The air was warm, the sun was shining, and the radio was

pealing records that had juiced my speedy and untroubled three-thousand-mile jaunt: the Supremes' "Where Did Our Love Go," the Newbeats' "Bread and Butter," and anything you could think of by the Beatles, who were climaxing their U.S. tour at the Paramount between number ones—the five months from "A Hard Day's Night" in July to "I Feel Fine" in December didn't slow their conquest of radio a week. For the pop ideologue I was fast becoming in a fine mood foreordained to darken—a pop ideologue who never reflected that "Where Did Our Love Go"'s upbeat motion came with a despairing title or that in two minutes flat the Newbeats' bread-and-butter man would lose his baby to a chicken-and-dumplings interloper—the high good cheer of this music epitomized my cultural euphoria.

At the same time, however, I was aware that this cultural euphoria was . . . not endangered, because few in any wing of my cohort yet understood how fragile the affluent society was, but half the story. As someone who hadn't rejected the seriousness of his church and college training and never would, I knew that this euphoria was what "Vacillation" called an antinomy or extremity: "And half and half consume what they renew." And that sense of thesis and antithesis was heightened by my growing suspicion that "militant apathy," as I'd cleverly dubbed my politics in my notebook one time, would no longer do—a hunch that had kicked me in the gut the June morning the boyish face of Queens College student turned civil rights martyr Andrew Goodman shared the front page of the *San Francisco Chronicle* with his black and white co-martyrs James Chaney and Mickey Schwerner. As autumn went on, the Free Speech Movement would go nationwide from the bohemian leisure paradise where I'd summered as the Vietnam drumbeat I'd sidestepped grew louder. Budding pop ideologue me wanted the music on the radio to account for the dark stuff. And soon the sardonic faux-Americanism of the Rolling Stones and the faux-tragic Queensism of the Shangri-Las was doing the trick.

Steadily my commitment to pop culture was gaining depth and detail. So while keeping my options open—writing fiction, taking courses in American governance and the nineteenth-century American novel, acing the GREs with an eye on NYU's American studies program—I set myself on a pop career path. And in just four months I'd learn what an Ivy League Phi Bet was good for. Effortlessly, I landed three entry-level journalism jobs of gradually ascending status and salary: copy boy at my beloved *Herald Tribune*, court reporter at the menswear paper the *Daily News Record*, and police reporter at the Dorf Feature Service, keeping an eye on the suburban police blotter and high school sports for the *Newark Star-Ledger*. Sportswriting—now there was a subgenre fully equipped with a beginning, a middle, and an end.

7

THE HIGH '60S

Mid-January of 1965 I was headed for the Montclair police station my first night on the Essex County north beat and my second day on the job. I was no longer driving my '50 Plymouth, having cracked its block and what was left of my heart because I didn't know how antifreeze worked. The Plymouth had served me faithfully till after my second trip to Michigan, where M. and I had a date to hear Robert Cree-ley read. On the first I'd spent an intoxicating weekend in the Detroit suburbs looking for chances to stroke and eat and fuck my sweetheart behind her mother's back. On the second, she came down from her dorm in East Lansing, got into the Plymouth, and informed me that she didn't want to see me anymore. When I asked why she hadn't told me this over the phone, her reply was pure Catherine: "I wanted to make sure you'd believe me." So I skipped the reading and drove home nonstop as I absorbed a trauma that wouldn't lift for years. A few weeks later came the cold snap that killed my other sweetheart. A First Pres friend of my dad helped dispose of the remains. He also found me the

'55 Chevy with which I rear-ended a '57 Nash Metropolitan that first night on the north beat.

This was bad shit times two because I was still driving without a license—I'd only taken my New York road test the day before. I saw no reason why my new boss should save my ass. But he did. He sweet-talked the cops, sent a workmate out to get me, put me up at his place, sweet-talked his insurance agent, let me use his New Jersey address on all the ensuing forms, and told me my road test was in the bag. No one passes first try, of course, and my day had been so icy I went into a skid. I did steer out of it, however. I passed.

A balding bachelor Bob Stanley's age, Lloyde Glicken was such a kind man that I doubt he ever regretted his generosity even though he'd soon learn that I lacked the journalist's schmoozing gene as well as the cub reporter's byline-grubbing hustle—having escaped a block full of cops in my teens, I had no stomach for talking them up in my twenties, and wouldn't have been much better in a locker room if anyone at Dorf reported games in person. On the other hand, I could write, and soon learned how to make phone calls and then make more phone calls—even, eventually, those excruciating ones where you find the traffic fatality's number in the book and ascertain his importance by asking his widow what he did for a living. Lloyde left me with two unforgettable lessons, neither of which I ended up following. The first was the high school football feature he crushed out when we were one short, typing directly onto the wire while simultaneously interviewing the surprised quarterback he was celebrating. The second was his explanation of how to end a piece, which I know no one will get anymore but must record for posterity: "Thirty." (Hint, for what it's worth—that might better be rendered "-30-.") I got pretty quick with the high school sports features myself. But my project was writing well, which I still believe takes time, and when I became an editor myself, I specialized in snazzier endings than that, which is often just a matter of filching a keyword or two from earlier in the text.

Long before that, however, I would hit the slicks. That was all the proof Lloyde needed that he'd done the right thing. He wanted all his boychiks to do well.

Not to be a whiner, but M. did traumatize me, and I mean sexually, my prevailing symptom not impotence but anesthesia. If I pulled on my penis long enough I could get hard and even come, but the orgasm felt like convulsive urination at best. The skin on my chest was numb too. You can see why I admire Mailer for emphasizing orgasm quality. If only he'd understood it.

Yet although this physical correlative of heartbreak was frightening and depressing, it failed to extinguish my cultural euphoria or my personal confidence. Instead the two extremities coexisted. Whatever they lacked as fiction material, my American studies had compelled me to fend for myself—not coolly, that's never been my way, but stalwartly, resiliently. And they'd also expanded my circles of socialization. Where before I made do with a few Manhattan friends, now I traveled half a dozen networks: Bob Brower's homies, Tony Fisher's classmates, Judy Rosenberg's girls, the increasingly bohemian crew at Dupont when I put in some hours, Newark pinball buddies, and more. As soon as I had some income I rented a grim fifty-dollar tub-in-the-kitchen at 135 Chrystie, across the wrecked Sara Delano Roosevelt Park from 122 Forsyth just south of Delancey, where one night I ripped nine finger-flaying layers of linoleum off the kitchen floor and found *Daily News* pages from 1903 at the bottom. But by April an upwardly mobile Dorf colleague had bequeathed me a sunny forty-five-dollar tub-in-the-kitchen just east of Tompkins Square Park, a nabe where the younger residents tended Puerto Rican, the older ones Ukrainian and Jewish, and an ample melting pot added uncountable exceptions to the mix. It came with the same big plain doorless metal wardrobe that anchors my bedroom today. I'd hit the East Village. I felt so at home there I equipped it

with my inaugural rock-LP purchases, including life favorites *The Beatles' Second Album*, *The Shirelles' Greatest Hits*, and *The Rolling Stones, Now!* (but not Martha and the Vandellas' *Dance Party*). I felt so at home there I got a phone.

By the end of 1964 two of my grandparents had died, my mother's mom Kitty just before I hit the road in 1963 after Tommy wasn't instructed to administer her digitalis, my dad's dad Pop of a 1964 stroke announced by a telegram with a typo that had Charlie Berg chortling in dismay: "LOP DIED." My brother was at Hunter, where I introduced him to C. S. Lewis's *A Preface to Paradise Lost* so he could write a Christian paper; my sister was at Flushing High, whence I invited her to a Bleecker Street Cinema pairing of *A Hard Day's Night* and *Breathless* to nudge her toward perdition. And my friends were starting to get married, most impressively George Szanto, who'd fallen in love with the daughter of a moderately distinguished Anglo-Canadian family on the boat to Europe and spent his Fulbright year hitchhiking to and then with her. They made it official in Paris and quickly conceived a daughter I was proud to sit for when they got to Cambridge, where George was acquiring a Harvard PhD. His slightly older wife, Kit, was and remains one of the warmest, wisest, and ablest humans I've known. For a year or so I pursued her younger sister Shoss in an enlarging albeit unconsummated courtship in Montreal, Quebec City, and—for just one fine weekend—Manhattan.

It was with Shoss that I witnessed my first rock concert proper: Rolling Stones at the Montreal Forum, October 1964, day-of-show tickets four bucks, forty minutes max of hits and covers semiaudible due to crap PA and shrieking throng, quite an up anyhow, biggest revelation hundreds of longhairs waiting to disappear back into the Laurentians in the bus terminal afterward. Soon followed Otis Redding at the Apollo with Judy Rosenberg and the Negro boyfriend she'd met in Mississippi. Where in Berkeley 1963 my most memorable musical palaver had con-

cerned Bob Dylan's "Who Killed Davey Moore?," an antiboxing song I'd never heard but opposed on the basis of its title alone, now everyone I knew was enthusing about rock and roll: Dupont-based Texan navy vet and painter imparting r&b wisdom, Bennington aesthete creaming for Marvin Gaye's flow, Bob Stanley heading up to Harlem for James Brown with his new friends in the Pop elite, Berkeley chum's ex-wife topping *Rubber Soul* with Nina Simone she thought, little sister so very tickled by the four-in-a-bathtub cover of the Mamas and the Papas' *If You Can Believe Your Eyes and Ears*, every damn body shouting the chorus of "Satisfaction."

Bob Stanley's saga bolstered my euphoria, because he was what they call in the art world hot. I loved his early Pop paintings and silkscreens, which began double-imaged but soon reduced to one, and which occasionally exploited op color flashes but usually enjoyed flat bright hues for their own sake. In a market primed for formally acute representations of the Beatles, Y. A. Tittle, and anonymous fuckers and suckers, they won the attention of Leo Castelli hypeman Ivan Karp and lesser Pop dealer Paul Bianchini, who gave Bob his first one-man show in 1965, the music at the opening topped off by Dobie Gray's high-flying "The 'In' Crowd." Having spent his pre-Dupont years painting in his winter jacket, Bob was dizzied by the high life the way the suddenly famous always are, even when their fame is limited and fleeting—a lesson I retained as I pursued my lifework. Soon he quit Dupont, left his wife, and rented a loft on 28th Street. For a while our friendship stalled slightly. But that didn't stop him from giving me a drawing that counterposed Willie Mays sliding into third base against a grinning male nude poking a reclining female nude, or—an even bigger deal—a big tricolor porn tempera I hung across the kitchen from the bathtub.

Also kind of hot was my Flushing High classmate Lenny Lipton. Like Charlie Berg, Lenny had yelled up unannounced at West 70th Street the autumn of my first year in Manhattan. There he told an un-

likely story about writing a hit song on a dare for his Cornell pal's group, whose Pete Seeger cover "If I Had a Hammer" was then annoying me on WABC. But sure enough, Peter, Paul & Mary's "Puff the Magic Dragon" was a smash by the time I began hitchhiking, and Lenny—who tells anyone who asks the truth, which is that all he knew about marijuana when he wrote that song was that it led to the harder stuff—was slightly rich. A physics major who'd always been good with both camera and typewriter, he landed an editing job at *Popular Photography*, where he decided that the "New American Cinema" Jonas Mekas kept raving about in *The Village Voice* was worth a story. So I accompanied him one Friday to a West 100th Street loft dubbed the Eventorium. Never a shy guy, Lenny was soon running the weekly screenings there, with me his faithful assistant—secretary, really.

Although the idea was to screen whatever came in off the street, Lenny made sure the Mekas pantheon was well represented. I respected without adoring the barely representational Dartmouth dropout Stan Brakhage—the placid smiles, distended grimaces, popped navel, slimy vagina, and meatloaf placenta of his childbirth short *Window Water Baby Moving* much more than the imagistic obscurities of his designated masterwork *Dog Star Man*. But I was captivated by multi-screen visionary Stan VanDerBeek. VanDerBeek's avant-gardism was so technophile—computerized, even—and so Pop. Dedicated to Chaplin and Keaton and driven by the looped instrumental hook of Screamin' Jay Hawkins's "I Put a Spell on You," his animated-collaged twelve-minute *Breathdeath* was by no means optimistic—it climaxed, in one of its cornier moments, with an A-bomb erupting from the Little Tramp's Ben-Day-dotted head. But it had a wit Brakhage's romanticism eschewed. Even funnier were our favorites, the eight-mm C-movie mock-epics of the Bronx-born-and-based Kuchar brothers, George and Mike: *Lust for Ecstasy*, *I Was a Teenage Rumpot*, the high-budget (i.e. sixteen-mm) *Sins of the Fleshapoids*, and many more. These were among the few narrative

films we showed, and although their burlesques were even more teenboy than class clown Lenny's wisecracks had been, they were also camp— both brothers eventually came out. Not that I knew what camp was yet. I just knew that this was pop and that it made me laugh like *Tristram Shandy*, E. E. Cummings, and *Mister Peepers*.

In a pattern that would become my norm, I sympathized in principle with the more recondite artists I encountered via the Eventorium— Kenneth Anger, Jack Smith, Marie Menken, a second Smith I think with a girl-group soundtrack, and others whose names I can no longer ascertain. (Bruce Conner's *A Movie*, three cheers; Gregory Markopoulos, spare me I beg you.) So my magazine debut, entitled "A New but Muddy Wave," was several cavils short of evangelical about Mekas's "underground cinema." As a pop guy, I preferred the narratively inclined picks of Mekas's *Voice* protege Andrew Sarris, and in the underground went for VanDerBeek's art-world Pop and the Kuchars' amateur pop. I'd eventually publish two features about VanDerBeek's multiple-projection "MovieDrome" space and one about the Kuchars, and even in the earliest of these was moving in on my journalistic goals: prose that valued edge as well as clarity and more ideas than outlets like *Popular Photography* normally preferred, although Lenny and his bosses never complained because journalism was opening up that way.

These goals I internalized as, sparked by nonpareil press critic Liebling, I became a journalism *fan*. In New York I'd traded in polysyllabic *Chronicle* sports columnist Charles McCabe and waggish *Chronicle* squib columnist Herb Caen for architectonic *Post* political columnist Murray Kempton and monosyllabic *Trib* Queens columnist Jimmy Breslin. I still followed the premier sportswriter of his era, the *Trib's* Red Smith, and knew that the *Post's* Al Aronowitz was occasionally covering pop music like the *Chronicle's* Ralph Gleason. I was aware too that Norman Mailer was covering presidential politics for *Esquire*, and soon I'd suck down two collections of dauntingly deft *Esquire* profiles: Gay

Talese's *The Over-Reachers* and Thomas B. Morgan's *Self-Creations: 13 Impersonalities.* But Tom Wolfe, who I'd first noticed during my two months at the *Tribune,* was what I'd been waiting for: an American studies connoisseur with an appetite for pop and a baroquely in-your-face version of the word-mad, gag-prone Americanese I also admired in Macdonald and Liebling and Pauline Kael, who I'd enjoyed without knowing her name in the unsigned program notes of the Berkeley Cinema Guild. Every Sunday I scanned the *Trib*'s *New York* supplement for Wolfe's byline. His reportage on Phil Spector, Murray the K, and the Peppermint Lounge, not to mention his irresponsibly scandalous takedown of *The New Yorker*'s William Shawn, all surfaced, like my two *Popular Photography* pieces, in the pregnant year of 1965.

On November 11 of that year, Lloyde asked me to help out the *Herald Tribune,* where Dorf did some stringing, by looking into a tragedy less mundane than a car crash: a woman my age who had starved to death in Clifton two days before. When I phoned her father after striking out with the police and the medical examiner, I discovered that for once the bereaved was eager to talk—because I'd read a minor Tom Wolfe piece about the macrobiotic diet that had killed Beth Ann Simon, I came in knowing that he was raving against a supposedly cleansing vegan regimen that fetishized brown rice, his daughter's sole sustenance for something over six months at the time of her death. My two-take report arrived too late to do the *Trib* any good, but that didn't stop me—as I described it later in *The Realist,* "I got a bug up my ass about the idea of a girl dying of the need for the absolute." Next day I hit the *Herald Tribune* around noon and climbed the stairs from the newsroom where I'd sorted mail and harvested wire copy to *New York*'s tiny pale-green office. I didn't even bring clips—just a belief that this was my story. Within minutes Clay Felker found out who I was and what I knew and gave me the assignment on spec—no guarantees, see ya when we see ya. As a bonus—a big one, I was starstruck—

Tom Wolfe himself proffered tips on New York's macrobiotic scene and wished me luck.

I fell into some, too: Beth Ann and Charlie Simon had art-world connections. The charismatic young bohemian couple had posed for a George Segal sculpture featured on a Green Gallery poster in which two supine nudes lay on an unmade bed, the man with his left knee raised so he could rest his foot between the woman's legs. So after getting a phone number from Bob Stanley, I drove to South Brunswick to interview Segal and his wife and networked from there. But I also visited the Ohsawa Foundation, NYC's macrobiotics central, and located half a dozen sources from the file of macrobiotic deaths and near misses gathered by Beth Ann's attorney father, Sess Wiener. Sess also connected me to Beth Ann's sister and brother-in-law, Wendy and Paul Klein, who lived a few blocks from me on East 7th Street, and we hit it off, remaining good friends well into the '70s. Finally, Paul hooked me up with Charlie Simon for an interview in a suburban New Jersey bar that cinched my story. I worked all day before the night shift and all morning before the day shift and day and night every day off. After two eighty-hour weeks of research and one of writing, I delivered three thousand words to a surprised Felker. And January 23 my life changed again.

"Beth Ann and Macrobioticism," which earned me three hundred dollars and ran unedited except for a footnote about the then obscure anorexia nervosa—Felker even retained the deliberately awkward "ism" of my title, a Philosophy 1-derived reference to Beth Ann Simon's true-believer tendencies—was more like my few short stories than anything else I'd ever publish. Tersely Hemingwayesque, with eyewitness testimony converted to third-person description and few direct quotes, it accurately and impassively described Georges Ohsawa's dubious dietary worldview, which would eventually sucker John Lennon and many

others—look Beth Ann up on the web today and read that she was a heroin addict, the lie with which today's true believers pervert the truth. When I didn't write the exposé Sess Weiner assumed I would, devoting less than a graf to his victim file, he accused me of sensationalizing his tragedy. In fact, as Wendy and Paul and Charlie himself understood, I sensationalized nothing unless that means arranging established facts for narrative effect. The Beth Ann piece was as affecting and lucid as anything I ever wrote. I'd done what I'd set out to do when I made my decision for journalism—create nonfiction with the impact of fiction.

But I found there was something else in it for me—ideas. Instinctively I wove in two issues I cared about on the way to my readymade climax, neither of which had much to do with Pop although I snuck some Pop in there too: my anti-religious animus and, useful for getting the story, a lifestyle that had chosen me as much as I'd chosen it. It wasn't just for the toilet-included that I preferred 608 East 9th to 135 Chrystie, which like my skid row digs in San Francisco was doubly grim because the block was so unresidential, or 215 West 70th, where I lived among normal Manhattanites of varying economic profiles. The surrounding poverty was deep and dangerous—during my decade east of B, I was mugged six times and burglarized six times, including a five a.m. b&e during which I fought off a leather-coated intruder while screaming for help, pulled on some pants, leapt down the stairs, and for two blocks chased him barefoot and yelling through the snow.

But where for some the life option of going into the city meant choosing Wall Street, or Madison Avenue, or Broadway, or the Upper West Side, for me it meant committing to the emergent bohemia of my coming-of-age. Walking Alphabet City's streets was a visible minority of young seekers roughly like me, with a smattering of cafes, bars, galleries, and performance spaces to match—even, not too far away, the Ohsawa Foundation itself, on Second Avenue just six blocks north of where I'd ultimately settle down. But three years on my own had made

me cheaper than my parents could imagine and sloppier than they could bear, and what I liked most about the East Village was how little it cost and how much it tolerated. Only in the performance spaces did I feel much fellowship with my fellow culturati—the Theater 80 rerun house where the Jazz Gallery had once stood, underground cinema at St. Mark's Church and live poetry at Les Deux Megots, and the relocated Five Spot on St. Mark's Place, where I'd stop by on my way home from Dorf and listen to Monk through the open windows. A few times I had a beer at one of Avenue B's two related boho bars, Stanley's and the Annex, seeking . . . what? Stimulating conversation? A hip young thing? Whatever it was, I gave up quick.

This fringe-bohemian alienation from the prevailing alienation was in my piece, the first quarter of which described the arty milieu where Charlie and Beth Ann functioned as "the enthusiasts, the extremists, the evangelists"—and how "wretched" it had made them in the end. My analysis was garnered from friends of theirs who talked freely because they knew where I lived and what I was, only maybe they were wrong about the latter. I wasn't sandbagging my interviewees (not much, anyhow)—I cared about both art and Beth Ann, and my skeptical tone expressed my honest reaction to what I'd learned. But that tone made my story a natural for the Sunday supplement of the *Herald Tribune*. It was why my parents were impressed and Lloyde said well done. It was why Tom Wolfe included "Beth Ann and Macrobioticism" along with Norman Mailer, Truman Capote, Joan Didion, and Richard Goldstein in his big 1973 *The New Journalism* collection. It was why I was the hottest young journalist in Manhattan for as much as a week and a half.

This wasn't like Bob Stanley's art-world high life because it was so brief. But for a while it was exciting just to open the mail. Book editors wanted to meet me, including Aaron Asher of Viking, later to work with Bellow, Roth, Kundera. The stand-up Byron Dobell of *Esquire*,

once Felker's colleague there and later his managing editor at *New York*, took me to lunch, and Marion Magid of *Commentary*, where Norman Podhoretz had yet to turn into America's vilest intellectual, called me in as well. Asher and the rest wanted books on Beth Ann and Charlie, and that was not to be: Charlie—destined for a long career as a bee-keeping uberhippie renamed Charlie Nothing who would release several obscure records and self-publish even more books, including a 1997 title about Beth Ann—wanted a chunk of money, oversight privileges, and his own chapters. But *Esquire* was where I became a rock critic. And *Commentary* had an equally profound effect on my life.

Although Marion Magid would prove Podhoretz's faithful enabler in the creation of the Jewish-American right, she was nice enough while it lasted—that is, until she politely rejected the piece that resulted from our meeting as naive. Unlike Dobell, who just thought I was a good writer, Magid had an editorial slot in mind: the youth beat. In very early 1966 she already felt that *Commentary* needed its own agent in the new bohemia she could glimpse downtown, and like my mom, she didn't even care if he was Jewish. Given *Commentary*'s political focus, this wasn't miraculously prescient given the antiwar protests by then materializing alongside the civil rights movement. Still, she saw that more than politics was involved—her first idea was a Dylan essay, which I declined on the grounds that I wasn't a true fan, although I had *Freewheelin'* in my tiny LP collection and liked it well enough. Only then did she suggest I do something on the new radical anti-institution dubbed the Free University of New York. The following Wednesday, my night off from Dorf, I was in a drafty 14th Street loft near Fifth Avenue.

Then up and running for about six months, the Free U counted many leftists of substance among its unpaid faculty, some of whom would mark my life. I don't mean such big names as pacifist community organizer Staughton Lynd or Communist Party historian Herbert Aptheker or dissident Marxist theorist Lyn Marcus, who as Lyndon LaRouche would

soon control the not-quite-fascist U.S. Labor Party cult. I mean union organizer and post-Marxist polymath Stanley Aronowitz, who would run for governor on the Green ticket in 2002; Harvard-educated Marxist mathematician Len Ragozin, who earned his living as a racetrack hand-icapper so gifted that some believed the Progressive Labor Party beefed up its bottom line playing the horses; archetypal bohemian and essential Fug Tuli Kupferberg, who in "Howl" had "jumped off the Brooklyn Bridge [Manhattan Bridge, Allen] this actually happened and walked away un-known and forgotten into the ghostly daze of Chinatown soup alleyways & firetrucks, not even one free beer"; and Paul Krassner, editor-publisher of *The Realist*, the satirical magazine that would offend right thinkers left and right for the rest of the '60s. It was sometime during Krassner's laff-a-minute spiel that a fair-skinned, frizzy-haired young woman touched my shoulder and said, "Aren't you Robert Christgau?" Her name was Ellen Willis, we'd gone to junior high school together, and we'd spend the high '60s a lot more together than that.

It's unchivalrous of me to say this, but Ellen scoffed at chivalry and it affected my thinking for a long time. Although before too long at all I found every one of her physical eccentricities both endearing and erotic, at the very outset I didn't find her sexually attractive. She had full breasts and exquisite skin and a face many describe as Pre-Raphaelite, but she was even clumsier than I am and generally not my type. I doubt I was hers, either—I was indifferent to my appearance and will note for the record that tub-in-the-kitchens are inconducive to personal cleanliness if the covered tub doubles as counter space. But we were ready for each other. I hadn't had sex for a year and a half, and Ellen was just past an early marriage in which, she told me, her geographer husband, who by the time I met her was in Africa with the Foreign Service, had willfully declined his conjugal duties.

After a breakaway affair with another Foreign Service trainee in DC, Ellen had returned to New York, where she'd graduated from Barnard in 1962 before moving to Berkeley to pursue and abandon a graduate degree in comp lit. Her IQ was so obviously off the charts that she soon nabbed a job as articles editor at *Fact*, the black-and-white all-news counterpart to Ralph Ginzburg's luxury softcore-porn quarterly *Eros*. Ellen had come to the Free University in part to augment the man search she'd undertaken via a primitive computer dating service I'd also put money down on. My hookups were an English grad student specializing in medieval because there were jobs there, a bridge-playing mama's gal who would eventually publish many historical novels about *her* medieval specialty, and—finally! modernity!—a renowned journalist's niece already involved with a black jazz musician who, what a small world, lived downstairs from me. Ellen drew a Dartmouth '62 from Montclair, New Jersey, one of my class's five African-Americans. Did we get each other? Nah.

This spoke poorly of the computer—we were well matched. Not only were we both the eldest of three children, we both had younger brothers who became conservative clergymen, Ellen's in Jerusalem. And even bigger, Ellen's father was a cop. A cop isn't a fireman, and Melvin Willis was Jewish and an ex-Communist. But coming from Queens is a vaguer bond than coming from near-identical class backgrounds where your father wears a uniform and trades his physical courage for a living wage, with the bonus that neither father is prone to the sicker variants of sexism that flourish in such families. Both dads married highly intelligent women and were proud of it.

World War II vet Melvin Willis was a lieutenant and an NYPD lifer. Ellen didn't tell many stories about him, but three bear repeating. First is that patrolling labor parades in the '40s he'd keep an eye out for lugs with eggs in their pockets and casually let his nightstick bump against the telltale bulge. Second is that at Ellen's request he hustled a bar

owner for a faux-neon Miller High Life sign with which she decorated her apartment. Third is that occasionally (or was it just once?) he got laid on the job. Ellen was matter-of-fact about this, as I sure wouldn't have been, and writing it down I'm deeply uncertain what to make of it. Was Ellen just presuming, as she was prone to in matters involving sexual behavior? And if not, did Miriam know and not care? Forgive and forget? That would explain a lot, but I find it hard to get my mind around. In my parents' marriage, the most incidental infidelity would have meant a lengthy crisis at the very least. Artie Arent, who'd hooked my parents up and later employed Dad in his housepainting business, wrecked a twenty-five-year friendship by making a single drunken pass at my mom one New Year's Eve.

Ellen and I shared many other compatibilities, starting with our appetite for culture—artistic expression of every provenance, where I was somewhat more knowledgeable, and ideas, where she was. She was even a bit of a baseball fan—Giants not Yankees, but also Giants not Dodgers, the home team of New York's Jewish left. We were both nerdy eggheads if not quite nutty professors—four-eyed eyebrow-raisers often lost in thought. Ellen cared more about clothes than I did, but that was a very low standard, and we were both content to live in bohemian squalor that was really student squalor—neither of us could be bothered to make the single bed we slept in, and we shared what rudimentary housework got done when the prevailing mess became too much. We both liked to laugh and we both liked to eat, although I was the more enthusiastic cook as far as it went. We were both keen game players, so comfortable with competition that we didn't take our daily intellectual disputes personally. We were both warm, affectionate, and supportive. And we both loved sex.

That first night at the Free U, we were soon conversating away as I propounded my theory of pop. Ellen was a Warhol fan who admired his radically democratic notion of beauty, the self-aware cool with which

he sidestepped corn, and the serious fun he had with stardom, but she knew little of Wesselmann and the rest, and let me hold forth. Fifteen minutes in, however, she got the idea and started adding fillips of her own—finding analogies, adumbrating subtleties, generating subtheories, and of course formulating objections. It was quite a show. In verbal argument Ellen was, as she once described her Redstockings sister Kathie Sarachild, "such a tank." Many found this pushy, offputting, insulting, damned unattractive, and in the reflexively ultra-egalitarian women's movement of the early '70s she got flak for it, as did most functioning intellectuals. Me, I was snowed. If only because I'd always loved smart people, I'd always loved smart women—my girlfriend-in-absentia Shoss, strongly antiwar and a big fan of Simone de Beauvoir's *The Second Sex*, prominent among them. But Ellen was a cut above, and she liked me—even I could tell that. I drove her to her studio apartment across from the former St. Mark's Lutheran Church, suggested we go out after Free U the following Wednesday, and kissed her awkwardly on the sidewalk. She was the tenth woman I'd kissed in my life.

A week later we spent an hour with Bob Stanley, then repaired to her place without further ado, and after Ellen showered and powdered, we got into bed. Although the sex would get even better, it was spectacular from the outset, aided by my continuing trauma, which put me in the ring endurance-wise with Mailer's fictional Sergius O'Shaughnessy. For many months into our relationship my orgasm was a blunted thing, barely pleasurable at all, but over half an hour or more Ellen's made up for it, and that was exhilarating, as was her zaftig, creamy body and all the rest of what passed between us—the kissing, the sucking, the licking, the caressing, the moaning, the endearments, the embracing, the simple pressing of flesh on flesh. Ellen lived in her head a lot and theorized about sex a lot, a combination that has inspired more than one feminism-averse skeptic to tell me he suspected sex was too mental for her. Not by a longshot. I've never met a woman who so enjoyed the

physical sensations of sex. She wasn't terribly subtle when I knew her, and I was less so. We were young and inexperienced. But she was avid, open, and multi-orgasmic, and she wanted more. With the frustrations of her marriage in mind, she proposed a rule we stuck by for three and a half years—that neither of us could ever deny sex to the other.

So as the pivotal year of 1966 began, my writing took off and my sexual trauma paid off. But having noted that my trauma never staunched my cultural euphoria, I should now add the obvious point that this euphoria was cultural in the social as well as artistic sense— many young people were feeling it in many different ways. For me it was Pop and pop, for others core '60s stuff—drugs, enlightenment, politics, and just plain freedom, man, sexual included although I never saw as much of that as those who missed the party imagine was there. As it is now finally commonplace if not quite conventional wisdom to observe, this euphoria may have felt spiritual, man, but it had what they called at the Free U a material base—the unprecedented postwar rise in real median income that would slow drastically as the '60s ended. Yet if any of the Progressive Labor Party apparatchiks who ran the joint knew prosperity would hit a wall before the decade was over, they failed to convey this heavy insight to the young seekers they hoped to enlist in their version of the class struggle. And I would have noticed—I'd become an involved, enthusiastic participant observer. The reporter from Commentary was also a Free University student, and not just because his girlfriend was.

While well to my left politically, Ellen wasn't a typical red-diaper baby because her parents had declined to indoctrinate her. So with the significant exceptions of sex-positive Marxist psychiatrist Wilhelm Reich and, even more decisively, Simone de Beauvoir, only at the Free University did she start reading theory seriously: Marx and Marcuse via Aronowitz, anti-Franco martyr Christopher Caudwell via Ragozin. I read them too, although I finished only The 18th Brumaire, and firm

in my pop faith argued strenuously against Marcuse's covertly puritanical Frankfurt School notion of "repressive desublimation," a pretentious way to brand pleasure counterrevolutionary that Ellen wasn't crazy about either—her 1979 Marcuse obit was a pan. The Free University was also where we both got our first taste of left sectarianism, regularly siding with freewheeling liberationists like Krassner and Kupferberg. We even attended a cell meeting in Lyn Marcus's tiny West Village apartment.

What nobody nailed down, including those sure something was up, was that these conflicts were built into the Free University master plan. They had to be the fully anticipated outcome of a strategized Progressive Labor Party conspiracy. Without going into too many details, which in the grand tradition of left sectarianism are convoluted and inconclusive, I'll just say that PL was a Maoist CP offshoot also heavily involved with SDS (note three acronyms in one clause), and that the Free U was the attempt of PL's M2M youth arm to organize (educate, suborn, pervert, whatever) the peacenik counterculture it saw coming. In retrospect the acrimonious debates that undercut the Free U's surface pluralism were the only way leadership could effect the conversions the school existed to make. True conspiracies are so rare that much cannier observers than me didn't catch on either. But I was certainly naive to ignore the possibility in my piece, which eventually appeared in a slick called, hilariously, *Diplomat*.

Not that my failure to uncover a faction fight was why Marion Magid thought I was naive. For her, it was naive to give Free U ideology any credence whatsoever. Although Podhoretz actually liberalized his magazine before tacking right so hard in 1967 that he wound up well on the far side of Ronald Reagan, *Commentary* was adamantly anti-Communist, while I treated Marx with respect even if I said "Marxian" rather than "Marxist." If Magid expected something savvier or more nuanced—a brief for the union movement *Commentary* contributor Tom Kahn was still polemicizing for, or a satirical skewering of young

rads I found limited yet simpatico—she should have sent somebody who had some politics to begin with. Instead she'd pushed mine left, with lifelong consequences.

But Marion Magid deserves credit for sticking with another young writer—Ellen Willis. Magid's first idea for me, remember, was a Dylan piece, and by that fall I had called her and nominated Ellen for the job. Invited uptown to meet the gang, Ellen came back with the assignment and the news that Norman Podhoretz was the smartest square she'd ever met. Although she kind of dug how pugnacious he was, later she'd reduce his success-grubbing memoir *Making It* to stick figures and dialogue balloons in an unusually slapstick comic-book interpretation— normally Ellen was much funnier in person than on the page. It begins with a sex scene in which Podhoretz accommodates the Bitch Goddess, who straddles him groaning her consummation in Yiddish, and then complains that his pal Mailer "gets to make it with the **Gentile** Bitch Goddess." Unfortunately, it was never finalized by one of several evanescent periodicals we worked for, Richard Goldstein's *US*.

In March 1966 I quit Dorf to spend time with my lover and pursue my fortune. As my book prospects dried up, this was provided primarily by a generous and impulsive Clay Felker—once I popped into *New York* exclaiming about a Hitler doll I'd seen in a Sixth Avenue novelty store only to have Felker instantly assign a one-pager. I initiated a long-dreamed Chuck Berry profile by extracting a noncommittal interview over sweet-and-sour chicken before the secretive inventor of rock and roll eluded my grasp, but did much better with Ellen's hard-hustling boss Ralph Ginzburg, a left-liberal mensch Felker knew from *Esquire* whose obscene obscenity conviction had just been upheld by the Supreme Court.

Ellen had been away from New York so long she had almost no

friends there, so we saw mine except for Len Ragozin: Bob Stanley and his new girlfriend Marylin Herzka, Texan painter Russell Carley, the newly arrived Bruce Ennis and his wife, Nancy Lee, and Paul and Wendy Klein, who introduced us to pot and alerted Ellen to a bigger apartment on East 7th Street. That block was both one of the nicest east of A—the Kleins occupied a roomy floor-through in a row house— and a stronghold of a new bohemian style in which folkie work garb and mod primaries both gave way to a motley, longhaired style summed up by the belittling term "hippie."

In the summer we took a vacation in California—Ellen by bus, me by thumb. There we visited Chet Helms's Avalon Ballroom with Ed Hirsch and his Canadian-Zionist artist wife, Gilah. Two local bands— was one called the Lost?—preceded headliner Bo Diddley while Ellen and I, unimpressed, sat on a banquette in back playing a mathematical card game called Krypto. Glancing up to take in the twirling strobe dancers, Ellen observed, "There sure are a lot of hippies here." We also marched against the war with Lenny Lipton and his wife, Diane, before they kicked us out for reasons neither Lenny or I can now recall, although our housekeeping habits couldn't have helped. Then, before we headed south to convene with the Szantos, we spent a run of damp days in Charlie Berg's Pacifica beach shack wearing out his copy of John Fahey's *The Transfiguration of Blind Joe Death* and our copy of the Rolling Stones' *Aftermath*. Something was happening and we weren't yet attuned to what it was. But like so many others, we were making room for it anyway.

Released just before our trip, *Aftermath* was a foreshadowing, the first rock LP Ellen and I accessed as a unit, and for a long time it topped *The Rolling Stones, Now!* and *Beggars Banquet* and *Let It Bleed* for me—"the best album of its kind ever made," I wrote in the March 1969 *Stereo*

Review, and that "of its kind" was imposed by my editor. Listening back, I'd rank it behind all of those, but that's what first love is like. Naturally we owned the American version, which led with "Paint It Black" instead of "Mother's Little Helper," omitted "Out of Time," "Take It or Leave It," and "What to Do," and—the only unmitigated improvement, but a crucial one—climaxed side two with the eleven-minute "Goin' Home" where UK Decca put it at the end of side one. This mattered because on both versions side two began with the dark Ian Stewart boogie "Flight 505," a tale of the high life in which a rootless young man books a flight he identifies only by number and then sits calmly with the world at his feet and a drink in his hand as the plane crashes into the sea. "The end of flight number 505," goes the penultimate line. So does the ultimate one.

Three songs divide "Flight 505" and the finale: "High and Dry," in which gold-digging Mick is dumped by his rich girlfriend; "It's Not Easy," in which forlorn Mick lives lonely after taking a 'round-the-way girl for granted; and "I Am Waiting," in which slippery Mick longs for a girl and a savior simultaneously. All three are strong melodically and distinct musically—pseudo-country foray to Chuck Berry shuffle to dulcimer meditation. But the underappreciated "Goin' Home" was the clincher, a blues almost as elemental as "Honky Tonk Pt. 1." Keith's atmospheric guitar and Bill's slow-blooming bass are essential, Brian's harmonica fits in, Charlie lazes alongside the beat, and Mick is the star of the show—more than usual, little though we then understood how crucial the musicians were to this singer's band. He drawls, croons, vamps, riffs, ululates, expostulates, exhorts, interjects, sprechgesangs, melismatizes, scats, mutters, barks, stutters, yelps, squeals, hums, claps his hands, speaks in tongues, climaxes in a full-throated shout, and falls to the bed in a weary, satisfied aftermath. Like "Flight 505," "Goin' Home" imagines an airplane journey—packed suitcase to front door in seven hours, New York to London let's assume. The track has and is

and projects a happy ending—to the '60s, you could even imagine in 1966. Great godamighty we were going home. In the '70s I decided that music diluted sex rather than enhancing it. But before that I fucked to "Goin' Home" many times.

On side two, women are love objects or power figures. But side one's "Stupid Girl" and "Under My Thumb" are why *Aftermath* is remembered as the moment Mick's sexism came unbound. "Stupid Girl" bothered me more then than now. In the wake of too many hip-hop gold-digger songs, I've learned to grant that young men up to their eyeballs in starfuckers might get the wrong idea about women in general, and to recognize that "Stupid Girl" isn't directed at women in general. Nevertheless, it's so much meaner and so much less sexual than 1973's "Starfucker" itself, to give the Stones' 1973 groupie anthem "Star Star" its proper name. And what then makes "Under My Thumb" doubly striking is that it's even more sexual than "Starfucker"—it celebrates subjugation as a turn-on. For many sexual partners, of course, this is a physical fact as ineluctable as, for instance, my intermittent anesthesia. Some couples happily role-play around the metaphor, as is their consensual, differently stroking right. But knowing from my own experience how suggestible late teens are about sex, I've always looked askance at artists who advocate for sadomasochistic acting out.

And I've also always wondered a little about what some have called the "Willis test" for sexism in rock lyrics, which required a simple gender switch. In a 1971 piece about Berkeley's proto-feminist Joy of Cooking, Ellen compared Cat Stevens's putatively protective "Wild World" to "Under My Thumb," and Stevens got the worst of it. According to Ellen, no woman would tell a man that, as Stevens put it, "a lot of nice things turn bad out there" (which was truer in 1971 than it is now), while "Under My Thumb" 's "squirmin' dog who once had her way" could easily be a man. This was a major insight that made rock

and roll fair game for sex-positive feminists. But it was also, as Ellen acknowledged, a "crude" one—about "squirmin' dog" the argument is a lock, but the same reversal doesn't work so well on "Siamese cat of a girl" a few lines later. So I wonder about her motives. Ellen was hardly above using her supple mind to rationalize her pleasures. And she did love the Rolling Stones.

That October I was back in California on my first major *Esquire* assignment, a profile of Dean Martin, who I heard utter the schnozzled-sounding words "And as far as that *Esquire* thing, forget it" before being ushered away from the soundstage I'd been ushered to an hour before. Gay Talese had written the greatest celebrity profile of all time about Dino's pal Frank under such circumstances, but Byron Dobell did not hold me to this standard when I told him I wanted to try another L.A. story. Instead he gave me three days' expenses and two weeks of rent-a-car. I knew the outline of the story I pursued from Michael Levin, the Queens College grad who'd introduced me to M. As it happened, his latest girlfriend had flirted with me when Ellen and I had passed through in August, and after some expense-account Chateaubriand she took me home and made me come with skillful rapidity. This didn't seem to faze Levin. Instead he fed me leads on a long piece of reportage about a Queens College intellectual's painful love affair with a luxury car called the Dual Ghia. Like Levin, "Bowne"—he didn't want me to use his real name—had tested the limits of Frederick Jackson Turner's frontier thesis by emigrating to L.A. "The Supreme Achievement of the Second Industrial Revolution" was my American studies piece, and also my tribute to the seekers I'd grown up with. When I finally finished it, *Esquire* passed.

Finishing it took a while because I found out when I got home that while I was dallying with Levin's honey, Ellen had begun an affair with

Len Ragozin. Neither of us was breaking any rules—many times we'd discussed how we still craved "experience." But that didn't stop me from instantly fabricating a double standard in which I was so much more damaged than Ellen that she had to stop. Her counteroffer was a promise to limit her trysts to once a week. So I spent Tuesday nights alone in agony of shocking intensity, which failed to subside when I shared it with patient friends like Bruce and Nancy Lee, who even tried to fix me up once. And early on Bob Stanley delivered another shock by averring that of course it hurt, it always hurt. This was real now-he-tells-me stuff. In four years of sex tips, my no-bullshit life guide had left me with the distinct impression that fucking around was something experienced adults did, probably because even he wanted to look cooler than he was. I swore I'd never try to look cool like that myself, and I never have—not in my private life, and not, I hope, in my public life either.

Fortunately, Bob Stanley also impressed upon me the painful fact that if I wanted Ellen to be faithful to me I had to be faithful to her. Ellen loved me, and after a month or so of fending off my yelling, moaning, whining, and hairsplitting, she accepted Bob Stanley's compromise, but always under protest and I mean always. It came up a lot—quite bitterly early on when we shared a Free U-related dinner with Stanley Aronowitz and got the distinct impression he was making a play for her. Spouse-swapping fantasies sparked by the porn we both read were a continuing although minor feature of our sexual discourse. Nevertheless, it was good to be splitting hairs primarily about pop and politics as we made a lot of love and worked to resolve a fundamental difference mutually acknowledged and accepted: Ellen was a utopian and I was a pragmatist.

The way I see it, this was because I had rejected a religious background and she hadn't. I'd struggled so hard to embrace contingency that for me it became a credo: as a critic, I always scoffed at notions of purity and got over the related mirage of authenticity quicker than

most. The fact that Ellen was never indoctrinated in Communism (as I understand it, her dad left the party in the '30s and may never have truly joined) only made her more susceptible to its vision of a perfectible future, as did a temperament that was speculative the way more ethereal mystics are dreamy. Beyond opposites attract, the reason this split was workable was that Ellen was such a practical, good-government utopian—to cite a tiny instance, she scorned the hippie disdain for motorcycle helmet laws on the grounds that she didn't want her taxes supporting the brain-damaged libertarians who were statistically certain to bet wrong. But it was also workable because I lost more arguments than I won. Ellen wasn't the only tank in the house, but although in theory we were equally intelligent, we weren't. I've come across a few other candidates in a life seldom privy to the higher reaches of genius— Marshall Berman, Simon Frith, Dave Hickey, Stanley Aronowitz himself. But Ellen was the smartest person I've ever known. At her funeral in 2006, Aronowitz, with whom she mated permanently circa 1980, said she was smarter than him, too.

Ellen and I did not strictly speaking cohabit and would not till late 1968. But since we slept together six nights out of seven and did almost everything as a unit, assume that the first person plural signifies the two of us for the rest of this chapter. On our anniversary we invited Paul Krassner to dinner at her place, where she prepared her only culinary specialty, enchiladas suizas. By then a big change was under way, as the row of new LPs flanking her portable record player attested. A while back we'd called original rock critic Richard Goldstein to discuss WMCA's refusal to play the druggy Byrds classic "Eight Miles High." When Goldstein and his wife, Judith, walked down through Morningside Park to meet us at an Indian restaurant we'd found in Harlem just a year after the Hart-Celler Act opened immigration to people of color, we hoped we were making a professional contact and perhaps a friend, which we were. But Ellen didn't imagine that forty years later Gold-

stein, a postal worker's son who came out as gay in the mid-'70s, would identify himself as an inheritor and apostle of the pan-aesthetic, pro-sex, left-wing feminism she'd spend her life promulgating. And I didn't imagine that soon I'd be Goldstein's colleague, the first rock critic at a national publication.

I inherited my quarter-annual, twenty-five-hundred-word *Esquire* column from David Newman, who had just co-written a flick called *Bonnie and Clyde* that rendered his journalistic income extraneous. Newman devised the perfect column he'd called Secular Music and freely offered his expert advice—peel off the promo stickers before cashing in your booty at Sam Goody's. Born in 1937, he felt pop deeply enough to co-write the first three *Superman* movies. He was a fan of great American songbook types and the right jazz. But after clearing his throat by calling pop music "a wispy area for formal criticism and one where only fools have tred," he proceeded to act the fool himself whenever he got near rock and roll. If Elvis was "a really solid, talented rock-and-roll singer," the Beatles were "bunk," then later granted in passing to have improved in an overview that ignored Motown, for instance, while envisioning a stellar future for Lesley Gore. Two years later, my first *Esquire* column squeezed in Chuck Berry, the Coasters, Little Richard, the Monkees, Jefferson Airplane, Love, the Doors, Big Maybelle, and Sam and Dave, who had wowed Ellen and me opening at the Apollo and were on the jukebox at our Indian restaurant. Staring cockily across this generational divide, my lead was a dare on its way to a manifesto: "I ought to warn that I am one of the barbarians—I love rock and roll."

Which I did more than ever as the sudden flood of LPs—Ellen's complete Dylan topped by my Berry-Coasters-Airplane-Doors-etc. crapola—left us giddy. Like my expense-account Chateaubriand, it

was an auspiciously ridiculous malfunction of the affluent society: two geeky bohemians-by-default diverting runoff from the American cornucopia to the East Village. To reiterate, the tumultuously conflicted half decade of peace, love, mind expansion, and cultural positivity now called the '60s couldn't have been tumultuous or positive if it wasn't also a time of plenty. So we took advantage. The magazine business was wide open, and although freelance rates were modest, corrected for inflation they approximated those of the late pre-internet days and dwarfed those of the crash that followed. The still-extant rent control laws held my annual housing outlay below six hundred dollars and Ellen's around nine hundred. I usually had an old car and room to park it. We took a month or two off every year. No one expected us to dress for success. And hand-me-down furniture was fine with us. Yet let the record state that the jukebox I gave Ellen for her twenty-sixth birthday looked snazzy in our white-floored bedroom, and that when we finally bought a TV it was a console too enormous for any single burglar to get down the stairs.

I recall all this action, promise, and selective consumption with affection and a sense of loss—but not, please, nostalgia. Sixties nostalgia has been turning my stomach since approximately 1974. I can't stand how grossly misremembered those years are—by hippies and politicos, journalists and academics, Dylan fanatics and soul diehards, old punks and young "psych" connoisseurs, red-diaper peaceniks and Pod-people who blame free love on FDR. Worst is the way politicos and heads are conflated into a "counterculture" that was never as homogeneous as that potentially useful term implied—that from my vantage looked bifurcated. It wasn't the supposedly "uptight" politicos who were narrow-minded, but the hippies, and not just because they had less brain to begin with. Movement types were better at getting high—and occasionally, after they hit capital's brick wall, finding God—than heads were at marching for peace, much less working for justice. Ellen shared

my views, although she was more a politico, and also, once we broke up and she started experimenting with acid and the like, more a hippie too. We exemplified how roomy and heterogeneous a concept "counterculture" could be. Although we were politico-identified, our musical involvements threw us in with the hippie-identified; although our lifestyle was more bohemian than our friends', as journalists we continued to negotiate the straight world. And in 1967, that meant above all taking rock criticism pop.

When Hunter College graduate and Columbia Journalism School misfit Goldstein began his Pop Eye column in the *Voice* in June '66, Ellen and I were psyched. Even without the rock and roll angle, this was what we thought journalism could be—experimental, thoughtful, personal, cheeky, defiantly young—and the "pop" in the column hed waved a flag. Aware that Ralph Gleason and Al Aronowitz had already forayed into rock, I'd find out a year later that seventeen-year-old Paul Williams had gotten there first in his mimeographed *Crawdaddy!* and decades later that Jane Scott claimed the *Cleveland Plain Dealer*'s Beatles beat in 1964—at forty-five!—and kept at it till 2002. Nevertheless, Goldstein doesn't just get my vote as the first rock critic. He was so ballsy about putting himself out there that I say he jump-started the weekend-hippie journalism that culminated in the short-lived *Cheetah* and *Eye* in 1967—although not the far more significant *Rolling Stone*, which Jann Wenner, who was covering rock for San Francisco's short-lived *Sunday Ramparts* by the fall of 1966, would have run with regardless. All that granted, however, what Goldstein wrote was closer to narrative or profile journalism than to criticism. His pieces were often imaginative—as in "Gear," the third-person interior monologue of a fictional Bronx teen, or his Mama Cass profile "The Fat Angel." But they were analytic in fits and starts and seldom specific about musical detail. Plenty of early rock criticism was like that, including too much of my own.

Ellen's "Dylan" wasn't specific enough about musical detail either—

that remained a lacuna for her. But it was sure analytic, and crystalline by anyone's measure. "Dylan"'s eight thousand words took months to perfect. For hours Ellen would sit at the table or lie in bed thinking, occasionally writing or crossing out in a spiral notebook or rising to pump her fist to "Pledging My Time" or groan out a "Memphis Blues Again" impression. Since we edited each other more stringently than anyone uptown did, I'd read the whole thing several times before she submitted it, and I've tacked on dozens of readings since. It's inexhaustible—for me, rock criticism's founding text. I'd never claim to have written anything as good as "Ahab and Nemesis." But I do think Ellen did.

Half a century after the fact, "Dylan" may seem less miraculous than it once did. By now we take a lot of these things for granted. But "Dylan" is one reason we do. Not only does it manage to describe a bohemian subculture in situ, a rare feat, but again and again it nails truths Ellen expressed early and usually first with an acuteness seldom approached since. And although in a general way her analysis arose from our ongoing pop bull sessions, the ideas found calm language for mutual brainstorms when they didn't take me altogether by surprise. With Dylan Ellen had an advantage—she had been a folkie herself, and could strum her some acoustic guitar. (So I believe, anyway—showing off how cool I was when we met, I'd told her never to play for me, and no matter how much I begged and apologized later she never did, a warning sign I chose to ignore.) Having given folk music her usual surfeit of thought, she presented Dylan as "a fifth-columnist from the past." But to the dismay of Marion Magid—who Ellen always said expected comparisons to Robert Burns, not Andy Warhol—as well as authenticity hounds who believed, as she put it, "forget his public presence, listen to his songs," her overriding concept was to situate Dylan in a media environment where he specialized in "exploit[ing] his image as a vehicle for artistic statement."

This quintessentially pop thesis Ellen first glimpsed in grad school,

where she wrote a paper arguing that Robert Frost added both ironic tension and audience appeal to his grim verse by cultivating a grandfatherly, nature-loving persona—an undeniable hypothesis that won her an A and the warning that she was unfit for academia. My training in re Yeatsian masks and fascination with Nicky the bottle blonde prepared me well for this hypothesis. Long-term, it has a drawback: personas depend on the fluctuations of public knowledge as songs do not. But in "Dylan" it anchored an overview packed with crucial ideas about rock in its first fruition. Some were mere phrases: a voice negotiating "an evocative range somewhere between abrasion and sentimentality," blacks reduced by white rock fans to "a dual symbol of suffering and life-force," folkies "whose attitude toward the common man resembled that of White Russian expatriates toward the communized peasants." Others were succinct summations. "Folk-rock was never a form, but a simpleminded inspiration responsible for all sorts of hybrids." "The British groups successfully assimilated Negro music, neither vitiating rhythm-and-blues nor imitating it, but refining it to reflect their own milieu—white, urban, technological, materialistic, tough-minded." "Psychedelic lyrics, heavily influenced by Dylan, used the conventions of the romantic pop song to express sexual and mystical rather than sentimental love and focused on the trip—especially the flight—the way folk music focused on the road." "If pop art is about commodities, Dylan's art is about celebrity."

Career-making though this single essay would prove, it took most of the year to appear in print, after tank warfare with Magid I remember nothing of, with Ellen presumably making a few adjustments just to pretend she knew her place. So she was functionally my sidekick as we got the hang of a journalistic beat just taking shape as of early 1967—attending to "rock" rather than popular music or dumb old rock and roll. With artists still breaking on AM radio, even the LPs that piled up were something new: the album wasn't yet established as rock's

"artistic unit," to recall a forgotten term that hung around until around 1970, after the album-as-commercial-unit had rendered the record industry, as the trades huzzahed, a billion-dollar business. Nor was chowing down at press parties yet a way of life on a club circuit that was rudimentary if you hated folksingers as much as I did.

We did catch the Fugs at the Players Theatre, where we dug the sex as much as the politics and Ed Sanders's stage shtick more than either, and the Doors at Ondine, where we were almost as impressed that someone had tucked a boite under the Queensboro Bridge as by a band whose "Break On Through" was surging from WMCA. Having "borrowed" two singles by an obscure English band called the Who at a Clay Felker party, we caught Peter Townshend's band for twenty mid-afternoon minutes at a Murray the K teenorama, where their rendition of the unreleased "Tattoo" added a third life-changing song to "Substitute" and "Anyway, Anyhow, Anywhere," the rooty-toot-toots it goes out on such a Pop move. I also wrote about the Velvet Underground at Warhol's Exploding Plastic Inevitable on St. Mark's Place for titty-mag-with-dreams *Cavalier*. But between s&m-miming Gerard Malanga, Teutonic top Nico, and stone-faced Lou Reed, I found the crudely VanDerBeekian multimedia barrage more noteworthy than the band, whose album finally caught our ear over the Cafe Au Go Go PA as we waited to see either the Mothers or the Dead a few months later. And around then everything changed, for us and for the culture, with the June double whammy of *Sgt. Pepper's Lonely Hearts Club Band* and the Monterey Pop Festival.

Like everyone else, I'd heard *Sgt. Pepper* dozens of times before I hit Monterey, where it played on infinite repeat. This immersion began one pot-stoked evening on Riverside Drive with an affinity group gathered by Tom Wolfe protege Larry Dietz, who had migrated east for the *Cheetah* startup. If Capitol gave out fewer than a dozen press copies of *Sgt. Pepper*, as some have claimed and I doubt, me and Dietz got

two of them and a third went to our pal Goldstein, whose gutsy if wrongheaded mixed review in the *Times* was read as a pan and signaled his disillusion with the beat I was getting the hang of. But that didn't stop Goldstein from raving about Monterey. Everybody raved about Monterey. Giving Richard and Judith a lift from San Francisco in my *Esquire*-underwritten Chevrolet, we picked up a hitchhiker named Lee Michaels who slept on the floor of their motel room. Between 1969 and 1973, Michaels released six *Billboard*-charting artistic units, yet is remembered solely for his organ-pumped 1971 heavy-pop single "Do You Know What I Mean." In the parlance of less credulous times, he was a one-hit wonder, credulously joining what my *Esquire* piece, citing Otis Redding in its lead, called "the love crowd."

Goldstein and I differed about many things before he passed me his *Voice* gig, but we saw Monterey similarly except that he liked Jimi Hendrix even less than I did. "There is no sublimity to his music, just brutality," he charged, but my gaffe was even clumsier: describing a performance I remain convinced was much longer on provocation than music, which didn't stop me from grabbing a large hunk of the guitar he demolished and tossed into the press section (which was later, I swear it, thrown out along with my Otis Redding telegram by a subletter), I called Hendrix "a psychedelic Uncle Tom," only then *Esquire*'s lawyer told me that "psychedelic"—not "Uncle Tom," the fool, "psychedelic"— risked libel by imputing drug use. Ignorant of libel lawyers, I folded to the disastrous "just another Uncle Tom." I've reinstated the original language in reprints. It's what I wrote, and although it obviously misses a lot—not just terminological politesse, but the theatrical provocations Hendrix always built into his music, music I came to love—it illuminated the intersection of black artists and white audience at Monterey, a major theme of my piece. But like Goldstein, I focused on the love crowd itself, which he called "the largest single influx of hippies on record." Witness to the Summer of Love proper by deadline time,

and schooled in bohemian theory by Ellen and her well-worn copy of Malcolm Cowley's *Exile's Return,* I trumped that by claiming, "there are no hippies—they have disappeared in an avalanche of copy." The love crowd, I explained, was "America's affair with bohemia"—an infatuation with youth, rock, and getting high that was so exhilarating it briefly seemed like liberation itself.

With Beth Ann's wretchedness unforgotten and Groovy Hutchinson and Linda Fitzpatrick about to be murdered in a basement a few blocks from us on Avenue B—a tale Goldstein's bitter "A Groovy Idea While He Lasted" told from the hippie survivors' side while Anthony Lukas won a Pulitzer for getting to the parents—Ellen and I were as cognizant of the limits of that "liberation" as he was. But for us the absorption of the love crowd by a music business it changed mightily in the process was the way pop should work. Nor did we get exercised by the then-nascent notion of "hype," which in 1972 I defined as "a term often applied to someone else's promotion," and which my Monterey piece mocked by concocting the term "autohype" to designate the audience's tendency to feed on its own desire to get off. Goldstein's distrust for hype coexisted with and was informed by his flair for self-promotion, in which his confidently self-deprecating first person and tireless exploration of his journalistic turf soon had Felker publishing him too and occasioned a witty *Newsweek* photo depicting chubby five-foot-four Goldstein alongside craggy six-foot-four John Wayne, with the little guy the star of the story. Since the *Voice* paid Goldstein twenty dollars a column, he couldn't afford to turn Felker down and didn't really want to. But as his political consciousness asserted itself, he grew uneasy. Not us. *Cavalier? Diplomat? Stereo Review?* Bring 'em on.

In one windfall, my *Diplomat* editor moved to *The Saturday Evening Post* and needed to fill out a June bathing-suit spread. So she asked the chic Miss Willis, a scanner of *Times* fashion ads and a reader of *Times* fashion coverage, to interview a designer and file overnight, and over-

night the normally painstaking Ellen produced five hundred words as if Lloyde Glicken was looking over her shoulder. For these labors she was paid—can this be?—fifteen hundred dollars. Maybe it was only five hundred. A lot. Anyhow, here's the lead of her uptown debut: "To the average American female the beach means trial by exposure, separating the women (bulging and blemished) from the girls (trim and smooth). Conditioned to show only what can be defended, who but a well-proportioned teen-ager has the courage or the figure for this summer's new Nude Look suits?" This imperturbably subversive report on the objectified female body was way ahead of its time if you see it as solely feminist, less so if you also see it as countercultural—as did Ellen, who was so invested in the transformative potential of image manipulation that she'd soon value Janis Joplin as much for her frizzy hair and beautifully homely face as for the galvanizing vocal presence that rendered them iconic. All of pop culture seemed to radiate that kind of possibility in the Summer of Love.

Movies, for instance. In a year when underground documentarian Frederick Wiseman announced himself with *Titicut Follies*, when underground storyteller Jim McBride unveiled *David Holzman's Diary*, when Gillo Pontecorvo's *The Battle of Algiers* turned left-wing cinema box-office, when Milos Forman's *The Firemen's Ball* poked through the Iron Curtain, when Hawks undercut Wayne and Mitchum in *El Dorado*, when Godfrey Cambridge played a CIA agent with his own shrink in *The President's Analyst*, and when Peter Watkins's putatively progressive anti-star tract *Privilege* made our gorges rise, our favorite flick by far—and minus the Watkins we loved all of these—was *Bonnie and Clyde*, which we took as the fulfillment of prophecy. Where the *Times*'s outraged Bosley Crowther expostulated, "This blending of farce with brutal killings is as pointless as it is lacking in taste," Pauline Kael bum-rushed *The New Yorker* with a long essay that laid down many precepts we shared: "you don't express your love of life by denying the

comedy or the horror of it"; "Once something is said or done on the screens of the world, once it has entered mass art, it can never again be the possession of an educated, or 'knowing,' group"; "*Bonnie and Clyde* is the first film demonstration that the put-on can be used for the purposes of art."

To resort to a cant term then decades down the road, *Bonnie and Clyde* was transgressive. It sensationalized American sex and violence without overstating the facts or demonizing perpetrators who were also victims, and the inappropriate guffaws it went for exposed Crowther's and Watkins's moralizations as irrelevant evasions. That said, Ellen and I each developed hipper ways to moralize soon enough. We had to, because undercutting and intensifying an elation that fused fond pop irony, charming hippie foolishness, moderate quantities of marijuana, and the day-to-day excitement of being in love was a political anxiety that shaded everything we thought about and most of what we enjoyed—such a bummer sometimes that it's no wonder the hippie wing fended it off with make-love-not-war bromides. Public support for the war was eroding, in part due to the pop effects we believed in—even while manipulating public opinion, which was all Frankfurt Schoolers could see, the culture industry reflected and sometimes spurred public unease, via not just music and movies but the journalism where many young creative types besides us expressed their own beliefs, sometimes in the guise of "objective" reporting. But as the protests got bigger and louder, the hostilities kept escalating, and the counterculture began choking on the cud of its own privilege and drowning in the undertow of its own euphoria.

Hence 1967 was also the year when SDS-style meliorists lost their heart and blew their cool. Outraged by the war they couldn't stop, all of them had become frustrated with changing the system from within, and some of them were so mad they wanted to start a war of their own. Soon white radicals' revolutionary fantasies seemed to come true as

inner-city riots spread from Newark and Detroit. And although that was fantasy for sure—the riots were autonomous events proving only that armed rebellions would be efficiently suppressed, although they did generate a few meliorist perks long-term—these rebellions certainly intensified the disorienting black power rhetoric that had already been passed from Student Nonviolent Coordinating Committee intellectual Stokely Carmichael to gangsta-in-waiting H. Rap Brown. For years white anti-racists could arrive at no way to respond reasonably to the reasonable demand that black people run their own movement. With white politicos who strove to conform to the shifting new racial structures soon doing somersaults over the edge of a cliff, the separatism that grew out of black power seemed the only sane response—and to some, also the only respectful one. Given the cultural origins of American popular music, that didn't make taking rock criticism pop any easier. It was a hard time to get your bearings.

Into this world-historical turmoil lurched a capitalist absurdity that would engage our professional and creative energy into 1968. *Cheetah* was the brainchild of Matty Simmons and Len Mogel, who'd made their bundle with a slick keyed to the Diner's Club's newfangled "credit card"—a mag whose extensive ad space targeted club "members" who formalized (and monetized) their lust for consumer goods by signing up for one of the magic thingies. *Cheetah* was also linked to a club, but of a different sort—a small chain of newfangled "discos" whose New York branch was located at Broadway and 53rd, two blocks from the office. Insofar as Cheetah had members, they constituted a less voracious, coherent, and exploitable market than Diner's Clubbers, and *Cheetah* generated ad space to match. It lasted eight issues. Matty and Len did much better with their next venture, *Weight Watchers*.

Like Marion Magid, these hondelers wanted a piece of the new

youth culture. But since they were profiteers rather than intellectuals, for them servicing the new mass bohemia felt like a status move—they coveted its cultural cachet. So they tolerated its harebrained ways until they'd actually worked with handpicked editor-in-chief Jules Siegel, a thirty-five-year-old, Wolfe-inspired rock journalism pioneer straight outta *Cavalier* and *The Saturday Evening Post*. Siegel led the first issue with an expanded version of his Brian Wilson encyclical "Goodbye Surfing, Hello God!"—rejected by the *Post*, he claimed, because his editors had demanded a putdown, unaware that sincerity had replaced camp as the "hip" attitude. This was astute enough, although I'd add that "hip" had also lost its hip—the 1967 word was "groovy." In the end, which came quickly, *Cheetah*'s first editor proved not only too old for the gig but as far out of his gourd as Brian Wilson himself. The only speed I ever did came from Jules Siegel. Soon *Cheetah* had been handed over to Larry Dietz. And that's when things got interesting.

Dietz was a Philadelphia-raised Brandeis dropout who'd followed a girlfriend to Los Angeles, commenced a lifelong relationship with Wolfe via a Wolfe-style profile of beatnik chronicler Lawrence Lipton, and published a folk-rock feature in *New York* in 1965. An affable, slow-talking twenty-seven-year-old who smoked a lot of dope and cracked a lot of wise, he spent much of the *Cheetah* period carrying the torch for a sexy blonde named Roxanne Dunbar, who before 1968 was over would found Boston's Cell 16, a fearsomely militant feminist group with both a Marxist class analysis and a pro-celibacy line. Dietz had the active mind but not the iron will of the gifted editor-in-chief. At a magazine beset from its inception by lax concept and inept ownership, his tenure added an extra soupcon of catch-as-catch-can. But the results were readable and adventurous, and for half a year fun for us.

Dietz loved the Beth Ann piece and my *Esquire* column, so I was on board from the start as film critic and contributing editor, an amorphous title that with me meant something. I was on the premises a

lot—Siegel's speed came my way as I labored over "Rock Lyrics Are Poetry (Maybe)" for the third issue—and before long I was line-editing at no extra charge Dietz's handpicked rock critic, Princeton musicology PhD candidate Peter Winkler, which did limited good for the time it took. My recollection is that Ellen was always around our confabs. But Dietz believes he only became aware of her post-"Dylan," the clarity and depth of which so gobsmacked him that he instantly assigned a post-*John Wesley Harding* revision for *Cheetah* and appointed her associate editor. Although my gratis work with Winkler suggests how casually communal the operation was, the epitome was the zoo column Ellen conceived after a few tokes one evening in Dietz's West 79th Street apartment. After all, she reasoned, we had to do something to justify our stupid name. Dietz chortled, as was his wont, and put her on a quarter-annual track. Two were published, San Diego and Bronx, under her hed: "At Home."

Cheetah was much better than its stupid name. It never got its look together—there was lots of putatively psychedelic color and, especially toward the end, too much large type shouting filler, although the money-saving ploy of reprinting a page of nuggets from the underground press was sharp. But *Cheetah* also made room for many column inches of smaller type—pieces ran long in those good old days. There were scene reports from L.A., Boston, Miami, and draft-dodger central Toronto as well as substantial looks at the draft and the drug world and in the final issue abortion. Tom Nolan's Wolfeian Wolfman Jack piece was classic, as was Doon Arbus's stammering verbatim interview with *Bonnie and Clyde* Oscar nominee Michael J. Pollard. *Voice* counterculture correspondent Don McNeill, our cupid Paul Krassner, Tom Wolfe himself in reprint, and eloquent bizzers Derek Taylor and Andy Wickham all scored bylines, and friends of ours also got their inches, much more justifiably with Dietz (future L.A. *Times* honcho Digby Diehl, movie maven Joel Siegel, and Spinal Tapper/*Simpsons* dubber

Harry Shearer) than me (George Szanto, Sandy Lattimore, even Bob Stanley in a photo spread that reserved a feature role for one of Marylin Herzka's breasts). But networking favoritism is standard at publications far more prestigious than *Cheetah*—at all of them, far as I know. And the main friends who got inches were me and Ellen.

I had five features in the eight issues, including "The Supreme Achievement of the Second Industrial Revolution," a report on two contrasting Wilson Pickett concerts at the Apollo, and the best rock criticism I published pre-*Voice:* the speed-enhanced "Rock Lyrics Are Poetry (Maybe)," an attack on genteel diction and simplistic obscurantism that cast aspersions on Paul Simon while going all in for the Mamas and the Papas' not-yet-coked-out John Phillips and the redolent basic English of the Beatles' "Hello Goodbye" and "All You Need Is Love." Rereading the film columns, I'm proud of how contentiously and unpretentiously they stated facts and explored ideas about omnivorous everyday moviegoing, often by counterposing two very different flicks: Luis Bunuel's *The Exterminating Angel* versus Richard Rush's *Thunder Alley*, both of which I praised, or *The Graduate* versus recent Kuchar brothers, both of which I found wanting.

Ellen published less, but she started later and was also editing full-time until Len Mogel fired her a few months before he lowered the boom on the rest of us. Her coup was the only celebrity profile she ever wrote, a deft, homey, unpsychedelic portrait of second-generation Communist and Free Speech Movement leader Bettina Aptheker. But Ellen peaked in the book coverage she edited and most of the time wrote. She maintained a pop veneer in an essay on the science fiction she'd read as a girl and a coherent, respectful piece in which she gulped down ten "Ballantyne Mod Books." January's skeptical two-page review of Stokely Carmichael's *Black Power,* on the other hand, was a gantlet: fifteen hundred words of leftist theory in a magazine named after a disco. Although not so hot on race itself, it calmly assumed urban riots

were natural events and disdained "the white liberal" and "the electoral process"—while simultaneously pointing out that "real revolution is out of the question." What could Len Mogel have felt when he picked up his Michael J. Pollard issue and read "the revolutionary task of our age may be destruction, not creation"? Did he vow to can her right then?

With the Free U in pieces and none of our running buddies committed radicals, these ideas emerged full-grown from Ellen's reading and ever-churning mind, with me and other debate partners sounding boards. The two of us also happily sampled the trippy be-ins, shambolic free concerts, and far-out costumery of hippiedom—I owned both a royal-blue doorman's jacket with gold piping and a pinstriped orange sport coat that led a bored Ridgewood teenager to mistake me for half of Peter & Gordon one Easter Sunday. Yet our opposition to capitalism encompassed a class animus that distinguished us from politicos who romanticized poverty as well as hippies who ignored money. Not only did we see the best in art non-counterculturalists liked, but our fathers wore uniforms. So at demos and marches we quickly got peeved with the term "pig," which both hippies and politicos threw at every cop who crossed their path. And soon we noticed how turned off we were by the abuse protesters heaped on soldiers. Nothing in the stoic eyes and acne-shadowed faces of these young noncollegiates said baby killer to us. Absent specific evidence to the contrary, we just saw young guys with limited choices risking their lives inside an oppressive institution.

As *Cheetah* wound down in 1968 we got to know a University of Chicago dropout turned conscientious objector whose ideas about pop paralleled ours at a less developed and more extreme level. Tom Smucker was the Midwestern son of a Mennonite clergyman who was mad for the Beach Boys. As original in his schlocky tastes and comedic tone as anyone who ever published rock criticism, eventual author of a visionary appreciation of Debby Boone's "You Light Up My Life" as well as the disco article in the first *Rolling Stone Illustrated History of Rock & Roll*, he was dazzled by the nuance and detail of our pop

polemics. But he became more grounded politically than either of us just by doing his CO service at Lincoln hospital, where watching Black Panthers, Young Lords, Sullivanian shrinks, and radical MDs duke it out sparked his enduring fascination with the tragicomedy of left sectarianism.

A few months later, a heavier and less reliable leftist entered our lives. Fred Gardner both occasioned the end of my relationship with Ellen and introduced me to the woman I'd marry. For the few years we were friends, he was as charismatic as anyone I've known unless John Lennon counts, including many whose public and private achievements have by now far exceeded his. Fred was a red-diaper baby, Harvard graduate, second-generation journalist, acerbic singer-songwriter, and onetime army reservist who as creator of the GI coffeehouse movement was the true hero of the American Servicemen's Union cover piece I wrote for *Esquire*. Having figured out early that plenty of draftees had their doubts about the war, Fred provided friendly places for them to hang out and talk about it—inexpensive spots where they could hear good music and rub shoulders with other draftees who wished they weren't in the damn army. Given the role disaffected GIs played in the gradual collapse of the war effort, this approach may seem obvious now, but few on the left were ever as ready as Gardner was to let soldiers themselves decide what to do next. We hit it off because he was a genuinely democratic strategist who appreciated my outsider perspective and soon appreciated Ellen's more, and it was through him that we connected to the larger movement.

Our professional life, however, remained pretty engrossing. *Cheetah* looked iffy from the first of the year, but Ellen worked like it meant something—she only stopped trying to convince Wolfe to review Podhoretz's *Making It* when he proposed a piece that read in its entirety "Norman who?" "Dylan" had elicited calls from *New Republic* and *Ramparts* as well as two publishing houses she turned down in hopes of selling either a Wilhelm Reich book or a joint project in which we put

our ongoing theory of pop on paper—a plan that won us a $5,000 contract with Random House in June. I returned with Ellen to Dartmouth as part of a five-man "new journalism" panel also featuring Paul Krassner, Richard Goldstein, Jack Newfield, and Ed Sanders, an antic presence who invidiously compared the van we drove up in to a Warners limo and refused the mushroom soup we were offered on the grounds that it contained "the demon chicken." I reported, wrote, and botched a *Saturday Evening Post* feature on an escaped bank robber who'd passed himself off as an engineer at Expo 67, and after *Cheetah* went under was very briefly named film critic at *Ramparts.* I kept networking for my friends too, although my journalistic matchmaking for Bill Hjortsberg and Tom Smucker was nothing compared to what I did for Paul Klein, who'd formed a band called the Wind in the Willows and through a shrewd, amused PR hipster I'd bonded with—Dominic Sicilia by name, he sold me Ellen's jukebox at a discount and fed us industry gossip for years—signed with Capitol via future Woodstock confabulator Artie Kornfeld. If the band name looks familiar, well, they're a footnote: their quiet chick singer with the long mouse-brown hair was named Debbie Harry. I never noticed how luscious her mouth was. Never guessed what a big brain she had either.

Watching my friends peak at 195 in *Billboard,* however, was nothing compared to having the phone ring and a gent ask for Miss Willis in a voice so unassuming I could hardly hear it. It belonged to William Shawn. He'd been very impressed by her Dylan piece and was most pleased when she agreed to write about rock music for *The New Yorker.*

In mid-1967 Ellen had moved again, to a four-room with full bath at 308 East 8th Street, a block south of my 608 East 9th pad. While I didn't move in officially till November—the big commitment was walking the metal wardrobe down three flights and up two—this was our place.

When I bought my first serious stereo with six hundred bucks in Sam Goody's credit, the 308 living room was where it went; at 608 I made do with a suitcase portable. Rumor traced our luxe abode back to, of all people, Richie Havens, who became our symbol of folkie smarm when he sought sing-along by "forgetting" "With a Little Help from My Friends" at the Fillmore East. But the rent receipts Ellen got were made out to one Amber Kovanda, who we assumed had pasted the glow-in-the-dark stars on the dark-blue living room ceiling, glued an Indian bedspread to one wall, and hung a Union Jack over the airshaft window. We added shelving for our books and records—industrial-strength for the latter—and a hideous mustard-colored living room carpet. The sturdy, double-leafed, cockroach-friendly maple kitchen table was from Ellen's parents. This item must have been a newlywed hit circa 1940—I had an identical table from my parents at 608. Cockroaches aside, I miss it.

Ellen, who later made a public point of not celebrating Christmas, had the grace to accompany me to not just Christmas but Easter, and my parents had the grace to accept our living in sin. This was a bigger stretch for them than for the Willises, as was everything about the '60s. It helped that Doug had kept the faith—in June 1967 he married a nurse from North Shore Baptist and then relocated to California to work for Brigade. But in general my folks were pretty brave about it. Ellen scared them—she scared Len Mogel, for Chrissake—but we loved each other, and they saw that. Once my dad pointed out that I'd never know what it was like to make love to one woman my whole life, but when I responded that he'd never know what it was like to make love to more than one, he assented and we left it at that. He also showed his support by shoring up our domestic plant—the two of us spent hours securing that hi-fi to large pieces of furniture.

That was the neighborhood that came with the rent, and for me the long walk to the subway was a bigger burden than the occasional prickle

of dread on the back of my neck. By then the mixed-use St. Mark's Place of 1960 had become a hippie rialto, crammed with beggars I ignored and dealers I took to regaling with "Got any aspirin? How about No-Doz?" But Avenue B was where I'd settled down. We ate bargain lox from Avenue C until the purveyor died, copious bad Cantonese on Avenue B, the new "falafel" sandwiches an Israeli purveyor on First Avenue started at fifteen cents and slowly raised to half a buck, kasha varnishkes at Ratner's, and pastrami at the Second Avenue Deli. I stopped going to the barber and sometimes braved the broken glass and went barefoot in Tompkins Square Park. But I also owned a basketball, surprising the local Puerto Ricans and project blacks with my stubborn hustle and rebounder's ass. Usually the only longhair on the court, I was accepted for the competent third man I was. In many years of hoops I only had one ball stolen, for which I got karmic giveback one night as I crossed the park, when two Puerto Rican subteens emerged from near the parkie's office with knives and hesitantly demanded my money. From the shadows I heard a whisper: "Not him—he's a ballplayer."

Dad and I secured my new stereo because once Ellen had left a window open at my 9th Street place and was chagrined to find that stereo gone when she got back, and once she was merely amused when a ten-year-old boy felt her ass and asked, "Did you like it?" But then, in the early spring of 1968, she was raped. Followed into 308, shown a knife, entered for a minute on the first-floor landing, over and out. She didn't resist and suffered no additional violence. Put at a loss by both my helplessness and Ellen's matter-of-factness—she didn't even call the cops—I responded clumsily at best, and have long regretted that later that night we had sex. Looking back, however, I think it might have been as mutual as I believed at the time—a reassertion of the normal. At my suggestion, Ellen went next day to talk to Marylin Herzka, who still marvels at her rationality and calm. "She didn't get hurt, she wasn't a virgin, she didn't see any point in reporting it. She was such a stable

person." Seven years later, Ellen published an exhaustively reported *Rolling Stone* piece about a date rape that I think is in the running for the second-strongest thing she ever wrote.

Nineteen sixty-eight earned its horrendous reputation. It's a litany I'm obliged to repeat: MLK and RFK assassinated, Warhol shot, race riots post-MLK, Columbia strike a token away, uprisings in Paris and Prague and—much smaller in scale, but larger in the American mind—Chicago. As the war got bigger and harder, the new left proved as riven if not yet as sectarian as the old, and everyone I knew was moving left from wherever they'd just been, as were their parents. Me too, but not as fast as Ellen, for all the usual reasons plus one above all. Always a feminist who used the word, she was thinking about the women's caucuses that had emerged at SDS and elsewhere, partly in response to the separatist logic of black power. In this Fred Gardner played almost as large a role as her reading. Gardner genuinely loved women, and not just because they were crucial colleagues (and attractions) in his coffeehouses. Married with two kids, he counted many female friends and acquaintances as intellectual equals and sometimes mentors (and slept with more of these comrades than he ever revealed to me, although brag slyly he did). Just in our interactions with him, Ellen and I met quite a few women who could talk politics better than I could—women's issues especially. Men too.

Yet we also met many fools this way—during one memorable cab ride, SDS firebrand Jeff Shero proposed organizing the Mafia: "They've got the guns and we've got the ideology"—and so our alliance remained strong. It was less idyllic—our fights weren't just about ideas anymore. But despite a few blips—my genital chakra having regained its sweetness, I was no longer Sergius O'Shaughnessy—the sex was frequent and pleasurable, and near as I could tell the underlying relationship was deep and mutual. It was also increasingly prosperous. My big features had a way of falling through—Aretha Franklin eluded me at *The Satur-*

day *Evening Post*, and a strange *Esquire* assignment to profile Broadway producer Hilly Elkins ended up a laborious dud—but I was still making more money than a cheapskate knew what to do with, and Ellen's job paid her a hundred fifty bucks a week for twelve Rock, Etc. columns and two features a year. We even thought about escaping to a rural retreat, a very 1968 fantasy that lasted to the end. But although Ellen valued her gig and I was nothing but proud she had it, she also worried it would cramp her style. One reason she was hired was the cool lucidity of her rhetoric, but she cherished her right to be impolite, especially about sex, where Mr. Shawn's delicate feelings were legendary—and also about an anticapitalist overview that was picking up ideological thrust and contrarian nuance all the time.

I was in Oklahoma with the army union when King was killed, so we experienced that tragedy separately, but it prepared us for the RFK horror by suggesting as Malcolm X could not that the JFK horror was no fluke. Like Fred Gardner, the *Voice*'s Jack Newfield, and other lefties we knew, we were big Bobby Kennedy fans. For me this came naturally—in a rare autonomous political act, I'd even fallen in with the ad hoc Citizens for Kennedy-Fulbright in early 1967—while Ellen's reservations about the electoral process were overcome by her belief in the transformative power of public image and her gut feeling that Americans wanted out of the war. But King's death had already instigated a crisis mindset intensified by the shooting that most moved us personally—Warhol's just two days before RFK's. As Willis recalled in her 1987 Warhol obituary (no rave, but kinder than the Marcuse), we were so shocked we went to the hospital to wait for news. In that piece she also declared herself bemused that anyone could take shooter Valerie Solanas's *S.C.U.M. Manifesto* literally, although, just as some now remember Beth Ann Simon as a junkie, soon intelligent women led by Dietz's ex Roxanne Dunbar would begin the rehabilitation that transformed a deranged lesbian pamphleteer into someone Wikipe-

dia designates a "radical feminist." Independent feminist Willis saw the unplanned shooting not as a crazed strike at some crudely defined gender enemy but as the fulfillment of her widely shared premonition that when artists' "personas were at the core of their art," murder could become criticism in action. And then Sirhan Sirhan shot RFK and made that apocalyptic foreboding come true.

As an antiutopian, I had less to lose psychologically in a disillusion that soon turned panic. Anyway, in a time that felt at least a little apocalyptic to anyone who'd opposed the war long enough to get discouraged, Ellen's hedonism more than counterbalanced her unease—with mixed envy and disdain, Gardner's *San Francisco Express Times* pal Marvin Garson called me and Ellen "the happy people." So my memories of our final year-plus are mixed. One image I've never lost is our ritual trek to the Fillmore East, which opened in March 1968—digging the stereo, sharing a joint, feeding our munchies (anchovies with sour cream topped off with Sara Lee, very contrasty), and then gallumphing south of the park and past the Ukrainian funeral home to the late show. Another is hitching a ride to the Grand Canyon with a caravan of sedans, trailers, and pickups after our last Chevy bit the dust in Arizona, only our biker benefactors took so much acid they never got past the souvenir shop, so we announced we were Greyhounding it home—hurrying, we explained absurdly, so we could vote for the antiwar Republican in our congressional district, which we both did. Right then was also when we decided to move in together for real, and worked out the rest of our life plan. We wouldn't marry; Ellen was so absolute on that I could parrot her rationale verbatim. But by then many of our friends had children—the Kleins, Gatz and his wife, the Gardners' two toddlers, Marylin's wonderful eleven- and six-year-old, and especially George and Kit Szanto, with whom we'd grown close over weeks in their miraculous Del Mar beach house, which thirteen years after they bought it would go for *thirty-five times* what they'd paid (they sold when

the multiple was three). I loved all these kids, and had never given up my dream of a son named Tom. And so we'd have a child—after we'd put in a year of political organizing, running a coffeehouse for Gardner.

"But," I suppose should be my next word. A big fat "but." But that was never how it felt to me. Right, having talked women's liberation aplenty in San Francisco with Fred's future ex, Jenny, Ellen started attending the contentious weekly meetings of the New York Radical Feminists as soon as we got back. And right, by January she and her exciting new friend Shulamith Firestone had gotten so fed up with the NYRF's old-new-left refusal to ascribe their male comrades' piggishness to any historical-economic pattern that they formed the Redstockings cenacle. Probably I should have gotten nervous about where I fit in, but I felt so feminist-identified that I trusted our relationship—my main complaint was the way she and Shulie tied up the phone before call-waiting was invented. Without worrying overmuch about what Redstockings thought of me, I was glad she'd found girlfriends and her own political movement—considered it, as I wrote Gatz, "very nice since I'm *not allowed* to participate." About a month after we split, Ellen wrote from Colorado, "Our relationship was in trouble in New York . . . and it was affecting me sexually and emotionally long before I got here, even if I didn't articulate it to myself." Nor, of course, did she articulate it to me.

Ellen was so busy consciousness-raising, as Kathie Sarachild had dubbed it—and so preoccupied with her effort to inject psychological nuance into what quickly evolved into Redstockings' "pro-woman line"—that she officially shelved our book, which to my irritation she'd been putting off while I spent weeks in the Fifth Avenue Library researching my chapter on mass culture theory. But that research—in which I not only studied the then-standard *Mass Culture* and *Culture for the Millions*

anthologies but read every serious popular culture piece I could locate in the *Reader's Guide* and *International Index*—was there to ground my thinking forever. Not only did Clement Greenberg on "kitsch" and Ernest van den Haag on the wastes of Brooklyn arouse my lifelong ire, but Colin MacInnes, Stuart Hall, and Oscar Handlin, to name just three, went on my A list. And since it had long been clear that the book wasn't going to be done by our silly June 1969 deadline, I too put it off as I embarked upon the most significant career move of my life: a *Village Voice* column called Rock & Roll &.

Unbelievable though it now may seem, what was not yet called a meme had arisen out of the crisis mindset of 1968: "Rock Is Dead." This panicked response to the music's failure to remake human consciousness was mostly the fault of a biz that signed groups left and right post-Monterey. As I described it in a never-published essay: "The temptations of contrivance and chaos—one epitomized by the control-room cool of *Sgt. Pepper,* the other by the heady success of improvised psychedelica—have led dozens of record companies and thousands of longhairs down paths of economic and artistic delusion. So many groups! so many discoveries! so many artists! Some even justify the hype! But most don't!" *Crawdaddy!* was a locus of this meme—Williams was soon off to follow mind-control guru Mel Lyman, and Richard Meltzer, the most brilliant and verkakte of Williams's discoveries, was still reiterating the 1968 deathdate in his 2000 rockcrit anthology *A Whore Just Like the Rest,* which was written almost entirely 1969 and after. Due to deadline burnout and political despair, Goldstein too had lost the rockcrit calling. But for *Esquire*'s trend-mad, jazz-digging editor Harold Hayes, the prevailing disillusion was more fun than a second martini—matoor values reasserting themselves. So he assigned me a rock-is-dead piece, I explained why it wasn't in the aforequoted seven-thousand-word essay, it was rejected, and after eight installments Secular Music was dead instead. I later learned that the year before Hayes

had proposed a Fillmore piece to my acquaintance Jacob Brackman, who declined with the observation that I was more into music than he was. "Yeah," Hayes replied. "He's too into it."

Which I suppose I must have been, because that was when I discovered something basic about my career in journalism: I wanted to be a rock critic. Not exclusively—despite the big assignments gone awry, I hadn't yet accepted Jack Hirschman's dictum that criticism was my calling. But I had no doubt that I loved the beat. So I approached *Voice* editor Dan Wolf in his tiny Sheridan Square office, told my sad tale, and was given a monthly column on the spot—one reason being, apparently, that Wolf remembered my name from snarky letters he'd published over the years.

Where my final Secular Music earned me five hundred dollars, my first Rock & Roll & paid forty, and I responded in kind, cramming out the two-thousand-word "Gap Again" in a single February all-nighter. But despite signs of rush second half—too much "freak," "bag," and "thing," and some of the judgments are slack—its breakdown of the "sectarianism" of rock's once-unified audience ranks with the best criticism I'd yet written and compares well with Ellen's *New Yorker* work. Soon I was so impressed by a critic for Marvin Garson's paper that I sent Greil Marcus a fan letter, kicking off an idea-chocked correspondence with a new ally who functioned as my own Shulie Firestone. Since Ellen found it distracting when I played piles of new LPs in the apartment, I took to doing my power listening on 9th Street, in 608, then bringing my finds home. Thus it came to be that in July I unilaterally rendered Rock & Roll & semimonthly with the abbreviated letter-graded reviews of a feature that I dubbed the Consumer Guide to razz a counterculture that considered consumption counterrevolutionary and didn't like grades either. Hands-off arts editor Diane Fisher, who starred as Annie Fisher in a review section whose most astute touch was the header Riffs, kicked up a mild fuss about this space grab,

but it petered out. I got forty bucks for that too. At a Grateful Dead-Joe Cocker concert shortly after the first CG appeared, I ran into *Crawdaddy!* contributor turned *Eye* columnist turned *Rolling Stone* stalwart Jon Landau, who predicted that the Consumer Guide would make me the king of rock criticism. I wasn't positive this was a good thing. But I appreciated the compliment.

By now I've name-checked every key player in early rock criticism. Note that some well-remembered names hadn't surfaced by the end of 1968. Dave Marsh wouldn't become top dog at the supposedly communal *Creem* till late 1969; Lester Bangs wouldn't publish until mid-summer of that year with new *Rolling Stone* review editor Marcus. Lisa Mehlman had yet to meet future husband Richard Robinson; original folk-rocker Paul Nelson—of *Little Sandy Review, Sing Out!, Circus,* and others, including *Crawdaddy!*—remained a recluse until he got his lunch budget at Mercury Records in 1970; Australian stringer turned *Rock Encyclopedia* author Lillian Roxon wouldn't land her *Daily News* gig till 1971; and yes, there were others of note who would start early and stick at it for a spell, especially in Boston and California. But when I try to figure out what the hell we thought we were doing back then, and how well we were doing it, who I mean by "we" is Goldstein-Williams-Meltzer-Landau-Willis-Marcus. Plus Christgau, of course. (Albert Goldman? Who?) Note that five of the seven are Jewish, and that Landau and Meltzer were also Queens kids. Of the five later names, only two were Jewish, and only one, Lisa Robinson, was a New Yorker.

Like most young critics—it's in the job description—I was pretty damn sure of myself. Having read *Cash Box*, rejected folk, absorbed jazz, theorized pop, and ramped up my prose, I didn't feel like the king (or the dean), but I did feel like the best. Much as I liked Goldstein personally, I continued to think he overwrote and got too exercised by

the commercial machinations surrounding a music designed to be sold. Discovering *Crawdaddy!* in a 1967 *Esquire* rock-goes-to-college piece, I was complimentary, impressed even, but condescending—crowing over Meltzer's patently outrageous application of Hegelian ontology to the Jamies' "Summertime" without grasping how ludic and apt it was, and comparing Swarthmore dropout Paul Williams's essays to college papers. As late as 1972, well aware that in 1967 both *Eye* and *Rolling Stone* had hired Brandeis junior Landau because "as an analyst of the guts (or machinery) of rock and roll he has no peer," I was carping that his style had "evolved from the clubfooted to the pedestrian." About Willis, of course, I was much more positive; stylistically and intellectually, her early columns—topped by her Newport Folk Festival report and Who and Stones pieces—also had no peer. Yet I wrote Greil that I preferred my own rock writing, observing, accurately enough: "For her, it's mostly a good money gig, though I always agree with what she has to say. It's getting to where we don't find each other's writing superilluminating anymore—we've been trading ideas about music for over three years."

There was theory aplenty in those early *New Yorker* pieces, most noticeably in an audacious abstraction collected as "The Star, the Sound, and the Scene." But the giveaway sentence begins the first of her many Rolling Stones essays: "It's my theory that rock and roll happens between fans and stars, rather than between listeners and musicians." That was our line, and in the end our weakness. The first half is not only right as far as it goes, it's the secret of rock criticism, which at its best and on the average countenances more irrational enthusiasm and rooting interest than any other kind—including film criticism, where most of us adore Pauline Kael for beating us to it. But as neither Ellen nor I was ready to see or hear, the dichotomy wasn't so neat.

Ellen and I were hardly alone in missing the core musicality of not just Motown and the Rolling Stones but '50s rock and roll, where

Chuck Berry and Jerry Lee Lewis, to choose the prime examples, were major instrumentalists—one endlessly imitated, the other all but inimitable—while an unheralded cadre of studio musicians turned the beat around on the way to the big BANG-thwonga-bang-chicka-blare-BANG-unh of James Brown's "Papa's Got a Brand New Bag," recorded in 1965 to major commercial and zero critical notice. But each of us was concealing an ulterior motive. With Ellen it was her distaste for jazz, which impaired her ability to distinguish high improvisation from stoned noodling (she never warmed to Hendrix or Clapton), with me my formal ignorance, which set me to rationalizing the primacy of sociology in self-defense (Ellen could at least play guitar). Not counting Landau, who was producing albums by 1969, we shared our failure to describe music per se with every major early rock critic. But despite *Crawdaddy!*'s psychedelic fatuity (see the sixty-three-page Paul Williams-David Anderle rap session about Brian Wilson that puffs up Williams's *Outlaw Blues*), Williams's mag at least gave some good writers space to try. Sometimes the approach was formalist—Landau going long on Motown, Sandy Pearlman analyzing raga-rock. Other times it was almost, well, psychedelic—Williams himself cut-by-cutting the aural quiddities of *Their Satanic Majesties Request*, Meltzer ferreting out Chuck Berry, Four Seasons, Zombies, and Rolling Stones moves in Herman's Hermits' "A Little Bit Better."

Prosewise, Willis was the most developed of us, Landau the least, although under Jann Wenner's browbeating tutelage he upped his game somewhat. The most demonstrative stylists of the bunch were Goldstein and Meltzer, both of whom improved their control later on—Goldstein's style got quieter, more J-school, imbued with a leftism long on feminist principle and gay pride, while Meltzer's gained sinew and syntax, flaunting, as I put it much later, "ideas by the bucketful, mockery of that there, jokes for jokes' sake, a word born every minute, a childish refusal to curb his orality." Never flashy although inescapably

trippy, Williams returned to rock criticism in the '80s clearer and terser, a utilitarian eccentric who never gave the sense that he savored lucidity like Willis or language like Goldstein and Meltzer. I was funnier and blunter than Willis, clearer and more cerebral than Goldstein, but not yet as fully formed as either.

As a cohort we took too long to generate the kind of adjectival arsenal critics are obliged to perfect, vary, and elaborate for every undocumented genre. There was too much "beautiful" and "groovy," "brilliant" and "successful," even "good" and "excellent," although someone at *Crawdaddy!* came up with "kinetic," still a useful concept now and then. Even worse, with Landau a major exception, we shied away from Motown and Southern soul as well as James Brown's daunting funk. In this the most egregious offenders were Williams and Goldstein (a onetime Congress of Racial Equality activist who did a pained, impassioned MLK piece for the *Voice* in 1966), although Willis's early *Aretha in Paris* column is one of her flattest, and except for one Stevie Wonder piece she never made up for it. I tried harder and got somewhere, but not far enough. The Wilson Pickett piece mixed sympathy and savvy, and the blues column I wrote for *Esquire* regurgitated enough listening and reading to put Harold Hayes off his feed. But convinced though I was that rock criticism ignored African-American music at its historically established peril, it was years before a weekly *Newsday* column plus an exhaustive Al Green feature put me at my ease around black pop.

I've omitted Marcus from this overview because he wasn't in the New York conversation. In 1969, however, would come his overlooked first book. *Rock and Roll Will Stand* is a collection featuring Bay Area writers that Marcus conceived, edited, and keynoted. His four pieces— including a waggish reprint called "The Legend of Blind Steamer Trunk" that you can tell was written by the same guy who'd later invent the Masked Marauders and ask Dylan's *Self-Portrait* "What is this

shit?"—presage what is to come. The prose is as assured as Willis's, and flows better. He's aggressive about the aesthetic stature of '50s rock and roll and, recapitulating the "Don't trust anyone over thirty" sloganeering of the Free Speech Movement, surprisingly ideological about the uniqueness of the generation that grew up on it. He writes as a radical who's come to despise the one-dimensionality of the "message song." He's ignorant about Tin Pan Alley as all of us were. And although his descriptive chops need work, he insists on honoring the primacy of rock and roll as *music*. At twenty-three, he's eighty percent of the way to proving himself a sui generis cultural critic.

Maybe Ellen was right to worry *The New Yorker* would cramp her style, or maybe rock criticism just cramped her status. Either way, it wasn't in the groundbreaking Rock, Etc. that she advanced her own standing as a sui generis cultural critic. Her convention piece "Learning from Chicago" was assigned by *New American Review*, which paid our hotel bill while we checked in with Gardner at the *Ramparts*-sponsored *Wall Poster* and jogged hither and yon whiffing wisps of tear gas in Lincoln Park. It spoke up for GIs, insisted that cops were "not by definition vicious subhumans," mocked the "insurrectionary myth" in which macho adventurists claimed "the people" would outkill said subhumans ten to one, argued that America was more like a vacuum cleaner than a gun, and—crucially—dismissed the new left's burgeoning revolutionary fantasies. It praised Dick Gregory, challenged Tom Hayden, dissed Mark Rudd, and concluded: "The next step is for radicals in significant numbers to break out of their ghettos and go live in America." Some nine months later, the two-thousand-word "Consumerism and Women" was ground out free overnight for a women's liberation conference, transforming ideas Ellen had pondered for years into feminist theory: buying things is labor, buying things is fun, and owning things

is better than not owning them in a culture that denies women solider satisfactions, particularly sexual autonomy and meaningful work. Since many of its points applied equally to men, it helped crystallize the Consumer Guide, just as "Learning from Chicago" inspired the July Rock & Roll & I called "Rock 'n' Revolution," where I spent a whole damn week building a musical frame for the sentence "All revolutions are unpleasant, but the ones you lose are really for shit."

As 1969 sturmed and dranged, leftists were no longer saying this out loud. Even Ellen, surrounded by less hardheaded sisters and fascinated by the possibility that sexism was the fundamental oppression, was keeping her own counsel. But I didn't fully identify as a leftist anyway, not quite, and the march of political events I experienced personally demanded a personal political response. The counter-inaugural where Shulie was booed by left-wing yahoos and Ellen called Dave Dellinger a schmuck at the top of her lungs. The coffeehouse idea jelling so that by March I was asking Colorado Springs's pacifist materfamilias to pin down a rental near Fort Collins. The Redstockings abortion speakout at Washington Square Church. The piece of yellow legal paper on which I printed the coordinates of some fifteen abortion providers—sometimes just a name and a town. Reading about Stonewall in the *Voice* and agreeing immediately that we'd never thought about homosexuality that way and that had been stupid hadn't it. Listening for once as Tom Smucker and his friend Miles Mogulescu tried to recalibrate their politics after PL played the moderates at an SDS plenum where Dylan fans the Weathermen promoted full-bore terrorist violence. Tagging along to a meeting of the Mailer-Breslin 51st State campaign at Gloria Steinem's, where Ellen helped power a Dump Mailer caucus and snapped "Don't call me nigger" at a black pol who called her a girl. Economics PhD Tony Fisher emerging very much alive from a tank battle about rent control with Ellen and me in Bruce and Nancy Lee's living room. A movement guy asking fellow dinner guest Ellen what she was "into in

women's liberation," and Ellen answering that she was into being pissed off at men who didn't clear the table. Explaining to a woman named Marianne Partridge, in from L.A. with her new husband, Larry Dietz, why Ellen and I didn't believe in marriage. Flying to see Elvis in Vegas in Kirk Kerkorian's jet and getting the nice RCA publicist to route us back through Denver so we could confer with a couple who were help-ing Gardner prep our coffeehouse.

Elvis in Vegas was educational musically too—Ellen raved for her stipend, me for my forty bucks. But 1969's big musical event was Woodstock, which put the quietus on what remained of the "Rock Is Dead" meme even though music per se had not much to do with it, as was noted in both Ellen's coolly unhornswoggled "Cultural Revo-lution Saved from Drowning" for *The New Yorker* and Tom Smucker's sharp, soulful, hilarious, unliterary "The Politics of Rock: Movement Vs. Groovement" for *Fusion*. Ellen and I rode to Bethel in Dominic Sicilia's convertible. Once at the site we never found Greil, who'd spent Thursday night with us before going backstage for *Rolling Stone*, or Bruce and Nan, who we were supposed to meet in a press area that turned into a field hospital. But we did bump into Bob Brow-er's friend Josh Brackett, who invited us to sleep in his and Babette's big leakproof tent, share their steak, and dandle their boy Nathan, who would edit me at *Rolling Stone* thirty years later. We skipped Joan Baez, Richie Havens, and Dominic's boy Bert Sommer as Fri-day's rains crashed down, then spent Saturday goofing around like everyone else. We smoked a lot of dope. We swam naked and fucked in the woods. We even found a patch of mud as a somebody or two—Janis? Sly? Ten Years After? no idea—did their underamplified thing a quarter mile away.

Woodstock ended August 18. Ellen left early because she was on deadline, missing Hendrix's "Star Spangled Banner," which I'm not sure I remember myself, although I guarantee he was better than in

Monterey. Two weeks later Ellen was living in America—in Colorado, setting up the Home Front coffeehouse as I reported on documentarians Leacock-Pennebaker of *Monterey Pop* fame for the inaugural issue of a movie magazine called *Show*. For this story I got the reporter's dream, and also the documentarian's: unlimited access. I even interviewed Pennebaker's sometime collaborator Norman Mailer, who was so impressed I was done in my promised ten minutes he told me to come back anytime, which I never did. Then suddenly it transpired that Leacock-Pennebaker would shoot the Toronto Rock and Roll Revival the next weekend. On the bill, among others, were Chuck Berry, Jerry Lee Lewis, a gimpy Gene Vincent, an unknown Alice Cooper, the Doors, and—a last-minute addition—the Plastic Ono Band. I flew up September 12, bunking with my ex-girlfriend Shoss, who stationed herself just across the press fence from me for a long, hot, exciting Saturday of music.

We'd never had sex, our relationship was by then firmly platonic, and she had a serious out-of-town boyfriend. I'd slept in her apartment Friday night without incident. She wasn't even a rock fan. But it had been an exhilarating day, and when we got home at four in the morning, in a moment I recall as totally unpremeditated, we fell on each other. Only then, on a second irresistible impulse, I pulled back. In Ellen's absence I'd been having scared feelings about the coffeehouse, about the strength of my political commitment. But I remembered that we'd made a promise, and for the first time I felt as if I'd fully internalized that promise—I really didn't want to sleep with anyone else. Regretfully and apologetically, I told Shoss we had to stop. It was an epiphany.

Back in New York I finished my reporting, dealt with Ellen's cartons, located her guitar tablature books, sublet 608 to a young woman so pretty I could remember eyeing her with Lenny Lipton four years before, watched the Miracle Mets overtake the Cubs, packed our re-

cords for transport, and flew to Martha's Vineyard, where I spent a good fifteen minutes with Gardner's close personal friend Lillian Hellman before driving back to New York in the used Peugeot she'd donated to the coffeehouse. It took a while before the radio was fixed, but at three p.m. one week after Toronto I began a nonstop drive that got me to Colorado Springs forty hours later. And there I remained for a total of six days.

I rolled in Monday morning, got into bed with Ellen, fucked her gratefully, and took my rest. But by Tuesday it was clear something was wrong. Ellen had a serious crush on the cute, blond, draft-resisting, twenty-four-year-old son of the aforementioned materfamilias, and intended to sleep with him as soon as possible. Her monogamy-smashing plan was that I'd share her with Steve in proportions to be determined on an ad hoc basis that didn't favor me. My mother-of-my-unborn-children plan was no way Jose even if the split was fifty-fifty, or ninety-ten. Then there was another new thing Ellen wanted to try—LSD, which we'd never gone near, although Ellen, whose utopian tendencies came equipped with an explicitly religious component, had long been interested. With nothing to lose but the rest of my mind, I grasped at this straw. I'd prove how flexible I was, and maybe she'd see the light. So on Wednesday me, Ellen, and swear to God Steve dropped our tabs and drove into the mountains with a likable if somewhat fatuous young activist named Becca. Well up a trail that followed a stream, Becca sweetly instructed each of us to bring her something beautiful. Steve couldn't find anything he thought suitable. I eyeballed the stream until I spied a man-made object—a piece of cellophane, perfect. Ellen tried to cup the rushing water in her hands and carry it to our guide, but each time the crystal-clear, life-giving elixir slipped between her fingers. I found this image tremendously endearing. But I also found it devastating.

I couldn't stand to go back to 308 East 8th, so Larry and Marianne

offered to put me up in L.A., and Sunday morning the boyfriend of a friend drove the seventy miles down from Denver and then took me back to the airport. The '60s were like that, and they weren't over—not till McGovern got whipped is my theory. But they sure had a big hole in them.

8

AFTERMATH

Nuts to the educational value of suffering. Like the tragic sense of life, it's a story the overseers tell to keep unruly seekers on their prescribed path and stop the unlucky from realizing that that wasn't luck at all, buster—it was what troublemakers call oppression (or, lately, inequality). I learned a lot in the three years after Ellen. I got a bunch of sexual experience under my belt, which was always interesting, usually enjoyable, and often pretty deep. I lived in Los Angeles for eight months. I launched a teaching sideline. I was politically active in my fashion. I bonded with Greil. I lost Grandpa. I had trouble writing. I got better at writing. But in all this—except maybe for Grandpa, where the hurt was sharp but undercut by how his dementia had shrunk him, and where I was the family member charged with reminding the few graveside mourners how deeply life had moved him—suffering was ancillary at best.

To be clear, I suffered longer than most romantically bereaved. The misery was worst at first, naturally. But its persistence and intensity

beat all the give-it-time estimates I was fed by friends, friends of friends, women likely and unlikely, and strangers caught unawares—hundreds of them, I was blabbing out of control. None of which means suffering was my teacher the way it was, for instance, when I was forced to figure out that if Ellen couldn't sleep with other people neither could I. On paper and in my head, all my arguing with the woman I still in some fashion loved sharpened and in a few crucial matters shaped my thinking, reactively. But I learned more from the good times. Even my writing difficulties were less suffering than the no-pain-no-gain exertions mastering a skill entails. Ellen was a presence for several years and a nagging problem well after that. But I'll keep her out of what follows when I can.

My strongest memory of the six weeks I spent in California is the unconditional kindness of two couples—Larry Dietz and Marianne Partridge in L.A., Greil and Jenny Marcus in Berkeley. Not only did they put me up longer than any houseguest deserves, with both Marianne and Jenny lending me their cars, but all four of them endured my endless wailing, worrying, speculating, theorizing, second-guessing, worrying, and wailing. Thanks too to my brother Doug and his wife, Christine, who hosted a writing week in San Jose so gloomy even the Mets couldn't brighten it, and to Ed and Gilah Hirsch, on whose daybed Ellen and I spent a chaste night while pursuing a delusory reconciliation and an inconclusive interview with Mick Jagger—he was two hours late, we were in outer space, end of story. But Marianne, who hadn't believed my anti-marriage pledge in New York, and Jenny, seven months pregnant and busting to get to the next phase, were so generous. That neither of these strong, smart women identified as feminists didn't make me feel any less feminist myself. But it meant a lot that where Jenny Gardner, at war with her doggish husband, told me that marrying a wife was equivalent to hiring a scab, they sympathized.

My relationship with Greil—then of five months' duration as per the

surviving correspondence, although we both feel like it was longer—had been entirely epistolatory except for his pre-Woodstock stopover, and we had a lot to talk about. Sleeping poorly, I spent many hours at my Olivetti portable in Greil's kitchenside office with the little Jeanne Moreau pic on the wall; grinding toward an American studies PhD as he worked for *Rolling Stone*, Greil was often out or occupied. We played a lot of three-handed hearts, and Jenny and I played cards with each other too. But all October Greil and I talked, incessantly it sometimes seemed, about anything that came to mind including our very different personal histories, and listened to music too. Although most rock critics had politics, few conceived their criticism as bound up in those politics, so with Ellen gone and Dave Marsh still unknown to us, Greil had become my comrade-in-words. His American studies specialty was an affinity not even Ellen shared, as were the meatier particularities of his prose. So for many years we talked like that—on the phone to supplement our letters, in person when the travel worked out. A few times in the '80s, we went so far as to meet at JFK during layovers between California and Europe, two couples forming what Chuck Berry once called a cozy clan of four.

Throughout my disconsolate if enlarging little exile, I kept writing. First week in L.A. I sweated out a shrewd, iconoclastic little piece for the *Times* that I call "Barbra Streisand, Featuring Mary Hopkin"—easily the kindest and sharpest thing any rock critic had yet published about pre-rock pop, and the best early articulation of my "Dylan"-fueled belief that in rock, self-expression is a "conceit." Then I was on the eight-thousand-word behemoth *Show* squeezed into its debut issue as "Leacock Pennebaker: The MGM of the Underground?" I don't know how I did it—especially since, in the last half of October alone, I also wrote Ellen some twenty thousand words of reason, entreaty, and vituperation. Nor do I know how *Show* editor Dick Adler tolerated my wailing, worrying, and so forth. It's my most accomplished magazine

feature, droll throughout and spiced with fiduciary detail and tech-specs jargon. Its artistic protagonists were colorful, and prominent too. But it's not a celebrity profile—it's a report on art as a job. And like "The Supreme Achievement of the Second Industrial Revolution," it's a stab at a new journalism of everyday life—as it turned out, the only kind I really wanted to write.

Soon I was pecking away at a piece of the personal journalism for which the *Voice* was notorious. With half an exception for Landau, early rock criticism was fannish as a matter of principle, excited and informal; even Greil dotted his critiques with stuff friends had said. So I'm proud that when Ellen wanted to illustrate the critical first person to the prospective arts journalists she taught at NYU for the last fifteen years of her life, she featured my "In Memory of the Dave Clark Five," which chronicled our breakup in terms of the songs I'd been hearing on AM radio and ended with me replacing "Let's Spend the Night To-gether" with "You Can't Always Get What You Want" on the 308 juke-box. Unfortunately, a last-minute futon ad necessitated the deletion of the part where I hit it off with an exceptionally kind woman named Sue in Detroit. But at least it wasn't cut from the bottom, daily-style, leaving room for the part where I drove with Sue and her Commie friends to the November 15 Moratorium in DC. There I whiffed some more tear gas and ran into Tom Smucker chanting, "Chuck, Chuck, Chuck Berry / Stop the trial / Free Jerry."

Altamont came down December 6, shortly after I returned to New York. Distraught yet oddly calm after interviewing the family of Mer-edith Hunter, the young African-American murdered by Hells Angels "security" at the Rolling Stones' satanically unmajestic Woodstock fol-low-up, Greil called me while I was listening to "Gimme Shelter" with a sister who was right then just a kiss away—the gorgeous subletter who'd

tossed my piece of Hendrix's guitar, actually, so maybe I should have taken Greil's intervention as a warning. He had been under the gun the previous summer—also bayonets, and gas far worse than anything I was ever hit with—in the underreported paramilitary sweep around People's Park in Berkeley, the proximate inspiration for my "Rock 'n' Revolution" column. Greil would end up co-writing a rather radical book on Altamont that Jann Wenner would end up not publishing. The debacle shook him up in a more than metaphorical way. I didn't play the Stones for a year myself.

Nevertheless, the '60s hadn't ended. For many, in fact, the early '70s were when the '60s came true. Ellen lived in a commune, tripped a lot, and organized GIs as best she could. Prodded by Nancy Lee, Bruce Ennis quit his Wall Street job to head the NYCLU's Mental Patients' Rights Project and eventually became chief counsel at the ACLU. Tom Smucker and his girlfriend Laura Kogel emigrated to Queens, where he and his Astoria Collective hoped to organize their working-class neighbors by getting working-class jobs, which is how it came to pass that Tom retired from the phone company after thirty years of union activism in 2002. Consigned to Taylor in Indiana to protect her faith, Georgia was smoking pot and hooking up with an unsaved cartoonist who'd end up at *Creem* and the *Voice*. And via the May student strike at NYU, where she was pursuing an MA in American studies, the girl that I'd marry discovered the women's movement and hippiedom in close succession.

To put my political commitments into practice after abandoning the Home Front, and also to meet girls, I checked out the Alternate U, an attempt by Stanley Aronowitz and others to resurrect the Free University idea without PL's mitts on it. Sadly, the main thing I achieved there was to firm up my unflattering view of rank-and-file radicals. Both of my "classes" were really meetings, discussion groups with a program: Ecology Action East, led in principle by absentee anarchist Murray

Bookchin, and the Rock and Revolution Workshop, led in practice by a suburban jerk with bad skin who talked about the pigs a lot. Attracted to ecology because it was so limit-conscious, hence anti-utopian, I favored recycling but opposed the equally novel bottled water and kept my own counsel about the leadership's benignly impossible revolutionary projections; I was detained briefly at our anti-Earth Day demo and once chaired a meeting where I was accused of power-tripping for trying to wangle shy foot soldiers speaking time. Rock and Revolution-wise, my piddle of fame aroused both suspicion and dreams of glory; my chief memories are a fraternal set-to with the Young Lords, the first time I laid eyes on Pablo Guzman, and circling the track at a Randall's Island rock festival our group had horned in on with a memorably bland and idea-free teenager named Leslie Bacon. Eight months later, her face was on the front page of the *Los Angeles Times*. "Holy cow," I thought, "*that girl bombed the Capitol?*" Only she hadn't—some informant had set the poor sucker up.

I did get to know two other women at the Alternate U, neither of whom came close to matching my Detroit discovery Sue, a red-diaper baby of unmistakable goodness and the most lovable rank-and-file radical it was ever my luck to meet. After she was done harvesting sugarcane with the Venceremos Brigade, we had so much fun together we decided she'd relocate to New York and move in with me. But intellectually we weren't a match, and after she left I got real and admitted to myself that it couldn't work. I was setting this fine woman up for a fall. So I did the right thing M. hadn't done for me—dialed Detroit and delivered my bad news by telephone. It hurt Sue plenty. I still feel guilty about it sometimes.

The Alternate U was as close as I ever got to activism, and followed my usual anti-bohemian bohemian pattern, which would recur in both of my forthcoming teaching jobs and for that matter at the *Voice* and for that matter on the parents' committee of the progressive public

school my daughter attended in the '90s: always left-identified, always the true unbeliever, and with a mouth on him too. I was somewhat to the left of Bob Stanley and Basil Condos, who'd soon be working for Adlai Stevenson III, but not of Greil Marcus or George Szanto, a community antiwar organizer as of 1967 whose teaching job at UC San Diego made him a colleague-in-arms of Herbert Marcuse himself. By then politics were everywhere in the world I inhabited, even my family. With my father teaching shop as a guidance-counselor-in-waiting after eking out a master's and my mother established as one of those school secretaries who runs the joint, my parents had upscaled their empty nest to a much prettier original-owner-designed house near the Nassau border in Douglaston and soon joined their new socioeconomic cohort in deciding the war was a bad idea. And my sister was spurred by a visiting alumnus at Taylor's required thrice-weekly chapel to cover the DC Kent State protest for the school paper. I hitchhiked there myself with Bob Brower's ex-Christian ex-girlfriend. Ellen's closest cousin, wife of a slick *Washington Post* reporter, put us up. For the cause—millions thought that way.

I was still tight with Gardner, who floated the idea of a Fort Riley coffeehouse that came to nothing. Then one warm late-spring morning he invited me to breakfast at Ratner's, and when I arrived was sitting beside a pretty, slender brunette with a generous mouth and the kind of hair you want to put your face in. She seemed to be glowing slightly, which you could say was because she was coming down off a sleepless night of mescaline and sex just after she split with her husband, but I say was because for me she just naturally glowed. After arguing with Fred about Carl Oglesby's stolid album I argued with her about Godard's verkakte Dziga Vertov collective. She thought I was obnoxious; I thought she was really something, feisty and intense and very cute. A week or two later I admired her from a discreet distance at an alternative journalism conference at Goddard where two couples critiqued

our powwow by fucking on the floor of the plenum, and I was even more impressed a little after that when Fred left his four-year-old with her so he could go testify in Washington. Then one morning he asked me to meet him at the Village View co-op on First Avenue, where he was staying with his aunt. "You like that woman Carola, right?" he said. Sure do. "Well, here's her phone number. I have a new girlfriend." I swear he was half-smirking. "Jane Fonda." Wow. I was so impressed I forgot to tell him to watch out for his buddy Hayden.

I dialed AL 4-4578 three-four-five times, but Carola Amir was never home. She attended a lot of meetings in those days. And then in late July I was sitting in the sand on Cape Cod, where Judy Pritchett nee Rosenberg and her huggable young son Slim had a rented house with some friends. Down the strand strode Fred Gardner. "Christgau!" he exclaimed. "How's Carola?" Looking up, the woman across the blanket did some exclaiming herself. "You know Carola!?" It was Carola's oldest friend, Dominique. Obviously we were meant for each other.

Dominique is an unusual name if you're not French, although I've known two quite well. Carola—pronounced the pretty way, as in "Carola the barrel-a," which is what mean PS 41 kids used to call her as a chubby child—is a more unusual name. So Dominique was right to assume a connection, and it wasn't our only one. Never in the same city and half the time three thousand miles apart, Dominique and I were an item for a year and a half. But as it turned out she was just keeping me warm for Carola. It took time, and thought, and experience, and suffering too. But reader, I married her.

In the preliminary matter of convincing Carola I wasn't obnoxious, it helped that I'd fallen for Dominique, a rather beautiful New Haven elementary school teacher just weeks past a painful marriage with a left-wing lawyer who kicked her out because he wanted his freedom.

Although Dominique grew up in the Village and came of progressive stock—her maternal grandfather was both a Weimar minister and the first Jewish public official executed by the Nazis, her divorced working mother a trained attorney turned hotel housekeeper turned hotel housekeepers' union leader—she was the straightest girlfriend I ever had. For her my anti-bohemian bohemianism was a good match. So was the way I rolled down the hill with Slim Pritchett, and the pleasure I took in losing a card game she taught me. The one hitch was that with me in place her husband underwent a mysterious change of heart, and Dominique felt she owed him another chance. But first we spent two weeks driving cross-country to L.A., where I was about to start a job at the Disney-funded California Institute of the Arts. And before that we hooked up when we could in Manhattan—including a visit to Carola's big rent-controlled find of a brownstone walk-up south of Gramercy Park.

Here's how Carola described that meeting in a contribution—unfortunately but unsurprisingly unfinished and unpublished—to the festschrift I was presented for my sixtieth birthday: "Jesus! Affectionate!? You had to pry him off her. Also, he agreed with me about Dreiser. I didn't know then how short life is, or I would have said life is too short to spend a minute with anyone who doesn't agree with me about Dreiser." Thank you, o plodding womanizer of the Wabash! All set to fend off another dis, the ideal woman on my back burner found instead that I admired this perpetually declasse writer for the same reasons she did. What neither of us remembers is when or whether I retrieved the albums I'd left at her place the day Fred handed off his four-year-old. They were for Fred too, of course, and Carola tells me he went and bought them all: *Jesse Winchester, Tracy Nelson Country, Joy of Cooking,* Randy Newman's *12 Songs.* But Fred, being Fred, had moved on. So they ended up with Carola, who played them over and over on her suitcase stereo.

Dominique and I drove to L.A. with LPs lining the entire rear of the brand-new Toyota Corona Mark II hatchback I'd bought for cash after my parents gave each of the three grandchildren three thousand dollars of Tommy's savings in what I assume was some sort of divestment strategy. Second day we visited the Baseball Hall of Fame, shared a joint, and took arbitrary lefts and rights through upstate New York in the general direction of Shoss's family reunion in Ontario, radio blasting our theme song, the giddy Mungo Jerry fluke "In the Summertime." The war was raging, the movement was in pieces, and we were both pretty damaged ourselves, although I concealed it worse—the night we stopped in Colorado I broke down and cried. It was the summertime, rendered both giddier and more intense by its expiration date. Yet as we'd swooped under an overpass on the Major Deegan I'd had the spooky false premonition that this romance would cut me off from Carola forever, and although the romance had deepened markedly by the end of the trip, when we visited Carola's ex-sister-in-law Jane in Claremont, California, Carola herself hadn't left my mind. In Claremont I also met the other Dominique, who was six, and her seven-year-old brother Julian. Their father, Carola's brother Adam, was gone and good riddance. Dominique the elder knew too much about him—his sexual problems were more than hang-ups, and that wasn't all. Uh-oh, the part of my mind that was still on Carola told me. I loved the kids, who were beautiful and bright and full of fun, and liked their exuberantly offbeat actress-schoolteacher mom. But even so—uh-oh.

I'd landed my Cal Arts job via Marianne Partridge, who then worked at what was derisively nicknamed Disney Tech and in her friendly way was friendly with both avant-garde theater honcho Herbert Blau, the provost, and countercultural Brandeis sociology honcho Maury Stein, charged with bringing his theory of "random life process" to the School of Critical Studies. Marianne—a direct,

unpretentious, good-humored, efficient woman with no visible hustler in her—had pointed out that Disney Tech could use a pop culture guy, and so I found myself the true unbeliever among both my Critical Studies colleagues, most of them grad students imported wholesale from Brandeis, and such hyper-avantists as video art icon Nam June Paik and Fluxus "intermedia" prophet Dick Higgins (whose Something Else Press had published Meltzer's *The Aesthetics of Rock*). Almost immediately Stein's militantly unstructured program came under attack from Blau and Cal Arts president Robert Corrigan, who himself would be accused of sins against structure and replaced by a Disney in-law in 1972, and soon Stein's cohort was mounting protests I bet counted as random-life-process classwork, with me tagging loyally along. By January Stein was fired, and shortly thereafter I was informed that I would not be renewed. Back in New York, Bob Brower's ex-Christian ex-girlfriend landed me a similar 1971–72 job at CUNY's Richmond College in Staten Island.

It wasn't that I saw academia as a career. It was that I saw Cal Arts as an interesting job at an interesting place when I was still clocking forty bucks a column (which did eventually rise to sixty, thanks a lot Dan). And I also saw it as a chance to sample a city that had always fascinated the urbanist in me. Although I was often sad in L.A.—a provisional romance with a colleague expired when her Brandeis boyfriend rejoined her in March—I loved living there. I loved the sun, the freeways, the supermarkets, the skinny-dipping in the campus pool, weekending with my friends in Berkeley and Del Mar. Luckily for me, construction on the futuristic campus further north was far behind schedule, so first-year classes were held at a defunct Catholic girls' school in Burbank, and I rented the roomy second story of a backyard add-on in North Hollywood. Coming from Avenue B, I found this big cheap bright suburban space miraculously commodious, but for all Cal Arts' talk of "community," few other faculty members resided in

the San Fernando Valley—that is, near campus. My class in popular culture and rock history ran all Tuesday night in my living room, car service provided, and required every student to prepare dinner for the group once a term.

I taught Paul Williams's *Outlaw Blues*, Nik Cohn's *Rock from the Beginning*, and Peter Guralnick's *Feels Like Going Home*; Charles Keil on Chicago blues and Bill C. Malone on country music; "Ahab and Nemesis," Tom Wolfe, and S. J. Perelman; and two solid introductory weeks on Richard Schickel's *The Disney Version*—all, as my star student put it, "counterintuitive" for '60s babies in search of the artier-than-thou. I preached my theory of pop, led a writing workshop, and helmed a science fiction seminar taught by students and guests. A stickler by random-life-process standards, I was a hippie by Dartmouth's, demanding too little of myself and my students. But it was the post-'60s, and by the end I'd touched quite a few. I got to know the two children of Atlantic Records genius and Cal Arts board member Jerry Wexler, especially his doomed daughter Anita, who would die of AIDS after a long heroin addiction. I mentored one journalist who'd date my sister and another who'd pump the Sex Pistols and another who'd cover rock for the gay press till AIDS killed him in 2008. And I initiated a long friendship with nineteen-year-old Bennington transfer student Sean Daniel, who'd soon shepherd *Coal Miner's Daughter* and *Animal House* through Hollywood and serve five years as president of Universal Pictures.

At the end of the year Sean and I raced back to New York in a Toyota top-heavy with the LPs we'd loaded into one of those rooftop pods U-Haul no longer rents out. For fifty-three hours including a blown tire in West Virginia, we gabbed and speeded and turned the radio up and slept shotgun. One pitch-dark four a.m. there was a close call. Unable to keep my eyes open, I gave Sean a nudge. Groaning, he shook me off. So I mounted an argument. "Sean, we're in Wentzville,

Missouri—the home of Berry Park, Sean. Chuck Berry's amusement park." Touched by magic, Sean took the wheel and we were off.

One thing I concluded about Los Angeles was that beyond Cal Arts there weren't enough smart women there. And one thing I concluded about teaching college was not to feel intimidated by anybody's degree. Having walked in at Cal Arts and later Richmond expecting my colleagues to outgun me intellectually, I found that even when the IQ was high, which wasn't a lock, the purview was so narrow I'd learn more from my students. Of course there were exceptions, such as art critic Max Kozloff at Cal Arts. But although over the years I'd have many friends in academia and admire many writers there, I'd always find Grub Street more stimulating. And explaining how that worked for me will require a bit of backtracking.

In L.A., I knew lots of label people and saw lots of shows, but my journalistic contacts were Dietz's friends rather than the local rock writers, few of whom I connected with. In the Manhattan I'd just left, however, a growing community of critics often got me thinking whether we were friends or not—I had no designs on the circle that gathered around Lisa Robinson, for instance, but I learned plenty from Lillian Roxon and Lenny Kaye. Like so many quality twentieth-century journalists, the rock critics I mixed with were as intelligent as all but a few of the academics I met and far more likely to keep their ears in the air and their feet on the ground. And by 1970 the billion-dollar business was throwing money at this cohort, adding catered food and free alcohol to the cannabis we walked in with at press parties overseen by hirsute publicists dubbed company freaks. It was at a Lincoln Center affair for pop-soul tunemongers the 5th Dimension that I blurted out the most effective self-promotion of my life on several glasses of champagne. Someone asked who I was, I quipped

"I'm the Dean of American Rock Critics," everyone laughed, and thus it became so.

I swear the dean thing was a joke—a year later at Cal Arts, where Maury Stein's deanship was a political issue, my class provided all takers with silk-screened T-shirts bearing a likeness of Little Richard and the legend "Dean/School of Rock & Roll." But it had its measure of truth. By 1970, just three years after I'd started at *Esquire*, there'd been so many dropouts that my seniority was a simple fact. So were my letter grades, and such prose as: "Of course, each band that succeeded with this formula had its own concept, an identifying characteristic that distinguished it from the others. Iron Butterfly was very slow and Ten Years After was very fast. Jeff Beck capitalized on distortion and Santana on Latino rhythms." I'm fine with those sentences—they're clear, unpretentious, and insightful as far as they go. I still write like that when need be. But not only are they Latinate and schematic, which to most journalists and readers equals academic, they're very theory-of-pop. They appeared in a February 1970 Delaney & Bonnie column that's not bad at all by the standards of the time and not much good by mine.

Given my tendency to squander energy on unsent letters to Ellen, I was no longer cramming anything out overnight. I never got to page two of the plum *Jules and Jim* essay *Show* assigned; *Esquire* turned down an ecology pitch, proposing instead a ten-thousand-worder about me and Ellen that Ellen, understandably, vetoed. Two Rock & Roll &s that I did finish covered perversely rock-critical topics—the lowdown on the Masked Marauders, the fictional supergroup Greil invented that sold ninety thousand factual albums for Warner Bros., and a painfully composed, casual-looking trifle on Meltzer that ended: "It has always seemed to me that Meltzer should end his pieces in the middle." In another column, an uncharacteristically gracious Miles Davis tried to explain modality to me and I responded by failing to explain *In a Silent Way* to anyone else.

But the worst writing I did in that period was in other respects the most successful: the Consumer Guide. Readers and bizzers lapped the concept up—at one point *Rolling Stone,* where I'd already exchanged some harsh words with Jann Wenner, offered my agent two hundred a pop for it—and I can understand why. Living alone, I was free to spin review albums ten or twelve hours a day, a breadth of listening experience I've been maximizing ever since. My opinions were informed, my ears were opening fast, and I was finding records few others noticed. I wasn't big on that great distorting fallacy of journalistic criticism, Getting There First, but it happened anyway, and not just because I gave "commercial" and "soul" albums equal time with "underground" "rock"—which enabled me, with a crucial push from a Bayside-based critic named Aaron Fuchs, to "discover" Al Green. But although I told Greil I regarded the CG as "a service feature, as far from criticism-for-criticism's-sake as could be," how serviceable was it? It mattered to award Van Morrison's *Moondance* an A at a moment when *Astral Weeks* was still an overrated critics' secret. But "brilliant, catchy, poetic, and completely successful" is woefully unspecific by standards I'd soon impose on myself and others.

Take as an example the Insect Trust's great lost *Hoboken Saturday Night,* featuring both critic Robert Palmer and future a&r cynosure Nancy Jeffries. As I put it in liner notes for a 2004 reissue: "Anyone who wonders what the hippie '60s were like—or could be like, with the arrant nonsense and obsessive backbiting avoided or suppressed—can find out from this true collective." That record was my baby, and knowing I had to make a case in the May 1970 Consumer Guide where I first reviewed it, I equipped my A with details: "Easily the most charming and inventive record of the year. Jazz-based, well-sung and well-played, full of experiments that work. Best use of horns in a rock band. Wonderful songs. Joyous." Yet that still says too little too generally. Among the hundreds of early-'70s reviews I revamped in 1980 for my first Consumer Guide book was this one: "Thomas Pynchon, Louis 'Moondog'

Hardin, and an unidentified child (who else would say 'busketty' for 'spaghetti'?) are among the guest composers, Elvin Jones and an unidentified child among the guest musicians. Former president James Garfield makes a cameo appearance. Vocalist Nancy Jeffries applies her tobacco voice to a feminist lyric called 'Trip on Me' that I recommend to Janis Joplin. The blues scholars in the group have been listening to a lot of Arabic and Eastern European music lately, but this doesn't stop Elvin Jones from sounding just like Elvin Jones. In short, these passionate humanists also sound friendly and have come up with a charming, joyous, irrepressibly experimental record. And every experiment works." That's more like it.

The big event of 1970 in New York's evolving rock critic community was the Velvets' summer residence at Max's Kansas City, plotted by Harvard Law dropout, fanmag editor, Warhol scenester, and company freak Danny Fields—angel of the Stooges and the MC5, prophet of the Ramones. Besotted with the quiet and commercially undetectable 1969 *The Velvet Underground* (as was Ellen with no tip from me), I dropped in at Max's three or four times, and others were true regulars, dancing and decadancing and seeding a genuine New York rock scene whose theme song would be "Sweet Jane." My buddies on this scene, however, weren't the Fields-Robinson inner circle but future disco savant Vince Aletti and Karin Berg, a onetime Congress of Racial Equality employee then transitioning through journalism to sign to Elektra and then Warners the Dictators, Television, the Cars, Dire Straits, Laurie Anderson, Hüsker Dü, and the list goes on. Born in 1936 and the rare jazz fan of her generation who genuinely loved all kinds of pop, Karin was quite an insightful person to listen to records with. Although I was still too anti-folkie to hear what a master her man John Prine was, she did lead me to a plainspoken, long-forgotten feminist gem, 1971's

Helen Reddy, after Reddy first recorded "I Am Woman" and before her husband schlocked it up into an AM anthem.

But my chief consultant remained Greil Marcus, who packed his letters with thousands of words about a "vocation"—a term whose combination of job and calling I never forgot—neither of us yet had a handle on. From the beginning of our correspondence Greil was militantly San Franciscan, distrustful of L.A. and explicitly antagonistic toward "the other side of the continent": "I feel like it is out to get me and the things that I love, and also that I am out to get it." American studies guy that he was, he connected the outlaw themes of American rock to the freedom-denied of Frederick Jackson Turner's frontier thesis (example: *Workingman's Dead*), and in mid-1970 he got down to cases: "Well look. What I write about is America. Sounds pompous, but I mean it, and like I said in the Dylan review, we are condemned to be Americans." And by late 1971 he'd taken that further: "Anyway what rock and roll needs is rock and roll theory integrated into a theory(ies) of American culture and the relationship of community and politics in America."

Greil's radicalism was a given even if his willingness to write about it wasn't. There were no conservative or even centrist-liberal rock critics back then, although Wenner—who by 2000 would turn *Rolling Stone* into the most left-inclined mass-circulation magazine in the United States, financing no-holds-barred investigative journalism with hidebound music coverage—did what he could to derail the Chicago mobilization. Figuring out where to write, however, was a challenge for Greil, especially with academia's constrictions chafing him from the other side. Having shepherded Lester Bangs into a prominence Wenner soon squelched and tried mightily to get a politically preoccupied Tom Smucker to write for *Rolling Stone*, Greil hung in there well after he'd passed the review section to an overmatched Ed Ward, who was soon succeeded by Landau, whose promotion of Andrew Sarris's genius-hawking auteur theory Greil considered a last resort—a desper-

ate embrace of what he called the "one body of pop culture theory that is not anti-pop culture." But he didn't much like Goldstein's *US*, which was soon gone anyway, and detested the Boston-based *Fusion*, where I eventually became movie critic—not least because it seemed under the sway of Meltzer, whose intelligence Greil was too intelligent to deny but who drove him up a tree ("no unperverse emotional content," he charged, which was so true it was the point). But as early as May 1970 Greil was also bemoaning the "RS-Jann antipathy toward what you and I would understand as criticism in favor of celebrity mongering and description." And then, during my Cal Arts year, he made contact with the Detroit-based upstart *Creem*, where twenty-year-old dynamo Dave Marsh would prove the most politically committed of all the major early rock critics.

Since Ellen and I never wrote our book, our "body of pop culture theory" was never formalized or finalized, but just as it pokes through Ellen's *New Yorker* columns, it rises to the surface of my *Voice* columns, my unpublished 1969 death-of-rock piece, my unpublished mass culture theory chapter, and also my correspondence with Greil, ridden with first-draft overstatement and infelicity though it was on both sides (and reproduced here with obvious typos corrected). I responded to his West Coast flag-waving by propounding a Pop-in-the-Warhol-sense challenge to the religion of art and "the corny humanists who soak up the sun out in the Golden West."

For me this challenge inhered most of all in the organic irony and conceptual acuity that coexisted with shows of expression and bedrock musical pleasure in the Beatles-Stones-Dylan triumvirate and their lessers. Exhibit A at the time was the Flying Burrito Brothers' *The Gilded Palace of Sin*, which Ellen and I loved and Greil considered an L.A.-concocted "musical press release": wealthy Georgia-raised Harvard dropout Gram Parsons channeling his pain, compassion, dislocation, and junkie cynicism into the country music he'd grown up

disdaining, topped off by ex-Byrd Chris Hillman's political sick joke "Hippie Boy." But in the same letter I insisted: "I am also very sensitive to the idea that ordinary people have a right to art, probably the most important right (definitely the most important right), but I also think . . . there is no reason why this kind of humanism can't be reconciled with the most abstract New York pop."

In my conception, the pop artist who nailed this synthesis was Bob Stanley, the ironies of whose simultaneously abstract and representational polarizations were so palpably unsatiric—and so beautiful—that *Sports Illustrated* gave him work. And gradually my sense of the synthesis evolved. I always sought out "concept," Bob's term the way "vocation" was Greil's and often what Ellen's "The Star, the Sound, and the Scene" meant by "sound," and starting from "star" also joined that essay's attack on the New Critical myth of "the integrity of the art object." The weak term in Ellen's formulation was "scene," which she linked vaguely to Swinging London and MGM Records' 1968 "Bosstown Sound" farrago. The word I preferred was "audience"—the pop fans I'd long believed in trusting, critically of course, on the well-established grounds that music large swaths of people liked and you didn't might well have good points you were too bigheaded to hear. In 1950 the pioneering popular culture advocate Gilbert Seldes published a book whose title subsumes its argument: *The Great Audience*. That phrase is attributed to me in Greil's *Mystery Train*, and writing to him about Captain Beefheart, who I admired more skeptically than he did, I turned it sideways: "I insist that love for the audience is essential to the kind of music I think is most important, at least in the beginning and maybe always." As I cogitated, corresponded, listened, and felt sorry for myself, my politics evolved away from Ellen's, and imagining audiences became an m.o. Invisible republics, you could even call them.

Starting with "We Should Be Together," about the crowd at a Jefferson Airplane show just before the May 9 Kent State protest in Wash-

ington, Rock & Roll & began clicking. Of the ten essays I published there between May 1970 and July 1971, eight were keepers: "We Should Be Together" and the equally personal Monterey-revisited audience report "A Musical Weekend"; artist analyses of Beefheart, Creedence, Joy of Cooking, and, why not, Bill Graham; and two think pieces. In a year when feminist broadsides shelled every philosophical underpinning of human civilization, when my muso friend Karin helped turn Jeff Shero's *Rat* into a women's lib weekly, when a feminist intellectual held the rock criticism chair at a major national magazine, my July 1970 "Look at That Stupid Girl" fused nine months of thwarted passion and rumination into the first published feminist analysis of rock and roll, proposing "a sexually integrated music" and concluding: "Maybe the sensibilities of all of us will be extended in ways difficult to imagine and trying to undergo, but deeply pleasurable when we get there. Whenever that is."

Then there was the column I mailed in from California four months later, which put the name of my lifework in the public record. This had begun as another stroke of stoned luck. After a few tokes at a Young Lords party, I was expounding me some theory-of-pop when the phrase "semipopular music" came out of my mouth. I kept thinking about it, and in November put it on paper. With the music picking up fans faster than it was losing them, "Rock Is Obsolescent, but So Are You" attributed "the rock-is-dead movement" to a natural "cycle of ennui and excitement" and a failure of star power that went well beyond the self-inflicted departures of Janis and Jimi. Warily but gratefully, it noted how many albums of quality weren't hits, with special nods to the Flying Burrito Brothers and the Stooges, "whose sole purported attraction, Iggy, continues to possess every star quality except fame." The key? "Semipopular music is music that is appreciated—I use the term advisedly—for having all the earmarks of popular music except one: popularity."

I knew the semipopular wasn't what I'd signed up for, knew it side-stepped the political potential Ellen and I had had the starry-eyed chutzpah to see in rock—its capacity to prefigure and facilitate positive social change whether revolutionary or democratic. But I also knew the semipopular was *pleasurable,* a crucial term of praise that had just entered my arsenal as of "Look at That Stupid Girl." Wary but grateful, I wasn't about to turn that pleasure down. Six months or so later, head-lining the June 1971 *Creem* over Lester Bangs's "Psychotic Reaction and Carburetor Dung," Greil weighed in on similar themes and many more in the eight-thousand-word "Rock-a-Hula Clarified." Impossible to find now, it was the definitive rockcrit manifesto of the early years, discussed by everyone I knew. And although I was supposedly the pure pop guy, it was much warier of the semipopular than I was, instead advocating what it always uppercases as POP.

Greil once told me the best thing about "Rock-a-Hula Clarified" is its title. Aware and indeed proud that it "mattered," a piece of rhetoric he applied to music for many years, he nevertheless regards it now as some-what naive, as how could it not be? But in its naivete inhered much of its power—how wholeheartedly this straight-talking intellectual made common cause with his generation and voiced a defiant political de-spondency that allowed even Weatherman a certain dark attraction. And in its concepts and concerns inhered the crucial themes of his two most renowned books. It begins with the same Little Richard pro-logue as *Mystery Train,* and builds to a long section on the Band, who embody the freedom-in-community and danger-in-community *Mystery Train* strives to comprehend. But it's also where Greil starts exploring "secret" culture, a fixation that went book-length in *Lipstick Traces: A Secret History of the 20th Century.* It turns more than once on the verb "to matter." And it argues that music matters most as "POP."

The POP section of "Rock-a-Hula Clarified" goes on for four para-graphs before segueing into Grand Funk Railroad, whose declasse star-

dom I'd broken down in a feature assigned and rejected by *The New York Times Magazine* and that I later cannibalized for *Newsday*. Topping bold declarative with bold declarative, it's vintage Greil Marcus bravura.

> POP is energy publically organized around art. POP means that no matter how devoted the fan, listening to rock and roll with the solitary solemnity of a man poring over the Dead Sea Scrolls will always lack what may be the most important thing of all: the POP sense of being where the action is. POP is a sense that someone else is missing something, but you're not, and when it really works, it's a sense that someone else is missing something, but *we're* not. That is the spirit that lifted the Fifties rockers into fame, that made the Beatles matter, and like it or not, that makes Grand Funk a bigger draw than any other group in the country.

Thus those who share the POP secret are as exclusive and exclusionary as any art-world coterie. But they're a larger, worthier, and humbler class of people: the generational *we*, Greil's invisible republic of the time. POP stands in contradistinction to "the assimilation of rock and roll into the general mass culture," the inevitable naturalizing process that soon renders any shock of the new "accessible to everyone and not particularly valuable to anyone." About this process Greil is gloomy, limning the limitations of such recent candidates as Grand Funk and the Jackson Five's "I Want You Back"—complimentary though he is about the first and wildly enthusiastic about the second—and guessing that the next time the world goes POP he and his readers will be too old, and too immersed in their separate privacies, to get with it, which turned out to be untrue for him with punk and "Smells Like Teen Spirit" and true with hip-hop, acid house, and the boy-group bubble. Mocking "the Death of Rock," he cites thirty-three mostly low-selling albums of palpable "vitality" and "ambition" from the previous year, including well-remembered milestones like *Moondance*, *Layla*, and *12 Songs*, critical picks like *Joy of Cooking*, *Jesse Winchester*, *Hoboken Sat-*

urday Night, and the Velvet Underground's *Loaded,* and a few LPs I've never heard (the Frut's *Keep On Truckin'?*). These he augments with a dozen-plus singles. But he also explains why all these "good records" can't suffice: "Audience cults structure privacy out of what was once ruled by the thrill of POP, and they maintain rock and roll *as music.* Hopefully, that won't be enough."

At the time, I was down with all of this. In the heyday of singer-songwriterdom's pastoral escapism, with the matched movements of metal and prog a-borning, I shared Greil's tastes, loved how politically explicit he was, and was grateful to know a theorist who could make me think one-on-one the way Ellen had. Moreover, I still rejected any aesthetic of rock that reduced it to mere music, a tendency of Landau's *Rolling Stone* posse. Yet even as he hammered that point home, Greil was too complete a critic and too big a rock and roll fan to dismiss music—far from it. Squirreled away in "Rock-a-Hula Clarified" were some of the most eloquent descriptions of rock and roll *as music* yet published. Soon the "strange out-of-time ensemble shouts," "weird extended throat rasp they use to punctuate," and "new kind of Motown beat for the clean music of the rest of the band" in the Band section would be driven over the fence in the second graf of his *Creem* review of Rod Stewart's *Never a Dull Moment,* which celebrated the idiosyncratic mesh of Stewart's studio band in a colloquial detail devoid of musicological technicalities. Most remarkable of all was "Rock-a-Hula"'s unmatched description of a hook: "the right words snagged onto the best beat, thrown into chords and half-hidden in noise, sung not too clearly, words that eventually move out of their song as a musical phrase representing the sound itself, taking force from the illusionary power of music as such, not as words for a slogan, but a phrase out of the sound capable of being dumped on or inserted into all sorts of situations that by their reception of metaphor become linked to one another and are made coherent as shared experience."

Whew. As much as anything in "Rock-a-Hula Clarified," that passage prefigures writing Greil would be doing for the rest of his life. It was his way, not mine, and it has its pitfalls. But it was an example to live up to.

But enough about rock criticism. Let's talk about me.

My narrative has emerged from behind blue eyes that aren't actually blue—nor hazel as per my driver's license, more blue-green-gray-bleh. I presume you figure I was an articulate striver with a contrarian streak, a high-energy guy who went his own way. What may be harder to tell is what a weirdo I was. So let me add some detail.

Repeat repeat repeat—I was a slob, the future SP Mrs. Tully called "the sloppiest boy I have ever taught." My high metabolism was no match for a ravenous appetite that inflated my five-nine frame from a bony 145 at twenty to a bovine 187 at twenty-six, when I weighed in at Beth Israel to get my neuroma fixed (only it wasn't). Although there was already talk of "sex objects" in the air, I believed in self-objectification (see mask, image, persona, etc.), so I took the weight off and have never been nearly that fat again. But I remained a clueless dresser, favoring blue jeans or chinos, short-sleeved wash 'n' wear or T-shirts in the summer and flannel or plaid the rest of the time, Converse sneakers and "shower sandals" and sensible shoes down at the heel, all mixed in with a few countercultural oddments. I seldom wore a hat and thought earflaps practical when I did. My shoelaces were always coming untied and I lugged around a black leather bookbag. I fell naturally into a Groucho Marx gait, always ahead of the crowd with my head forward like a turkey. I parted my straight long hair to the side and bought glasses with the cheapest black plastic frames available. My sex object potential remained invisible to the unschooled eye.

Due to my compulsive candor, my impatience with hippie mellow,

and my general ignorance of social niceties, some found me arrogant, and for sure I said hurtful things I regret even if I don't remember exactly what they were. Taking no shit, I initiated more than my share of altercations, and often got emotional in public when something went wrong. Between my metabolism and my character formation, I talked loud, talked a lot, and argued with anyone about anything. Hence I was no longer shy around women as long as I could debate them. Not every woman found this attractive, of course, but enough took it as the sign of respect it was and those were the kind of women I liked anyway, especially if they were philosophical about how I jiggled my leg. Unfortunately, the women I liked also weren't inclined to proffer fashion tips. The first to work on my style was Dominique, who advised me to part my hair in the middle and quickly found me a purple tanktop that showed off my shoulders, which thanks to my dad's genes were handsome shoulders.

Dominique and I were a functioning couple as soon as I returned to New York and remained one for the last half of 1971. Although it never felt altogether right, I fantasized impractically about relocating to New Haven and read Charles Silberman's *Crisis in the Classroom* to prep for a fine day with her holistic third-and-fourth grade. In the end, however, she liked my line of work even more—after leaving me for a late-night DJ she became a volunteer disc jockey on the Yale station and eventually a full-time broadcast journalist. Dominique loved going to music and was mad for the Beatles, especially John, for whom Ringo failed to compensate at George Harrison's Concert for Bangla Desh. I panned that event five weeks late in a Rock & Roll & called "Living Without the Beatles" that focused on what I labeled the "IPMC": the International Pop Music Community. Although "the locus of some of my favorite rock," the IPMC was also the locus of "a fundamental change-over, from Pop to Music," in which a new cabal of stars interacted more with each other than with the audience. Two weeks later came

"Like a Horse and Carriage," which culminated two years of brooding about both pop and romantic love by giving equal time to two married couples, John-and-Yoko and Paul-and-Linda. Among other things, it was a coded statement of principle to Ellen. Dominique edited it for clarity. Takeaway: "What the breakup of the Beatles represents on the largest symbolic scale is a central problem of our time—the inability of couples to coexist within cooperative groups."

Somewhat less transparent was a side comment about John's Paul-bashing "How Do You Sleep?": "the kind of public act committed by a lover who wants to make sure he will never return in momentary weakness to the one who has rejected him so cruelly." So I should mention a junket that flew dozens of journalists to San Francisco to mark the launch of Jefferson Airplane's short-lived (naturally) Grunt label. Having gone mostly to see Greil and Jenny, I became, well, enraged when I found Ellen sitting with them after I did time on the dessert line. So I threw a piece of pie at her, not the "paper plate full of food" she recalled many years later. Rather than devising a "metaphor for gender relations in rock-critic land," as she conjectured during the same recollection, I acted as a torch-carrying schmo whose ex was hogging his dearest friends. Ellen did have a knack for tendentious plausibility.

"Like a Horse and Carriage" wasn't entirely complimentary about Ono's avant-garde past nor entirely sanguine about Lennon's pop future. But it was respectful at a time when Ono was getting badmouthed everywhere as the uppity woman who broke up the Beatles. And shortly after it appeared I got a phone call suggesting that I meet with them. I agreed without hesitation, as I would have even if I hadn't known Dominique would have flipped if I'd chosen any other course. Still, this was not generally my way. Wary of fame ever since Bob Stanley had his tiny brush with it, I hung out with the stars less than any rock critic except Ellen herself.

I mean, my war stories up till then—and there haven't been many since, either—weren't much. Interviewing an unknown Randy Newman for BMI and going one-on-one with him at a public basketball hoop afterward. Catching the end of our ride to Woodstock in a limo with recent co-interviewee Pete Townshend. Spending a stoned Saturday night with Anita Wexler listening to Bonnie Bramlett and Lorraine Rebennack dish their doggish husbands, Lorraine proudly pointing out the cocksucking lines in the outro of "Wash, Mama, Wash." And especially backstage with the Grateful Dead, who I saw at least a dozen times in this stretch—"the greatest artistic entity in creation," I wrote Ellen. One night Sue and I shared some pot while baking marijuana chocolate chip cookies that I then downed three at a time with munchies-fueled gluttony, getting as high on cannabis as I ever did on acid and eventually finding an amused guide through the innards of Port Chester's Capitol Theatre in Phil Lesh. And one night I sucked on a joint backstage at the Fillmore East and went blind. This didn't alarm the girl behind my right shoulder in the slightest. "There's nothing to be afraid of," she assured me invisibly in a wavery voice. "It's just that your soul has left your body." More solicitous and also possibly more liable, Jerry led me to the john, where I couldn't piss or shit, then talked me through gently until it passed twenty or thirty minutes later. DMT, some have ventured.

Anyway, one day in early autumn a Rolls-Royce pulled up on East 8th Street and John and Yoko—who inspired less hubbub than the limo among the street urchins—climbed the two flights to my apartment. Sara Lee coffee cake failed to break the ice, but when the three of us repaired to Barney Josephson's Cookery on the tonier Greenwich Village version of East 8th Street things livened up. I'd met Mick Jagger, remember, and had interviewed Janis Joplin, Aretha Franklin, Miles Davis. But there was no comparison wattage-wise—this guy was intense. Yoko was outspoken about her work and their image as a married

couple, but he did most of the talking, about Chuck Berry's jail years and the tangled ins and outs of managing a persona.

Soon after, a hooky-playing Dominique and I were on a hired jet full of Yoko's Fluxus cronies headed for John's thirty-first birthday party and Yoko's ten-year retrospective at the Everson Museum in Syracuse. Dominique noticed the security on our floor, surmised that our hosts were down the hall, and kept at me until I asked a rent-a-cop to show John my ID and we were brought in. When I introduced my thrilled girl-friend, John thrilled her some more with a rendition of the Singing Nun's "Dominique." She was struck by how Yoko kept popping in wearing different outfits and asking John how she looked, just like an ordinary wife, and how each time he told her she always looked beautiful, just like an ordinary husband. Dominique extracted twenty-six Lennon autographs for her class and distributed twenty the following Monday. But soon she decided that in 1971 few nine-year-olds had any idea who John Lennon was and decided that the day's absentees had lost their chance; one of the remainder went in a PTA auction, and the other five are in a cool, dark place. John guided us around the show himself as my respect for Ono's avant-gardist enigma/whimsy/provocation rose several notches.

And that's about it for dancing with the stars. I keep in touch with a few young-to-aging faves in an era when many quality artists need more help than any cult can provide. And because we both went to the same chiropractor and both became parents late, I became truly friendly with a very friendly man named Peter Stampfel, next to Bob Dylan the best thing ever to happen to MacDougal Street, although my anti-folk bias kept me from noticing until 1976 revealed the magnificent *Have Moicy!* But otherwise my friends are my friends, many older ones already named here, the more recent often fellow critics or even fans, into which latter category I guess we could stuff the late great Marshall Berman, although I became his bigger fan when 1982 revealed the magnificent *All That Is Solid Melts into Air.*

As a broadcast journalist, Dominique encountered Ronald Reagan, many lesser rock stars, and a full panoply of Connecticut muckamucks (most cordially—eek! yeucch!—Joe Lieberman). There could have been more, she says, but after just that once with her dream lover she didn't have the hunger. And once was enough, because like any sensible person she can see the obvious. The famous are different from you and me— they know more people. I'm sure there's something to be said for the pearls-of-wisdom and hem-of-his-garment models—sure any kind of contact with a genius like Lennon, however partial and distracted and perpetually at risk, has rewards that are by definition unavailable else- where, because geniuses are each very much of a kind. And there are major journalists—in my field Robert Hilburn is the most prominent and honorable American—who cultivate many such relationships for reasons that are personal as well as professional. But great artists tend to be egotists, which is less a character flaw than a reality of the calling, and you need never brush up against fame to know how much trouble egotists can be. Moreover, critics tend to be egotists too, which makes for extra mismatching, as does the established fact that critics understand art better than artists understand criticism (another thing I learned from Bob Stanley, although he didn't know it himself). So in the end, not only didn't I dance with the stars, I stopped profiling them. I'm a pretty good reporter, and there are exceptions I'm proud of. But I interview less than any full-time rock critic, and don't regret it.

My Beatles diptych was written in the wake of not just the August 1 Concert for Bangla Desh but the September 9 release of Lennon's second true solo album, *Imagine*. Flanked at each end by the all-purpose but fundamentally progressive hymn "Imagine" and the specific but fundamentally all-purpose marital-love song "Oh Yoko!," it was con- ceived as a change of pace from Lennon's first solo album, *Plastic Ono*

Band. I pity sourpusses who find it soft—inducing the masses to sing "imagine no religion" is a sellout? But I've found *Plastic Ono Band* even more playable. As my life turned out, there are no records I put on even monthly after their currency has eroded. Terrific ones sink to the bottom for years. *Plastic Ono Band* I never forget.

Its harmonic surface uninviting, its rhythms almost crude, its tempos too deliberate even when they speed up a little, this music isn't just spare—it's stark, somber, as befits the "primal screams" in which John was then publicly invested, a pop-psych connection that some skeptics never got over. Scornful though I was of not just Arthur Janov's con game but John and Yoko's peace-is-yours-if-you-want-it bromides, I didn't let either bother me, because even then I didn't confuse rock stars' belief systems, which were never systematic anyway, with the music their beliefs fed into. And then one gray winter afternoon I played the album for my Cal Arts tech guru Peter Kirby, the first person ever to utter the word "software" in my presence. Soon two different classes of insight emerged as he exclaimed over what he heard. One played into my theory-of-pop notions of irony and persona. The other nudged me toward music itself.

Rock-as-art figurehead Phil Spector deserves credit for once. Forbidden to ask Tchaikovsky the news, he hones his expertise to deep, durable, subliminal effect. Every minimal note reverberates. The drums Ringo Starr pounds suggest a funeral, the piano Lennon pounds contains an orchestra, and Klaus Voormann's metronomic bass is rock solid, devoid of grace or funk. Often praised for its unmediated nakedness, Lennon's singing is in fact cunningly varied in timbre and affect—solemn, conversational, delicate, agonized, childlike—and anything but unmediated. Sometimes it's magnified by echo tricks we're sometimes unsure are there, and also on occasion doubled outright, to especially double-edged effect at the end of "Isolation." All the posturing about the real John Lennon laid bare buys myths of authenticity John

knew the spotlight too well to believe, which isn't to say he was above enlisting them for persona management purposes. But by isolating his voice to full expressive effect, *Plastic Ono Band* establishes its versatility, authority, and stature. It's where I began to believe that rock proper has produced no better singer.

There are, of course, also lyrics. I'll mention just three. A year past Altamont, "Working Class Hero" became the first rock song to address class as a political idea and remains one of the wisest and most complete. The much-mocked "God is a concept by which we measure our pain" means—duh—"the more you hurt the more you think you need God," which is kinda true, innit? And for me the key lines are on the album closer "God," a performance even naysayers sense is epochal: "I just believe in me / Yoko and me / And that's reality." Forty years after the fact—I was not a regular *New Yorker* reader till my in-laws gave me a subscription—I was surprised to learn that Ellen had quoted them quite approvingly in her own review.

"Like a Horse and Carriage" didn't just win me a date with John and Yoko. It won me a job, or so I was told in January 1972 by managing editor Don Forst when his Long Island tabloid *Newsday* anointed me its first rock critic, although my page-one rave about Ed Sanders's Charlie Manson inquest *The Family* in *The New York Times Book Review* couldn't have hurt either. Between writing and teaching I was already rolling in dough by Avenue B's measure, so all I could do when Forst offered to double my income with a starting salary of $24,000 was not look flabbergasted and brag that I still intended to cover Nassau County from the Lower East Side. Forst told me he'd bide his time. Having just been turned away from the Greenwich Village gourmet haven of his choice because his new hire wasn't wearing a jacket, he predicted—sardonically, his default mode—that I'd be commuting from a co-op on

Riverside Drive in two years tops. When Forst was brought in to edit the *Voice* thirty-five years later, I did own a co-op. But it was miles from Riverside Drive.

The *Newsday* job lasted twenty-nine months with a six-month hiatus and was great for me in every way. Forst and my congenial, bibulous, Mississippi-born editor Joe Koenenn let me write what I wanted the way I wanted within the formal limits of a writerly daily that would take on Jimmy Breslin and Murray Kempton after my time. This suited the pop theorist in me fine, just as reporting from east of the border suited the Queens boy. Granted the book rights that made my 1973 *Any Old Way You Choose It* collection possible and the freedom to write "record capsules" that I could republish in a monthly *Creem* Consumer Guide, I still missed the *Voice* sometimes, but because Dan Wolf was such a skinflint, moving on was a folkway there. I didn't miss Richmond College, where the academic politics were even more sectarian than at Cal Arts and I never glimpsed that this gangly Gene Klein kid hiding in the back of my rock writing class was plotting to become Gene Simmons.

But it wasn't just my professional life that took off in the first half of 1972, and love comes first. *Newsday* coexisted with teaching well into May, which should have kept me busy enough. But that was also when I finished getting my "experience." Chronically lonely, needy by definition, dumped none too cleanly by Dominique, still hung up on Ellen, I was more successful with women than I understood. Once I even went home with a groupie from Max's and got the crabs I was cruising for, and for a month or so I dated two intelligent dyed blondes at once. Everything was aboveboard and affectionate and I remained friendly with both afterward. But as I told Ellen during the first of two experimental meetings, I basically hated it. By May I was down to a fan from Boston—Ellin Hirst, a piano-playing leftist who under the stage name Ms. Clawdy wrote tough, soulful, articulate feminist songs she never

recorded for release. The relationship was intense but troubled—she thought holding hands in public was sexist, and I only started to understand our sex life when she came out as a lesbian in the end, which was around the time Ellen Willis emerged as Ms. Clawdy's biggest critical supporter, in *The New Yorker* and then in the 1977 *Voice* cri de coeur that provided the title of her 1981 collection *Beginning to See the Light*.

Yet through all this Carola remained in my life and the back of my mind. In California I wrote her a letter whose premise was a message to an officially incommunicado Dominique, and then another after I learned that she'd reunited with Fred—who sometime in there requested sex tips regarding Ellen, on spec I believe, and sometime later in there broke with me because I wasn't a revolutionary, a job description he didn't claim when I met him and doesn't claim now. But before any of that I learned that Fred and Carola were again kaput and that she had shacked up with a lesbian—a feminist choice I saw a lot of in those days. What no one yet knew was how often such choices would prove as temporary as liaisons with Fred Gardner. So when I returned to New York in June, Carola was about to embark on a cross-country car trip with a woman who was her best friend merely. And at the end of August she was back from her American adventure and visiting Dominique and me on East 8th Street.

We all shared a joint and I got her attention with talk of the Beatles' joyful irony, which she says was the first time she'd ever understood how smart I was, or maybe just how I was smart. Then I started playing forty-fives. Dominique had taught Carola to dance to some of these songs, not that we remember which exactly except for a side previously cited here as "the 3 Friends' deeply sappy 'Blanche'"—a white-doowop NYC-only hit I told her was the worst record I'd ever liked. And between the pot and my commentary and how smart she is, she began to hear these songs as she never had before—in her words, "some bunch of obscurities from an era when the language itself had such vigor that

everything in it seemed to have its own necessity," e.g. "And I decided that I'd take a chance / Just to see how happy life would be / With only Blanche and me." Carola could have gone home on the Avenue B bus, which ended its route half a block from her apartment. Instead I volunteered to give her a lift. It was uneventful—I'm no kind of dog. But when I got back Dominique was cleaning the apartment for the first and last time.

So I kept in touch with my girlfriend's friend and then my ex-girlfriend's friend. In October she called to network for her estranged filmmaker husband and I guiltily blurted out the Ellen-pieing story, about which she was unjudgmental—from where she sat as a feminist, my confession proved I could talk like a girl. Occasionally I dropped by her hectic 16th Street menage to give her records and converse awkwardly with her lover of the moment—the hirsute one, the slick one, the graying short-haired laugh-a-minute Ritalin addict she called Crazy Eddie. I visited her progressive daycare center on East 6th Street and loved how patient and appreciative and comical she was with the kids. She danced saucily and ecstatically in the rear of a Dead concert where Dominique and I boogied in the jammed third row. I read a long story she'd spun off her marriage and found it personally heartrending and formally jaw-dropping. I took her on two totally platonic dates, one pre-dump and one post-dump. Before was a *Panic in Needle Park*/*Vanishing Point* double feature at the Charles on Avenue B followed by a bounteous Lisa Robinson party for RCA's newly signed Kinks where Carola, who'd begun the evening by explaining her hypoglycemia, downed many scallops in cream sauce. After was the Cockettes at the Anderson Theatre followed by an engrossing if digressive conversation regarding matters emotional, intellectual, and far out in a comfortably grotty Bowery bar called Hilly's, where we admired the beer neon. As I continued to think she was really something, she continued to think of me as pioneering that fascinating category, the male friend. Once

my heart sank as she and her women's-group pal talked astrology. Once my heart leaped as she described trying to kiss Quicksilver drummer Greg Elmore onstage, only the bassist horned in with a sloppy one she could have done without. I'd never much liked that band. But when a Quicksilver kite came to the *Newsday* office, I made sure to forward it. And she made sure to call and thank me. That was a good talk.

I should specify that this was Carola's radical feminist period, sexual research period, and hippie chick period all at once. She ate all those scallops because she got hungry living on fifty dollars a week—her share of the government check that only she received at Children's Welcome because only she had the required BA. But it was some BA—Radcliffe magna in English, '66—and she'd learned how to live poor by putting her husband through film school as a London preschool teacher. Amir was a Pakistani who had picked her up on the tube a few weeks into the European adventure she'd financed with eight months of typing and acting classy at Harper & Row. Carola had had a number of smart boyfriends and been engaged once. But Amir, who loved B movies as much as he hated the British empire, was sharper and more original than anyone she'd dated at Harvard. He was kind and he was funny. But although Carola believes the marriage would have run out of steam anyway, he was also pathologically jealous for no reason whatsoever except that he was in over his head.

Tipped off by Dominic Sicilia, I'd been wowed by the stylistic eclecticism and boffo laugh lines of my favorite new artist at the Bitter End, and Ms. Clawdy was similarly wowed. But such was the nature of my relationship with Ellin that when I was invited to Bette Midler's Carnegie Hall debut June 23, she did the been-there-done-that and gave me leave to invite Carola, who as it happened had roomed with one of Ellin's movement allies at Radcliffe. In Carola's mind I was still her male friend. But such was the nature of my relationship with Ellin that I had other thoughts, as with Carola I so often did.

This was a fraught time for her. She'd recently been tossed out of Children's Welcome in a feminist scourging typical of the time, and was staying with her roadmate Tina on Thompson Street because her own place was occupied by her brother Adam, who at that moment was a murder suspect. It's certain now that he was innocent, and firmly believed that the murderer was an even crazier relative of someone else in the homey old Village co-op where she'd grown up. But she didn't know that, and that co-op is where the murder—of a renowned children's book author named Irma Black—had gone down five days before. This all spilled out in ten anxious minutes, and somehow I gave off the right signals—concerned, supportive, unfreaked, and well aware that Adam was trouble. It was such a disorienting moment for her that she was freed up to look at me in a different way, as someone who got her. And I did. I got her. At last.

We smoked some, used my press plates to park at Seventh and 55th, bought cherries, and strolled into Carnegie Hall. Carola had never heard of Bette Midler. I told her she'd get the picture, and before Bette even came onstage—Miss M was, yes, fabulous that night—the mix of gay peacocks and suburban couples had won Carola's sizable heart. There was quite a second act, too: a Smokey Robinson & the Miracles farewell at Madison Square Garden. Between sets we walked around the Garden's perimeter conversing, and when I proffered my hand she took it, almost ceremonially. We didn't sleep together that Friday night—just kissed amorously by the car after I'd treated half a dozen hippies to dinner at Bobo's on my *Newsday* expense account. Briefly cupping one of her small, hard breasts, I felt hairs between them. Next day I thought about those hairs a lot. I also thought about how much fun we'd had. So when she called Sunday morning the first thing I said was, "I was just thinking about you."

She asked me out Tuesday with the proviso that we'd share the date with Tina, who'd won a raffle to tour New York Harbor on the Pete

Seeger sloop *Clearwater*. But we met at my place, and were well past kissing when we were interrupted by a surprise visit from my Cal Arts students Sean and Kevin. Oh well—no hurry. I hate boats, and although Carola comes from a sailing family it was so cold out there that visions of rum toddies danced in her head. The symbolism of sexual love running parallel to feminist sisterhood being heavy, Tina came back for the toddies. But she was discreet enough to keep it short, whereupon Carola and I finally made love. It was good, warm, surprisingly comfortable, but not spectacular. Ditto for the morning. She walked me to the Stuyvesant Station PO and we said good-bye with a warm, juicy kiss. In the ensuing weeks, she thought about that kiss a lot.

Three days later Carola departed for a yoga ashram in Pennsylvania having fucked three men in a week in a slam-bang farewell to the fleshpots. Hey, at least I was last. I knew this was her way, and accepted it—in fact, valued it, because I'd developed the theory that monogamy would come more naturally to those sexually well-traveled enough not to moon about craving "experience." But I really didn't know what would happen. Ellin Hirst, officially my girlfriend, kept her distance. Ellen Willis, negotiating a rough spot with Steve that included a spouse-swap gone awry, kept her hand in. I was theorizing marriage through a post-Beatles prism and my dream girl was the most sexually proactive, pragmatic, and promiscuous woman I'd ever cared for. I was militantly secular and my dream girl was seeking monastic enlightenment in the Poconos. Nor did the wicked case of poison ivy that coincided with my first big Stones piece, to which Ellin contributed generously, calm my mind. But as July zigzagged on there was a moment. I was spending some of my *Newsday* windfall on Larry Dietz's old shrink, and although Leah wasn't always on my wavelength, she cut through this mess with a single question. If I were to describe my best outcome, however unlikely, what would it be? After not much thought, I knew: "A monogamous relationship with Carola."

I'd mailed an *Exile on Main Street* postcard that closed with "Say hello to Mr. Berra for me" and two checkable boxes marked "Love" and "Your friend," and she'd mailed a letter about self-purification and the lugs at a rock festival, and "old Mr. Immanent" mailed a letter that closed, "So, impurely, but with high-positive-energy and some high-negative-energy, and assuring you that you have not been living in any sewer I know about, and that you are as different from the folks at the Poconos Rock Festival as I am, which is plenty, though I'm sure not in the same way, I remain, your loving friend, Bob." Then there was nothing and my expectations zagged down. And then, chronology unclear but say Thursday, July 20, with Carola having fled self-abnegation on July 14 and then fled Manhattan to recuperate in a summer house where she'd once au paired, she phoned and conveyed that after meditating through a three-day silence imposed on her big mouth by her historically Jewish swami, she'd decided that she'd take a chance, just to see how happy life would be, with only her and me. Say I began my Dead column and got stuck and drove out to *Newsday* and did laps to the finish and drove east some more, reaching the Shelter Island ferry around dawn. Found the house. Got into bed with my sleepyhead. Fucked her nervously because so much was at stake. Oh well—no hurry.

We had a lovely two days. Marriage wasn't mentioned, kids were. What each of us remembers most vividly is wading into Shelter Island Sound until we were up over our waists so Carola could carry me through the water like I was a baby, or a bride at the threshold.

9

LIKE A HORSE AND CARRIAGE

"Go together like a horse and carriage," did he say? Like a lot of pop songs, "Love and Marriage" isn't as simple as you think. Of course you can have a horse without a carriage, although a carriage without a horse is a clumsier proposition, which is why they invented the horseless carriage. Also, who's the horse and who's the carriage? When Carola held me in her arms in Shelter Island Sound, was she the horse or the carriage? Carry me, Carola. Sister, carry. And she has, many times.

So much happened so fast that we can't quite remember what came when, although first up for sure was Ellin Hirst, who took the news so badly I had to tell her twice, in Vermont and then California. In Vermont we had sex I watched from the ceiling, after which I snuck off to call Carola and say what had been left unsaid, that I really really wanted to be monogamous—which she'd assumed and had so advised my chief rival, an aspiring dental student from Queens, while he took a

bath at 308. In California I wrote a *Newsday* column before flying to St. Louis, where Carola, as part of our fifty-fifty wheel-time program, had driven the Toyota to meet Georgia and her cartoonist boyfriend Wes. From there began a road trip that included Rendezvous ribs in Memphis, a night in a by-the-hour motel in the Delta, *Bang the Drum Slowly* starring Michael Moriarty in Knoxville, and two days in Georgialina with a music-loving pothead couple she knew from the *Newsweek* letters department. Driving up through Virginia we had our first fight, which involved the nutritional properties of almond protein, her belief that driving in lane on an empty highway was for squares, and my inability to resist her nipples. There would be many others. Carola was both a hippie and the nicest person in the world, but she had grown up the youngest of four kids around an unemployed lawyer with a temper. So she'd learned to stand up for herself.

We met each other's families quick. She charmed and was charmed by Georgia, who had bloomed after escaping college, and my parents knew good news when they saw it. That spring my dad, sleeping on my couch after a professional meeting to simplify his commute to the tragicomic job he'd finally landed counseling if not guiding teenagers of color at Seward Park High School, could only grin and bear it when Ellin Hirst passed him on her way to pee. And my mom, who had subjected me to a once-in-a-lifetime tongue-lashing the day she learned Georgia and Wes were living together, was seeing her outsider cohort at First Pres go through far worse with their kids. So at a Vermont lake house belonging to Doug's in-laws, my mother and my beloved enjoyed each other's ongoing goodwill as my father signed off on Carola's shoulders in five forthright Ridgewood-accented words: "She looks like a swimmuh."

The Dibbells were less of a challenge, but more complicated. At the long trestle table in the basement of 26 Jones Street, her moody, scrupulously democratic Yale '28 dad, Charlie Dibbell, ribbed me clumsily

about Dartmouth, and her infinitely subtle genteel-eccentric Barnard '28 mom, Helen Hope Dibbell, hoped kindly that I too was kind. Soon we'd weekended with the 30 Jones contingent, her sister Joy Harvey and Joy's husband, Larry, and their two little girls and, well, the unmarried teenage couple they were putting up. For this was an unusually tolerant and unusually charitable family, or so I gather as far as the unusual part is concerned. True, First Pres was dominated by WASPs. But beyond Shoss and Kit and I suppose Bob Stanley, I've been close to very few of them, even at Dartmouth, where prime candidate Bruce Ennis insisted he was Scotch-Irish. The Dibbells—and for that matter the Harveys, public-spirited rehab architect Larry being a second cousin of some kind—were WASP to the core. Yet when my polymath pal Marshall Berman exclaimed "I've never met gentry before" upon entering the Dibbells' Clinton, Connecticut, manse, a circa-1860 painted-brick structure with faux-Attic columns on the heavily trafficked Post Road some twenty miles east of New Haven, it just went to show that polymaths don't know everything. The Dibbells were not gentry.

There is a Captain Dibbell House in Clinton, and Dibbells from the 1600s are buried there, but the Dibbells got by as farmers and bookkeepers and small businessmen who Charlie liked to say "never amounted to anything." Charlie attended Yale on scholarship, a well-built local boy who worked summers as a laborer. He amounted to something until 1953, when he was forced out of a white-shoe Wall Street firm where he'd never been comfortable helping the rich avoid their taxes. He then lived off his savings and an inheritance that had just come to his wife, whose grandfather had immigrated from England later than the Christgaus had immigrated from Germany in a futile quest for North Carolina gold—and whose father had worked his way up from fourteen-year-old brokerage clerk to president of the New York Stock Exchange. Frank Hope married Blanche Lovett, a Boston University alumna from a family of revivalist do-gooders, who in Tarrytown and

then Darien oversaw mansions she transformed into boardinghouses, mostly for less fortunate Lovetts. Frank left Blanche twice while siring five children, the second of them Helen, who like many cool Barnard girls of her era went by her surname and was called Hope. With Charlie out of work, the Dibbells lived frugally until the money was gone, which came naturally to both parents anyway. Then Charlie secured a job in a classmate's law firm and commuted daily to New Haven well into his seventies.

Unfortunately, Charlie didn't just have a temper—he had a screw loose. Without ever getting physical, he was so scary so often the only word is "abusive." But while his son had a handful of nuts loose, none of his three girls was seriously damaged, and he was also a good and interesting man. It was New England Republican Charlie, for instance, who figured out in the '30s that the row houses they and their neighbors rented on the same Greenwich Village block where the cover of *The Freewheelin' Bob Dylan* was shot could be transformed into a nonprofit co-op under the U.S. Department of Agriculture. But the best thing about Charlie was Hope, who gave up graduate work in psychology after a blind date with Charlie in 1931 bowled her over—there was a visible sexual bond between them that prevailed over rather than fed off Charlie's rage. And for half a century Hope focused her high IQ and born-and-bred charity on Greenwich Village as a site of domestic life—especially on its children. Her used toys, tasty snacks, stealth humor, extreme tolerance, and radiant kindness made the triple backyard behind 26-30 Jones a kid magnet almost as powerful as the Greenwich House settlement, whose thrift shop Hope ran for a time. Carola was one of many girls and several boys who learned to act and sing and do eurhythmics at Greenwich House in a theater program run by a redoubtable probable lesbian named Helen Murphy, half freethinker and half apostle of respectable noblesse oblige.

Greenwich House attracted neighborhood bohemians up to and in-

cluding poet Anne Waldman and neighborhood Italians up to and in-
cluding singer Maria d'Amato, Maria Muldaur to you; the future Jenny
Gardner was there for a while. No slouch in that company, Carola then
followed her sister Joy into all-girl Hunter College High School, the
best public school in the city as well as her version of the wonderful
world of Jews. There she was a star like none at Flushing—seventh in
her class, editor of a literary magazine featuring several future profes-
sional writers, co-author of a scandalous senior show called *The Un-
teachables*, good at everything but her SATs. Something about SAT
gamesmanship rubbed her the wrong way, for Carola is a person who
both hates losing and doesn't relish winning. For a while I inveigled
her into playing a card game called Mille Bornes. It was ninety percent
luck, but she lost disproportionately. One evening she announced that
if she didn't win she'd never play again, and the cards went so totally
my way that I couldn't have taken a dive if I'd wanted to. Good-bye,
Mille Bornes.

I connected less comfortably with Carola's friends than with her
family, although I swear I tried—didn't meet any I grokked until a No-
vember visit to Boston, where one from Hunter and one from Radcliffe
had settled. But she made it a mission to get with three different-but-
equal couples I loved: Tom and Laura settled one-on-one in post-
collective Astoria, Bruce and Nancy Lee with Nan a public defender,
and the now-married Bob and Marylin with her two kids racing around
their Crosby Street loft on foot and various wheeled conveyances—a
chessboard-and-Ping-Pong-equipped art-world salon where we spent
several evenings a week with others famous and obscure. All these
friends understood that we were serious, and not just because I was
crowing about it. Carola treated me differently—she was visibly com-
mitted, tender and proprietary.

This was what she understood to be our deal, but also how she
approached whatever world she chose to explore—on its own terms.

Where as a hippie feminist she'd gone all raised-consciousness and heart-to-heart with her NYU girlfriends, not one her intellectual equal but all with lessons to impart, now she plunged into rock and roll like no woman I'd been with except Ms. Clawdy, Ellen and Dominique included—it was my life, she liked that it was my life, and she also liked my need to share it, with her and with everybody. A longtime but sporadic fan who'd returned to the States in 1969 knowing more about Alla Rakha than Eric Clapton, she never made me turn off the record player (back then, anyway). So we shared our second week together with new albums from Rod Stewart and Van Morrison, permanently imprinting "You Wear It Well" and the heavenly "Jackie Wilson Said" on how we know each other. And soon I was hitting her with proven reliables like *Dusty in Memphis*, *The Marvelettes' Greatest Hits*, and Norman Greenbaum's *Spirit in the Sky* as well as 1972 stuff: *Paul Simon* sans Garfunkel, *Crazy Horse*, *Nilsson Schmilsson*, the Christgau cult classic *Manfred Mann's Earth Band*. *Kink Kronikles*—how she loved "Waterloo Sunset." *Young, Gifted and Black* and *Spirit in the Dark* and the "You Send Me" on *Aretha Now*. Coming up on the outside Bonnie Raitt's *Give It Up* pointing back at Chris Smither's *Don't It Drag On* and across at the boogieing first side of Marc Benno's *Ambush*. In November Joni Mitchell's *For the Roses* and Steely Dan's *Can't Buy a Thrill*. Al Green, Al Green, Al Green. And in the car, AM radio nonstop except for baseball: the Chi-Lites and her beloved Stylistics and she swears the Detroit Emeralds too; "Coconut" and—two years late—"Layla"; "Freddie's Dead" and "Back Stabbers" and "I Can See Clearly Now" and you bet "Use Me" only not the "use me up" part; Alice Cooper's impossible "School's Out"; the horrible "Taxi" which she kind of liked anyhow, by Villager Harry Chapin, whose famous grandfather's painting of Hope in a T-shirt hung at 26 Jones. And although she skipped some Nassau shows, more often she would work on her fiction at a *Newsday* typewriter while I wrote my review. Her appetite for live music

meshed undetectably with our appetite for each other's company, and for the sandwiches she devised by the bagful for the two-day Festival of Hope at Roosevelt Raceway and a Kinks-Beach Boys bill with Tom and Laura in the South Jersey wilds. For Al Green at the Copa, we dressed to our version of the nines at a table with Vince Aletti, Lenny Kaye, Richard and Lisa Robinson, Vernon Gibbs, and Aaron Fuchs. We have the house photo to prove it. Vince sports a mustache.

Yet music wasn't even our main point of aesthetic contact. Movies either, although Amir was a self-made cineaste and Carola has done film work with him and others. What bound us artistically was words. Carola is a writer—in my opinion more gifted than I am except in certain all too essential practical and conceptual matters—who kept working all through her poor and druggy hippie period, when she eked out the long story I so admired, "A Misunderstanding." And she's also a reader, one of the hungriest I've known. So having never processed a scrap of rock criticism as of Shelter Island, she began working through my old stuff, sampling *Rolling Stone,* and wolfing down *Creem.* In return, I joined her fiction club. Before September was over I'd downed two of her favorite novels, which became two of mine. One was Margaret Drabble's 144-page 1965 *The Millstone,* the tale of a literary Fabian who remains a virgin too far into her twenties, conceives the first and only time she has sex, and decides she wants the kid. We gave it to our mothers for Christmas. The other was Doris Lessing's 654-page 1969 *The Four-Gated City,* the culmination of Lessing's quasi-autobiographical Martha Quest series, replete with sex, madness, adolescent seekers, and literary politics, its climax an apocalyptic future-fiction postscript that presages Lessing's underrated forays into political space opera and spoke to my recent interest in genre fiction, which in sci-fi included such Bob Stanley picks as Samuel R. Delany's half-structuralist *Babel-17* and John Brunner's pre-dystopic *Stand on Zanzibar.* Except that both are by and about British women, the Drabble and Lessing appeared to

be radically dissimilar books—one so slight and wry, the other so ponderous and fantastic. But both depict the '60s from inside the '60s, both take child-rearing seriously, and both exploit pop forms—the Lessing science fiction, the Drabble the chick-lit now epitomized by Helen Fielding's foolishly disrespected *Bridget Jones's Diary*. And in both I see foreshadowings of Carola's first published novel, *The Only Ones*, set in Queens and scheduled to materialize around the time this book does.

These affinities went back to Dreiser, as in: "I didn't know then how short life is, or I would have said life is too short to spend a minute with anyone who doesn't agree with me about Dreiser." I had too many opinions to stake my life on any one of them, but facts are facts. Till death do us part, Carola and I will share the same two favorite twentieth-century novels. Moreover, we encountered each the same way: Theodore Dreiser's *Sister Carrie* during aborted baby steps toward an American studies specialty, and Christina Stead's *The Man Who Loved Children*—which each of us read ten laborious pages at a time until downing the final hundred in one long wee-hours rush—via Fred Gardner, who told me about it and bought Carola her copy. Although Georgia, now a high school English teacher, is also a *Sister Carrie* fanatic, I doubt another person on the planet would pair it with *The Man Who Loved Children* atop a life list. Together they must have a story to tell about why Carola and I love each other so much.

Because I had staked so much on it, I was nervous about rereading *The Man Who Loved Children*. It had been forty-three years; with music I can easily check back and rationalize my youthful overenthusiasms, but with fiction I feel enough outsider anxiety to want to be right every time, at least by my own outsider standards. So it was with some unease that I set about rereading it on a semi-vacation in the Dibbells' Clinton house. There I soon concluded that all I had to worry about was

whether *Sister Carrie* would match up. So having plowed through the last four hundred pages of the Stead, I took a day off and a deep breath and raced through the first hundred fifty of the Dreiser. The only way it didn't match up is that this time I liked the Stead even better.

The two novels have plenty in common. They're pessimistic, naturalistic hard reads weighing in at five hundred pages by writers of limited personal charm whose Communist ties didn't win friends or influence people. Both care about class and obsess about money. Although Dreiser is too big a totem to omit from best-novels lists, his 1925 bestseller *An American Tragedy* generally tops his 1900 debut on the status meter. And *The Man Who Loved Children* cracked no such lists as the century turned, although it might yet sneak up on the canon like *Moby-Dick*. Importuned for a ten-best-novels list in 2006, Jonathan Lethem placed it third all-time, after *Great Expectations* and *The Trial*, and in 2010 the co-founder of the College of Jonathans, surnamed Franzen, explained at length to *The New York Times Book Review* why he'd been rereading the thing periodically since 1983—always worrying that it wouldn't hold up.

When *Sister Carrie* first surfaced, Dreiser was a twenty-nine-year-old journalist who may or may not have co-written the huge 1890s hit "On the Banks of the Wabash, Far Away," the pinnacle of his songwriter brother Paul Dresser's career. Although the novel was championed by Dreiser's naturalistic forebear Frank Norris, it was initially reviled by almost everyone else, most saliently his publisher's wife, as both sordid and obscene, as in its very dirtiest part: "Instantly, there flamed up in his body the all-compelling desire. His affection took an ardent form." You can sum up its plot as "small-town innocent becomes rialto singing star, ditching two lovers along the way." But you need to squint to notice how savvily Dreiser elucidates Carrie's pop appeal—a half-conscious yearning that surfaces with winning awkwardness in her unperfected singing and on her very pretty yet unexquisite face. That's

because the foreground is occupied by class struggles—not *the* class struggle, although Dreiser grew up in poverty and died a member of the Communist Party, but the rises and falls of his three protagonists: the restless small-town girl Carrie; the buoyantly complacent ladies' man Drouet; and the tragic Hurstwood, who achieves prominence as the affable manager of a swank Chicago eatery, leaves the good life behind for love of Carrie, and find his affability disastrously less fungible after he flees with her to Manhattan.

Dreiser feels these three weak people. Drouet is a roué, but he treats Carrie kindly, dimly perceives her distinction, and doesn't make an honest woman out of her mostly because she's so quick to figure out how shallow he is. Thirty pages are devoted to Carrie's deadening quest for menial work, and by extension to every eighteen-year-old girl's, and she never harms out of malice or schemes for the success she lucks into and deserves. Hurstwood is a decent, intelligent fellow who intuits Carrie's superiority even though he lacks the sensitivity to husband it and the character to satisfy her modest material needs. He spends a good quarter of the book deteriorating into unemployment and home-lessness step by unbearable step—when he scabs during a transit strike, you root for him, not the strikers. And everywhere Dreiser counts the money. How trolley fare erodes Carrie's shoe-finishing wages. The jacket costing double a week's pay that lures her into sin. How much of the stolen cash Hurstwood returns and how much is left. The size of Carrie's raise when she gets to lead a chorus line. The array of denom-inations in which she's handed her later leap to a hundred fifty a week. How many pennies Hurstwood needs to rent the Bowery room where he turns on the gas.

One reason Carola and I responded so deeply to this book is that we both cared about class for ingrained personal and evolving politi-cal reasons—by 1972 it had finally come into its own as a movement issue. In this respect *The Man Who Loved Children* hit even closer to

home—the saw that it's "one of the most truthful and terrifying horror stories ever written about family life," to quote the *Time* blurb on the cover of a 1966 Avon reprint that has survived my two readings due to advances in cellophane tape technology, is only creditable if you allow that few families are horrified by poverty quite so byzantine and gothic. As awful as Sam and Henny Pollit are, they might have achieved a workable truce if egotistical idealist Sam had any grasp of domestic finance or office politics and budget-fudging Henny had reined in her needs as the spoiled daughter of a moneyed wastrel or milked her over-leveraged family for funds.

Yet in a book of five thousand details, Stead's determination to pin down the Pollits' fall from genteel eccentricity to genteel penury is dwarfed by her facility at imagining unique voices for Sam, Henny, and Sam's daughter by his first marriage, Louie. And her genius is to make each of these voices a mark of genius itself. The voices don't stop there—Louie's structurally unnecessary stopover with her dead mother's people is only one locale where other distinct conversationalists emerge. But those three signature vernaculars dominate everyone else's except, crucially, Stead's. All three—Sam's baby talk and hideous eugenic-socialist theories, Henny's tirades and snobbish contumely, the bibliophiliac grandiosity Louie affects as she balloons into adolescence—read slowly, as prose poetry so often does, and Stead's own prose, which it's said she seldom revised, is poetic as well. This doesn't mean it's literary, however—sentences patter on past their appointed destination, crawling with stray modifiers and substantives but always hewing to a hectoring beat of their own. If you try to read her too quickly, you miss all the fun, or whatever that species of pleasure is called. I prefer novels that move, as was soon the case with the ferociously utilitarian *Sister Carrie*, where nothing intervenes between reader and tale—only if you think prose should go down like fine wine is Dreiser's supposedly barbarous style actually a hard read. But Stead's

not for oenophiles either. In addition to savoring descriptive patches that vie with anyone's—the Baltimore precis that begins the chapter called "Tahoga to Spa" is a stunner—I began to hear her fed-up third person as a sane and welcome respite from the principals, who were nevertheless sure to fascinate the next time they opened their mouths.

Stead was Australian, the daughter of a naturalist very much like Sam Pollit. Her husband was an American Marxist economist named William Blake, an arbitrageur who turned to writing successful and then unsuccessful historical novels. *The Man Who Loved Children* was her fifth published book. She was persuaded to reset its story in Washington on the grounds that no one wanted to read about Sydney, but although it was well reviewed when it appeared in 1940, no one wanted to read about Washington either, and Mary McCarthy, ever the stickler and just conceivably miffed with the Blake-Steads' failure to condemn the Hitler-Stalin pact, complained that she got her local color wrong. But that's not how it read in 1970 or reads now—Sam's Artemus Ward steals, to single out one touch McCarthy bitched about, are no less plausible than the rest of his personal lingo, which is said to mimic that of Stead's father with devastating accuracy. And although the book does make a horror story of a family's life if not "family life," the horror story is also a fairy tale, a bildungsroman, and a low comedy.

Egomaniac and shrew Sam and Henny are, but their six kids are acutely drawn individuals who are having a ball, romping more than cowering through the pseudoscientific fantasia Sam would call nurturance and others abuse as their world never quite falls down. It's rare for a major novel to observe children with such gimlet-eyed affection, and since a respect for the pre-adult imbued the different kinds of work Carola and I had taken up, that achievement alone drew us to this one. Soon we were cheering the belief in her own teenage "genius" that powers Louie's struggle against abuse—ungainly as her verbal outpourings are, her will, appetite, productivity, and sincerity are so in-

domitable that the half-accidental murder she half-commits feels like a natural event and the inauspicious escape she manages feels like a denouement. And throughout the book we were laughing. Arbiters of taste looking to put a seal of approval on *The Man Who Loved Children* like to sum Sam up as a monster, but he's also a comedian, which is why his kids adore him and why his unexcerptable monologues make you grin and shake your head. Henny's tirades are appalling—in their unleashed fury reminiscent in my experience only of Charlie Dibbell's, with the codicil that her rhetoric puts her in a league with Pope and Celine. That rhetoric is an amazement almost as much as a terror, and like Sam's exerts a head-spinning comic magnetism. "Black comedy" became a thing well after 1940, but Stead was onto it.

So what was there in these two underrated novels that made Carola and me bond with them for life? Start with Stead's vision of childhood (for which there's no equivalent in Dreiser) even though Blake, while a decent husband, denied Stead children of her own—she's better at kids than Dickens, who we both adore. And although I was the one who'd grown up lower middle-class, Charlie's long unemployment and Amir's inability to hold down a job had sensitized Carola to the precariousness of Hurstwood's prosperity with a specificity my father's dimming Depression memories couldn't match. Beyond that, I'll quote two sentences from the Stead obituary Carola did for the *Voice* in 1983: "She cared less about the conflict between choice and the inexorable, consequence and inconsequence, pattern and disorder than she did about the mesh, and, astonishingly, she caught it. She got it in words."

So Stead was a partisan of contingency. No utopian she. No utopian Dreiser either, obviously. But like Stead, if oh so differently, he too piled up language as an ardent admirer of the physical world. Both were leftists, but neither believed all that much good would come of it. Carola and I were younger and not yet aware that the rich were closing down on the affluent society (although the movement's late-breaking class

focus clearly reflected subliminal anxiety on that score), so we weren't pessimists and in fact still aren't—it's not in our raising or our somatic makeup. But we were set on enjoying the world even if it didn't evolve to our liking. And to do that we needed Stead's penetrating complexity, needed Dreiser's tragic tolerance—and needed pop that accounted for the dark stuff too.

One more thing. Stead and Dreiser were both skillful writers who used their skills to honor the rough not the smooth, the commonplace not the high-flown. Literarily, they had bad manners. Skillful writers too, our values compelled us to pursue the same goal with more jokes. We've always loved that in each other.

No one has affected my writing like Carola, but it was changing big-time anyway just as we fell in love. In June and July of 1972, as I juggled Ell*ns and waited on Carola and agonized to my shrink, I also hit my stride at *Newsday*, producing seven pieces I ended up collecting. There was a celebration of AM radio, an appreciation of Smokey Robinson as the domestic paragon he actually wasn't, a leftist pan of John and Yoko's agitprop *Some Time in New York City,* and the other half of the Elvis Presley essay I'd begun post-Vegas. There were two Rolling Stones pieces: my Ellin-assisted disquisition on "mass bohemianism," which took weeks, and a concert review scrawled in ninety minutes on a legal pad and dictated over a pay phone at the press party, with the desk tacking on an apt hed for once: "They Need Us; We Need Them." And there was the column where I took a transition by the horns by noting, after two paragraphs of blandly judicious praise, "Another thing that interests me about the Eagles is that I hate them." Over the years, that sentence proved my most quotable quote this side of "Mick Jagger should fold up his penis and go home."

Newsday was an afternoon paper, which meant overnight reviews

were both expected and possible—I didn't have to skedaddle before the encore and finish in half an hour to make deadline. After a show at Nassau Coliseum with its industrial acoustics or the Westbury Music Fair with its revolving stage or My Father's Place with its hip booking policy, I'd drive to the office and grind out six hundred words, which usually took around two hours with the night-desk burnouts wondering what was holding me up. But Manhattan shows I'd do at home, then read to women I never met who always got something wrong ("Phelonious Monk"!) while transcribing my copy in preparation for the ritual headline debacle. And every Sunday evening at 308, I'd begin a thousand-word column for the following Sunday, work till four or five with thoughts of Carola's nubby body luring me bedward, rise before eleven, hit Hempstead early afternoon, and finish the next evening although not always before Joe Koenenn left for dinner. Shortfalls are inevitable at such a pace—I count three David Bowies alone. But even the shortfalls reached for something. Without a peep from Joe or Don, I elaborated and hammered home my pet ideas about musical community and the aesthetics of the popular. I never soft-pedaled my politics, calling out sexism and campaigning in so many words for what I insisted on designating "black music," thus arousing the explicit ire of many of the progboys outraged by my Yes pan. By the time I moved on, I'd handed in so much copy that I'd never suffer writer's block again, and had examined my themes from so many angles that they'd sunk deep into my judgments, rhetoric, and joking around.

It was strange and stimulating to address an audience that had escaped Queens in the opposite direction. Sometimes this was only a metaphor—many of my readers were so young they were still figuring out how to go into the city themselves, including one I wish hadn't. But often it was literal. So if there was anything to my idealistic fancy that music could crystallize a virtual community of shared pleasures and values outside the half-bohemian domain of the semipopular, it

was my job to enjoy those pleasures and articulate those values while stretching the daily-newspaper aesthetic—to convince suburbanites to get with the Chi-Lites, Randy Newman, and the New York Dolls, pay closer attention to Helen Reddy, Gladys Knight, and the Rolling Stones, and see through Cat Stevens, Carly Simon, and Yes. Working for a daily complicated this process. No other writer at *Newsday* looked like a hippie, and no other critic was such a big-dome—the best was humorist Marvin Kitman, whose many years of TV coverage get less respect than they deserve just because he's such a wag. So Forst and Koenenn were putting themselves out for someone who wasn't the kind of front-of-the-book newshound desk burnouts believe in if they believe in anything. There's evidence of reporting in many of my *Newsday* pieces, but seldom a direct quote. Interviews are reduced to an atmospheric lead or a few illustrative nuggets—I've always eschewed q&a's, and once offended deposed Columbia Records headman Clive Davis by sitting with him for an hour without reproducing a single one of his sentences.

What I did instead was describe audiences I'd formerly only imagined, each an experimental minipolis in rock and roll's invisible republic, many of them what Robert Palmer would later dub temporary autonomous zones. Teenagers boogieing on cue to Three Dog Night at the Coliseum. Housewives ten years my senior outclassing their adored Engelbert Humperdinck at Westbury Music Fair. The minute discriminations of Berkeley bar-band cognoscenti. John Sinclair's utopian remaking of the Ann Arbor Blues Festival. A dull band brightening a sad state rehab center. The optimistic finery of the citizens of Watts outshining the depleted star power of the artists of Stax. Gladys Knight at the Waldorf (integrated, well-heeled), in Newark (African-American, working-class), and on Westbury's revolving stage ("the usual sort of heterogeneous crowd" for black acts there). Helen Reddy's half house at Westbury epitomizing the tolerance "of the healthy audience in this

time of mass cults and snobbish cliques." Casual fans ditching free Carole King one dank May afternoon in Central Park. Preteens turning up their discriminating noses at free "jazz for kids" in Central Park. A grab bag of laid-back second-raters beseeching three thousand sun-stunned weekend hippies to boogie at a half-deserted Islip Speedway "festival." Sitting way up and way back with a utopian assortment of Grand Funk fans in Madison Square Garden. Hitching to and from a Dead concert when my muffler got busted.

Quantifying my *Newsday* workweek is impossible. My twenty-two hundred words a week was productive but not prolific as front-of-the-book folk count things, and exactly how to calculate record-listening hours and press showcases has mystified me all my life. I figure I worked full-time and then some, but with far more autonomy than a reporter who goes to the office. Instead I checked in by phone; every day it was "Hi Joe, anything going on?" and "Nothing for you, thanks." So it came to be that one May morning found me in Fort Tryon Park dropping acid with Georgia. It was my third trip—there'd been one in the Catskills the summer before with Judy and the Ennises. Having chosen the Fort Tryon greensward for Cloisters culture plus Hudson view, I soon became aware that it sat atop a Washington Heights strewn with trash and crawling with people I didn't know—not a bum trip, but no sunny vista either. So where Georgia was captivated by the unicorn tapestries, what got me was sitting under a tree with my five-foot-eight little sister, weeping so long and hard about Ellen that I soaked through the shoulder of her blue workshirt. At two or so we drove down to Crosby Street to visit Bob and Marylin, and I phoned in. "Hi Joe, anything going on?" "I'm so glad you called. WLIR is being sold and we need you to come do the story."

It seemed only fair to tell Joe I was tripping, but I wasn't about to beg off. So having emphasized that acid was not a regular thing for me, I persuaded him that I was up to the job. You can be sure I drove

carefully, which was my only choice anyway with the Grand Central Parkway backed up for miles. And coming down in a traffic jam, I had a revelation—what the hell was I doing here? I didn't need all this money. Why not work six months and spend the other six pursuing my muse and enjoying myself? At five miles an hour, I had time to dwell on that. But eventually I reached Hempstead, got a bead on what was up with Long Island's only free-form station, repaired to the office, and wrote my beginning, my middle, and my end. My concentration wasn't ideal, but I was coherent enough. By taking LSD, I'd proved my professionalism.

Within a month I'd hit my stride, which was fulfilling in its own way. But the revelation stayed with me. Even today, after forty years of sixty-hour weeks on a job I want to do, I get the occasional flashback.

I never tripped again, and although Carola had tripped more, on mescaline mostly, post-ashram she was through too. By October, in fact, we'd given up pot, which was making her paranoid and deadening my dick. It was also in October that Tina kicked Carola out of Thompson Street for no clear reason and Carola rented a place upstairs at 308 East 8th while moving into mine—and also in October that I kept sniping at her for no good reason until she pointed out that the onset of my irritability coincided precisely with our cohabitation, whereupon I had another revelation and stopped. Carola's dope nerves stemmed from Irma Black's murder rather than any uneasiness about staking her life on me. But my genital anesthesia, which hadn't been an issue post-Ellen, was a clear sign that however elated I was, I was scared too—commitment is dangerous by definition. These fears would continue, and generate serious pain. Yet mostly we were elated.

Carola did some substitute teaching after her unemployment ran out, but the six thirty a.m. phone assignments meshed poorly with our

nightbird lifestyle, and soon we decided we'd both rather she write full-time and let me shoulder the financial consequences, which Carola had never dreamed possible. Every day she'd climb to the top-floor apartment where she never spent a night—and where a burglary promptly relieved her of her suitcase stereo, her sewing machine, and her Royal portable—and work on a "nonfiction novel" that would now be called a memoir about the ashram. But I encouraged her to do journalism, too—to write for money and to an audience. And in rode the *Playboy* spinoff *Oui*, then striving futilely to meet the *Penthouse* challenge with a more youth- and pubis-friendly title that in 1973 and 1974 featured our consumer guides to coffee, beer, and—alongside a drawing of a lickable young woman dripping white stuff with a plump strawberry perched four inches below her buttocks—yogurt. Not only did Carola know food and excel at physical description, she was a comedian with a slapstick streak, and took primary responsibility for these shared by-lines. So while the grind that "tasted strongly of water" may have been mine, figure both the mean-ass "Looks like miniature buffalo chips. Tastes like it was brewed in iodine" and the sweet-tempered "It starts black, ends delicately, almost tenderly" were hers.

Although we were far from the magazine's only writers of quality, *Oui* obviously had its political limitations. Carola was too openminded, and too proud she was getting paid, to object on principle, but she infinitely preferred a more countercultural assault on propriety—the rockcrit gonzo of *Creem*, where the shameless subjectivity and googly-eyed comedy of Lester Bangs and his merry band of stink-bombing sky-rockets gave her new ideas about physical language, lowbrow comedy, and aesthetic judgment. More than me, Lester inspired Carola as a writer, suggesting zanier ways out of the highbrow-lowbrow dilemmas I'd made my specialty.

For Carola these issues were organic. Villagers though they were, her family was arty only in a rather old-fashioned way—when her

father left White & Case, he took up not modern poetry but narrative verse, laboring over an unpublished epic in which an architect quits his job and retreats to a tower. Concomitantly, she'd been raised to look down on snobbery. This aesthetic principle she maintained even when waxing abstruse about the unreliable narrator for the Harvard English department. She stuck by the Hollywood musicals of her childhood while the Beatles rocked her as irresistibly as they did a million other college kids, and the B movies Amir was into added a hard edge to her pop proclivities as she underwent two years of day-to-day poverty and racism supporting her dark-skinned husband in bedsit London. But Amir wasn't into pop—he was amused but confused when Carola sang him oldies from memory. Only back in the States did she reaccess rock. So as my theory met *Creem*'s practice, she began to see how by writing for the people you could preach to the unconverted. It was somewhat speculative, but that was the way her intelligence worked.

I knew lots of people who cared about my vocation, as how could I not? Greil. Tom. Karin. Vince. Elder statesman Paul Nelson, defender of electric Dylan before any of us published and feeder of freeloading freelancers from the day he landed his Mercury PR gig. Georgia and Wes, who'd join *Creem* the following summer. Plus gaggles of press-party adepts, eccentrics, and hacks. But I didn't know anybody as gaga for rock criticism as the woman I loved—she'd sit chuckling at *Creem* like it was an amalgam of *Mad*, head comix, and Pauline Kael. Carola would never be more than an occasional rock critic even though she'd had more than her share of musical crushes, many danceable—from *American Bandstand* as a young teen to the Beatles and Marvin Gaye and "Heat Wave" at Radcliffe to the hippie hippie shake that got her kissed by Quicksilver's bassist. But she wasn't shy about urging me to goose my language, just as I wasn't shy about stealing her ideas. I did this with everyone I met, but she was my prime source. James Taylor "moving with the exaggerated calm of a very nervous person"? Carola.

David Bowie as "Gwen Verdon with her hair straightened into a long crewcut"? Ditto. My live reviews described the stage garb she could reel off from memory. And gradually the record capsules I recycled in *Creem* took on texture and detail.

We were in love, we were a team, we were rolling. Already clocking professional money in a lumpenboho slum, I was ordered by a motherly yenta of a secretary to join the club and cheat on my expense account, so we checked out restaurants gratis as well as working the food lines at press parties. Sometimes too we ate with our surrogate family at Bob and Marylin's, a family that would prove permanent even though it filled no vacuum, because the Christgaus saw beneath Carola's bohemian panache a spectacularly warm person who would stick around and the Dibbells saw beneath my shoulder-length locks the most successful and affectionate man their daughter had ever brought home. Conceiving our relationship as a feminist adventure, we shared the kitchen even though Carola was ten times the cook I was, and also shared not doing the housework—Carola was so relieved I wasn't one of those anal Virgos that she theorized that odd couples on the Felix-and-Oscar model should never mate. As we drove all over Manhattan with my NYP plates, the fifty-fifty wheel-time program turned her into a more intrepid driver. After all, she too was an Aries, albeit "on the cusp"—born April 20, 1945, three years and two days after me in the very same St. Vincent's Hospital, which for my mom was a prestige destination and for hers the neighborhood place.

Sex was hot, crucial, and engrossing, but not simple—she was pickier and more changeable than I was used to in hot relationships, and my faulty pleasure receptors, while not impinging on my performance quote unquote, generated emotional disconnects as they gradually righted themselves. But Carola's special bounty was how intently she insisted on her own pleasure, and although she had to fend me off sometimes, she appreciated my enthusiasm, which never waned even

when I wasn't coming good. And then Joe Koenenn had the lovely idea of an April visit to Jamaica to report on the reggae music he'd been reading about. With Carola doubling as photographer and consultant on British ex-colonials, I became the first non-Jamaican to interview dub visionary Big Youth, whose six hits that month my Island Records contacts considered a fluke, and who charged seventy-five well-concealed expense-account dollars for my visit to his muddy, dusty, no-plumbing-or-electric Trenchtown yard. We suspended our marijuana restrictions under circumstances that included reggae Jesus Bob Marley rolling a cigar-sized spliff in a page of *The Daily Gleaner* and reggae John the Baptist Joe Higgs cooking up ackee and saltfish while reasoning through the story of the prodigal son in terms that seemed crystal clear at the time. The ganja didn't make us stoners any more than the Red Stripe we got into made us drunks. What did happen, however, is that Jamaica turned us into sex gods. Every night, straight more often than not, we'd get into bed and fuck like we'd just gotten the hang of what this equipment was for. It was so easy and so mind-blowing we barely talked about it. We just did it.

We never forgot that euphoric connection. But it was so intense that back in New York it backfired on me. Never one for manners or small talk, I'd made a practice of ignoring Ellen at musical events, and in March she'd sent me a hurt letter about it. I wrote back explaining that I couldn't trust her with the feelings she still aroused in me and that my priority was sparing Carola pain, adding with suspiciously reckless candor: "Carola is as remarkable a person as I've ever met, and I love her, but I don't love her as much as either of us would like; as she says, I'm not hard-to-get, but long-to-get." By late May, in fact, Carola and I were sparring plenty. And then Richard Goldstein invited us to a party. Because Ellen and Steve would be there, I told him we couldn't go. But he talked me into it, and Saturday night there I was alone with Ellen on the stairs outside his apartment. I remember not a word except that

we'd missed each other, but I left believing that she wanted to give our relationship another try. This tormented me—there was an excitement to the way her mind worked that I missed so much, or thought I did. So I spilled to my therapist, who this time came back with a challenge rather than a question. If I thought Ellen wanted back in, why not call and make sure? The phone was right out in the hall.

I sat in that hall for quite a while—however long it took me to think over the life Carola and I had made and recognize that I didn't trust Ellen as far as I could phone her. So I never dialed her number. After Ellen began working at the *Voice*, I got to where I could converse with her once in a while, usually about the paper. But we wouldn't be anything like friends for twenty years.

The timing of these emotional maneuvers was tight, because my acid revelation on the LIE had stuck with me so vividly that I'd worked out a deal with *Newsday*. Remarkably, I'd been granted a six-month leave and got to nominate a replacement I conceived as splitting the *Newsday* gig with me in perpetuity: Dave Marsh, who—having served as de facto editor of the supposedly collective *Creem* as Lester Bangs redefined the mag by force of personality—was ready to go pro, and to occupy our apartment while Carola and I drove the Toyota through twenty-three states and two provinces. What proved my final cross-country road trip lasted into October and included extended stays with friends in L.A., Berkeley, and Laramie, Wyoming, where Kit was teaching while George wrote and househusbanded. We visited our *Oui* editor in Chicago and the *Creem* house outside Detroit and, early on, Joe Koenenn's parents' house west of Biloxi, whence we'd transport my bored boss to New Orleans, capping off a guided tour that ended with Sazeracs and a full dinner by taking him home and then retracing the seventy miles to our cheap motel. We feasted on the most sumptuous peaches

of our lives while waiting five days for a new engine in Florence, South Carolina, and made out in the Rio Grande mud of Big Bend National Park—where we also took a trail ride with *Voice* staffer Paul Cowan's family, after we ran into Paul in the coffee shop. We traveled with LPs and a suitcase stereo so I could keep Consumer Guide-ing and a Styrofoam ice chest stocked with local yogurts. We got along much better than Carola and Tina had.

Yet it wasn't what it might have been because I'd been such a chump about Ellen. In fact, it was a miracle that Carola managed to be both game and into it while tending a big hurt that left a big bruise. It didn't help that my sexual anesthesia was in effect all the way to Laramie, where to our mutual delight it lifted sweet as you please, never to return for more than a bad day or two. Maybe this was because I loved George and Kit as a couple and a family too, maybe just because it was time—in the end, those three months had been as good as I'd hoped in a way I hadn't dared expect.

Carola and I were never apart much in New York anyway, and we did considerable writing in Berkeley as well as some in Laramie and Detroit, where Lester dubbed us the Scott and Zelda of rock criticism and Carola held out for John and Yoko. But even so our togetherness approached 24/7. And although we certainly quarreled about our relationship as well as arguing ideas—Carola's propensity to both stand up for herself and throw the occasional snit was foundational—I never got tired of her nor her of me. I'd developed excellent skills while pursuing the collegiate ideal of Just Being Alive. But Carola was a genius at it. I'd never met anyone so engaged. She noticed so much, laughed so easy, cared so deep, and with or without the aid of an actual work of art, her aesthetic responsiveness was unending. All these gifts she put into her loving—and her liking, which since she was meeting many of my friends for the first time eased our way. She even did me the honor of playing word games as we hauled ass from Carlsbad Caverns to San

Diego in one long run with a mysteriously sockless young African-American hitchhiker in the backseat.

When we returned to New York, we'd gotten to some other side personally. And we were headed someplace professionally as well. Carola plugged away at the ashram memoir we'd entitled *The Woman Who Studied Yoga*, submitted "A Misunderstanding" hither and yon, pursued journalistic opportunities, and poked at a novel based on her road trip with Tina that she'd begun in the Marcuses' attic. And before moving to *Esquire* and scoring us our final food collaboration for the college issue, *Oui* editor John Lombardi assigned my crucial Al Green profile. During the pre-Beatles day-the-music-died period, I learned, the pop charts had been creased by not only Motown artists in profusion but a full complement of "soul" singers, who from James Brown to Curtis Mayfield to Wilson Pickett to Aretha Franklin had propelled many minor hits onto the *Billboard* chart—often toward the bottom, but whose fault was that? Varying a theme I'd explored at *Newsday*, I concluded that the history of pop looks different when you don't limit it to winsome white boys like Buddy Holly and the Beatles, whose quality was indubitable but whose primacy they themselves would instantly deny. That's not the only reason my lengthy profile ultimately appeared in Boston's *Real Paper* rather than the higher-paying *Oui*. But it's certainly one of them.

And then in November, culminating a year of prep work, I had my own collection just like A. J. Liebling and Pauline Kael: *Any Old Way You Choose It*, brought to Penguin by onetime *Commentary* hand Harris Dienstfrey. Dienstfrey had already published fine books with Charlie Gillett and Peter Guralnick as well as working with Greil, who hooked me up, and in the days when books were actually edited taught me little things about grammar I'd never noticed. In addition, Carola inspected every word of the copy I was always sharpening and oversaw the introduction-as-overview "A Counter in Search of a Culture,"

which marshaled such keywords as "contingent," "persona," "pleasure," "democrat," "bohemian," "antibohemian," and "theory of pop" as I finally took the bit and explained what the hell I thought I was doing. The last-written selection pointed forward with the then-unrecorded New York Dolls, who'd quickly become my favorite band after Joe sent me to see them at the Mercer Arts Center: a gang of scuzzed-out, glammed-up proles from my parents' old nabe led by my opposite number from the outermost of the outer boroughs, Staten Island: polymorphous comedian-savant David Johansen, whose wit and heart and spiritual appetite would fuel the two-album oeuvre I'd celebrate in Greil's *Stranded* anthology, and who after an indomitable solo scuffle would bring the Dolls back as the Buddhist comedian-savant I'd celebrate in my very last essay for *The Village Voice*. But that was 2006. In 1973, the Dolls could only be followed by a tribute to my top ten singles of 1972, which at Greil's suggestion I resequenced bottom-to-top so it ended with the O'Jays' "Back Stabbers" and a warning: "Trust your brother, but not too damn much."

With its Chuck Berry title and desperately-seeking-currency Lennon-Mitchell-(Alice) Cooper cover, the paperback-only *Any Old Way You Choose It* was widely and positively reviewed in the rock press (although not *Rolling Stone*) and got good ink elsewhere, most auspiciously *The New York Times*, where the recently arrived John Rockwell adjudged me "pushy" and "flip" but concluded that I could both think and write. I'd never met Rockwell, so Karin Berg bought us lunch on Elektra, launching a friendship that's suffered scarcely a bump in forty years. Rockwell was raised by well-off but devoutly New Deal parents in San Francisco, and long after his Harvard BA and Berkeley PhD retained the accent of the Andover boy he also was. Artistically, his deepest craving is for classical music. The eye he lost to cancer at age two contributes to his distracted air. But his sensibility is as omnivorous as his intelligence, and his friends all share the pleasure of knowing

how well he treats his friends. With the obvious female exceptions, I've never known anyone easier to talk to.

Intellection consorting with slang, exposition with a crush on the punch line, the persona as aesthetic actor, the audience as aesthetic factor, the audience as political microcosm, reporting shading into criticism and vice versa—all these approaches to taking fun seriously surfaced as the boomer boom ended and a multitude of quasi-bohemians scuffled for paying work they wanted to do. Every one would have surfaced whether or not *Any Old Way You Choose It* had concentrated them in book form. Nevertheless, people I'm proud to know have told me that it was my collection that seeded their own rock-critic dreams. So did a Nassau County twenty-year-old I'll call Stephen O'Laughlin so as not to spell his name right, who entered my life at a sparsely attended signing near *Newsday*. But well before I got over the thrill of seeing, feeling, and surreptitiously smelling a brand-new book with my name on the cover, I'd begun to think more concretely about a fantasy I'd long mulled with Carola: a showcase for the varieties of rock-critical experience.

Proposition A: If *Creem* was a circus, *Rolling Stone* was a forum, and while Carola had taught me I was a circus guy at heart, I remained a forum guy in my head, plus there were writers absent from both venues who were good enough for either—Paul Nelson, then proudly sacrificing his unlikely a&r gig to the New York Dolls, or Tom Smucker, who'd taken to sliding in some Lawrence Welk when we went out to Astoria to watch Mary Tyler Moore with him and Laura. Proposition B: Every week Carola and I perused a local paper where an old friend and I had both once chronicled the pop beat with some aplomb. There we learned plenty about lifestyle politics, something about power politics, a bit about movies, and next to nothing about pop music, and not just because Annie Fisher's deadly Riffs section favored the folkier and jazzier precincts of the rock "scene." Ergo, C: Why not transform Riffs into a place where livelier writers could promote their passions, float their ideas, and

kid around? But when I alerted *Voice* managing editor Ross Wetzsteon to this possibility, all he could do was take it under advisement—there were internal politics roiling there I still don't understand, although I know he considered Fisher a disaster. So I shrugged, stuck with my excellent day job, and put more money in the bank.

Looking over my 1974 *Newsday* portfolio, I see quite a few second and third pieces on artists I'd nailed the first time as well as awkward conceptual stretches—a jaunty but oft off-base roundup of twenty "heavy" bands, a three-quarter-assed retry at giving the Who their precise portion of respect, a preliminary attempt to understand Frank Sinatra. I see the birth of Dick Clark's populist American Music Awards and Allan Pepper and Stanley Snadowsky's biz-tailored Bottom Line club. But I also see a Sunday feature on lay musicologist Henry Pleasants, whose *The Great American Popular Singers* showed slummers like Ned Rorem and Wilfrid Mellers how to apply epicurean values to vernacular artists, and a pan of Sly Stone's nuptials with Kathy Silva in—yes, this did happen, and I was there—Madison Square Garden: "This is the only wedding I've ever witnessed where the bride appeared first and waited for the star to show. And although I was glad that Sly's home bishop, or rather, his mother's home bishop, officiated (rumors had given the job to a San Francisco disc jockey), it would have been nice if he hadn't called the bride Kathy Sylvia and Cynthia before getting her name right." My dad liked that one so much he kept it in his wallet.

Marriage was on the musical agenda in 1974. Released just before Christmas, Al Green's *Livin' for You* followed the title single with a "witty elaboration of [an] already intricate mesh of words and voice and music" called "Let's Get Married," shortening it by a minute to save the entire associative outro and stress its kinkiest line, which was "Might as well." Dylan's *Planet Waves* topped *New Morning*'s parental-sex paean "One More Weekend" with a song about feeding the baby at night called "You Angel You" and went out on the conflicted, unequivocal "Wedding Song." All that pain and passion, I told Long Island, was

"directed at the same person in different moods," troubling memories included. Following through on these thematics, I overrated Gladys Knight's *Claudine* soundtrack after falling for the movie, in which a welfare mother fell for a garbageman.

Beyond these personal preoccupations, there was more general excitement on the daily critic's round than propagandists for the up-and-coming punk and disco tendencies have the spiritual wherewithal to know was there. Before March was over I'd witnessed two life-list arena-rock shows, the Uniondale stop of the breakneck Dylan-Band tour memorialized on *Before the Flood* and new superstar Stevie Wonder's illimitable March 25 Garden concert. On *461 Ocean Boulevard*, Eric Clapton added sleazy blues backbone to the passive languor with which the hippie wing of the counterculture negotiated the '60s' crack-up, and although he wasted too much of what remained of his long career tinkering with the formula, that album remains a seductive argument for the laid-back ethos. In its way, so does protofeminist blues gal Bonnie Raitt's adaptation of Chris Smither's "Love You Like a Man," trumped in 1975 by her rendition of John and Johanna Hall's "Good Enough," as humane a song about long-term sex as was ever written, no matter that the Halls eventually divorced.

Although the post-psychedelic Clapton and the roots-respecting Raitt were both taken as proof of the home truth that the blues were eternal, the blues also flourished beneath the hubbub of the New York Dolls, who Carola and I witnessed live at least a dozen times during their brief time on earth—and who for all their camp, glam, and punk-oid aggression gave classic r&b more love than any major act of the decade with one huge exception: Bruce Springsteen. Before I even left *Newsday*, I'd thought Springsteen was going places from both Max's Kansas City and the Westbury Music Fair. But unlike Jon Landau, I certainly didn't foresee his "rock and roll future" as an international superstar only a prig or a poptart could disrespect. Asbury Park's favorite son was such a force he would define the careers of two major

rock critics: manager, strategist, and producer-collaborator Landau and biographer Dave Marsh—whose wife, Barbara Carr, would establish herself as Landau's second-in-command as her husband evolved into a political gadfly who took as his critical mission the promulgation of the class identity and r&b tropes he pugnaciously and recalcitrantly insisted were rock's core values.

But the other two linchpin artists of the early '70s—I'm omitting David Bowie, sue me—portended a less auspicious future for blues. The lesser of these was the meta-ironic UK art band Roxy Music, who were more consistent and less mercurial than Bowie, especially after they bifurcated into Bryan Ferry and Brian Eno, the latter of whom was among many other things Bowie's most astute collaborator. And the two guys whose 1974 album provided months of breakfast music were equally classy gents—in fact, since unlike Bryan and Brian they weren't working-class art students on self-betterment campaigns, classier: suburban musos from exclusively exurban Bard College whose dry, congenial cynicism suited a musical zeitgeist they didn't know was there themselves.

Just as the heedlessly unschooled Dolls presaged the primitivist punk that would ultimately transform semipopular music into a cultural stronghold, the scrupulously virtuosic Steely Dan presaged the high-overhead AOR that made punk's rough stratagems a matter of musical life and death. Yet somehow, in thirty months spanning the four calendar years 1972 to 1975, they released four albums we never stopped playing. Rather than looking back at their strange pop moment, I'll condense our respective attempts to make sense of Steely Dan in situ. Mine was written in 1975, shortly before they withdrew to the studio like they were the Beatles or something. Carola's is from 1995, shortly after they contemplated their balance sheets and returned to the road. I've put our passages in quotation marks, but that didn't stop me from fiddling with them slightly as needed.

Without reintroducing the term "semipopular," mine pondered the progress of that concept since I'd first raised its specter four years before. It also did musical detail my way.

> In a fever of indirectness I once referred to Steely Dan as the Grateful Dead of bad vibes. The perfect tag, really—not only was it impossible to know what it meant, it was impossible to tell whether it was complimentary. What the band is up to is so elusive that, having absorbed their disenchanted boogie over hundreds of hours of listening pleasure, I still can't think of a better hook. And however much Steely Dan deserve ambiguity, they also deserve a hook.
>
> Like all good Steely Dan, their three hits sound unconventional, yet somehow familiar. Bass lines and guitar bits echo half-identified through the forebrain, defining a rock impulse unaccountably tinged with jazz; the singularly poetic and acerbic lyrics go unnoticed at first, then take shape as riddles which turn out to have obvious answers, or no answers at all. The gestalt is unmistakable, yet something about it is deliberately anonymous and MOR. Even at its rockingest the beat rarely blasts or blisters, leaning instead toward a suave suggestion of cocktail swing. The distinctiveness of the solos isn't so much personal or expressive as functional. The vocals take on so many overdubs and harmonies that even when Donald Fagen's lead dominates as it comes from the speakers, it tends to sink into the mix in the mind's ear—the golden mean of pop ensemble singing, only stripped of histrionics and shows of technique, almost . . . sincere, modest.
>
> The risk of such musical anomie is obscurity. It goes against those standards of sound engineering in which cleanliness and specificity, every nuance in outline, signal the-survival-of-the-individual-in-our-overmechanized-world-today. But the reward of Donald Fagen and Walter Becker's sound has proven to be the hit singles themselves. Roxy Music may explore the notion of pop, the New York Dolls the notion of the hit, but only Steely Dan is willing to blend into a top-forty radio grown as idiosyncratic as an Interstate. The facelessness of this music is an aspect of the band's

identity, maybe even a conscious camouflage. It annoys observers who equate art with "self-expression." But it works as an affirmation. It is the less that permits Steely Dan's more.

For not only does Steely Dan slip the usages of bebop and symbolist poetry into the hummable amenities of the hit single, it does so while embracing masscult at its dreariest. On the most superficial, heard-in-the-background level, the band sets up expectations of banality. Then it violates them joyfully, again and again. Never solely suave or functional, the music is full of clever, sometimes disquieting harmonic and rhythmic surprises; the sour intelligence of the lyrics belies the bland cheerfulness implied by the sound of the voices. For the listener, the end result is an intelligent, sometimes disquieting elation. This effect is more symbolic than real. But I'll settle.

Without using the term "late capitalism," Carola's 1995 piece celebrated and satirized the peace we and our allies had made with the pseudo-prosperity AOR epitomized.

Filing into Roseland to hear Steely Dan, I think of Lester Bangs's Elvis obit: "So I won't bother saying good-bye to his corpse. I will say good-bye to you." The last time I saw this band in concert was just months before they launched almost two decades of not touring. But they didn't go away. They spent their seclusion in my living room. They spent it in my car stereo, on my chiropractor's sound system, in department store boutiques. When I closed my eyes for plane takeoff or opened my mouth for the high-speed drill, they were there, smelling like mouthwash and Herculon. But this is the first time I'll share Steely Dan with a live audience in twenty-one years. So I don't bother saying hello to Steely Dan. I say hello to you.

This is the Steely Dan story: technopathic misanthropes, easy to misunderstand, their music somewhere between "too cheesy" and "too bizarre." As Fagen lamented upon the release of *Pretzel*

Logic: "We've more or less abandoned the hope of being one of the big, important rock groups." This explains why they have five platinum albums. This explains why they are so hard to explain that conventional critical wisdom, always stressing how hard they are to explain, always makes the same easily understood points.

"Hippie muzak," "boprock"—the strange bedfellows argument. Under this murkily elegant band lurk even murkier secrets, such as glee club harmonies and Les Baxter. Under the impenetrable sadness, Danish modern. Under Horace Silver, Burt Bacharach. Under Wayne Shorter-era Miles Davis, *Sketches of Spain*. Hipsters in secret love nest with rink-a-dink. Some secret—the word "cheesy" gets more play in the Dan press kit than in *The Betty Crocker Fondue Cookbook*. Becker and Fagen shuffle musical and verbal cliches with merciless irresolution until the suspense is killing me: it's generic, no it's lovely, no it's Steely Dan! This doesn't even puzzle me any more. What does is why I can't put my finger on whatever it is in the music that links me to its millions of other fans, and what this says about them—and me. Questions flit across my mind like shy conversations on a first date. I like waiting rooms, how about you? I actually like 'The Shadow of Your Smile,' how about you? Astor Piazzolla, how about you?

"We're playing old stuff," Fagen quipped, "because we don't have any new stuff. We're taking suggestions for song concepts." Here are some of mine. Formally, try shorter and fewer sax fills. Thematically, the Apple of the '90s oozes Steely Dan potential. Main Street, Flushing. Russian gangsters run a jazz club (Moscow or Brighton Beach, your choice). Rock star (male) marries corporate lawyer. The demise of Medicare. Or leave New York and try Bordertown. See you when we see you, boys. And where.

I could have stayed with *Newsday*, and done good work there too. But it was turning into a grind; no Steely Dan myself, I missed writing for my hipster homies, masscult be damned. So I jumped when in late June the internal politics of the *Voice* took a startling turn. The paper,

which had been sold for mucho dough by Dan Wolf and his partner Ed Fancher to Vanderbilt scion and liberal pol Carter Burden in January 1970, had been sold again—to Clay Felker! After the *Trib* went under in 1967, Felker had transformed *New York* into a weekly glossy. It was never as profitable as he pretended, but expansion was his way— he'd always been a spend-money-to-make-money high liver and star-schmoozing celebrity rider. Without Carter Burden's patrician cool to put a reassuring surface on it, this scared the bejeezus out of most *Voice* old-timers, and it certainly had its downside. But it boded well for Riffs.

The official date of sale was June 5, 1974, the official date of Ross Wetzsteon's elevation to executive editor July 22. I assume but don't recall for certain that I called him or vice versa before the latter date. A few other things I'm surer of. I'm sure that Carola and I drove to Brighton Beach one hot weekday, whence I called Wetzsteon from a pay phone to discuss some aspect of the job of *Voice* music editor. I'm sure that I gave *Newsday* two weeks' notice and must have spent at least a few days doubling up. I'm sure Vince Aletti on the Jackson 5 led the otherwise old-style August 1 Riffs, and that Meltzer on Waylon Jennings led my first full section August 8. I'm sure I was hired along with new arts editor Richard Goldstein, and followed shortly by new senior editor Karen Durbin. I'm sure that for the privilege of tackling this taxing job I took a pay cut of nine grand. And I'm sure I never regretted it. But this chapter is about horses and carriages.

In November or so Carola and I had done some thinking and realized that she'd never gotten pregnant and I'd never knocked anyone up. On the one hand *Roe v. Wade* had come down in January, and on the other the Marcus and Szanto kids had reminded us how much we wanted children of our own. So with nothing to lose she put away her diaphragm and I my condoms. That March we adopted two kittens from our in-laws Joy and Larry and pampered them like babies—even took them on car trips. But not on the September vacation I'd made a

condition of my *Voice* employment—Yanks at Fenway, Uncle Harv's egg farm in Maine, getting my face wet at my first lobster pound, Quebec by ourselves and Montreal with McGill hire George Szanto. And one morning back home I looked down at Carola on our double mattress on the floor and felt an impulse. The light was gray, I remember, and we must have made love sometime in there, and I just have to describe the face I was peering at. Broad forehead, high cheekbones, longish nose with a slight bump I love, alert and playful eyes shading cobalt to gray to green, and that welcoming mouth—those are the documentable facts. Exactly what promise I saw in these features I'd be making up and you wouldn't believe. But whatever it was, I was right. So within seconds I said, "Want to get married?" Said Carola: "Sure."

It was a busy three months to the date we chose. Telling my tickled parents at Joe Allen's in the theater district. Carola complaining to the bar association so the lefty lawyer she'd hired would finally finalize her divorce papers. The many consultations regarding how best to assure that her surname would remain Dibbell. The NYCLU enlisting us to challenge the Manhattan county clerk's asinine brides-must-wear-skirts rule, and the velvet suits we bought—hers pigeon gray from a tailor, mine royal blue from Alexander's—in case we won, which we didn't. Instead we were legally wed in the chambers of a civil-libertarian judge early on Friday, December 20, and that night Bob and Marylin hosted our professional party, rockcrits and bizzers and the many *Voice* folk we enjoyed, catered by Shah Bagh, cheap pioneering outpost of East 6th Street's Little India.

The wedding that counted was a home affair at Jones Street the next day for forty-odd guests, including Greil all the way from Berkeley and Dominique hugging me at the door. It was catered by our families, from the wheel of brie and jorum of Jack we splurged on to Aunt Mildred's deviled eggs to a three-sectioned wedding cake baked and constructed by Hope and evoking not a castle but a highway cloverleaf.

Four couples—Hope and Charlie, George and Virginia, Joy and Larry, George and Kit—delivered the Book of Common Prayer rewrite we'd thrashed out between wording disputes. Larry read the intro: "Dearly beloved, we are gathered here together in the face of this company, to join together this man and this woman in matrimony; which is an estate instituted by humankind to perpetuate an erotic relationship within society, and to foster the continuation of society. It is not entered into lightly, but reverently, advisedly, joyfully, and hopefully, in the spirit of the marriages to which each of them was born." Kit read the envoi: "Friends, send your blessings upon these fellows, this man and this woman, whom we bless together in this glad ceremony; that they, living faithfully together, may surely perform and keep the vow and covenant betwixt them made, and they may ever remain in human love and struggle together, and return our blessings to us and to human history. And if they should enjoy the gift and heritage of children, may they raise them after the truth of their own experience, with the energy and unselfishness with which they themselves were raised."

We kissed deep, ate hearty, drank more than usual, and while dancing—Carola is the only woman I'll dance with, because she knows how to lead and everyone watches her, not me—doffed our matching ruffled shirts to reveal the matching T's she'd had made: blue with the single word MONOGAMY reaching to our hearts in white. For we were aware that as sweet and inevitable as getting married felt to us, it was also, in that peculiar subcultural moment, an ideological act. We knew many married couples, but none of '70s vintage—for five years no one in our little world had elected to validate that supposedly sexist institution. So having replaced God in our vows with the flawed, loving human beings we knew to be the source of our faith, we also took care to specify our linked commitment to eros, struggle, and history. But we savored that traditional diction, too—"betwixt," "glad ceremony," yeah. Divorcée Carola experienced Shelter Island as the

locus of our commitment, but for me that winter solstice afternoon at 26 Jones Street was the deal. In that peculiar subcultural moment, many shunned the supposedly male chauvinist "my wife." And I admit, the word felt pretty strange. For weeks I kept saying it to myself—wife, wife, wife.

10

FOUR OWNERS, SIX EDITORS, ONE PAPER

Not to waste time on sectarian squabbles that have been dwindling into irrelevance for decades, but like most bohemian enterprises, *The Village Voice* has inspired more than its share of golden-ageism. Just as the "real" bohemia is always said to be stuck in an irretrievable past cruelly wracked by modernity and commerce, readers and contributors cherish "real" *Voices* that go back to automotive columnist Dan List distributing the paper from the back of his Hillman. So I'm obliged to assert what I believe: that the *Voice*'s heyday wasn't the Dan Wolf years, worthy though they were even after he sold out to the feckless Carter Burden, but the Felker and God help us Murdoch and gradually contracting Leonard Stern years. The *Voice* I rejoined in 1974 was a case study in economic expansion engendering cultural ferment—all over the paper, we gained more good writing than we lost. And in music, the differential was huge.

I first encountered "real" *Voice* syndrome before I started writing there, when I kept meeting people who "used to" read the *Voice* and noticing how often their complaints said more about what had happened to them than about the thriving newspaper itself. Admittedly, after I was fired in 2006, I myself never got back in the habit. But the paper certainly shrank by every objective measure after its hostile takeover, and that's as far as my golden-ageism goes. Sometimes I would read it more, sometimes less, but my "real" *Voice* ran 1955–2006. It's been popping up in this narrative ever since I was in high school because it was essential reading for a New Yorker of my generation and cultural outlook. It certainly helped that this eccentric, seminal, gutsy New York weekly was what many in its fractious cadre like to call a "writers' paper." But that can mean many things.

Put simply, as the meaning of "New Yorker," "generation," and "cultural outlook" evolved, the *Voice* was compelled to evolve with them. There were always new artists, media pros, and college students coming into the city, and these trended inexorably younger, with changing notions of what art, culture, and education meant, particularly as regards pop. As the demolition of rent control and the onslaught of the banking industry transformed Manhattan into the unaffordable place to live it is today, Greenwich Village changed with these changes, only more drastically. And politics changed too—although the *Voice* is often pigeonholed as a left-wing rag, in fact Wolf and many of his proteges were contrarian liberals who edged rightward during the '60s in the manner of early *Voice* hero Ed Koch, the Villager who became mayor in 1977 and hired the belatedly wealthy Wolf—who earned little or nothing from the paper long after it began—as his dollar-a-year aide de camp. Instead the *Voice* was radicalized during Felker's brief reign, with the principals the leftward-ranging Goldstein, Ellen Willis's close friend Karen Durbin, and to a lesser extent myself—plus, crucially, press columnist Alexander Cockburn, a Wolf hire Wolf's minions deride as

a radical opportunist, which indeed he was, but an opportunist who never got rich and could write backbiters under the table on a three-hour deadline. The *Voice* was not a left-wing rag. But we three newbies and many to follow made sure left-wing reporting and analysis were essential to its mix.

One reason this change was major was that Dan Wolf's notion of what it meant to be a writers' paper was the most radical thing about him except how much he didn't pay. In theory, his code was to publish whatever his writers brought him without laying a pencil on it. In practice, he was more manipulative. Having brought the writers in to begin with, often via the unsolicited submissions he had a genius for winnowing out, he'd generally talk stories through before his proteges went out and got them. Nor was he above ensuring that major events got their column inches, as was only sane, or freezing out contributors who displeased him, as was mainly passive-aggressive. About the pencil-laying, however, he was consistent. Done right, as it usually isn't, pencil-laying is very labor-intensive, and even if Wolf had had the skill he didn't have the time. Felker believed in it—more by 1974 than back when he was overseeing his own weekly with minimal help. I believed in it a lot.

My idea of a writers' music section was to assign reviews using artistic-value, coverage-expansion, or writer-subject criteria while remaining wide open to pitches. But I laid a lot of pencil—more than anyone there except, eventually, *Village Voice Literary Supplement* visionary M. Mark. Let me add two provisos, however. First, because I believed rock criticism needed more new blood than other kinds, I brought in more untried writers than anyone, and untried writers require line editing like none other. Second, I always worked in direct consultation, and was religious about helping writers say what they wanted to say in their own voices. At times I'd quarrel with opinions or ideas I found cliched, ahistorical, in-consistent, or egregiously wrongheaded—Gary Giddins and I had some

donnybrooks about mass culture in the first six months of what turned into the most rewarding editorial relationship of my life. Occasionally I won. But winning wasn't the goal, and more often I'd end up strengthening arguments I personally found less convincing than did contributors I'd brought in because they were worth arguing with.

Thus I was the opposite of Diane Fisher, a proud and defensive anti-intellectual music fan who claimed never to read the rock or underground press. The *Voice*'s layout chief and nominal back-of-the-book editor well before she launched Riffs in 1968, she was an early adopter of the saw that "record reviews are just more verbal garbage about a nonverbal art." With Riffs she fell into the familiar pattern of fannish enthusiasm jaded by more experience than she could stand, so that first her own writing petered out and then her oversight slackened. By 1974 Riffs was a crude aggregation of going-out reports, mostly club stuff—folk-rock, jazz, cabaret, folk, blues. Album reviews were sporadic, and beyond random '60s totems and rock bands, the section gave short shrift to actually existing popular music and ignored or despised the resurgent post-soul of Top 40 radio. With the major exceptions of jazz specialists Gary Giddins and J. R. Taylor and office kids James Wolcott and David Tipmore, the writing was drab and idea-free, with a folkie hack I have no desire to insult by name granted a weekly roundup as a reward for extruding the grayest prose of all. Wolcott's *Lucking Out* recalls that Fisher didn't assign the pieces she published, just picked winners out of a folder of unsoliciteds on her desk. Sentences like "For this reason it is the most accessible on the record, with perhaps the best chance of succeeding" went unmarked unless they began a graf, in which case she would inscribe the copy editor's traditional L-shape under the first word while continuing to talk on the telephone.

There were more lames in Fisher's posse than anywhere else at the paper, especially as she disengaged. But all the *Voice*'s stars ran off at

the mouth, and as a slob in life who's a neatnik about his own copy, I solemnly vow that any writer including me can benefit from a writer-friendly edit—word-by-word fine-tuning respectful of personal rhythms and diction that sharpens language and enlarges ideas. In this I found Goldstein intrusively tin-eared early on, although I'm told and believe he lightened up, but Durbin—who'd met Willis as a menial at *The New Yorker*, where line editing is a monastic practice—certainly had the gift. And Mark was a master. That's why I asked her to edit me while she was still in the copy department, with which I engaged in so much back-and-forth about punctuation that she once gave me a box of marzipan commas for Christmas. Saddled solely with features, Goldstein and Durbin worked harder on structure than me. Structure is less problematic in reviews, which are shorter and more narrowly focused, which is doubly fortunate because the Riffs I loved best were stretches, from Richard Meltzer cataloguing Beatles collectibles and Tom Smucker analyzing Roosevelt Raceway's sound system at the outset to Lester Bangs absorbing Tangerine Dream through a cough-syrup scrim and Dave Hickey consulting an imaginary skateboarder named Marvin when we were in gear.

With structure a given, pace was paramount. I regularly condensed basics and deleted dull words so brighter ones shone, and quickly got used to paring down leads, which writers often overload while figuring out what to say, and fixing up endings, which writers often skimp on after dallying too long with the lead. But mostly I just noticed when something wasn't quite right, from commas to rhythms to word choices to ideas to entire arguments, and explained every change I imposed or requested, at length if necessary. I don't know exactly where I learned this. Although I'd gotten my share of expert once-overs, only Ellen Willis and Harris Dienstfrey had sunk their teeth in, and gently. Yet by the time I reached the *Voice* I was examining my own copy so closely that I assumed it was my job to proffer the same scrutiny to everyone else. In 2002 I was presented with a festschrift where a number of col-

leagues extolled my editing style. In the interest of not looking like an asshole, I'll resist quoting them verbatim. But Gary Giddins, Tom Carson, and Dave Hickey (whose MacArthur-storming *Air Guitar*, written long after we parted, I think beats Kael's *I Lost It at the Movies*) all say I got them over the hump as writers. I know they're exaggerating. But there's no way I'm leaving that out.

Socially, the *Voice* was an enlarging place even though I spent half the week at home. Only Ross Wetzsteon had an enclosed office on the fifth floor of 80 University Place, where all the editors except soon-departed metro matron Mary Perot Nichols were stationed, and we regularly chewed each other's ears off on the way to art or copy. Staff writers from the front-of-the-book warren a flight down sniped away as they pursued their perpetual turf war, and so did freelancers in for a schmooze. Felker quickly instituted an alcohol-included Wednesday luncheon for editors and specially invited writers, and Mondays there was a closing-day buffet to cut off unauthorized dinner breaks at the pass. In the office I worked very long Mondays, half and sometimes half-potted Wednesdays, and full Fridays. I always picked up the phone, but never schmoozed except with friends, and was regarded as rude for asking publicists just exactly why we should review their client and telling them why that didn't work for me. But in addition I edited a lot at home. Since Carola and I didn't own even a fan for a while, I often received writers shirtless in the summertime, but not as I recall in my underwear and certainly not naked—the source of that tale, the great Lester Bangs, never let facts ruin a colorful story. Every Riffs contributor had my number and permission to use it, with moderate discretion assumed but not guaranteed—one guy called so regularly that when the phone rang one afternoon while Carola and I were making love we both just knew it was him (and, yes, picked up—there were no answering machines in that primitive bygone). Also, I made house calls, sometimes in the Toyota but mostly on the

bicycle I started riding everywhere. As the weekly close loomed but also for reasons that ranged from jolting the blocked to easing busy lives, this eccentricity was my idea of efficient time management. Waiting made me nervous.

These recollections may seem suspiciously idyllic to the diminishing number of alumni with memories of their own to compare, and for sure Felker left defenders writhing in pain with every broken-field run through the office. A florid, fleshy man, he was disruptive by nature, deficient in the killer calm it takes to win the money games his executive ambition and editorial vision drove him toward—he'd only own the *Voice* until early 1977, when Rupert Murdoch swallowed it by mistake while gobbling up *New York*. And what exactly he was doing there I don't think he ever got a grip on. The few uptowners he'd installed weren't tough enough to prevail against a downtown culture that included not just the three new editors but Wolf-era staffers jeering and sniping from the fourth floor. For our gang of three the strategy was to ignore, work around, and occasionally feed to the beast one of the "trend"-spotting provocations with which Felker hoped to woo the yuppies he saw coming but never got to exploit. Instead we just tried to assign stories, profiles, essays, and reviews with discernible sizzle and point, a goal we all went for in our own writing anyway. So Felker raged and flattered and brainstormed and galumphed until the bottle the Montana-born Wetzsteon hid in his desk no longer sufficed and the poor guy demoted himself to theater critic—and ultimately proved a highly efficient theater editor who also wrote an excellent literary history of the Village. So a year after I arrived, following a few months with Felker throwing a shitfit every Monday, there was a third editor: Lindsay PR liaison turned Rockefeller in-law Thomas B. Morgan, whose *Self-Creations: 13 Impersonalities* I considered the peak of the magazine-profile aesthetic and few of my colleagues knew existed.

I had three major run-ins with Felker at the *Voice*—one public, one private, one in committee. The public one saw Felker chasing me around the office waving an ad for *The Harder They Come* while complaining that our music coverage wasn't "hot" enough and demanding to know why we hadn't hyped budding reggae superstar Jimmy Cliff. Because he wasn't going to be famous, I replied, and then ended a string of overheated "Why?"s by explaining, "Because he's not *talented* enough, that's why." The private dispute, which I stonewalled, dovetailed oddly with the public one: the time Felker snuck a look as I wrote up a forthcoming Apollo bill and instructed me that "our readers," the ones who would slaver over a "hot" Jamaican, didn't want to go to Harlem. Philosophically, that disagreement was the most important—not just because Felker was morally wrong, not just because I had an editorial commitment to black pop, but because the buppies Nelson George and others eyeballed for us in the '80s would soon be shoring up the paper's market share. But the most typical was the editorial meeting where Felker insisted that the two weekly classical critics I'd inherited, Leighton Kerner uptown and Tom Johnson downtown, be rotated biweekly. Always late and infernally convoluted although certainly a nice enough man, Kerner was a trial, but I loved Johnson, and in any case love wasn't the point—I had prerogatives to defend. So I told Felker that our classical reviews added crucial cred to our pop concentration, as was true enough. What was typical was that my colleagues supported me whether or not they read either writer. Dan Wolf we didn't miss. The paper he'd created we were committed to.

Morgan was a good guy and calming presence who only lasted thirteen months himself as Felker continued to throw shitfits over the phone. But I wish he'd been more of the celebrity journalist he came up as and less of the pol he'd moved up to. His sole editorial rule was classic front-of-the-book ideology: every headline needed a verb. This

makes sense in news stories, which describe events, but hogties think pieces, reviews included. True, one of my fondest Riffs memories is the night at Geoffrey Stokes's Tompkins Square floor-through when we shoehorned a tide metaphor into his Phlorescent Leech and Eddie review, thus justifying the headline "Flo and Eddie Flow and Eddy." But "Funkadelic Pee in Your Afro" was no more evocative or accurate a hed for Vernon Gibbs's prophetic P-Funk dispatch from the Apollo than "Average AWB Fans" was for Carola Dibbell's sociological Average White Band report from Avery Fisher Hall. Nor was there a better hed for the final column downtown minimalist Tom Johnson wrote in 1983, long after Felker and Morgan were forgotten, than his own "A Farewell Article." I didn't just permit this strange bird to publish sentences like "At first I didn't like having to go in for editorial meetings every week, and the work itself became more demanding too," I exulted in his commitment to a simplicity devoid of metaphors, semicolons, and fancy-dan adjectives. Ever the it-pays-to-increase-your-word-power guy, I preferred my prose with extra wontons. But Johnson was a Yale-schooled minimalist in full command of an altogether different expository aesthetic perfectly suited to his subject matter—and as a bonus introduced America to the literally revolutionary Prague art-rock band the Plastic People of the Universe. That was the kind of thing I was there to help happen.

Editing Riffs was the most fun I ever had in journalism. With '60s-diehard *Rolling Stone* provincial even after it moved to New York in 1977, metal-trending *Creem* in Lester's shadow even after he moved to New York in 1976, and downtown foe *Soho Weekly News* a bastion of boosterism, the section's range and ambition weren't just unequaled, they were unrivaled. Although we were on punk and hip-hop early, it was never my aim to be hot—to predict "trends." Nor did I feel obliged to celebrate local scenemakers or tender auteurist respect to every failed follow-up, although I made some bad calls in both cate-

gories. My standard was musical quality in the broadest sense, which I didn't equate with technical skill or aesthetic nicety and knew full well involved different strokes for different folks. Above all I was determined to publish *good writing*. Convinced that fresh perspectives— age, race, gender, genre, you name it—afforded species of journalistic distinction that no amount of general knowledge or verbal facility could bring to life, I was comfortable inviting outsiders in because I was always there to correct facts, buttress syntax, juice language, and pull zingers out of a hat. And before long the process got pretty emotional. Good editing is intimate and interactive—you feel people's rhythms, internalize their dialects, meet their nearest and dearest, feed their babies. I made many close friends and hundreds of warm acquaintances via Riffs. After a tough job or unlikely assignment that came up aces, I'd experience a satisfaction that combined byline pride with team spirit and the sweetness of a good deed well done. And it was still easier than writing, you bet.

Since Greenwich Village was the World Capital of Jazz and I was the Dean of American Rock Critics, my first order of business was to guarantee the nonpareil Gary Giddins a tri-weekly jazz column plus all the Riffs he could write, augmenting him with future Smithsonian archivist J. R. Taylor and others who came and went. I brought the Consumer Guide back home and wrote many Riffs and features, payment not one thin dime. I transferred monthly columnists Patrick Carr and Geoffrey Stokes to Riffs without a beef. Greil and Vince and Tom wrote a lot, as did Paul Nelson as his Mercury job fell apart. From the *Creem* side I enlisted Lester Bangs, R. Meltzer, and future *Newsday* rock critic Wayne Robins, from the *Rolling Stone* side Janet Maslin, Stephen Holden, and future New School dean Jim Miller. I was proud to publish NYC's only active African-American rock critic, Vernon Gibbs. I prevailed upon political columnist Nat Hentoff to review Tony Bennett, nominated political reporter Paul Cowan to review Dylan's crucial

Blood on the Tracks, and wheedled arts editor Richard Goldstein into concocting a review that called David Byrne both "a seagull talking to his shrink" and "the kid who held his farts in." Fisher holdovers Frank Rose and Jerry Leichtling wrote often, as did editorial assistants James Wolcott and David Tipmore. Tipmore nominated a young Antiguan with the nom de plume Jamaica Kincaid, who got hincty about Billy Preston, Sly Stone, and Millie Jackson before giving it up to the "very sexy, very conceited, very arrogant" Teddy Pendergrass. I was persuaded by Giddins to bring in L.A. emigre Stanley Crouch despite the poetry I'd heard Crouch declaim while covering an Oberlin "men's conference" for Ms. I deployed NYU senior Ken Tucker to frequent the Academy of Music and reduce a month of crap shows to a feature. A Great Neck eighteen-year-old named Lauren Agnelli pitched me so sassily that she published for years as Trixie A. Balm. Marylin Herzka's eighteen-year-old Perry Brandston explained the "anti-sexual" attractions of Jethro Tull. Having never read a word about the salsa that rattled my airshaft at 308, I asked Jerry Masucci of Fania Records for advice, and instead of finding the Nuyorican expert of my dreams was hipped to British-born John Storm Roberts. Rose Kaplan filed on Indian classical music for a while. I got a cranky letter from a genius in St. Louis named Tom Hull and asked him for the lowdown on Bachman-Turner Overdrive. I extracted a witty Linda Ronstadt review from Cal Arts whiz Sean Daniel but failed to muscle him into budding TV columnist Wolcott's abandoned desk job, whence I swear he would have risen to editor-in-chief. Yalie Kit Rachlis came in on the say-so of Dave Marsh, whose detestation of academia had just been sealed by a tour of duty at Boston's *Real Paper.* Yalie turned NYU prof Perry Meisel gave me his Thomas Hardy book in lieu of clips. My wife and my sister wrote Riffs. *Any Old Way You Choose It* acolyte Stephen O'Laughlin extolled the unsigned Television a year after I arrived. A year later his high school pal John Piccarella weighed in on Blue Öyster Cult.

Skimming the first few years of Riffs and rereading more than I have time for because the shit is good, I see lacunae—editing that could be sharper, still not enough women much less African-Americans, reviews of rockers more forgettable than any of the supposedly ephemeral black artistes I got into the paper. But in all these matters we outdid the competition, and I discern little of the rock-critical circle jerk Diane Fisher was neither the first to snipe at nor the last to imagine. Instead I see the growth of a critical vernacular that mashed up supposedly incompatible discourses to convey a notion of the aesthetic less snobbish and exclusionary and more imaginative and avant-garde than was current at *Rolling Stone* much less *The New York Times Book Review* much less *The New York Review of Books*. The proof of its vernacularity is how quickly and widely it spread, so that in coming decades there were thousands adapting it to their own incompatible needs. And although Riffs had no monopoly on this vernacular, the *Voice* remained its best-case scenario long after my tenure as music editor was over—into the next century, I'd say.

Not counting the Consumer Guide book I turned out in eight months of ninety-hour weeks on a 1980 leave, I wrote less during my tenure as music editor because editing takes time and writing does too. But I also wrote as much as I could, and more ambitiously than I ever had, because at the *Voice* Felker remade so clumsily that prospect was irresistible. It was a place where the writerly new journalism he'd helped conceive at *Esquire* was put to political, intellectual, confessional, and just plain eccentric uses he'd never intended by younger aficionados like we three newbies, a place where the Dan Wolf *Voice* was bent by thirtysomethings who had graduated from the '60s with their pop and political struts battered but intact. Insofar as it was also the heat-seeking consumer-fetishist ad bomb Felker lusted for—which is not to imply that he didn't also lust for good writing, because the man did

love magazines—we all understood this as a price of creativity under capitalism. It was the same kind of economic reality that underwrote ad campaigns for Hal Ashby's *Shampoo* and Bruce Springsteen's *Born to Run*, works of art that put bucks in our collective pocket in 1975—and that I still value as works of art today.

So as 1975 began, newlywed me crushed out two features in a week. One was a barbed takedown of cabaret darlings the Manhattan Transfer that I hope someone else headlined "A Blast from the Racist Past," although the line does approximate as well as sensationalize my sharply argued but shoddily researched gist. The other chronicled the Modern Language Association convention, where ten thousand English profs et al. pondered the shrinking rewards and clashing ideologies of the once cushy career path I'd rejected—and also where the "nihilistic bourgeois elitism" of self-made mandarin-and-proud William Gass and the "good politician" temporizing of MLA president-for-the-nonce John Hurt Fisher both sought to fend off the two-headed populist threat of the Radical Caucus and the Popular Culture Association. As it happened, that threat was embodied in a single person in 1974: a "paraliterature" exponent keynoting the Marxist Literary Group session named George Szanto, who would prove a big deal at McGill before retiring early to concentrate on fiction and publish more novels than any other Dartmouth '62.

Over the next ten years I'd do plenty of *Voice* music writing in addition to the Consumer Guide, which became my chief forum and was better for it—and which I continued to double-dip in *Creem*, where it was read by middle Americans I know today. There were Riffs, profiles, and feature reviews, four major punk-etc. reports, a slab of effrontery about a "rock critic establishment" comprising me and my friends, and the annual Pazz & Jop summums that began in earnest in 1979. But I was also free to explore other interests—major book reviews, baseball and Andy Kaufman and Les Blank and *1984* and Raymond Williams,

and the 1976 "An Ex-Believer Defends Jimmy Carter's Religion"—
about which my fellow secular humanists were the bigots, one of many
proofs being Carter's rejection of the Southern Baptist Convention for
the Cooperative Baptist Fellowship after the Christianist assault on de-
mocracy went commando in the '90s. After Felker was deposed, editors
even started getting paid for writing. Through all its ups, downs, and
hostile crossfire, the repurposed *Voice* rocked.

Carola thrived in this freewheeling environment. In addition to a
passel of Riffs, she published five features in 1975–76 alone, several for
Durbin, who provided crucial structural assistance. The two memoir-
istic pieces about her Manhattan girlhood—one hooked to a back-to-
the-roots Greenwich Village section, the other a piece about Hunter
for a package called "High School Confidential"—have a charm I find
irresistible, as I would. But the most formally remarkable posited what
I'll call a new journalism of fine distinctions.

One was a front-page profile of my old flame Jeanne Moreau.
Unlike Ellen, who scoffed at *Jules and Jim,* Carola admired Cath-
erine's playfulness and pride without deeming her endgame honor-
able or forgetting that the woman she really admired was the actress
who made the character flesh. She especially appreciated Moreau's
approach to beauty, in which the actress shaded her supposedly un-
photogenic face with expressive subtleties it became the writer's task
to describe as the interview progressed, and the vocal nuances that
went with it: " 'Gross' was spat out like a disgusting gobbet from some
fat old man with catarrh. 'War' involved a preliminary pause and a
hushing of the voice. 'Free' and 'freedom' were said with a shiver, as
if to describe a plunge into some cold, delicious pool." And in "Do
Women Lose More Than They Gain Through Self-Defense?," Carola
introduced her report on women and karate with a vision of feminism
atypical at the new *Voice:* "I had learned that I was more likely to get
what I wanted with patience, resilience, obscurity, and paradox than

with force, judgment, argument, and victory. In the women's movement I had discovered that the right to use such 'woman-identified' tactics was a feminist goal."

Well and bravely said. But what inspired the piece was that these tactics had stopped working for Carola the day she'd been mugged more than a year before, which probably happened because she was dressed middle-class for court on what was also the day she finally got her hard-won uncontested divorce. Accosted on the same landing where Ellen had been raped and somehow dealt with it, Carola was untouched yet traumatized, her character structure put seriously out of wack; soon she "dressed like a soldier, walked like a thug, and studied the street like it was a chessboard," replaced "goodwill" with "a little irony around the eyes," and grew to "appreciate the courage and stamina of those who, unlike me, would never be able to move away." Which inside of a year we did.

Carola liked to say that where the karate women had a code of honor, we had a code of cheapness. We pitied friends who got nervous visiting our rough neighborhood, and giggled when an usher inspected my transistor radio at Carnegie Hall only to watch a cockroach scamper out. But even to Carola—the anti-Virgo, the only white in her London bedsit, the baby beatnik whose mother loved thrift shops before retro was an adjective—Avenue B seemed scarier than necessary. It was the year of "Ford to City: Drop Dead," the year my father lost the new job he was so proud of as forty thousand city workers were laid off, and east toward Avenue C on East 8th Street several abandoned buildings and an abandoned lot foreshadowed worse to come. Because a lifetime of thinking about whatever I was thinking about had made me oblivious, because a decade on Avenue B had toughened me up, because I loved my job, and because I loved being married, none of this bothered me as much as it probably should have. But with Carola so spooked that on bad days she'd ask me to climb up to the fifth floor with her and secure her multiply burgled workspace, the idea of a more commodious dwelling place took

on extra appeal. As the weather warmed, we started checking out apartments on the respectable side of Tompkins Square Park.

I'd figure out over the years that the woman who'd explicated the hypoglycemia she didn't have five minutes into our first date and who turned sex into a polymorphous game of button-button with sweetmeats at the end was the same woman whose fine-tuned aesthetic and sexual responses were my manna—and also that she often kept her worries to herself for efficiency's sake, usually to our mutual benefit but once in a while to spill them out in one tortuous flood long after the fact. So she was sensitive—maybe hypersensitive. Yet our first year of marriage was moderately ecstatic. New musical doings were major, but so was her extra-journalistic worklife: she finished *The Woman Who Studied Yoga* and placed "A Misunderstanding" with *The Paris Review*. And so were two of the vacations we find so renewing (when they're not, watch out). One was the Memorial Day weekend we wended our way through the Catskills to Chenango Valley State Park, whose tame, democratic unpretension proved so precisely to Carola's taste that we'd return many times, for a weekend or for weeks. The other was my first trip to Europe.

Committed to a notion of the aesthetic that was American formally, in its affinity for the "mass culture" Europhile savants blamed on us vulgarians, and materially, in its rhythms and scales and slurs and drawls and Airmobiles, I'd long prided myself on steering clear of what Sandy Lattimore spelled Yurrup. But I'd completed my American studies—even spent a foreshortened honeymoon in Washington, DC. And I'd also stopped being such a puritan—given Carola's fluent French, I was pretty sure Europe would be fun. The pervasive ancientness of Rome, the rational drivability of France, two consecutive three-star dinners, and Simon and Gill Frith aren't all we still talk about. We talk about the Coke breaks that sweetened our stomachs, and how I drove the Route du Beaujolais with too much Pouilly-Fuissé down the hatch. I've since returned to Europe many times—even fantasized about a year in

Provence or a month in Sicily. I love the time-tempered landscapes, the food, the socialism. True, it still feels a mite exotic—an oversized historical theme park in the manner of Yellowstone or Big Bend rather than Colonial Williamsburg. But it's almost always fun.

After we got back to the States, a renewed Carola took on two crucial tasks. She found us our first infertility specialist. And marshaling her neatest outfit and warmest smile, she moved an aged real estate broker to pull a hidden file and send us to an elevator-equipped 1903 six-story at Second and 12th. Owned by an aged German immigrant named Martha Schneller and called Onyx Court in honor of the stone that finished a tiled lobby featuring the pseudo-French-classicist mural some pioneering East Villager had traded for rent, it comprised three vertical lines of five seven-room apartments plus a former dentist's office at street level. Mrs. Schneller wanted three fifty a month for the corner unit on the third floor. Our code of cheapness said three hundred. So we crossed Second Avenue and had a beer at the ancestral bar of Warhol superstar Jackie Curtis, Slugger Ann's. OK, we finally agreed—three twenty-five. When our prospective landlady insisted on an extra month's deposit, we conceded. What the hell, right?

Three hundred twenty-five dollars for seven medium-sized rooms at Second and 12th. Correct for inflation all you want, then understand what a different place Manhattan used to be. Within a year, three more such apartments would empty, and three more rock critics—Vince Aletti, Tom Smucker, and young Kit Rachlis, whose musical specialty soon gave way to broader editorships—would move in around us. For the decade-plus after 1975, Second and 12th was definitely a mixed-use neighborhood. Three or four prostitutes worked the busy crosstown street, including two transvestites given to shouting cross-talk in the wee hours, and during the crack epidemic a pair of jumpy little dealers fended off the Second Avenue chill on our front step for a spell. But

we were never mugged or burglarized there. Mrs. Schneller died a few years after the building went co-op in 1985, and in 1992 Georgia and her husband, Steven, bought her apartment.

The same night Richard Meltzer presented me with the copy of Kant's *Critique of Judgement* I never finished, he urged us to go see Television, who were connected to his Blue Öyster Cult buddies via Patti Smith, inamorata of both BÖC's Allen Lanier and TV's Tom Verlaine. So we caught them at Max's and thought they sucked, as by all accounts they often did back then, which doesn't mean I was right to leave it at that. But when the same Patti Smith embarked on a seven-week March-April stand at a refurbished version of the dive where Carola and I had connected post-Cockettes, we checked in early and came back often bringing friends. Barely aware that Smith's rock writin' had appeared in *Creem* but a collegial fan of critic-guitarist Lenny Kaye, I'd enjoyed her before—at St. Mark's Church and a West Village spot where some folk victim put his hands together to keep time, I cracked, "What is the sound of one asshole clapping?," and she laid out for a beat or two to reward me with one of her delighted cackles. But at CBGB, for that was the new name of the beer-bar, she'd added second guitarist Ivan Kral and, crucially, Jay Dee Daugherty on occasional drums. She had a band and I had a rooting interest. Wolcott's Patti Riff ran in early April.

The Tuesday after that review appeared, Tom Johnson invited me to get my avant on at the Kitchen. When the highly enjoyable performance ended, I remembered a flyer I'd gotten from four geeks in leather jackets: "The Ramones are not an oldies group, they are not a glitter group, they don't play boogie music and they don't play the blues. The Ramones are an original Rock and Roll group of 1975, and their songs are brief, to the point and every one a potential hit single." I was struck by the pop principles informing this manifesto, and Tom was as game to cross over as I'd

just been. So he climbed into the Toyota with me and Carola. CBGB was almost empty. Danny Fields said hello at the bar.

My best estimate is thirteen songs in twenty-three minutes with no intraband sniping—I saw the Ramones dozens of times without witnessing that piece of the legend. I was stunned by how much I liked them. Their uniforms-in-disguise disguising the class split between Forest Hills Joey and Middle Village Johnny, these stylized Queens boys traded the expressionist doomshows that mucked up their semi-popular antecedents the Stooges for deadpan comedy and killer hooks that didn't understate their alienation an iota. Ever the pop guy, I was an instant fan, albeit one concerned about that blitzkrieg song, while avant-minimalist Johnson recognized music whose limited means were simultaneously primitive and apt and dug it on formal grounds. Wolcott's mythological Ramones Riff, "Chord Killers," was in the July 21 *Voice,* two weeks after Stephen O'Laughlin's musicological TV-at-CBGB Riff. A month later came Wolcott's Goldstein-assigned feature on the CBGB Rock Festival, four or five bands a night between July 16 and August 1. There he posited the thesis that the "unpretentious-ness" of the CBGB stalwarts—topped at that moment, according to hippieish impresario Hilly Kristal, by Television, the Ramones, Talking Heads, the Heartbreakers, his managerial clients the Shirts, and, he swore, Johnny's Dance Band from Philadelphia—represented a "resurgence of communal faith" Wolcott traced to the '60s. This thesis was odd for Wolcott, no hippie himself, and odd for the punks, who hated hippies. But it was also prophetic, because just like hippies both the fledgling punks and the pre-*Vanity Fair* Wolcott were bohemians. From CBGB would evolve an alt-rock bohemia that would put its distrust of corporate capitalism into DIY practice. And while in recent years band culture has been pushed aside as social media transform the sub-cultural yet again, the indie business model has become standard, and its mystique remains an essential component of a hipsterdom that will

eventually be called something else but isn't as I write. Half a century later, we're still washing "The White Negro" out of our hair.

Carola and I had too much of a life to be scenesters. But we followed all the major bands, and would drop in regularly at CBGB on the way home from Crosby Street or Jones Street or the Bottom Line not to connect to the rockcrit network, which was usually represented, but to check out the music. Hilly never said no to a journalist, but he knew I in particular, along with John Rockwell, "went beyond what was expedient" and made CBGB the only club in my power-brokering career where there was never a delay at the door. Its long space bright in back, aglow near the stage, and dim in the middle, its floors cruddy and its walls impastoed, its squalid bathrooms more functional than history will record, its matchless sound system its only concession to success, CBGB was a fine place to hear music or ignore it as the talent onstage warranted—unless you cared about the headliner. In that case we'd often jostle for position along the bar and stand stewing in our own juices, especially if we arrived too late to have a choice. But other times we'd occupy a table up front and nurse beers through the crap opener Hilly wasn't paying a thin dime, leaving me with nothing to do but follow the beat and figure out how the drumming worked—or more often, didn't. I would have had trouble putting what I heard in words. But I permanently sharpened my sense of band dynamics that way.

Carola loved the music, and loved the CBGB version of bohemia more. Having smiled or squirmed through too much backbiting and hypocrisy while taking hippie communalism literally, she dug the provisional mistrust that was the club's standard affect because there was so much room for camaraderie just underneath. And she was psyched that three of the major bands featured women. In addition to very different leads Patti and Debbie, one role player was at least as groundbreaking: Talking Heads bassist Tina Weymouth, whose unassuming

competence and chop-cut chic projected a normality and necessity that had their own kind of feminist charisma. Women were sparse around CBGB at first, often favoring a hooker finery that reclaimed sexual candor when it wasn't just work clothes, and Debbie Harry's prophetic glamour poses mined the same vein. But Patti and Tina's distinct styles of unisex empowered dozens of women who'd infiltrate the next few waves of CBGB bands as hundreds of women gravitated to the scene, including many key photographers and *Punk* magazine Oxonian Mary Harron. Having taken fashion cues from youths of color in the wake of the mugging, Carola's clothes sense assumed a boyish cast that remained with her, although she can do girlish and womanly and if necessary classy when in the mood. What she won't ever do is grow her hair to the lustrous length it was when we married. This saddens me once in a while. But punk was worth the price.

"Punk was a musical movement that reacted against the pastoral sentimentality, expressionistic excess, and superstar bloat of '60s rock with short, fast, hard, acerbic songs," I explained to *The New York Times Book Review* twenty years after the fact. By design, this formula applied equally to the New York bohemians who devised the punk aesthetic and the London extremists who made a mass movement of it. Yet although Television were protopunks from jump street and played CBGB before anyone, they were barely punk at all once Tom Verlaine replaced style-setting, scene-ruling bassist Richard Hell with Blondie's capable, obliging Fred Smith. And by the time Karin Berg corralled the touchy Verlaine for Elektra and got *Marquee Moon* out of him—which didn't take long because Television had been playing those eight songs live for years—his band had been beaten to the rack jobbers by Patti Smith, the Ramones, and Blondie, with Hell's Voidoids not far behind. Here and in Britain, many indelible albums came out of punk—*Ramones; The*

Clash; *Never Mind the Bollocks, Here's the Sex Pistols*; Smith's *Horses*; Hell's *Blank Generation*; Blondie's *Parallel Lines*; Wire's *Pink Flag*; X-Ray Spex's *Germ-Free Adolescents*; Talking Heads' *More Songs About Buildings and Food*, on and on. But *Marquee Moon* was the one I never tired of. And that was in part because it wasn't punk. Its intensity wasn't manic; it didn't come in spurts. Nothing wrong with manic—punk made me crave that style of intensity all my life. But there's nothing wrong with endurance either.

One way the original Television were protopunks was their visual style, in which Hell was the safety-pinned fashionista and Verlaine's down-at-heel preppy maudit fit right in. Another was a cartoonlike, meta-ironic dissociation right out of the New York School poets they loved. But beyond their early ineptitude, what was most punk about them musically was crude garage-rock covers like the Count Five's "Psychotic Reaction" and the 13th Floor Elevators' "Fire Engine"—a frame of reference formally congruent to but culturally and sonically distinct from the Dolls' r&b novelties and the pre-Beatles macho mimicked by UK pub-rock. This is a post-Beatles vein nailed right off by the twelve-second intro to "See No Evil" and exploited by all six shorter songs on *Marquee Moon*—formally, not sonically, because they weren't raw enough. Verlaine's mellow, ululating drawl, so wimpy some hardasses in their own minds will never get over it, guarantees that. And on a militantly learn-while-doing scene, every guy in the band had more chops than garage rockers are supposed to: guitarist-forever Verlaine, his pop-leaning counterpart Richard Lloyd, jazz-hip drummer Billy Ficca, and knowledgeable middleman Smith. *Marquee Moon*—co-produced with Verlaine by Stones/Led Zep engineer Andy Johns—wasn't a punk album. It was a rock album.

It was also a vinyl album, forty-five minutes split right down the middle, and this sealed its status, because side one, which shifts materially song to unforgettable song without diluting a band sound that ig-

nores every parallel no matter how complimentary (Byrds-Dead-Stones are all miles away), is as good as album sides get, rushing forward as one thing yet revealing new details every time you play it again. With addictive guitar riffs securing each track, there's not a misplaced second, and much of it was recorded in one take. Side two can't possibly keep up, and doesn't—I find the devotional "Guiding Light" soupy myself, and only "Prove It" with its droll "Just the facts" stays with me like "See No Evil" or "Venus" or "Friction" or "Marquee Moon" itself. So make side two a high A minus. But side one is an A plus plus plus, and side one is why so many treasure *Marquee Moon* as a classic.

Going outside Manhattan and against type, I assigned the Riff to Virginia-born Boston Episcopalian Ken Emerson, who loved it, only not in the terms I did. For Emerson, *Marquee Moon* had it all over reductive Ramones and apocalyptic Patti because Television were "grown up." Everywhere he listened, music or lyrics, he found a "doubleness," "a golden mean," an "insistence on seeing things whole." But while the doubleness is certainly thematic, remembering how young I was when I latched onto "Vacillation" makes me wonder how grown up it is. What I love most about the lyrics of *Marquee Moon* is their evocation of that youthful moment when you're this close to figuring everything out, voicing in very few words a multivalence worthy of that adventure's complexity and confusion—beautifully, profoundly, naively, contradictorily, romantically, kinetically, jokily, cockily, fearfully, drunkenly, goofily, impudently—so nervous and excited you could fly, or is it faint? And with the single line "Broadway looked so medieval" added to what we know about its East Village provenance, it situates this philosophical action in the downtown night.

Like many great albums and more pretentious ones, *Marquee Moon* has gathered armies of exegetes set on getting to the bottom of every word, and bless 'em, really. But they're misguided. Not only don't I know what all the lyrics mean, Verlaine doesn't know what all the lyrics mean,

and it's a dead end to speculate. When we ran into this problem with Coleridge (who Verlaine would have ditched for being a junkie like Hell and Lloyd), it was because he let the poem get away from him. Here it's more like Verlaine *wanted* the poem to get away from him, because he knew the paradoxes it posed were unresolvable and because he knew the guitars would blast through and lift over. So say "See No Evil" is about the onrushing illimitability of desire and "Venus" is about the enveloping impossibility of love and "Friction" is about the bracing inevitability of conflict and I don't know what the fuck "Marquee Moon" is about except that it's ten minutes long and you feel it'll be perfectly OK with you if it goes on forever, like, er—some amalgam of show business and heaven? C'mon. "Elevation" and "Guiding Light"? Getting high and losing either God or love. "Prove It"? So funny it don't matter. "Torn Curtain"? Ten minutes again, only not much longer please because this case is closed you just said. Ba-da-boom.

In the long wake of punk's speedy demise and multiple afterlives, UK extremists and their offspring got permanently exercised about a double-ness that pitted "rockism" against—what, exactly? Sometimes the prog tendencies of "post-punk," sometimes just pop. This polarity is so stupid I generally refuse to discuss it, but in this case I'll suspend my disbelief in the interest of provisional clarification. Forced at gunpoint to choose, I'd call myself some kind of poppist—Pop Art was formative for me, I have a history of respecting the charts, and what are perception-altering short-fast-hard anythings if not pop? Note too that the two least punk of the indelible albums named above are pop—*Parallel Lines* proudly, *More Songs About Buildings and Food* ironically. And then recall that *Marquee Moon* is a rock album. Why do I believe the rockism-versus-poppism polarity is stupid? Because while most popular musicians who take themselves too seriously are mooncalves, now and again one will home in on something deeper than the pop-identified would dare—in a form livelier and more liberating than the highbrow-identified would

know was there if it bit them in the cranium. So I'll say it and you scoff if you want. The fact that *Marquee Moon* is a rock album is basic to why it's a masterpiece—a great work of art. Ba-da-boom.

Marquee Moon was hardly the only proof that CBGB wasn't monolithic. Like any true bohemia, CB's attracted one-of-a-kinds in bunches. So Carola and I weren't the only thirtysomethings around. But I bet we were the only thirtysomethings who'd sooner have been up all night with the baby. Well before *Ramones* dropped, Carola was on the starter fertility drug Clomid. Every month we'd time sex to coincide with her chemically regulated, thermometer-estimated ovulation, which was alienating sometimes; before the year was over her first surgery coincided with my most brutal workweek, which was alienating big-time. As each new menstrual flow busted our bubble, we got marginally tenser. But there was relief in CB's' release—living proof that the life the two of us already had was pregnant with possibility. And there was also a lesson about other possibilities. My theory-of-pop bias that scene coverage was a craven form of booster rah-rah evaporated as semipopular music continued its long march toward alt-rock—and as other musics crowded in from their various margins and hegemonies. For although I wasn't writing enough, editing had extended my critical reach and amplified my sonic pleasure. *Marquee Moon* was hardly the only proof that no single musical concept would ever do me right by itself.

I didn't need Gary Giddins to bring me back to jazz. Buying Monk's *Criss-Cross* at the Oakland flea market in 1970 did that, and since Carola had been into Miles and Django since her baby beatnik days, she was always happy to try something new—Gato Barbieri, say. But it was Giddins who pointed me back past bebop—to the '20s Ellington Steely Dan had picked up on, to the seminal Louis Armstrong-Earl Hines set ex-Voicers Martin Williams and J. R. Taylor powered up for

the Smithsonian, to swing man Ray Nance and bebop pianist Duke Jordan joining a bassist who was somebody's relative at a Thai restaurant on 51st Street. And he also got me listening to new records—from repatriated Yankee fan Dexter Gordon to Stanley Crouch confederate David Murray to so-called loft jazz, readying me for the harmolodic funk Ornette Coleman's progeny would tailor to my undreamt tastes well before my editing tour was through.

How much tailoring and dreaming those tastes could stand was impressed upon me by a few writers who were certain I'd boarded the P-Funk train at the wrong stop with my 1972 pan of Funkadelic's *America Eats Its Young*, recorded in the thrall of the same Process Church of the Final Judgment Charlie Manson flirted with. And sure enough, at decade's end I'd be declaring George Clinton one of the '70s' premier artists. In 1975, onetime Young Lords honcho Pablo "Yoruba" Guzman had sent me a spec review I mailed back bedecked with pencil. He hung it on his wall, and by late 1977 was writing both Riffs and political features and bending my ear about his favorite musician, a fellow named James Brown. Together with Vernon Gibbs's "Funkadelic Pee in Your Afro," Yoruba convinced me forever that it was impossible to cover black music right without input from black writers.

So although the late '70s were my punk years no question, they were also when I got the hang of the two greatest musicians of the twentieth century: Louis Armstrong via Gary and James Brown via Yoruba. And in the fall of 1976 Carola and I were invited to dinner in Park Slope by salsa specialist John Storm Roberts. Roberts had specialized in modern languages rather than musicology at Oxford, and proved what a good idea that was with 1972's aggressively antipurist *Black Music of Two Worlds*, an unprecedented book-length overview of the music of the African diaspora. As he fried the spices for a keema curry, he mentioned casually that in 1973 he'd compiled an LP comprising sixteen of

the African pop forty-fives he'd scored while working in Nairobi for the *East African Standard*. When I asked why he'd never told me this, he muttered something about not wanting to impose—a small-boned guy with a mustache that cried out for a pith helmet, Roberts wasn't meek, but he was very contained. So I brought home one of the eighty-odd copies of *Africa Dances* he had left. Many of these he sold when my rave—which ducked conflict-of-interest apologias by identifying this known *Voice* contributor as compiler-proprietor and leaving it at that— appeared just before Christmas. Thus began Roberts's lifework as the owner of the first and finest U.S.-based Afropop label, Original Music, and my lifework as the rock critic who loves Afropop—a music that's provided me more enjoyable hours than Louis Armstrong and James Brown combined.

Plus there was pop itself—everything that had engrossed me at *Newsday* just a few years before, evolving as it always does, most sa-liently as dance music straight up. "Death to Disco Shit, Long Live the Rock!" ejaculated the first issue of the drunk-comix *Punk* at the end of 1975, which was all I needed to know about John Holmstrom and Legs McNeil's white-and-proud musical concept. A 1975 Vince Aletti invite to David Mancuso's Loft, as utopian a communal space as the most benign Dead concert and as original culturally as CBGB itself, was all it took to convince me that anti-disco rhetoric, which culmi-nated in 1979 with the homophobic bonus of the odious slogan "Disco sucks," was as racially coded as AOR radio whining that Al Green was "commercial"—probably more so. Disco seeded a singles-vs.-albums po-larity more meaningful by far than pop-vs.-rock and, paradoxically, was an irreducible live music that rose up in the interface between DJ and dancers—as in jazz, every set was different. For both reasons it proved inconducive to criticism, although as the boom peaked Vince Aletti's sharp-eared *Record World* column landed him a lucrative if short-lived job in the biz. But the greatest disco singles—let me just remember

Vicki Sue Robinson's "Turn the Beat Around," Sister Sledge's "We Are Family," and McFadden & Whitehead's "Ain't No Stoppin' Us Now"— are as enduring as the greatest punk albums.

Arena-rock was evolving too, starting with its most accomplished act this side of the Stones, although we didn't know it yet: Bruce Springsteen, whose 1975 covers-of-*Time*-and-*Newsweek* blitz occasioned my long analysis of a Rockwell-Nelson-Marsh-Landau-Christgau "rock-critic establishment" as it opened a gulf between me and Marsh, who wasn't flattered that I called him its "kingpin" and never altogether forgave me for comparing his hero to musical comedy straight man Howard Keel. Nor was Springsteen all. After Lynyrd Skynyrd's 1977 plane crash, I told *Voice* readers that Ronnie Van Zant had died with more left to say than Elvis, and when I calibrated what was not yet designated the Dean's List for the fourth (or fifth) annual Pazz & Jop Critics' Poll, I put Fleetwood Mac's *Rumours* fourth, just like the voters, with the poll-winning Sex Pistols fifth. Also ahead of the Pistols was the second album by a folk sister duo Karin Berg was on early, Kate & Anna McGarrigle's *Dancer with Bruised Knees*. Another folk record had topped my 1976 list: *Have Moicy!*, which Peter Stampfel hand-delivered one Wednesday and I haven't stopped playing since. Google it now and you'll find my original review half a dozen links down.

Occasionally somebody tells me that Riffs was the making of NYC punk. I'm flattered, of course, but I know this is silly and I always say so. The CBGB greats were too great to keep down, and in media central too great not to notice. John Rockwell at the *Times* on one side and Alan Betrock at *Soho Weekly News* on the other didn't need Riffs to tell them that. Nor did Lester Bangs and his lessers at *Creem*. The *Voice* beckoned alienated young intellectuals nationwide, and Riffs got enough attention from smart college and high school locals to win for the Ramones, not to mention Talking Heads, exactly the kind of smartypants fans Legs McNeil has lived his life to insult from

a safe distance. But most of them would have figured it out eventually anyway. That's not the case, however, with *Africa Dances* or *Have Moicy!*

As I always insist, there's negative honor in getting there first if where you get is the pseudo-hot, meaning mediocre music with a news angle, or obscurity for its own sake, meaning some ill-recorded acoustic number believers swear will change your life if only you pay close heed to this guitar break here. And many '70s critics' records I'd still pan today—say Nick Drake's *Pink Moon,* another Karin Berg fave, or *Suicide*—have gained more historical weight over the years than *Africa Dances* or *Have Moicy!* Nevertheless, knowing that an album I still love wouldn't be there for others without my rave— and that these others impart to my rave an aura of fellowship and consensus when I relisten—is one of the satisfactions of having reviewed fourteen thousand of them. If you want a punk record with that profile, I'll add that I regret not having seeded a cult for Fluffy's 1996 *Black Eye.* But I admit that my failure to do so makes me wonder whether I overrated that one.

Just relistened—I didn't.

In July 1976, Felker loyalist Judy Daniels left the *Voice* to start a magazine for working women and Morgan hired a new managing editor from *Rolling Stone:* Marianne Partridge. Although I knew Marianne was at *Stone,* knew too that she'd edited Willis there, we'd lost touch after she split with Larry in 1972. But she was so easygoing it didn't matter. I've never known a boss whose office presence was so cheerful and tolerant; without being at all withdrawn, she was exceptionally even-keeled. Marianne had long since identified feminist, and I wasn't surprised when she invited Carola and Georgia into a women's group she rapidly organized—Marianne was a doer. The surprise came in late

September, when Morgan clashed with Felker over an endorsement and quit. Suddenly the editor of the *Voice* was someone I'd first known as a caring friend.

The last issue Morgan had his name on closed the same Monday Carola had her culdoscopy. It was fattened by six long pieces in a thirty-two-page music supplement, a six-byline music section, a monthly Pazz & Jop Product Report in which I took critics' top tens over the phone, and a late-finishing Frank Rose cover piece on Village teenagers—close to half an issue to put to bed while a gynecologist cut through the rear wall of my wife's vagina to view her reproductive apparatus, which supposedly beats having your belly cut open and really took it out of Carola nonetheless. Hope put in many hours at the hospital, scoring ginger ale to ease her daughter's nausea. Her son-in-law arrived late carrying proofs and utilized the pay phone during his brief visit. Nor was he terribly sympathetic when his wife spent the next week wiped out—his father, who claimed he'd never had a stomachache, had instilled in his children a skepticism about all ailments that lacked visible symptoms.

Ashamed in the wake of the ensuing recriminations, I visited Marianne in the office where once Ross Wetzsteon had snuck his swigs and told her that the music section plus my own writing constituted such a big job that I couldn't edit features anymore. She listened to my tale and agreed. Maybe this was special treatment, but I doubt it. The paltry *Voice* annals chronicle Marianne as an editor-by-accident buffeted by titans, particularly Rupert Murdoch and her successor David Schneiderman. But of the twelve de facto editors-in-chief I worked under during my thirty-two years as music editor and senior editor—that's twelve, only three of whom lasted even three years—I believe she was the best-liked and best-respected. Marianne was very fair and no pushover. Having watched the Goldstein faction including me turn on one of the fourth-floor cadre at our weekly editorial meeting, she imme-

diately kiboshed that institution in the interests of comity. Although most of the Wolfies had quit by then, she had an affinity for hard-boiled guys despite her background at *Rolling Stone* and Cal Arts—her father had trained racehorses. But how hard-boiled was it to bring in Ellen Willis as a columnist? It's possible she lacked editorial vision in the sense of entrepreneurial vision, although for three decades now she's somehow kept an alt-weekly alive in Santa Barbara, California, where she moved after leaving the *Voice* with the husband she met in the production department. But she brimmed with ideas for writers, and put in hours on their pieces with them. When they're done right, writers appreciate those things.

The buffeting began right after New Year's Day 1977, when a brief, bitter power struggle between Murdoch and Felker ended with Murdoch taking over *New York* and hence the *Voice*. *New York* briefly went on strike, but the *Voice* did not—as Geoff Stokes put it at a January 5 meeting, we didn't think it mattered that much which millionaire owned us. On January 7, even those members of the staff who counted Alexander Cockburn a scoundrel saw the wisdom of a typically acidulous Press Clips column—"Capitalism is a system journalists discover abruptly now and again in the course of their professional lives. Shortly thereafter, they usually discover the immense potential of the American labor movement"—and signed union cards with the left-leaning District 65. Also on January 7, Felker agreed to end the lawsuit he'd entered if Murdoch—in addition to providing certain moneys, naturally—would agree to retain the top two editors at Felker's publications. On January 11, Murdoch fired Marianne. That lasted three hours, as Newfield, Durbin, and Cockburn, by no means natural allies, all worked to end this power play before it began. Next day Murdoch arrived at University Place in a stretch limo, offered each of us his limp and puffy hand, and to back his ritual pledge of non-interference repeated the promise he'd just broken that Marianne would remain for two years.

Through this brouhaha with more to come, I kept doing what I'd already been doing, only better. All during the takeover I worked on a Patti Smith screed that carried the front page of Murdoch's first issue and ended up, minus fifteen hundred words or so, in the Harvard anthology I published in 1998. Two weeks later I was at Jimmy Carter's subfreezing inauguration for a piece whose greatest virtue, nice though it was to witness the Republicans exit the White House, was putting me and Carola in the same room as the Duke Ellington Orchestra—I've never enjoyed post-'20s Ellington as much as I'm supposed to, but under Mercer Ellington's baton it sure was great to follow her lead. Six months after the music supplement that collided with Carola's culdoscopy there was a second monster on British rock that included Mary Harron on the London punks who had yet to release an LP here and Simon Frith on UK tax exiles he calmly pinned to the wall even though every big name declined comment. Riffs' key 1977 debuts came from Tom Carson, who after focusing on music in his twenties morphed into an award-winning film and TV critic, and Roger Trilling, who after a career in management moved on to more quixotic pursuits. Both have remained close friends, and I'm proud that the Riffs template helped them go their separate ways. Few of the front-of-the-book panjandrums who think rock criticism is for starsuckers with glasses could last five minutes in political debate with either.

I have regrets, however. Examining the Riffs file through the end of 1977, where the *Voice*'s black music coverage was much stronger than in *Rolling Stone* or the *Times*, I notice two major shortfalls, artists ranked third and eighth in the decade overview I committed to the newsstands at the end of 1979: George Clinton and Bob Marley. After Vernon Gibbs's wake-up call, Clinton got only one pre-'78 review, a smart one indeed by Joe McEwen. Marley had better numbers, but all the Riffs were bitchy—the only time we did him justice was in a typically shrewd

and droll Patrick Carr feature in 1975. As previously indicated, Pablo Guzman's propaganda campaign started toward the end of 1977. You do the chronology from there.

When Greil Marcus's *Mystery Train* was published in 1975, it set a standard few including Greil have matched since. Visionary about America, visionary about our vocation, it towered over Charlie Gillett's brave *The Sound of the City* and R. Meltzer's contrarian *The Aesthetics of Rock*, and although a few fans have told me *Any Old Way You Choose It* meant more to them, that's hardly the consensus view. Above all, *Mystery Train* established Greil's notion of how much was "at stake" in any cultural discourse—which I put in quotes because, like "matter," "at stake" is his kind of idiom, at once colloquial and jam-packed with significance. Thus he linked unschooled Delta bluesman Robert Johnson to cerebral American godfather Jonathan Edwards, Sly Stone's rise and fall to the Panthers'. Thus he posited and then proved that Elvis Presley was an artist of unprecedented and unimagined substance, import, and absurdity. Thus he raised the stakes all around.

Yet although Greil's dream book was inspired, both perfect and slightly out of control, it ended up meaning less to me than a 1971 novel he alerted me to, which also came out of Berkeley. Where *Mystery Train* is audacious, Ishmael Reed's Afrocentric detective-novel-sorta *Mumbo Jumbo* is, to resort to cant once again, transgressive. It defies expectations. Set in the '20s with exact dates unspecified, it's committed to the metaphor that time is a pendulum rather than a river. So Reed makes a practice of messing with narrative motion by sprinkling his novels with anachronisms, here including as yet unrecorded Jelly Roll Morton and Fats Waller sides, the Wallflower Order's affinity for polymers, and "Walter" Mellon (the real tycoon was named Andrew, but Reed can't resist the pun or the paradox) plotting the Great Depression in the

wake of the assassination of octoroon president Warren G. Harding. Further muddying chronology is the way Reed pelts contemporaries with spitballs—Spiro Agnew, William Styron, Albert Goldman, James Baldwin, Warren Hinckle, the entire stereotyped population of the Berkeley hills. Two Altamont references sneak into the scene where Moses makes the crowd's ears bleed modernizing the Black Mud Sound. The man just loves fucking with us.

These provocations—augmented by the novel's autodidactic bibliography, asterisked footnotes, interpolated illustrations, alternative typefaces, and insistence on rendering the word "one" as "1"—help explain why *Mumbo Jumbo*'s sizable cult is still concentrated in what was just beginning to be called black studies when it materialized. But in the impolite discourse of rock criticism, provocations are attractions, and the novel's theme—in which the many-named '20s dance craze it designates Jes Grew does battle with Euro-capitalist "Atonists," a play on original Egyptian monotheist Akhenaton—was hard to resist. Never mind that Reed also had it in for Dylan and the Beatles, for Marx and Freud, because more than with most geniuses you have to accept that Reed is a crank. Even after winning a MacArthur in 1998 he remained an embattled figure who inspired his defenders to legitimize him as "postmodernist"—living proof of Lyotard and Kristeva, coequal of Auster and Acker. Preferring Reed to these new worthies by a wide margin, I think this connection diminishes Reed. He doesn't need status symbols because he has nothing to be defensive about. Over the entire twentieth century, modernism's mandarin presumptions were mocked, sidestepped, bum-rushed, undermined, and assaulted flat-out by an American popular music that is African at bottom no matter how cranky it is to read Dylan and the Beatles out of it.

So I love the Jes Grew thesis Reed fucks with so unpackably, love his indecorum and inconsistency, love above all his single-minded assault on "Atonism." Atonism isn't just monotheism. It's monism, the

belief that any 1 theory or principle is sufficient to the world's glory and difficulty. As I saw as a college freshman, it's any ism—any attempt at systematic escape from what I keep calling contingency, which might be defined as everything depending on everything else in a process that never ends. From Jane Austen to Steely Dan, I've dug me some artistic perfection. But as a devout slob, I treasure a fine mess even more, taking not just pleasure but solace in the crack that lets the light in and everything put together falling apart. And I also love how *Mumbo Jumbo* has jes grown for me. First time through I barely absorbed the Agatha Christie moment when vodun sleuth Papa LaBas holds forth on Moses and the Knights Templars' hijacking of Osiris's mysteries. Ancient Egypt, I thought—bor-ing. But by 2007 I was teaching the same scene to my NYU students, who find it more mystifying than I once did—until I explain that it's a "foundation myth for the music we'll be reading and talking about all term" and they see the light. Some of them, anyway—that's the way contingency is.

I should add, lest you had any doubts, that my strictures regarding monism do not extend to mon-ogamy. Trying to put into words what she thought I meant by contingency, my lifemate quoted our favorite Bonnie Raitt song: "Just how good good enough can be." That's a good enough way to put it.

The culdoscopy trauma was the worst setback of our two-year marriage, but it was only a setback. Still optimistic that we'd conceive a child sooner or later and probably sooner, we continued to enjoy the extended youth that infertility freed us up for without turning our "lifestyle" into "I Don't Want to Grow Up," as the stealth-smart second-generation punks the Descendents would expostulate brattily and satirically a decade later. This doubleness had a permanent, positive impact on how I experienced music. Mindfully mature and struggling to be more so, I was also as fancy-free as someone with a full-time job can be, and a

good thing too, because as I put it decades later: "In my job, the idea is to have fun. If you don't have fun most of the time, you're not doing your job." For forty years now I've loved both the music of alienated kids figuring things out and the music of the same kids who as they turn thirty, forty, fifty, sixty, and even older are still figuring things out. My ten years stuck between conditions helped.

CBGB was only the epicenter of our life together in the '70s. We went out plenty, seeing lots of movies as well as music two or three times a week and socializing with all our old friends and many new ones—most prominently the lively and game Kate Wenner, who'd become Carola's closest girlfriend through Marianne's women's group. My Midwestern find Tom Hull slept two weeks on our couch before finding his own Manhattan digs; my Midwestern sharer Tom Smucker married red-diaper baby Laura Kogel two floors above us and spent their wedding night in our daisy-strewn bed while we slept across town; my Midwestern guide Charlie Berg showed off his new wife, son, and yurt on the Michigan peninsula. We got high on pheromones and adrenaline in Yankee Stadium watching Chris Chambliss hit his pennant winner and shared with Bob and Marylin the World Series bleacher seats I scored in a sleeping-bag vigil reading Bob Wills's biography under a streetlight. And two delicious weekends with Carola's college roommate Shelly Rosaldo and her husband, Renato, Stanford anthropologists doing a year at Princeton's Institute for Advanced Study, started us borrowing recipes and buying cookbooks. Already a kitchen magician, Hope's onetime apprentice gradually took over that traditionally female aspect of our domestic life, just as I took over the traditionally male city driving. But I did develop culinary specialties of my own. Our first Chenango vacation we clocked more time in bed than we had in Jamaica. But the highlight, believe it or not, was a two-day visit from my parents. I made the boeuf bourguignon all by myself.

From "Ford to City: Drop Dead" to "the Bronx is burning," these were parlous times in New York City, and everyone at the *Voice* knew

it—nose-to-the-sidewalk Newfield and office-chair Marxist Cockburn were on the continuing fiscal crisis harder than any uptown stiff. Nor was there comfort in the knowledge that some of us had worked for five editors in just three years and most for four in just two—or that our current proprietor's right-wing lowbrow made the vulgarian he'd vanquished look like Harold Ross. Yet added to the thrill of punk— that high-energy fungu so often oversimplified in memory to the down-and-out spawn of Bowery grime and boho anomie—there was an excitement at the *Voice* unknown to journos north of 14th Street. Before Felker, something over a dozen *Voice* regulars made a living on the editorial side. Now a workforce of over a hundred, including some fifty or sixty editorial when Murdoch made his grab, had j-o-b jobs in journalism, low-paying by Guild or glossy standards but livable in a Manhattan where gentrification was not yet a blight. Turf war or no turf war, we all shared an embattled camaraderie because all of us were ready to fight to get paid for doing the things that we wanted to.

As I see it, the turf war was a straight front-of-the-book versus back-of-the-book set-to with some sexual politics below the belt— hardheaded anti-intellectuals resenting pointy-headed starsuckers with everybody leaning left and nobody quite that reductive. From the perspective of my fifth-floor cohort, it was driven by a '60s-averse rejection of cultural leftism incorporating the usual fear of feminism plus a strain of homophobia rendered doubly nasty by its close proximity to Stonewall and its children; from theirs, it was inspired by self-indulgent exegeses on Jeanne Moreau and Patti Smith hogging newsprint better devoted to Felix Rohatyn and bad cops going into the city from Suffolk County. As a male heterosexual acquaintance of Newfield from back in the day who was genuinely close to Paul Cowan, I got along passably with the fourth floor myself; ideologically, my closest ally at the whole paper was the sharp-witted, congenitally congenial, upstairs-downstairs Geoff Stokes, an ex-pol as opposed to ex-politico who still

dropped the occasional tab of acid, showed off his culinary wiles as a cooking columnist dubbed Vladimir Estragon, and announced his literary philosophy as "You want a ham sandwich, I'll give you a ham sandwich. Ham and cheese, I'll give you ham and cheese. You want mustard on that, OK." And if the guys with their eyes on *The Daily News* thought was I an arrogating egghead, well, their resident intellectual Cockburn praised my Patti piece while observing that it could have done with some section breaks, advice I heeded when I reprinted it. Believe me, nobody upstairs wanted less Felix Rohatyn or bad cops commuting from Suffolk County.

But it rankled when the front-of-the-book crowd made a big deal of their working-class bona fides. Joe Flaherty and Jack Newfield and Denis Hamill had come up poor for sure, but Newfield had married money and Hamill was Pete's kid brother. *Daily News*-worshipping Mike Daly got great prose out of the pose, but once he'd moved on up to the *News* itself he was outed fondly by his fourth-floor friend Mark Jacobson, himself the son of two Flushing shop teachers, as a Yale graduate with family ties to the Kennedys. Why couldn't these guys absorb that Goldstein and I had never been middle-class either, or that auteur theorist Andrew Sarris, raised in downwardly mobile penury so constricting that he was still living with his mother in his thirties, was also the *Voice*'s most aggressive centrist? When I think about it, in fact, I realize that where my colleagues on both floors were all either single or in a two-income marriage, Carola's grand or two a year put us on the low end of the class ladder per capita no matter who her grandfather was. No wonder we considered Chenango Valley State Park vacation paradise enow while my co-workers summered at the wrong end of the Long Island Expressway. Class is a complicated thing.

In 1977, Carola's income rose when she was hired by her college roommate Janet Mendelsohn to co-write a national forest documentary. She was on location for a pair of week-plus stays, longer than I'd

ever traveled with Al Green or Lynyrd Skynyrd. During one of these I consoled myself with an eight-day going-out diary that included two visits to CBGB and two to jazz clubs as well as one each to the Lone Star, Folk City, the Soho boite the Ballroom, Ray Charles rocking Labor Day at Belmont, a George Jones no-show at the Bottom Line, and Max's Kansas City, where I sat through one underwhelming and one godawful set so I could finally catch Teenage Jesus and the Jerks and scrammed fifteen minutes after they went on. In concentrated form, that was what checking out New York music was like in those years. But that November the two of us spent ten jam-packed days sampling an up-and-coming scene where the percentages were better. Among the twenty acts we caught in England were Elvis Costello, X-Ray Spex, Ian Dury, Nick Lowe, Wreckless Eric, Magazine, Sham 69, the Cortinas, and the eyeblink Killjoys, who left the world the great lost forty-five "Johnny Won't Get to Heaven"/"Naive" before Kevin Rowland sold his soul to Dexy's Midnight Runners. We also watched our junk-sick homeboy Richard Hell get over at the University of Leeds while supporting the most intense rock show we ever saw.

Like everyone I knew, I'd found the Clash album forbidding when I bought it as an import, only then the tunes and riffs sank in and I learned to love Joe Strummer's friendly, wet-mouthed, muttery snarl. And there they were, marching and leaping and falling to the floor as a not quite sold-out crowd of eighteen hundred pogoed wildly while hollering "I'm so bored with the Yew Ess Ay" and *The Clash* was transformed into one of my permanent floating favorite-of-all-times. In their hotel lobby afterward, Mick Jones told me my advance cassette of the Ramones' *Rocket to Russia* was pop, not punk, and Strummer instructed a pretty college student decked out in Frederick's of Hollywood support garments to translate a message into French: "*Tu ressembles á Woody Allen, mais tu as les cheveux longs.*" I really liked these guys. Unlike Johnny Rotten, they were headed somewhere they wanted to go

even though they were smart enough to know that by its very nature it wasn't somewhere they'd be able to stay. And like me, they hoped they'd suss how to deal with that problem when and if it happened.

CBGB hangers-on who've parlayed their moment into a nostalgia-hawking profit center resent British punk even more than Yurrupean propagandists with a musical inferiority complex belittle CBGB. As someone whose 1977 Pazz & Jop top five (sans Clash because imports were ineligible) ran Television-Ramones-McGarrigles-Fleetwood Mac-Sex Pistols, I love and respect both. But hitting England just when we did—with the impending doom of the Sex Pistols distracting such early punk propagandists as my Cal Arts trainee Jonh Ingham from musical action that had barely gotten started—was a conversion experience.

The first night we were both there—we flew separately—Carola transcended her jetlag and we wandered out to see I don't remember who I don't know where. The Killjoys, conceivably, I used to think at the Marquee, but the Marquee is a true club and this was more a repurposed movie theater. We were the oldest people there by ten years and I sported the only *cheveux longs*—Carola had just cut her hair as part of her fashion offensive. As whatever band it was slammed out its forcebeat and a few fools up front started gobbing, most of the crowd pogoed, a fad that hadn't hit the States. What we noticed was the eye contact. No matter how excited CBGBites got, they maintained their cool. These much younger fans were elated, and as they leaped in the air, often clutching each other's throats if male-on-male, they gazed at each other as fondly as lovers, or grinned like revolutionaries who had just breached the barricade. They grinned at us, too, simply because we were there, and soon we were pogoing ourselves as if we didn't know what a meniscus was, which at the time we didn't. Never was there a hint of hostility. Maybe they hated hippies. But they reminded us of hippies.

Nor was it just the music. We bonded with Simon and Gill Frith, visited Bronte Village with rock scholar Dave Laing, interviewed Andy

Fairweather Low if you know that name and Pete Fowler because there was no other way you'd know that one. And we checked out a communally organized record store I'd heard tell of called Rough Trade and found de facto proprietor Geoff Travis simultaneously chatting with an urbane young man named Jon Savage and sweeping the floor. Savage advised us to go see Wire, but I decided Sham 69 was the better story, which it was: Carola got a definitive quote out of a blue-haired punkette about how she was different from her snobby schoolmates because "I've got something they ha'n't got—I've got Johnny Rotten, ha'n't I?" Travis would become a legendary record man and sleep on our couch, not in that order. Savage would write the definitive Sex Pistols biography. Carola would never forget that I'd made us miss Wire.

Published Christmas week, my eight-thousand-word punk England report came with not just section breaks but section heds and was entitled "We Have to Deal with It," a lift from the Clash's "Hate and War" that continued, "It is the currency." It argued that, rather than "authentically" working-class, English punk was a bohemia that valued and incorporated class analysis. The piece was the Clash's first serious U.S. ink and in the opinion of Epic's New York publicist Susan Blond—a Warholite who was one of the great biz eccentrics in those flush years—the making of the band in the Yew Ess Ay; when they finally hit the Palladium a year later I requested and received twenty tickets and comped in everyone I could think of on both floors of the *Voice*, including an impressed Stanley Crouch. And although Epic provided airfare and some hotel, it wouldn't have happened if Marianne Partridge hadn't freed up expense money and given me my head.

And then on May 10, beginning a series of events barely reported in any print medium except Cockburn's Press Clips (although Larry Dietz's L.A. pal Joel Siegel, by then a TV newsman in NYC, stepped into the breach), Marianne was fired again. This took longer to resolve than the first contretemps, and was consequently more uplifting. Soon

eighty-four *Voice* employees, including almost every writer and editor on both floors, had pledged to walk out if Marianne's contract wasn't honored through its January termination date. The serious negotiations happened later, including a word from District 65's David Livingston, but the moment everyone remembers is when the staff walked Marianne and her dog Lizzie up University Place and into the office the morning of May 11. "Act of solidarity, it used to be called in the old days," Cockburn wrote, "though I'd say—given the sleeping habits of many of my comrades—unusual gallantry would be the proper phrase." Either way, all of us were fighting to get paid for doing the things that we wanted to, and headed somewhere we wanted to go even though we were smart enough to know that by its very nature it likely wasn't somewhere we'd be able to stay. I never had a better '60s moment.

11

BON BON VIE

As originally mapped out, this book would have ended in 1978, primarily because I didn't want people to think it was about the *Voice*. That's a book worth writing, but I don't know by who—untangling the paper's interactions is not for outsiders, and judging its achievement is not for the newshounds who generally shoulder such projects. Me, I was there a long time. But I reported for duty to get my work done, not to gossip or scheme—I wanted autonomy, not power, and I didn't follow office politics except to recommend the occasional hire, although I did once collaborate with Stokes in a union dispute. Even nailing facts for the glimpses I've provided was a chore. There presumably will be a *Voice* book sometime—by an academic, perhaps. I bet I don't like it.

But there was also a second reason, which is that I was shy about describing an event honesty would oblige me to include. Since I've been anything but shy so far, some might call this inconsistent, but nu? Sometimes you're just shy, that's all. Where for the most part it was an enjoyable job to reaccess my romantic marriage, I didn't look forward to

excavating the event in question, especially insofar as it involved loved ones, friends, and acquaintances whose privacy I respected as well as someone whose name I didn't want to spell right.

About the excavation I was right—it was wrenching. But I'm still glad the central player convinced me to go for it. Anyone who's read this far may well believe that Carola has already tolerated much too much of the dreaded Too Much Information. But I've told all with her cooperation or in one or two cases acquiescence. She's glad this book takes love so seriously, and although she's less bold than I am, she very much agrees that to shilly-shally about love is a species of lying. That's why she argued that to be shy this time would be counterproductive— that the book I planned would end up shilling for the wrong happy ending when the right one was standing there in front of me. So I decided to recount the event, but partially—some aspects I've left out.

We no longer remember when exactly we gave up on Clomid. Say after two years or so—late '77, early '78. The tension was building. Carola would menstruate and the world would end, only then we'd go to the right show or just share the right joke and the life cycle would begin again. But it kept getting harder. Once she got her period on a day we'd invited John and Loretta Piccarella for dinner. As she sorted laundry in the bedroom, I put on Gavin Bryars's *Jesus' Blood Never Failed Me Yet*, a Tom Johnson find in which Bryars orchestrates a loop of an old tramp unsteadily singing, "Jesus' blood never failed me yet / Never failed me yet / Never failed me yet / Jesus' blood never failed me yet / There's one thing I know / For he loves me so." And somehow the blood plus the faith plus the cyclical construction just got her. She was still sitting there crying when the Piccarellas walked in the door.

I was hurting too, but I had more distractions and Carola had other things to worry about. She'd shortened "A Misunderstanding" while

fighting a courteous but distracted and dilatory George Plimpton to retain the repetitions that delivered its hard pathos, and it finally came out in *The Paris Review* as we left for England. But this had no discernible effect on the steady flow of rejection letters for *The Woman Who Studied Yoga*. So Carola was stuck in the ex-pantry we'd projected as the baby's room, writing to a reader who was disappearing before her eyes. It was pushing five years since she'd begun her road-trip novel *Girl Talk*, and the agent she'd picked up in the wake of a Christina Stead review was withdrawing the way agents do. Carola had assumed fiction would be her work as she raised the kids she'd wanted since she was a kid herself. Now both vocations were denied her.

Carola did force out some fine criticism as the decade petered away month by month. But under ideal circumstances she was a free-associating slow finisher with closure issues, and while she'd taken her nieces to that Shaun Cassidy show "last Saturday," her Roches and Pere Ubu Riffs had to be situated "a while ago" and "a while back." "Pere Ubu Live in This Shit!" strung dozens of hard-won observations—"the convincing imitation of randomness in the use of randomlike sounds tucked into deep but tactfully casual structures"—into a convincing imitation of an argument devised for her by her editor. Then there was "How I Quit Re-Reading Dreiser and Found Neo-Realism in a Comic Book from Cleveland," the first serious notice (and with jokes yet!) for Harvey Pekar, whom we'd discovered via a conscientious objector friend of Tom Smucker who was from Cleveland himself. It took her two or three weeks a *Voice* page, and the pages had lotsa pictures.

In the fall of 1978 began a disastrous infertility venture with a Belgian-born gynecologist—a prominent researcher who after endless tests put Carola on Parlodel. Parlodel is bromocriptine, a Parkinson's and diabetes medication Dr. V. enlisted off-label to straighten out her hormones. This wasn't nuts—it's used that way on-label today. But Parlodel has side effects, and Carola—like her sisters and especially Hope,

who got by on quarter-doses of her meds until she died at ninety-six—is medication-"permeable," as our marriage counselor was soon putting it. She became so nauseous and dizzy that her weight dipped markedly, and breathed so unsteadily she had to sleep propped on pillows. Dr. V. was a stern paternalist who always saw her an hour or two late and a proponent of the endometrial biopsy. I had my nose biopsied once and yelled so loud they could hear me down the hall. Carola had eight or nine—every month her uterine lining was clipped through her cervix. This was not a procedure adequately rendered by words like "this will pinch a little" or "ouch." The pain was bad; she told him she'd had enough; he insisted there was no alternative. Carola saw Dr. V. two mornings a month at Columbia Presbyterian in Washington Heights, an hour away on the L and AA, usually leaving while I was half asleep. I made the schlep three times max.

We were still a fully committed couple who had a lot of fun. We liked the nightlife. We developed our culinary chops and entertained often. Summer of 1978 a one-day, nine-hundred-mile car trek bridged the two halves of a vacation when we bonded with two Friths who'd read their books in the backseat as we waited for a tow in Virginia and with our niece and nephew Julian and Dominique in Maine. But the bliss had dissipated. Carola was arguing more and winning less, often about the terms of our code of cheapness—what constituted extravagance in ourselves and others. I disdained restaurants with tablecloths; I bemoaned what meat cost in the supermarket; I tamped down home improvement initiatives; I disparaged the materialism of others. But we also fought more about sex, and more unprofitably too. I liked to gorge and she liked to savor was our basic disconnect, but the details shifted and stung.

I recognize that all reasonable persons assume bliss dissipates, and grant that our timing coincided neatly with the seven-year paradigm popularized by philosopher of human nature Billy Wilder. But we never

bought this line, and in the long run we were right. Of course we had our itches—we both liked sex too much not to. Of course we took too much for granted—that's an organic process. But pure bliss was never our plan, and impurity had never made it less enlarging or engrossing even if exhilarating came and went. Still, you can see what was on my mind when my English punk report defined "maturing—exotic term" as the "process of becoming aware that other people exist." Half a life-time after telling Miriam I was a bit dense when it came to empathy, I'd improved considerably. But I'm ashamed of how much I ignored and how much I failed to understand. The love of my life was distraught, and I didn't see it.

The main reason my empathy had improved was that Carola was as empathetic as anyone I've known except a few bleeding hearts who should put a cork in it. By argument and example, she'd educated me. But although I'd educated her too—to see when someone was taking advantage, to cold-shoulder her vile brother, to pass a semi on the Connecticut Turnpike—now too many failures were killing her moxie. Raised by a father who'd spent a decade writing in lieu of earning and never published a thing, she found herself hogtied by her own perfec-tionism and began to experience my concentration at deadline time as withdrawal. And the hard work of mothering her role model of a mother had prepared her for receded further from reach with every fruitless month.

When David Schneiderman finally replaced Marianne Partridge at the turn of 1979 I had edited Riffs for four and a half years. I would continue to run the music section for six more, and I believe it kept getting better—as younger writers displaced '60s holdovers, as punk spawned new wave spawned alt-rock, as hip-hop began to stir. I edited more stringently as my chops improved, and I enjoyed the company at

the *Voice*'s new digs at Broadway and 13th, where my cubicle was set off enough for ongoing rockcrit confabs. But the challenge and excitement diminished slightly, in part because I had other things to think about and in part because Schneiderman was a stabilizing force.

Plucked by Rupert Murdoch from *The New York Times* op-ed section, David Schneiderman put in the seven months his investiture was delayed by our defense of Marianne at a midtown office where he studied the paper and conferred with its major players, myself included. A shrewd, efficient, highly intelligent man whose decent instincts succumbed only gradually to his interest in power, he was to remain editor-in-fact till 1985 and oversee the paper until 2005, as its publisher and eventually its overreaching proprietor—"owner" seems too simplistic a term to suit the debt-laden deal he engineered in 2001, which held off the werewolves of Arizona for five years before it cost him his shirt. A Voicer ten years longer than Dan Wolf (although not as long as Nat Hentoff, Richard Goldstein, or yours truly), Schneiderman was well supplied with editorial vision as entrepreneurial vision. This he demonstrated early by leading his third issue with the fifth (or sixth) annual Pazz & Jop Critics' Poll and giving me five thousand words to describe what page one trumpeted as a "Triumph of the New Wave," although my own hed was the more equivocal (and accurate) (and abstruse) "New Wave Hegemony and the Bebop Question." Oh well—as Greil said when his bicentennial essay "In America Even the Humblest Harmony Is an Incredible Dream" was saddled with the cover line "What Patriotism Really Is": "You can call it 'Donny Fucks Marie' on the cover as long as you use mine inside."

Announced as an afterthought to the final 1971 Consumer Guide, Pazz & Jop began as the whim of a stat geek who would soon be beckoned away from Avenue B by a Long Island newspaper he barely knew existed. The first P&J poll comprised my two final pre-*Newsday* Rock & Roll &s and certified everyone who submitted a ballot on the grounds

that by so doing each had manifested a critic's proper "interest and arrogance." Then the project was shelved until I returned to the *Voice*. Hence the running joke that drove every editor crazy, in which the 1978 poll was designated "the fifth (or sixth)"—was 1971 a true critics' poll or not? The title was a play on the defunct *Jazz & Pop* magazine, where the point system originated. As I explained in my fourth (or fifth) essay: "I like the term Pazz & Jop because it once set Clay Felker to concocting alternate back-cover flags and is regarded by my current boss as virtually unpronounceable. It sounds dumb, and it gives me an out." Yet dumb or not, Pazz & Jop proved an even more salable brand than Dean of American Rock Critics, which people are always misremembering. And Schneiderman saw that potential. So first he put it on page one and then, in 1985, he gave me room to reprint the voluble comments of an army lieutenant in Germany named Chuck Eddy, an experiment that soon turned Pazz & Jop into a national rockcrit confab, a pullout supplement, and my kind of cash cow.

So in early 1979, with Carola ever more bummed about both Dr. V. and her novel, the new boss put a charge in me as good new bosses will. The branding of Pazz & Jop established me as a franchise player, and the overstated "triumph" of the cover line made my spontaneous embrace of punk in 1975 look trend-savvy even though my essay went on about the black music the poll ignored and ended by playfully positing a "new wave disco" that wasn't such a bad trend call itself, as Blondie's "Heart of Glass" would prove forthwith. So I ventured confidently off to ponder subjects like Les Blank and Andy Kaufman, and having been turned down for a Nieman at Harvard in 1977 on the grounds that I was "overqualified," also started reading cultural theory on my own, preferring British sociohistorical beef to French philosophical piffle: E. P. Thompson, Stuart Hall, and lots of Raymond Williams, plus enough of American reconceptualizer Fredric Jameson to fend off the Continental contingent. Yet at the same time I stepped off in the opposite

direction to shop a '70s Consumer Guide book that looked kinda commercial as the decade drew to a clearly demarcated close. By late spring I had a contract.

Because the Consumer Guide's prose had begun vestigial and major figures were undercovered or missed altogether, I soon saw that my published columns would provide less than two-thirds of a book that would properly represent the decade. I had hundreds of records to find out about, hundreds to find, hundreds to re-review, hundreds to touch up. So in late July we hauled a stereo and a load of LPs to a boathouse across an inlet from my favorite Maine Hopes. Although we had our fun on this working vacation, it was in sum a downer and a washout. We'd seen *Halloween* shortly before we left, and the stone gateway to our approach road reminded Carola so much of an image in that film that she had nightmares about it. A nonfan of horror-pop since EC Comics, I've stayed away from slasher flicks ever since.

As I revved up to a ninety-hour week things got grimmer. Fighting or not, we'd never gone to bed mad. Now disagreements simmered, the gravest over adoption—I wanted to pursue more treatment, Carola to stop torturing herself and start looking into agencies and orphanages. So we agreed to find a marriage counselor, my condition being an affirmative answer to the question "Do you give advice?" We settled on Jimmy Serafini, a friend of a therapist Carola had hooked up with at NYU named Larry McCready, who was a presence in her life until he died of AIDS in 1995. Although in retrospect I can see that I related more comfortably to Jimmy than Carola did—he was intellectually proactive, sexually explicit, and very male albeit gay—the therapy brought problems into the open where we could look at them. Then came the fraught March session when Carola admitted that she'd been cultivating a hot crush on my Nassau County protege Stephen O'Laughlin, by then a close friend who lived a few blocks from us. Dolefully, she swore she had never acted on these feelings and never would, and that

moreover the admission had broken the spell, culminating our therapy. Between my code of cheapness and my ninety-hour week, I was glad to concur.

Writing *Christgau's Record Guide: Rock Albums of the '70s* was so grueling that for most of 1980 I was barely aware of the music of the moment, the only such hiatus in what is now fifty years. I never took a day off from the start of February until the end of July, not even the balmy April 19 when I co-hosted our mutual birthday party, and I wasn't done till mid-September. Most of the book's 1970–74 reviews are either totally new or substantially revised, as are quite a few of the 1975–79s, although I cannibalized from published material when I could, not just to poach language but to inject what sense of the moment I could. Starting with James Brown—all of whose barely documented Polydor output was owned by my neighbor Vince Aletti, without whose record library the book couldn't have happened—I reviewed artists' oeuvres chronologically to minimize hindsight. When possible, I piled on the changer artists I actually felt like hearing that day in a ploy intended to scare up the excited little feeling in the pit of my stomach without which I am loath to give any album an A.

Published in the fall of 1981, my first Consumer Guide book was two years behind *The Rolling Stone Record Guide,* edited by Dave Marsh and sometime Riffer John Swenson and written by upward of thirty freelancers including many other Riffs contributors, among them Greil, Georgia, and Tom. I think mine is better, but that's not worth arguing. What's undeniable is that mine was written by one person, and was therefore an act of sensibility rather than cultural fiat, with no canonizing intention albeit some canonizing effect (which was soon nullified by the Rock and Roll Hall of Fame, a status grab far more effective than any book). It did, however, greatly enhance my personal profile as

well as reaching readers I'm proud are still out there. And it also came this close to ruining my life.

From Carola's perspective, 1980 was a terrible time for me to bury myself in work. We postponed further parenthood strategization. We hardly ever went out. The apartment sank to new depths of disarray as LPs and paper migrated into the dining room. And since I was home every minute with the stereo on, my life partner could never be alone, with herself or with her work. She started taking two-hour walks as a regular thing, and then a girlfriend with a job offered to let her write in the girlfriend's air-conditioned Village apartment during the day. That was generous and sensible. But it didn't stop me from wishing Carola was at her desk in the pantry we wished was a baby's room. Missing her acutely one warm afternoon, I kept getting a busy signal, so I biked downtown and buzzed. We made love in the girlfriend's bed. It wasn't a good one.

A brutal June heat wave upped our stress levels. I spent entire days in shorts alone, slipping into flip-flops and an unbuttoned shirt to go buy coffee. Sometimes I even worked naked; in fact, the only time I remember receiving a guest unclothed was when Stephen O'Laughlin came over to talk records once. By then O'Laughlin and John Piccarella had been in bands that broke up and then formed a new one together, with O'Laughlin the frontman. In late June they gigged in a club at the north end of Crosby Street and I biked through the steamy night to join Carola at a show that was almost over. Afterward there was much hugging in the street, and trippy talk of a European tour where Carola would serve as road manager. Despite her gift for languages, this was not a role to which she seemed especially well suited.

I assume you know what's going to happen here. I didn't, at least consciously. But by the end of July I did know I needed to escape the city, and grabbed the chance when John Rockwell and Linda Mevorach offered us their secluded Dutchess County A-frame. We fought

so bitterly driving up that I missed a turnoff and wandered through Darien trying to backtrack. Hours late, we skinny-dipped as we loved to do and had disconnected sex by the pond. I put on a George Jones LP as we made dinner. Then we fought some more and tried to end it in bed, which felt so weird that I broke off from kissing her feet and asked her what the fuck was wrong anyway this was fucked up. So she told me. "I'm sleeping with Stephen."

This stunned me momentarily. It's not as if the thought had never crossed my mind, but she'd promised. Only then everything made sense and I was in full rage mode. The marriage was over and I was kicking her out, period: "Eight years of my life down the fucking drain." Between insults I pressed for details and got some. The emotional breakthrough came at our birthday party, the physical consummation a week and a half later; May had been intense, June overheated, July fractious; O'Laughlin's live-in girlfriend had just been told. Well after midnight I dialed my rival's number and shouted something like "You've ruined my life, you scumbag, you knew this was something I couldn't tolerate, I've always been clear about that." He began muttering a defensive sentence. Before it was over, I hung up.

Sunup Wednesday we went back into the city, on the Taconic parkway because it seemed safer on no sleep. We got lost in the Bronx, arriving at Second Avenue around nine. In twenty minutes Carola had biked off to her girlfriend's boyfriend's Little Italy apartment with a backpack of clothing and a bankbook I told her to take. Immediately I set myself to reviewing George Jones, who begged his beloved to "Tell Me My Lying Eyes Are Wrong," and Hall and Oates, who meant so little to me that my mood didn't matter. Once I looked up from my typewriter and calculated that I'd been brooding for two hours without writing a word.

On Friday my mailbox contained a four- or five-page letter from O'Laughlin. Folded in sixths and stuffed into a small envelope, it was

hard to rip up unopened, but I managed. I put the pieces in a ten-inch envelope and mailed them back.

Kicking Carola out was a good idea even if calling it an idea exaggerates the quantity of brain involved, because it proved almost instantly how much each of us craved the other. Scared to call me, Carola spent hours in conference with Kate Wenner, who stayed over the first night, as well as Dominique, Georgia, Bob and Marylin. Fighting off nightmares of Colorado, I did some power-conferring myself—I do blab in a crisis. Some friends proved tongue-tied, for reasons I figure ranged from embarrassment to reservations about monogamy to suspicions I was due for a comeuppance. But old confidants stepped up—Georgia, Greil, Bob Stanley—and two newer ones were tremendously kind: Roger Trilling, who with no prompting from me lit into bohemian mores as soon as he heard the story, and John Piccarella, who to my delight was furious with his old friend. I was so out of my head that my network kept calling to check up on me. And every time the phone rang I wished it was Carola.

On Saturday, it was. Purportedly, she needed to set a time when I'd be out so she could pick up more clothes. Purportedly, I provided one. Only then I stuck around. I remember nothing of the wails and recriminations I have no doubt ensued. I do remember the excellent news that when O'Laughlin told Carola he'd do anything to help she told him that what he could do was never see her again. And I do remember that we wound up in bed. In fact, I remember it very well. So does Carola.

Thus began our second courtship, with Carola the pursuer. We lived apart for most of a sunstruck August, but we talked every day, especially if wordless bellows over the phone at three in the morning count as talking, and saw each other almost as often. We went on old-fashioned

"dates"; we had phone sex; we playacted mildly for the only time in our relationship; we took bike rides through the half-rebuilt lower Manhattan riverfront with me following her slower lead. But we also played at domestic partnership—sometimes she'd just call in the afternoon and create yet another delicious meal. Although I was no longer putting in my fourteen hours—too many dates for that, and too many arguments—I was still in book mode, and she strove to provide the tough edits I needed. I vented more days than not and she handled it. I've never felt more cherished in my life.

This account is too one-sided, however. Carola considered it her responsibility to let me vent, but she was no doormat—the arguments were arguments. Looking back, she posits that one reason we came out of the split stronger and ultimately happier was that she was so completely in the wrong on the fundamental issue that I felt freer to admit smaller failings of my own. This wasn't Colorado, she kept telling me. She hadn't been smashing monogamy because she'd never believed she was doing the right thing. She'd hated lying to me. Leaving me hadn't crossed her mind. And no matter how exciting the affair could be in the moment, it was always troubled, often crazy, and never happy. Yet the arguments were arguments—she held on to her self-respect, and to her grievances. And because I felt cherished and was all too aware of how much I craved her regardless, I heard those grievances.

The one that hit quick was my callousness about Dr. V. This was Feminism 101 stuff, and I'd blown it as I never would again—as regards infertility, anyway. In Carola's analysis, infertility was at the root of a sexual experiment based on magical thinking. Since being good had done her no good, she hoped against bereft hope that being bad would change her luck. Not that pregnancy was any kind of goal, she remained mindful of her ovulation date, but a Russian roulette aspect remained. Crucially, O'Laughlin was relentless once Carola opened the door by admitting an attraction that wasn't bizarre as mere attrac-

tion—as friends, we all shared real affinities. Also crucially, Carola was feeling like a failure and sex was something she knew she was good at. This represented a serious backfire for my theory that a woman who'd had lots of partners would be readier for monogamy than one who hadn't. But it turned out I was right, because Carola was experienced enough to put a disastrous experiment quickly and firmly behind her.

Back and forth, back and forth we excavated these themes and many others, in some cases for years. By fall we were seeing an Eastern European marriage counselor we soon found all too sophisticated as well as our own therapists, Larry McCready for Carola and Jimmy Serafini for me. It was Jimmy who pointed out that as an infant I'd lost my mother to my father every twenty-four hours and that as a three-year-old I'd lost my mother to my brother twenty-four/seven. So although I don't believe early-life experiences are determinative, I do kind of believe in separation anxiety. It was also Jimmy who challenged me when I told him I couldn't stop thinking about O'Laughlin. "Of course you can stop thinking about him. You have a will, don't you? Just stop. Think about something else." This was exactly what I'd had in mind when I insisted on a therapist who gave advice.

By then, however, the worst was long over, and I'd changed. I accepted that it was OK to submit my manuscript a few weeks late. I grew fond of a very modestly upscale restaurant dubbed 103 for its number on Second Avenue, a few doors down from the long-gone Ratner's. I reached the general conclusion that all marital-maintenance expenditures counted as necessities. I continued to slow my pace when we rode our bikes. And in an independent decision—Carola dropped not a hint—I cut my *cheveux longs*. I'd never been a hippie anyway. I was just stubborn, and cheap—haircuts cost money. But women are always switching hairstyles to mark metamorphoses. And even I could tell I looked better.

Carola moved back in September, and when the book was done we

flew to California for three weeks. There were fierce fights, and once she almost drowned in tricky surf as I cluelessly marveled at her swimming prowess from the shore. But it was restorative, and I was left with an image from a place we both loved—the hummingbird house of the San Diego Zoo. We sat in awed silence, watching the tiny creatures waft intently from feeder to feeder, always hungry, always needing more. I told Carola I was just like them—I always needed more. She told me she was the same. We promised to try our best to give it.

What didn't kill us made us stronger and all that jazz, but that doesn't mean we're glad it happened. We're just glad we love each other as much as we do, and sorry that's what it took to get a grip on it. The split left scars. But it also had an upside we didn't count on: it unblocked Carola, and if that's just because it gave her something to prove, we'll take it. She managed some terrific criticism while buckling down to *Girl Talk*, which she completed in the early spring of 1982—more book pieces than Riffs after the 1981 launch of the *Voice Literary Supplement*. M. Mark defined "literary" so expansively in its early days that Carola's magnum opus there was a six-thousand-word omnibus review of self-help titles called *Your Search for Fertility, Getting Pregnant in the 1980s*, and the like. Summed up by the perfect hed "Thinking About the Inconceivable," it was simultaneously emotional and cerebral, attracting the notice of the inchoate infertility community and epitomizing why I've told so many writers that journalism is worth putting your all into.

Once I'd reimmersed in contemporary music—I'm still convinced most of 1980's major albums appeared in the fall—I started writing a lot for M. too. Over the next few years there'd be a takedown of metafictioneer Robert Coover, a one-pager on *1984* as bestseller, eight thousand words on the Marxist literary critic Raymond Williams, who I'd come to value more than Pauline Kael herself. I'm proud of that

work, and sorry as a renegade English major that I haven't published more like it. But one book review resonated well beyond my academic retentions and aesthetic bloody-mindedness to connect me with a life-long mentor and friend.

Starting in 1977, when he called to apologize on behalf of his intellectual community for a low blow from highbrow boor William Phillips at a *Partisan Review* forum, Marshall Berman would phone once or twice a year to interrogate me about something I'd written. By the time M. assigned me *All That Is Solid Melts into Air* in early 1982, however, we were out of touch. Marshall had been bummed about the tendentious arch-postmodernist hatchet job the Sunday *Times* had sicced on him, and liked to say my rave had changed the book's public trajectory. I suspect it just cheered him up. Anyway, he phoned to thank me and kept talking, as was his wont. Soon he explained why he hadn't been calling. It wasn't just that he'd been preoccupied with his masterpiece. It was that on December 18, 1980, his wife had jumped out of their fifth-floor window holding their five-year-old son Marc. She had survived. Marc hadn't.

I was so far from the left gossip network by then that I knew nothing of this minor cause celebre, and soon it was me who was drawing Marshall out. We talked for hours and made a date, and within a month or two he and his soon-to-be second wife, Meredith Tax, who'd just published a bestselling feminist historical novel about the Jewish Lower East Side called *Rivington Street*, were among our closest friends. Marc's tragedy put our garden-variety crisis in perspective. Meredith's class-conscious feminism and naturalistic fiction were a double attraction for Carola. And Marshall and I just hit it off. I never met anyone with more to give intellectually—not Ellen, not Greil, not Simon Frith. It wasn't just vast erudition on instant recall, from ancient Greece to city government to the full spectrum of contemporary arts. It was that for all his immersion in Western Civ, he was a soulmate—an omniv-

orously democratic socialist who recognized that he was a citizen of capitalism. And as much as he had to impart, he always knew he had plenty to learn.

Marshall was fat and bearded and sported an ever-expanding collection of colorful T-shirts; he was regularly mistaken for Jerry Garcia until Garcia died and once or twice after. Although the students he treated like family came in all cultures, his friends were almost all Jewish, as were his three wives, and he attended a reform temple down the block from him on West End Avenue. Marshall put his sleep apnea to use by reading more than Simon Frith and then telling you about it. As a committed urbanist, he loved to walk the streets even though he had terrible knees, and only learned to drive when he was forty-three. He had a way of filling a room that got on some people's nerves. Meredith, not the world's most easygoing woman, dumped him hard in 1989 after literally saving his life in the wake of a botched brain abscess operation that was not his only brush with death. But Marshall was dogged and resilient, and his third marriage, to playwright turned high school teacher Shellie Sclan, was the tempestuous love match he'd dreamed. On September 11, 2013, he died instantly of a seizure-induced heart attack while eating a bagel at his favorite Broadway coffee shop.

All That Is Solid Melts into Air name-checks Buster Keaton, John Coltrane, R. Crumb, the Plastic People of the Universe, Sly Stone, and Bob Dylan while delving deep into Marx, Goethe, Baudelaire, and Dostoyevsky. I'd prefer more pop in this argument that the goal of modernism is "to give modern men and women the power to change the world that is changing them, to make them the subjects as well as the objects of modernization." But well before Berman's few pages on Pop Art—urban Oldenburg and Segal rather than suburban Wesselmann or metaironic Warhol—I recognized a fellow spirit. After taking

on Herbert Marcuse's elitism, Clement Greenberg's formalism, Harold Rosenberg's "tradition of overthrowing tradition," and—with somewhat less force—positivism from English Pop Art advocate Lawrence Alloway to uber-avant mystic John Cage, the introduction ends with a long volley at Michel Foucault, in whom I too smelled "an endless, excruciating series of variations on the Weberian themes of the iron cage and the human nullities whose souls are shaped to fit the bars." It was thrilling to encounter such a well-informed ally.

Berman doesn't worship the pantheon as an orthodox believer. His Marx is an exalted stylist as well as a dialectical theorist, his Faust a master builder as well as a driven seeker, his Baudelaire a scribbler for hire as well as a symbolist poet, his Dostoyevsky a gritty naturalist as well as a hyperconscious proto-existentialist. The long, Petersburg-based "The Modernism of Underdevelopment"—almost as long as the Goethe, Marx, and Baudelaire sections together—may lose you at moments. But it foregrounds Berman's core belief in modernism's political dimension as it returns insistently to the city street. The lowly clerks and alienated student *raznochintsy* on the Nevsky Prospect are his people, just as he focuses his analysis of *Faust* on those cast aside by the hero's progress and his account of Baudelaire on the ways happiness presupposes class privilege on Haussmann's boulevards. The heart of his urbanism is the way urban geography compels citizens to mingle and interact.

At under four hundred pages, *All That Is Solid* is not a weighty tome. But its "richness," to honor a clumsy word Marshall swore by, is immeasurable. Highbrow in its chosen artworks, it's populist in its definition of culture. And compared to most theory, it's a playground and a magic garden long before the apostrophe that transports the book into a realm of loopy literary fancy—a grand coup formally comparable to *Gulliver's Travels*'s disrespected "Voyage to Laputa" grab bag, or *Mystery Train*'s "Presliad," or *One Nation Under a Groove*'s "Promentalshitback-washpsychosis (The Doo Doo Chasers)."

Berman's vision of New York modernism stars Robert Moses, the bad-Faust urban planner he has the chutzpah to critique as an artist—one with good points at that. Then he pretends Jane Jacobs is a distinguished stylist like Karl Marx before her, in command of a "plain, almost artless" prose that makes her the poet of Hudson Street. And finally he covers over the retaining walls of Moses's Cross-Bronx Expressway with "the Bronx Mural," a myriad-styled fantasia stretching uncounted miles to Westchester. This imaginary visual celebration of all the Bronx's twentieth-century cultures features portraits by the hundred of its storied children, fifty-two of whom are named in a paragraph that includes George Segal, Barnett Newman, Bess Myerson, Bella Abzug, Stokely Carmichael, Calvin Klein, and the Kuchar brothers. In his *Times* review, Westchester native Leo Bersani snickers about the traffic pileups this artwork would cause, and it's true that Marshall never got automobiles. But he did understand the disruptive power of fantasy—which he told us again and again was a generative power as well.

Rereading *All That Is Solid* after Marshall died, I was briefly dismayed by my Jane Jacobs problem: her pastoral tendencies, her romanticization of the small-scale. But I'd forgotten something I would rediscover a few pages later—having glorified Jacobs like the disciple he is, Berman then brands her "pastoral" himself, particularly as regards race. He's quite critical about it. This kind of reversal happens regularly in *All That Is Solid,* most strikingly with Marx himself, for should society achieve the Marxian vision of historical turbulence dialectically synthesized, "it may be only a fleeting, transitory episode, gone in a moment, obsolete before it can ossify, swept away by the same tide of perpetual change and progress that brought it briefly within our reach." Where the academic left often brands Berman an optimist, tsk tsk, I sometimes think the romantic sufferer in him overstates the turmoil of everyday life. But two things are clear. First, how remarkable it was that he should have theorized turmoil before he was compelled to prevail

over the worst life trauma I've ever observed close up. And second, what a good idea it was to place Marx dead center in this analysis by plucking the phrase "all that is solid melts into air" from *The Communist Manifesto*.

All That Is Solid Melts into Air was conceived as a defense of modernism at a moment when Berman was gearing up presciently to combat the "postmodernist" reaction against the canon he still loved—a different battle inside the academy, where the theory crowd was instigating an opportunistic turf war, than in the pop world, where the anticanonical was a call to pleasure and pride. But terminologically, he picked the wrong fight—the term "modernist" remained obdurately mandarin, which Marshall obdurately was not. He stood proud as what he called a Marxist humanist because the term "humanist" was worth battling for and because claiming Marx is the loudest way to shout that class matters. But for Marshall, the humanist part came first. Unlike my other academic hero, "cultural materialist" Williams—whose UK was nominally socialist when he started out and who preferred his theorizing confreres across the channel to the cultural imperialists across the sea—Marshall never showed much interest in sectarian disputation beyond his long connection to the staunchly unsectarian *Dissent*. Instead he stayed true to his class by spending his academic career at the City University of New York, where for forty-five years he mentored working-class strivers not quite blessed enough to end up at Oxford and Harvard like him.

Not everyone thinks *All That Is Solid* is a masterpiece. It hasn't been translated into French or German because that's how Yurrupeans are, and even went out of print for a minute. But soon a translation had turned Marshall into a celebrity in Brazil, where he toured for a month in 1987 and returned many times, and since then it's also been translated into Japanese, Chinese, Spanish, and several less august languages, sometimes clandestinely—Marshall was proudest of the samizdat Farsi

edition in Iran. Without publishing another full-length book for over two decades, he remained a prolific essayist, lecturer, and reviewer. His *Voice* writing ranged from Lukacs to Harvey Pekar to Public Enemy. A 1995 history of Times Square for a *Voice* section on its redevelopment seeded 2006's *On the Town*, which focused almost entirely on the entertainments of the urban hub—and also, of course, its streets.

Marshall was such a romantic he could get goopy about street life—he loved the up-and-coming street-fair hustle, for instance, which I saw as a faux-retro signifier like bare bricks. The street had also gotten out of control as a trope in the resurgent rock I rooted for, although less in punk than in the still-skyrocketing Bruce Springsteen, who Marshall adored. But by the time Marshall and I met, a cacophony of boomboxes was blaring for all to hear that New York was generating a street music my posse could get behind for what it was without dreaming what it would become—not just the first music to arise literally from the sidewalks of New York since doowop, not just a fresh conduit for populist poetics, but the most formally and culturally decisive development in rock and roll since the Beatles except insofar as "Papa's Got a Brand New Bag" got there first.

Record nerd that I was, however, it's poetry enow that I was converted to hip-hop at home—and not initially by its poetics, either. My epiphany came one evening in December of 1980, when I lay on the floor of my office so captivated by the instrumental B side of the Funky Four Plus One's "That's the Joint" that it took half a dozen plays before I remembered to turn it over. This wasn't my first Sugar Hill twelve-inch. None other than Stephen O'Laughlin had recommended Grandmaster Flash's "Freedom" in July, and in November 1979, Baltimore-based newcomer J. D. Considine had reviewed the fifteen-minute novelty record "Rapper's Delight" in one of the brief Licks I'd started append-

ing to the Riffs section. For that matter, a new writer named Davitt Sigerson had raved earlier in 1979 about Apollo warmup act DJ Hollywood, who Carola and I—like Ellen and I giggling cluelessly over the hippie population of the Avalon Ballroom—had thought a Jocko Henderson-channeling oddity when we'd caught Al Green there. This is why Davitt got to run Polydor Records while I remained the Dean of American Rock Critics. I really don't do trends.

But I do have the courage of my enthusiasms, and I fell for this instrumental almost as hard as I'd fallen for "Honky Tonk" in Flushing twenty-five years before. I dug guitarist Skip McDonald stating the perky melody, got off on the crowd noises and rapped chorus and spoken interjections, fell for the cheerful sass of Ms. Plus One, a.k.a. Sha-Rock, and went gaga for Doug Wimbish's bass line. This wasn't the terse Bernard Edwards steal that propelled the Sugarhill Gang's opening shot into eternity—it was almost a lead instrument, carefully planned but busting with flash, filigree, and thwong. And on the A side I couldn't get enough of five golden voices and hearts of steel in "constant interplay around the solo moves, rap-rhyming in almost choral arrangements and quick counterpoint," as Vince Aletti put it when Sugar Hill Records hit the Ritz in March. We caught that show too, and brought Sue Steward, a onetime Sex Pistols publicist we'd met on our punk trip. Sue in turn flew back to London bearing musical knowledge she shared with her partner David Toop. Toop in turn published *The Rap Attack: African Jive to New York Hip Hop* in 1984. But none of us would have been so quick to the mark without Barry Michael Cooper.

Cooper was a burly, bespectacled deep thinker from Harlem who'd hand-delivered an unassigned, polygroovalistic review of the Parliament album *Gloryhallastoopid* that I ran just before I went on leave. Cooper kept writing for my fill-in of choice, a Yale music major with perfect pitch who'd caught on fast after the shock of the pencil-laying on his first Riff in 1978. Before and after his *Voice* stint, Jon Pareles

would oversee *The Rolling Stone Encyclopedia of Rock & Roll*, and a little later he became lead critic at *The New York Times*. Although he didn't assign any rap Riffs, he was proactive about enlisting African-American writers: in addition to Yoruba and Crouch, proofreader turned copy editor turned senior editor Thulani Davis, prolific young proofreader Carol Cooper, and Barry Michael Cooper, who when I returned was spilling over, in his intense and deliberate way, with tales of the rap groundswell. It was Barry's enthusiasm that set me listening to "That's the Joint." "Buckaroos of the Bugaloo," his astute rundown of mixing and scratching and rapping to the beat, ran in January.

Barry got into the *Voice* over the transom, and he's not the only one. Tom Carson did that. Trixie A. Balm. Roger Trilling. Future downtown classical critic Greg Sandow showed up unannounced one Monday morning in 1976 with a photography-included feature on street singers that went to press—what a time that was—*the same day*. Davitt Sigerson came bearing a few UK clips, the self-assurance of a world beater, and eventually James Truman, who well before he ran Condé Nast reviewed rock and roll for *The Village Voice*, regularly demanding last-minute revisions to expertly turned pieces that were miraculously improved thereby. But for reasons anyone can grasp as well as reasons that are slimy, most new writers network. So a brief genealogy is in order.

In 1978, Caribbean-born Rudy Langlais was brought in as the *Voice*'s first black editor. He eventually moved to *Spin* and then Hollywood, and I always found him too slick by half. But it was Langlais who recommended I talk to David Jackson, an eccentric all-purpose arts stirrer-upper from Memphis and Harlem who wrote five Riffs on Southern music from Al Green to the Allman Brothers in 1979. It was Jackson who brought in Thulani Davis, a poet of distinguished African-American lineage. And it was Thulani who told me about this well-bred Washington wildman she thought I'd cotton to: Gregory "Ironman" Tate, as he first dubbed himself. Meanwhile, it was transom

diver Barry Michael Cooper who urged me to try again with a writer whose first clips were so crude I'd rejected them posthaste: Nelson George, from Brownsville's Samuel J. Tilden Houses.

For me, this embodiment of my belief that, as Tate later put it, "Afro-diasporic musics should on occasion be covered by people who weren't strangers to those communities"—that it was impossible to cover black music right without input from black writers—was the most significant professional event of my late editorship. But many other excellent writers also surfaced, including such enduring pros as RJ Smith, James Hunter, Glenn Kenny, and future music editors Doug Simmons and Chuck Eddy—as well as others for whom rock criticism proved a way station, from future South Carolina English prof Debra Rae Cohen and future Karin Berg hire Michael Hill to future Seward Park English teacher Steve Anderson and future San Francisco health services communications manager Rosemary Passantino. I always thought the vocation was better off attracting temps and occasionals as well as lifers myself.

By then the notion of the rock and roll lifer was taking on a life of its own. For artists but also for scriveners like me and mine, it kept getting clearer that this music for kids could evolve into not just a career but a lifework. Many fools couldn't see past the surface contradiction, and many careerists were content to remain nothing more. But quite a few others seized the opportunity to, among other things, reconceive youthfulness itself, a boomer project if ever there was one. And for some that proved a losing battle. Major rock and rollers didn't stop dying after Brian, Jimi, Janis, and Jim founded their stupid club: Ronnie Van Zant went down flying, Keith Moon obliterated himself, Ian Curtis succeeded at suicide. But the three major rock deaths of the early '80s—including, I insist, the rock critic's—all left especially painful memories of promise laid waste.

It was after ten p.m. when the news of John Lennon's murder broke

on Monday, December 8, 1980, and I was at the paper heatedly protecting Carola's feminist Blondie Riff from an unflattering image chosen by photo editor Fred McDarrah. Instantly, McDarrah conceded and I went home to write my obit, where Carola raised a question of logic: "Why is it always Bobby Kennedy or John Lennon? Why isn't it Richard Nixon or Paul McCartney?" The front-page thousand-worder I completed at six thirty in the morning quoted her question and concluded that famous people who gave ordinary mortals hope often got blamed when hopes were dashed, and by Thursday we both had been widely accused of advocating the assassination of gifted Wings bassist McCartney. Even Carola was more bemused than discomfited by the misreading. But we were gratified when Cockburn came riding to our defense: "I can't see what the commotion is about. People do think, and say such things, in such times, and Christgau cashed the sentiment correctly." Lennon had just released the John-and-Yoko comeback album *Double Fantasy*, and although I admit I heard more in its antipunk polish after he died than I had before, I'm certain I was right the second time. Within a year I'd write two major Lennon pieces—one on his music, a collaboration with John Piccarella, and one on his marriage.

The news of Lester Bangs's accidental death from not much Darvon came by phone over Saturday breakfast on May 1, 1982, as his best friend, the quiet country music specialist John Morthland, worked his way down a long list of people who cared. My sister had bonded with Lester at the *Creem* house, and we were friendly—for all his invective in print, Lester was an exceptionally congenial man. But except as editor and writer, a big except, we weren't close, in part because, as a few of his millions of unpublished words indicate, he thought I was flaunting my Ivy League diploma when I argued ideas with him, as I did with almost everyone. But by all accounts he liked working with me, and in fact had phoned me from a pay phone the day he died to extend a deadline—not a suicide's move. At the *Voice*, Lester had upped his

game a little while I tightened his game a little and occasionally nixed some errant outpouring. The result was an unstaunchable stream of well-turned reviews that were insanely funny and full of heart, the spontaneous rock yawp of a wordslinger who listened to music harder than you because he needed it more. He had lots of fans on the *Voice* staff, and I admired his writing so much that his death hit me almost as hard as Lennon's—this was someone with what his man Iggy called a lust for life, not someone who couldn't wait to get out of his skin. So I phoned Schneiderman to secure a two-page spread that ended up comprising my obit and tributes from Greil, Georgia, and Billy Altman— Morthland was too broken up to contribute. A few days later there was a small memorial service where we met Robert Quine, Joey Ramone, and Joey Ramone's mother, and shortly after that I helped organize a wake at CBGB. When *Rolling Stone* failed to mention Lester's passing in its year-end issue, Morthland, Altman, Georgia, and I wrote to inquire as to how this oversight could possibly have occurred.

The third death came in between, on May 11, 1981. It was less a shock because the cancer rumors had been circulating for months, and got less play in the paper because it was announced so close to closing on a Monday that Thulani Davis's five hundred words had to be squeezed in well behind Riffs and didn't make the table of contents at all. But it's not as if we'd been letting Bob Marley slide. Just nine months before, Carol Cooper had published an impassioned *Voice* report that came down with righteous scorn on how foolishly Marley's hippie-manque claque dismissed his desire to reach the African-American audience—an audience that would within a decade align itself with Marley's third-world deifiers worldwide. In May of 1982 Trinidadian journalist Isaac Fergusson added a more balanced and substantial appreciation. And what Davis squeezed out on that death deadline was so right: "I have no empty space. I have not been saved but I have heard what it sounds like to be free and not fear to exult 'in this life, in

this life / in this oh sweet life.' 'We've got to fulfill the book' is how it is. Bob Marley trusted and let us." Thulani was a poet before she got to the *Voice* and never stopped being one. Awestruck yet unsentimental, her tribute demonstrated why Afro-diasporic musics should on occasion be covered by people who aren't strangers to those communities.

Lester was irreplaceable, but no matter what they thought out at *Creem*, he was also inimitable. So I missed him as a one-of-a-kind writer rather than a critical thinker, especially since he was prone to the same rock-is-dead disease that had afflicted so many lesser idealists back in 1968. In my view music was mattering all over the place in those years. Every one of our black critics felt it. And for context note that among the forty or so artists tackled by my go-to guy Piccarella alone in the 1981–84 period were Bruce Springsteen, Elvis Costello, X, R.E.M., Donald Fagen, Lou Reed, Smokey Robinson, Bunny Wailer, Captain Beefheart, Kid Creole and the Coconuts, Warren Zevon, the Rain-coats, Flipper, Big Youth, Gregory Isaacs, Willie Nelson, Jamaaladeen Tacuma, Lester Bangs and the Jook Savages, and the Plastic People of the Universe. This is a highly semipopular list—only Springsteen qualified as POP. But Smokey Robinson was eternally pop, Fagen had been pop, R.E.M. would become pop, Kid Creole was Pop in the Pop Art sense, country icon Willie Nelson claimed all pop, the Jamaican icons were pop rebels, and—how much mattering do you want?—the Plastic People would in 1989 help instigate a Velvet Revolution named after Reed's old band. Pop significance comes in many forms.

Beyond Uncle Lou and Lester himself, however, there are no New Yorkers in the group, including proud Philadelphian Tacuma, the bass-ist who fronted one of the period's dozen or so terrific full-lengths show-casing the NYC-based harmolodic funk inspired by Ornette Coleman and spearheaded by Blood Ulmer, who Giddins and I had co-reviewed

with hype aforethought in 1979 and who came under the management of Roger Trilling shortly after my ex-writer climbed in the Tin Palace window to see his Stanley Crouch-booked set. The Beastie Boys were hardcore, Sonic Youth were still confused about sex, and Yo La Tengo hadn't found their bass player. True, there were Bergen County's Feelies, first hailed by Piccarella in a lead review that began its life as a pitch letter and also managed by Trilling for a time. Nevertheless, the major Amer-indie bands the CBGB glory days were generating in that era came from other cities, particularly L.A., Minneapolis, and Athens, Georgia—not New York. The likes of the B-52's, R.E.M., the Replacements, Los Lobos, X, and Hüsker Dü were seminal, generating a historically conscious, his-torically progressive indie-rock "alternative" where their British counter-parts tended prog even when claiming the poppist New Romantic label. And of course, right then black New Yorkers were inventing a music more momentous than punk, and it wasn't harmolodic funk.

By most measures this was a dark moment in black music. With disco scapegoated in an investment bubble floated by a cabal of coke-snorting white bizzers, pop radio hadn't been whiter since 1954. And radio was more integrated than the hot new MTV, which agreed to broadcast a notorious paean to street violence called "Beat It" by feared thug Michael Jackson only after CBS Records threatened to withdraw all its other content. Yet coincidentally, in a development attributable more to the civil rights movement than to any musical specific, Afro-diasporic sounds were attracting ambitious journalists from within and around their various communities. Schneiderman had already drafted me to edit Crouch, the paper's first black staff writer, and now, due to the genealogy I've described, Riffs was home base to two young black men with big futures there. But although they always got along and always admired each other, Nelson George and Greg Tate exemplified how foolish it is to pretend there's a single African-American culture.

Like Michael Daly, St. John's graduate George loved *The Daily*

News—it was his conscious goal never to write anything that couldn't be understood by a reader of New York's signature tabloid. The projects-raised son of a divorced mom who attended college at night and became an assistant principal, he was in the *Voice* less than Tate, but since he was holding down a job at *Billboard* and turning out an exemplary quickie bio of the thug Jackson, those were the breaks—the man worked so hard he literally wrote on the subway. His range was broad, he had friends in the rap business, and his first two *Voice* bylines were Licks: one on the Harlem World Crew, one on "The Adventures of Grandmaster Flash on the Wheels of Steel." But most of his Riffs praised r&b bestsellers: Luther Vandross, Rick James, Maze, the sublime DeBarge. Although Nelson's copy required considerable cleanup, he was always clear, and since he was an indefatigable learner who'd been on the beat since college, his insights were on point whether you agreed with his judgments or not. Later in the decade he'd write (and I'd edit) a general column called Native Son, which he later yoked with his reviews in a collection about "post-soul culture" entitled *Buppies, B-Boys, Baps & Bohos*. Nelson has published many nonfiction books and several novels and written and/or directed and/or produced many films both fictional and documentary, a few in conjunction with my old student Sean Daniel. He has been, in short, the kind of pop force my theory of pop once imagined all too vaguely. I'm proud to have had anything to do with him.

Of course, I'm proud to have had anything to do with Howard dropout Tate too, and he was altogether different: an explosive stylist who needed more trimming than cleanup as he applied his pyrotechnic rhetoric and giant brain to the lifelong task of defining and flabbergasting a broadly conceived African-American avant-garde. A self-designated "Black Bohemian Nationalist" of self-designated "black radical-professional parentage," he invented an Ebonics-goes-Phi Bet prose initially reserved for the *Voice*—a 1983 *Downbeat* survey of '70s

Miles was notably straighter, albeit colorful in that workaday context. Greg was funnier than Nelson and sometimes funnier than Lester, and jammed as many ideas up in there as me or Greil or Ellen Willis, although maybe not Simon Frith. And naturally his turf was well to Nelson's left. He broke down any kind of funk, jive-talked around jazz encyclopedist Giddins and jazz traditionalist Crouch, and pursued a minor in rock guitar. His debut hip-hop review extolled Rammellzee vs. K-Rob's graffiti-world "Beat Bop," which he reckoned made " 'The Message' sound like a rerun of *Good Times*." Black Bohemian Nationalist forever, he formed his Burnt Sugar ensemble in 1999, thirteen to thirty-five players I once triangulated as "electric Miles with soul, 'Maggot Brain' with a PhD, the Hendrix-Evans band of dreams." In some form or other, Burnt Sugar plays on as I write.

Riffs still reviewed more white artists than black ones. After all, there were more. But with Tate and George locked in and pan-Afro-diasporic Carol Cooper writing even more often, the percentage shift got noticed. Shortly before my editorship ended, Ira Kaplan, with Yo La Tengo still a decade from greatness, began a Riff about the fine little critic-led Dumptruck with an alphabetical list of twenty-four indie hopefuls he thought as worthy as "the seekers of the perfect beat that these pages are currently all but devoted to." He was right about a few—I should have nabbed a Fall piece and was too hard on Half Japanese. But most of them proved as forgettable as I figured, and not only that—I bet I could hear them better than Kaplan could hear DeBarge, "D" Train, or Mutabaruka. Which is not even to mention what was then known as rap.

At the urging of onetime Insect Trust sax man Robert Palmer, *The New York Times* was also on hip-hop quick, and only as the '80s progressed were there all that many hip-hop records to be on. Nevertheless, the *Voice* made the effort. Richard Goldstein loved graffiti. Sally Banes was into break dancing. And since the twelve-inch remained the mu-

sic's consumable of choice, the Licks option proved well timed, as did the singles chart I'd added to Pazz & Jop—although only Flash's "The Message" finished first, nine rap singles made the P&J top ten between 1981 and 1984. From John Morthland to Marshall Berman, everyone I knew could see that the music was just getting started, and the *Voice* was where to read extry-extry about it. No wonder serious Dumptruck fans were nervous. In the spring of 1984, when Profile finally released the first major rap album, the eponymous *Run-D.M.C.*, my reviewer was Carola Dibbell. "Not only are they unashamed of who they are, they're combative around it. A boast: 'I go to St. John's University.' An insult: 'You're fightin' all your life / You're cheatin' on your wife / You walk around town like a hoodlum with a knife.' Politics: 'We receive much lower pay. / It's like that / And that's the way it is.' Philosophy of life: 'Why you wear those glasses?' 'So I can see.'"

My bad for not assigning a lead.

As always, Carola and I were listening to all kinds of music in the early '80s. We danced to "DOR" (the briefly universal acronym for dance-oriented rock, which was in turn the respectable way to say new wave disco) at Hurrah and Danceteria, booked by our and everyone's friend Jim Fouratt, more than the supercool Mudd Club. We liked it when Amerindie bands split male-female: B-52's, X, Human Switchboard. We checked out tiny local gigs where Marylin's Stuyvesant-dropout son Perry was doing the sound. We returned from England in 1981 bearing a grotty cache of Nigerian-manufactured King Sunny Adé albums. We were the only writers we know of to witness the Twin Cities' Hüsker Dü run over a tiny crowd at the Bowery's bikerish Gildersleeves or Kinshasa's Franco motorvate an unimagined aggregation of decked-out Africans atop the Manhattan Center. And of course, the stereo groaned beneath vinyl on spec. But the vinyl we played at breakfast,

a leisure moment not yet relegated to Consumer Guide service, was twelve-inch singles often as not. Pile them on the changer, butter your English muffin, enjoy.

These included many rap records in addition to Flash and "That's the Joint." Pumpkin's bump and Kool Moe Dee's speed-rap pacing each other through the Treacherous Three's "The Body Rock." A lot of other Treacherous Three. The Fearless Four's staggered-electro chant-rap "Rockin' It." Run-D.M.C.'s guitar-flaunting avow-rap "Rock Box." The Sequence's woman-powered "Funk You Up." The Mean Machine's Español-powered "Disco Dream." Newcleus's Smurf-powered "Jam On It." Brother D. & Collective Effort's prematurely conscious "How We Gonna Make the Black Nation Rise?" Time Zone's pathologically conscious "World Destruction" uniting John Lydon and Afrika Bambaataa on one vinyl stage. The far more hopeful "Unity" uniting the selfsame Bambaataa with "The Godfather of Soul James Brown."

Bambaataa had initiated rap's electro phase with "Planet Rock," whose Kraftwerk samples I distrusted because I'm prejudiced against Germans. But the follow-up, "Looking for the Perfect Beat," became our most-played record of the era, one of the few twelve-inches on my unkempt shelves with a protective plastic sleeve. We even came to hear the bonus beats as part of the song. Of course, many would say the beats were the song—producers Arthur Baker and John Robie get top composer credit, which technically I'm sure they deserve. This was before virtuosos like Chuck D and the unprecedented Rakim eclipsed rappers as skilled as Kool Moe Dee. Crews were looking for the perfect beat in a literal sense, rockin' it and funking you up as they pursued their disco dream. And this well-named record provides a version of that perfection as long as it's understood that these are beats in the hip-hop sense—not grooves, just rhythm music, so hard to break down timewise it reduces you to naming sounds: pizzicato synth, click-track synth, bubble synth, orch/horns synth, synthed scratches, many synthed

vocals, countless treated (synthed?) drumbeats, rappers who bark like dogs, rappers who buzz like bees, rappers who go dooda-loodle-loodle-loo *loot*-doot-doo, rappers who rhyme in human-sounding voices. Mostly they rhyme about looking for what they already have: the perfect beat. In fact, the totality is so utopian that I can't help but credit that totality to Bambaataa, who is said to have abandoned his post as a Black Spade warlord to become a border-crosser committed to uniting Bronx youth through music. Key line: "Life has meaning, our music keeps on pleasing." Now and forever.

It's hard to remember that rap in this period, however phenomenal and foreseeable its potential, was from a pop perspective a subset of dance music—that is, disco, which responded to major-label cowardice by getting grittier and more daring after it supposedly went bust. So we listened to more dance twelve-inches than rap twelve-inches insofar as we made the distinction, our very favorite the long Taana Gardner tease "Heartbeat," a record so universal I watched Geoff Travis pitch the rough-hewn proprietor of West End Records to let Rough Trade distribute it in England for nothing up front and a huge per-unit return—an offer the goniff refused, costing himself a pretty penny. "Heartbeat" was among my top ten singles of the decade. But two others placed even higher.

T. S. Monk's "Bon Bon Vie" had no connection to Thelonious Monk except a big one—Monk's son, bandleader Thelonious Sphere Monk III, a.k.a. Toot, plus his sister Boo Boo and his fiancee Yvonne Fletcher. Their 1980 debut album was produced by Sandy Linzer, a veteran songwriter with enough catalog to keep a hack's head up—the Toys' "Lover's Concerto," the Four Seasons' "Workin' My Way Back to You," Odyssey's "Native New Yorker"—who had also recently produced Dr. Buzzard's Original Savannah Band, the rare artistic entity to claim retro and make it live. But not even Dr. Buzzard put such a spin on "the good life." "Bon Bon Vie" engineers its escape by devoting three stanzas to Toot's clock-punching weariness and alienation, one to how

much he loves New York anyway, and one to a champagne-quaffing night on the town, the final line of which leaves his last dime in a blind man's cup. Yet in all five stanzas the Chic-like spritz of Toot's arrangement and the good-humored ebullience of his vocal exemplify a Gramsci precept Marshall Berman loved: "pessimism of the intellect, optimism of the will." Linzer never gave the band another decent song. And then, in a Marshall-worthy turn, both Boo Boo Monk and Yvonne Fletcher died of breast cancer in 1984. After a period of seclusion, Toot emerged to head Boo Boo's brainchild, the long-running Thelonious Monk Institute of Jazz. He also started a pretty good jazz group. But even rearranging his father's indelible book, he never came up with anything as complex and distinguished as "Bon Bon Vie."

Imagination was a more durable and useful band than T. S. Monk. They always established a groove—steady-state funk-lite featuring the soft-edged falsetto of Leee John, a New York-educated gay Londoner of West Indian descent who named his group after a John Lennon song. This was a pragmatic sort of sex music that would never distract you from the act itself—"Body Talk," they called their first hit, which failed to break here. In 1982, "Just an Illusion" did break, at least on the dance and r&b charts, followed by the livelier and more explicit "Burnin' Up." But "Just an Illusion" was our song—in truth more Carola's than mine, although I grew to love it. "Searching for a destiny that's mine," began a lyric that repeated the word "illusion" thirty-two times, and no way did Carola think that illusion was unrequited love. The illusion was the hope she still felt every month, and that every month eluded her a lot more abruptly than the engineer lowering the volume to zero as Imagination sang on.

In December of 1984, we celebrated our tenth wedding anniversary. In the five years before our ceremony, no one we knew had gotten mar-

ried. In the subsequent ten, nearly a dozen close friends and many other fond acquaintances took their vows, including Tom and Laura, Dominique, Georgia, and Perry Brandston. Georgia met trumpet-playing, law-school-bound Steven Levi at the *Voice*, where he'd tried to organize a union, moved up to production manager, and quit when Murdoch's people implemented a union-busting scheme in the department he ran; Perry met Sara, who in not very long would be doing our taxes, as a green-haired DJ from the union-built co-ops in the deep Lower East Side. In these cases and almost every other, the marriages were conceived with a hope both less dewy-eyed and more aspirational than the couple's parents could have known. Not all of them lasted, although more did than didn't; Charlie Berg's ended when he died of cancer and Tom Hull's when his wife died of diabetes; three were second tries, including that of Bruce Ennis, who by December of 1984 was awaiting the son he'd thought he'd never have. There were already numerous kids in this bunch, and I should mention that Ellen Willis, who wouldn't marry Stanley Aronowitz officially till much later in what she always insisted was an economic maneuver, got past a miscarriage to bear Nona Willis Aronowitz in 1984. Dominique's daughter was named Carola, and two other girls were declared our godchildren in recognition of our plight. Georgia and Steven gave us a niece named Louise. Mom and Dad came into the city from Queens once a week to babysit as Georgia edited an ecology magazine.

Back in the baby chase ourselves as of late 1980, Carola and I had gone the distance with two humane, sharp-thinking infertility specialists by 1983, the first recommended at one of those weddings, the second by an admirer of "Thinking About the Inconceivable." Carola underwent a laparoscopy, I had surgery on my left testicle, and then we moved on to less invasive treatments, although the timing could be stressful. Twice we tried AIH—artificial insemination with the husband's sperm. But the sole fruit of all these efforts was Carola's painful,

skeptical, compassionate, funny little hospital story "Healing Grace," published by *The New Yorker* in 1981. Every month hope abruptly disappeared.

In 1984, there were two big changes at the *Voice*. First the rival *Boston Phoenix* reported that Alexander Cockburn had taken a ten-thousand-dollar book grant from a pro-Arab think tank to investigate Israeli incursions into Lebanon. Given the caustic anti-Zionism Cockburn came in with, this wasn't much of a scandal unless you thought Arabs were scandalous by definition, and initially Schneiderman seemed to defend his writer. But all of a sudden the finest left journalist in the country got canned in what was coyly labeled an indefinite suspension—the first indication of the centrist politics Schneiderman would favor as he bought into uptown cliches about the paper's supposedly irresponsible supposed radicalism. A week after the announcement *Voice* readers flooded a double-length letters section with statements of support. Cockburn always had enemies at the paper, and no one claimed he was above making a swift buck. But I knew few colleagues who weren't deeply disheartened.

The second change came in May, when my onetime writer and neighbor and longtime friend Kit Rachlis, who happened to be the arts editor of the *Phoenix* and before too long would become the award-winning editor-in-chief of three major periodicals in L.A. and one in Washington, was hired as the *Voice*'s arts editor. Soon Kit—at the behest of Schneiderman, who was chary of speaking up himself—was wondering out loud whether I mightn't consider changing my job at the paper. Was I writing enough? Did I really want to be music editor in perpetuity?

I'd been wondering myself, but for personal reasons. Ten years had passed since Carola put away her diaphragm and I my condoms, and I was finally ready to relinquish a dream of biological parenthood that was romantic two ways: erotic, flesh-and-blood proof of our sexual

bond, and spiritual, the old two-selves-made-one trick. After briefly checking out a new but screwy-looking allergy-based infertility theory, we decided enough was enough, and on yet another crucial Maine vacation resolved to pull out the stops on adoption, going for a newborn because we wanted input from inception—and also, admittedly, because we loved babies. As I conceived fatherhood, that would leave too little time for my Riffs babies, so I told my bosses I wanted to stop editing at the end of 1984.

The starry-eyed vibe surrounding adoption—the self-righteous presumption that it was among other things an act of charity—made us uneasy. So we jumped when we encountered a hardheaded, impolite talk by a specialist in international adoption with her own black-Vietnamese daughter. Her best contacts at that moment were in Honduras and Chile. Chilean infants were on average fairer-skinned and seldom under six months; Honduran adoptees tended younger, and she felt a warmth from her people there. Soon we'd contacted her Westchester-based Honduran partner, and before Christmas we were digging into the paperwork—weeks of it.

In December too there was a surprise non-retirement party for me at CBGB. More Riffs veterans than I could comprehend were there, including Paul Nelson, already embarked upon a seclusion that proved permanent, and Greil Marcus, by then ending his focus on the contemporary music beat as he labored over his acknowledged masterwork *Lipstick Traces*. Kit Rachlis, who'd been *Phoenix* music editor until mid-1982, recalls that to many there it felt like the end of an era. And in a way it was—rock criticism had certainly devolved from a vocation into a career, attracting too many hacks, middlebrows, and celebrity chasers. But no way did I believe my departure signaled any diminution of my own passion for music, or any loss of faith that the *Voice* would continue to find young seekers and crazies to cover it. Nor, looking back, do I think I was wrong.

Nevertheless, I had another future on my mind. Somewhere in a Central American country I was just beginning to read up on, at a moment I had no way of predicting, a new life would change mine. I was romantic about that too, but not so romantic I believed it would be anything but difficult. All I knew for certain was that without that new life my own life would never be what I wanted it to be. And about that I wasn't wrong either.

On June 20, 1985, Carola and I flew to San Pedro Sula, Honduras, where the following day we would meet Nina Dibbell Christgau, then exactly two weeks old. Daily, as I carried her in my arms around the humid streets while Carola sank into the afternoon nap she'd been longing for, I would tell my daughter over and over: "You are a cutie-pie. You are a troublemaker. And you are my favorite."

Well, there was her mom. But on the whole, right again.

ACKNOWLEDGMENTS

Thanks first of all to my faithful friend and agent Sarah Lazin for making me put months into mapping out this book and then spending more months than that finding a publisher. Thanks to Cal Morgan and Denise Oswald of HarperCollins's departed It imprint for taking a flier on a formally unconventional memoir and to Denise Oswald of HarperCollins's spanking new Dey Street imprint for keeping it that way. And thanks to my manuscript readers. In his own class was Tom Carson, who was quick, assiduous, and enthusiastic with general analysis, useful nitpicks, and answers to specific questions. Roger Trilling and Tom Hull proved equally eagle-eyed copy editors and proofreaders, and Stacey Anderson and Tom Smucker offered moral support.

Whenever possible I've augmented recollection with research, and I've had a lot of help. Georgia Christgau oversees our family archive and shared many crucial items with me, including the snapshot that kicks things off. Greil Marcus and Bill "Gatz" Hjortsberg photocopied my old letters for me. Larry Dietz let me consult his complete bound *Cheetah* for longer than I should have. Fran Greenwald Scheff did the same with our Flushing High School yearbook. Barbara Browner

Gilman unearthed the *Flushing Folios* I edited and then photocopied them for me to keep. Silver-Blue lifer Howard Papush did deeper Flushing High research. I don't know the names of the unfailingly accommodating (and unionized, fancy that) municipal employees who guided me around the Queens County Clerk's Office or the librarian at Dartmouth who located those old *Greensleeves*, but I'm thanking them anyway. I do know it was Susan Sgambati at Flushing High School who enabled me to peek at the dreaded "permanent record" teachers held over our heads. Brian McManus, Bob Baker, and Jesus Diaz welcomed me into the *Village Voice* library with its beloved card catalog for many visits to the paper's current office next door to the Federal Reserve, with Bob scanning and emailing crucial pieces. Billy Altman scanned a crucial piece from *Creem*. And Carola Dibbell, always Carola Dibbell, kept finding stuff for me, in our overstuffed apartment and her ample memory.

Sometimes in person, usually by phone, almost always via email either way, all of the following shared memories with me, sometimes for hours, sometimes for just a fact or two. I thank each of them for their input and, in almost every case, the ways they've added to my life that don't show up in this book, and apologize to anyone I've forgotten: Judy Adler, Vince Aletti, Paul Alter, Caroline Andrew, Nick Angrisano, Nona Willis Aronowitz, Stanley Aronowitz, Bob Baker, the late Marshall Berman, Nancy Ahlf Blumenberg, Perry Brandston, Patrick Carr, Tom Carson, Christine Christgau, Doug Christgau, Georgia Christgau, Naomi Feldman Collins, Judith English Conley, Blanche Wiesen Cook, Carol Cooper, Sean Daniel, Bill Daniels, Christopher Devine, Jesus Diaz, Dominique Dibbell, Julian Dibbell, Larry Dietz, Tony Fisher, the late Don Forst, Nelson George, Barbara Browner Gilman, Richard Goldstein, Rich Green, Marylin Herzka, Ed Hirsch, Bill "Gatz" Hjortsberg, Jim Hoberman, Mark Jacobson, Joe Koenenn, Laura Kogel, Judy Farran Lazev, Sarah Lazin, Steven Levi, Leonard Lipton, Greil Marcus,

Jenny Marcus, Dave Marsh, Linda Mevorach, Dominique Morrone, Dave Nesbitt, Howard Papush, Marianne Partridge, Rosemary Passantino, John Piccarella, Judy Pritchett, Ann Lynn Puddu, Kit Rachlis, Maruta Lietins Ray, Maryse Ritter, Lisa Robinson, John Rockwell, Frank Rose, Beverly Kantor Rosen, Phyllis Blaustein Rosenblum, Fran Greenwald Scheff, Shellie Sclan, Betty Sinowitz, Bea DiPaolo Skala, Vicki Custer Slater, Tom Smucker, Nan Stalnaker, George Szanto, Kit Szanto, Greg Tate, Diana Kahn Taylor, Dan Tompkins, Roger Trilling, Ed Victor, Julien Yoseloff, Evan Zuesse.

Finally, who else? As always only more so, my wife, Carola Dibbell. She did all the things spouses are supposed to do for authors—put up with their distractions and obsessions while offering physical support, restorative companionship, key advice, and unfailing love. Although I find it hard to believe other writers have been as lucky in these basic matters as I have, I know or at least hope that most of them feel the same about their spouses. But something else I'm somewhat surer of. Because Carola is a gifted stylist who knows more about extended narrative than I do and sometimes more about my life too—and also because she's Carola—I bet very few authors have enjoyed such savvy, empathetic, thought-through, and on occasion inspired editorial attention. Love you darlin'.

And as for Nina—thanks for providing me with not just one ending but, now, two. Love to you always.

ABOUT THE AUTHOR

Robert Christgau has covered popular music for *Esquire, Newsday, Creem, Playboy, Rolling Stone, Blender,* and MSN Music, and from 1969 until 2006 for *The Village Voice,* where he was a senior editor and chief music critic for thirty-two years. He is currently a columnist for Billboard.com, a contributing critic at NPR's *All Things Considered,* and a Visiting Arts Professor at New York University. The author of three books based on his hundreds of Consumer Guide columns and two essay collections, he has been a Guggenheim Fellow, a National Arts Journalism Program Senior Fellow, and a Ferris Teaching Fellow at Princeton. Born and raised in Queens, he has lived in Manhattan's East Village since 1965.

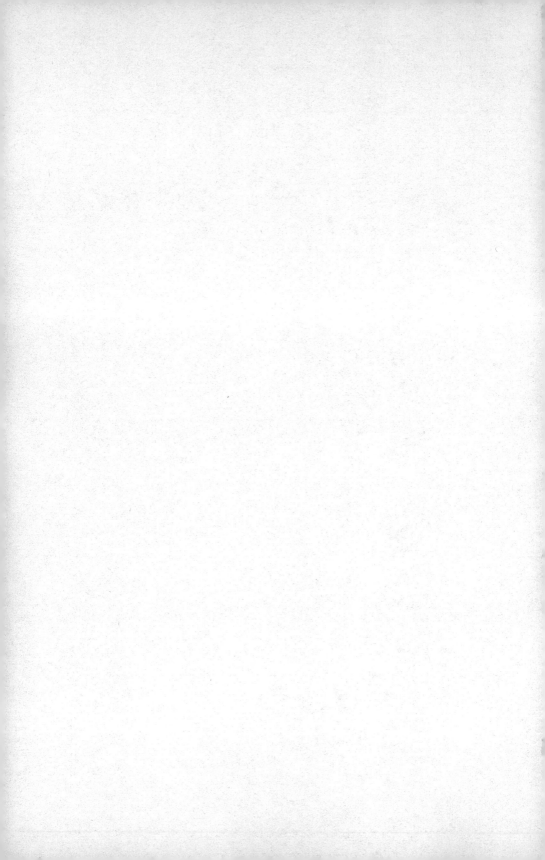